The C. R. Smith Collection of Western American Art

Published for The Archer M. Huntington Art Gallery, College of Fine Arts, The University of Texas at Austin

Collecting the West

by Richard H. Saunders

 University of Texas Press, Austin

First Edition, 1988

**Library of Congress Cataloging-in-Publication
Data**

The C. R. Smith Collection of western American art.
 Bibliography: p.
 Includes index.
 1. West (U.S.) in art — Catalogs. 2. Art, American —
Catalogs. 3. Art, Modern — 19th century — Cata-
logs. 4. Art, Modern — 20th century — Catalogs.
5. Smith, C. R. (Cyrus Rowlett), 1899– — Art collec-
tions — Texas — Austin — Catalogs. 6. Art —
Private collections — Texas — Austin — Catalogs.
7. Art — Texas — Austin — Catalogs. 8. Archer M.
Huntington Art Gallery — Catalogs. I. Saunders,
Richard H., 1949– . II. Archer M. Huntington Art
Gallery.
N8214.5.U6C2 1988 758′.9978 87-25526
ISBN 0-292-71112-3

Contents

Foreword 6

Preface 6

Collecting the West: Art Patronage and the American West, 1800–1950 8

 The Era of Exploration and Curiosity 9

 The Western Landscape 17

 Indians, Cavalry, and Cowboys 20

 The Cowboy Hero 25

 Sculpting the West 31

 Marketing the West 35

 The Rise of the Specialized Western Collection 37

 Ethnologists, Hunters, and Conservationists 40

 The Changing Climate for Western Art 42

 The Great Depression and the 1940s 45

 Postscript 50

Catalogue of the Collection 53

Works in the Collection Not Included in the Catalogue 198

Bibliography 201

Index 207

Foreword

Over the years one of the most respected and beloved friends of the University of Texas at Austin has been C. R. Smith. Austin and the university have always had a special place in Mr. Smith's affections and he has generously given both time and a substantial collection of western art to UT. A living legend in the aviation business, Mr. Smith served as chief executive officer for American Airlines, as U.S. secretary of commerce, and as major general in the U.S. Army Air Force. In 1963 he was selected to receive the Distinguished Alumnus Award of the University of Texas Ex-Students' Association.

Mr. Smith has given the majority of his collection of ninety-one works to the university over the last twenty years. This collection, a major teaching and research component of the Huntington Art Gallery, enjoys enormous popularity from a very diverse audience both at the university in Austin and in the state of Texas. Used primarily by students of American studies, American history, and American art history, this collection evokes the imagination of Americans everywhere. These works of art can be analyzed stylistically, related to the careers of the artists, related to the historical events that inspired them, and seen in relationship to the phenomenal development of the American West and western art itself.

The Archer M. Huntington Art Gallery is indebted to the National Endowment for the Arts, the University of Texas Press, and the Huntington Art Museum Fund for underwriting the publication of this catalogue of Mr. Smith's collection. In addition, we are indeed grateful to Dr. Richard Saunders, who began researching and writing this catalogue when he was teaching at the University of Texas at Austin, before assuming the position of director of the Christian A. Johnson Memorial Gallery, Middlebury College, Middlebury, Vermont.

On behalf of the Huntington, thanks go to all the individuals, organizations, and national agencies that have made possible this comprehensive catalogue of the American western art given to the university so generously by C. R. Smith.

ERIC MCCREADY
Director
Archer M. Huntington Art Gallery

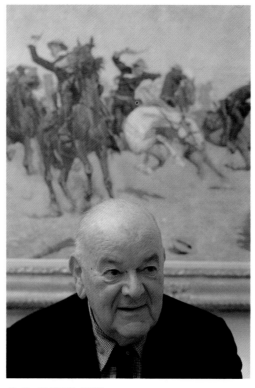

C. R. SMITH, 1975 Photograph © by Dan Wynn

Preface

In October 1934, C. R. Smith, then only thirty-five, was elected president of American Airlines, which had been organized four years earlier. Through his guidance over the next twenty-five years, the airline grew to become America's largest and most innovative air carrier. *Time* magazine aptly summarized his abilities:

With the shrewd calculations of a gambler, the financial sagacity of a banker and the dedication of a monk, he has propelled American Airlines into first place in the industry — and in the process has done more than any other man to improve the service and standards of U.S. airlines. (November 17, 1958)

During these years, in his few free moments, C. R. Smith applied these same abilities to the formation of a major collection of the art of the American West. With his first purchase, William Leigh's *The Roping* (p. 148), he became part of the calendar of collectors and patrons who since the beginning of the nineteenth century had in one form or another contributed to the expanding documentation and romanticization of life in the American West.

This appreciation of western imagery by artist and collector alike has continued uninterrupted to this day. But its genesis and the documentation of the actual chronology and specific nature of the relationship between the artist and collector, as well as the earlier patrons, has been addressed largely tangentially. The following essay, then, is a thread by which to chart the development of these symbiotic groups and to consider what fueled first the patrons' and later the collectors' appetites for western imagery.

Projects such as this involve the vision and encouragement of many people. I first of all wish to thank Eric McCready, Director, the Archer M. Huntington Art Gallery, who supported this project from the outset, and the Department of Art at the University of Texas for allowing me partial leave during fall 1983 to conduct research on collecting. Gallery

support enabled me to travel to Fort Worth and Houston on several occasions, as well as to Washington, D.C., to meet with C. R. Smith. Also, the project would never have come to fruition without the generous support of the University of Texas and the National Endowment for the Arts, both of whom provided funds for its publication.

This project began in 1983 as a graduate seminar taught at the University of Texas. I am particularly grateful to those students — Carolyn Appleton, Karen Bearor, Amy Oakland, Eileen Pols, Mark Smith, Lila Stillson, and Lisa Ward — for their participation and their subsequent contributions to the catalogue. Their enthusiasm for this project carried over to Natasha Bartalini, Francine Carraro, and Patricia Dannelley Hendricks, who completed the catalogue work. The entries on Henry Farny first appeared in the catalogue of the exhibition Henry Farney, 1847–1916, sponsored by the Huntington Art Gallery in 1983, which also grew out of a graduate seminar I taught at the university.

I am indebted to the collectors, dealers, librarians, and museum professionals who lent their time and knowledge. I particularly wish to thank Paul D. Benisek, Assistant Curator of the Railway Art Collection, Santa Fe Southern Pacific Corporation, Chicago, Illinois; Keith L. Bryant, Jr., Professor, Department of History, Texas A&M University, College Station, Texas; Hillary Cummings, University of Oregon Library, Eugene, Oregon; Mrs. Allerton Cushman, the former Mrs. George Rentschler, Millbrook, New York; Lynn D'Antonio, University of Arizona Library, Tucson, Arizona; Peter Davidson, New York; Rita S. Faulders, The Edward Laurence Doheny Memorial Library, St. John's Seminary, Camarillo, California; James Taylor Forrest, Director, University of Wyoming Art Museum; Patricia Geeson, National Museum of American Art, Washington, D.C.; Gene M. Gressley, Assistant to the President, American Heritage Center, University of Wyoming; Rebecca Haidt, Curatorial Assistant, Washington University Gallery of Art, St. Louis, Missouri; Peter H. Hassrick, Director, Buffalo Bill Historical Center, Cody, Wyoming; Charles E. Hilburn, Gulf States Paper Corporation, Tuscaloosa, Alabama; Katherine S. Howe, Curator of Decorative Arts, The Museum of Fine Arts, Houston; Joan Knudsen, Registrar, Robert H. Lowie Museum of Anthropology, University of California, Berkeley; Frederick W. Lapham, III, Lapham and Dibble Gallery, Shoreham, Vermont; Linda Stone Laws, Curator of Art, Woolaroc Museum, Bartlesville, Oklahoma; Nancy Little, Librarian, M. Knoedler & Co., Inc., New York; Laura C. Luckey, Director, The Bennington Museum, Bennington, Vermont; William R. Mackay, Sr., Roscoe, Montana; Kristina S. Marek, Oklahoma Tourism and Recreation Department, Oklahoma City, Oklahoma; Joan Metzger, Arizona Historical Society, Tucson, Arizona; Janet Michaelieu, Librarian, Arizona Historical Society, Phoenix, Arizona; Rose Montroni, Hoboken Library, Hoboken, New Jersey; Anne Morand, Curator of Art, Thomas Gilcrease Institute of American History and Art, Tulsa, Oklahoma; Clyde Newhouse, Newhouse Galleries, New York; John C. O'Brien, Chief, Division of Visitor Services and Interpretation, Grand Canyon National Park; Patrick L. Stewart, Curator of American Paintings, Dallas Museum of Art, Dallas, Texas; Carol S. Verble, Assistant Librarian, Missouri Historical Society, St. Louis, Missouri; Melody D. Ward, Assistant to the Director, Frederic Remington Art Museum, Ogdensburg, New York; and David Witt, Curator, The Harwood Foundation of the University of New Mexico, Taos, New Mexico.

Few states can boast more considerate museum staffs than Texas. At the Amon Carter Museum, I am especially grateful to Carol Clark, formerly Curator of Paintings; Nancy Graves Wynne, Librarian; Milan Hughston, Assistant Librarian; Virginia W. Strathdee, Administrative Assistant; and Kathie Bennewitz, Research Assistant. Ron Tyler, formerly Assistant Director at the Amon Carter Museum and now Director of the Texas State Historical Association, was patient enough to read and critique the manuscript, while Mrs. Ruth Carter Stevenson, Amon Carter's daughter, very graciously permitted me access to her father's personal papers.

At the Archer M. Huntington Art Gallery a number of staff members ensured that this project was completed smoothly. Jessie Otto Hite, Assistant Director for Public Affairs, coordinated the entire effort; Sue Ellen Jeffers, Registrar, provided access to the existing collection records; Patricia Dannelley Hendricks, Associate Curator, wrote several of the entries; George Holmes provided the photographs; Joe Fronek, Conservator, aided in the analysis of particular paintings; and Tanya Walker typed the manuscript.

This catalogue is a response to the vision of C. R. Smith. Through his boundless generosity he has reminded us all of the importance of our own native traditions, and I hope that this volume provides a measure of thanks.

RICHARD SAUNDERS
Middlebury, Vermont

Collecting the West:
Art Patronage and the American West, 1800–1950

1. West range of the Smithsonian Institution in 1862; several Indian portraits by Charles Bird King are on display. (Courtesy National Anthropological Archive, Smithsonian Institution.)

2. Samuel Seymour, *View of the Rocky Mountains on the Platte 50 Miles from Their Base;* from *The Long Expedition* by Edwin James. (Courtesy Beinecke Rare Book and Manuscript Library, Yale University.)

The federal government, over the years, has been at best a reluctant art patron. Unwittingly, perhaps, during the first half of the nineteenth century the government was the crucial determinant for the direction taken by a number of artists as their careers developed. By supervising exploration of the western territories, sponsoring surveys of the transcontinental rail routes, and purchasing portraits and decorative ensembles for its offices, the government played a significant role in underwriting the livelihood of those artists interested in western subjects. At first, the artists who focused on subjects dealing with aspects of life west of the Mississippi were few in number. Beginning in the 1820s several artists found opportunities to paint Indian visitors to Washington at the request of the government. The best known of these is Charles Bird King (1785–1862), who in 1822 was commissioned by Thomas L. McKenney, superintendent of Indian Trade, to paint portraits of western

Indians brought to Washington. For these King charged the government $20 for busts and $27 for full figures.[1] From their inception, McKenney conceived of the portraits as forming a government collection of prominent Indian visitors. In 1824 McKenney took charge of the War Department's Bureau of Indian Affairs, and through this office he was able to continue and enlarge the practice of acquiring Indian portraits to hang in government offices.[2] Washington had so many Indian visitors during the 1820s and 1830s that King asked assistance from George Cooke (1793–1849), a friend and pupil. By 1842, when King painted his last Indian portrait for the government, he had completed about 150 portraits and had been paid $3,500.[3] The portraits were exhibited in an Indian Gallery and later, in 1846, were acquired by the Smithsonian Institution (Fig. 1), only to be destroyed in the disastrous 1865 fire.[4]

The government also had a vested interest in exploring its western possessions, mapping the landscape and documenting its inhabitants. Through a series of expeditions, beginning with that of Lewis and Clark in 1804 and continuing into the 1870s with the Ferdinand V. Hayden surveys, the government repeatedly made efforts to gain exacting knowledge about the West. All the surveys, aside from that of Lewis and Clark, included artists. It is through these images that American curiosity about the West intensified and that slowly but steadily a vogue developed for images related to America's exotic and sometimes brutal western regions. The artists attracted to these expeditions, such as Samuel Seymour (1775–?), Titian Ramsay Peale (1797–1855), Samuel Carvalhol (1815–1894), and Richard Kern (1821–1853), were not primarily concerned with long-range goals of private patrons commissioning works or purchasing finished paintings. The artists were preoccupied with the immediate objective of producing small-scale

1. Herman J. Viola, Jr., *The Indian Legacy of Charles Bird King,* p. 20.

2. Ibid., pp. 12–13.

3. Ibid., p. 21.

4. William H. Goetzmann and Joseph C. Porter, *The West as Romantic Horizon,* pp. 95–96. Another artist who contributed to this collection was James Otto Lewis (1799–1858), who had visited the Great Lakes frontier with Gov. Lewis Cass of the Michigan Territory and who in 1823–1834 was assigned to visit Indian councils in Wisconsin, Indiana, and elsewhere to record portraits for the government. Fortunately, however, the collection is largely known through copies painted by Henry Inman (1801–1846) in the early 1830s. The copies were commissioned by McKenney in preparation for reproduction in his three-volume work, *History of the American Tribes of North America* (1837–1844).

works that were not intended for exhibition and sale but for reproduction, either as illustrations to expedition reports or in separate folios. For example, Samuel Seymour, who was the artist on the Long Expedition (1819–1820), made 150 landscape views during the trip, of which 11, including *View of the Rocky Mountains on the Platte 50 Miles from Their Base* (Fig. 2), were published in Edwin James' *The Long Expedition* (1822–1823).

Wealthy foreign citizens like the Prussian Prince Alexander Phillip Maximilian and the Scottish Capt. William Drummond Stewart also were among the first in a long line of foreign patrons of artists who pursued western subjects. Maximilian traveled west in 1833–1834 accompanied by the Swiss-born artist Karl Bodmer (1809–1893). They had as one of their goals the publication of a lavishly illustrated set of volumes documenting their experience. As a result of their trip, Bodmer's watercolors were used as illustrations for Maximilian's *Travels in the Interior of North America in the Years 1832 to 1834,* published in German, French, and English editions. Maximilian's interest had been largely to document the Indian inhabitants encountered in his party's travels through the Dakotas and Montana, and his publication was the first to contain full-color illustrations of the West.

Stewart commissioned Alfred Jacob Miller (1810–1874), a portrait painter in New Orleans, to accompany him on his 1837 journey to the Rocky Mountains. In the two years following this trip Miller painted for Stewart eighty-seven washes and eighteen finished oils, among them *Trappers around a Campfire with the Wind River Mountains of the Rockies in the Background* (Fig. 3).[5] The next year, Miller traveled to Perthshire, Scotland, where he remained for two years and painted his largest and most ambitious works, including *Attack of the Crows* (Murthly Castle, Perthshire, Scotland). Initially, he lived off

earnings derived from Stewart's commission. Miller spent the remainder of his career in Baltimore, where he continued to paint Indian subjects for the local trade. In 1858 he was commissioned by William T. Walters (1820–1894), a Baltimore merchant, railroad president, and art collector, to copy two hundred of his field sketches at $12 each. This collection of native American subjects, which Walters may have acquired as much for ethnographic as aesthetic reasons, was, for its day, among the largest of its kind. Only later did it become part of the art collections of the Walters Art Gallery.[6] In 1867, Alexander Brown, a little-known Englishman, had Miller copy another group of eight watercolors at $25 each, and Miller continued to receive occasional orders for paintings derived from his field sketches. The most he was ever paid was $200, which he received in 1858 from Walters for a large (32 × 48 inches) Rocky Mountains oil.[7] If his western travels had not made him a wealthy man, they had shown that such ventures could contribute significantly to an artist's income.

Other artists whose careers are synonymous with the West, such as George Catlin (1796–1872), set off on their western adventures without public or private sponsorship. Catlin roamed the western plains between 1830 and 1836, making an astonishingly exhaustive study of the activities of numerous tribes, among them the Mandans, Eastern Sioux, Sauk, and Fox. Unlike Seymour or Miller, Catlin employed oil primarily and his interest in Indian portraits led him to create some of the most compelling ever recorded. While Catlin did not have a sponsor for his travels, he did find the occasional patron. The first was Maj. Benjamin O'Fallon of St. Louis, a nephew of the expedition leader, Gen. William Clark, and principal of the American Fur Company. Catlin painted thirty-five Upper Missouri subjects for him between 1832 and 1835.[8]

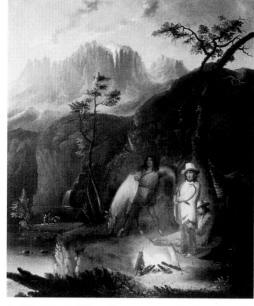

3. Alfred Jacob Miller, *Trappers around a Campfire with the Wind River Mountains of the Rockies in the Background,* ca. 1839, oil on canvas, 38¼ × 32⅛ inches. (Courtesy Warner Collection of Gulf States Paper Corporation, Tuscaloosa, Alabama.)

5. Ron Tyler, ed., *Alfred Jacob Miller: Artist on the Oregon Trail,* p. 37.

6. Other Baltimore collectors of Miller's work included Dr. Thomas Edmondson, a horticulturist, who acquired twelve works by Miller; Judge Z. Collins Less; Owen Gill; and O. C. Tiffany (see ibid., p. 65).

7. Marvin C. Ross, *The West of Alfred Jacob Miller,* Miller's account book (1846–1874), p. xxxiv; 1858, "1 picture Mr. Wm. T Walters [$]200."

8. William H. Truettner, *The Natural Man Observed: A Study of Catlin's Indian Gallery,* p. 137.

What Catlin initially lacked in patronage he made up for in ingenuity, and in 1837 he began a second career in New York as the operator of the "Indian Gallery." Here he exhibited his own paintings and collected artifacts while he accepted admission fees from a fascinated public. For the next eleven years Catlin exhibited his collections to large audiences in America and Europe. Beginning in 1839 he displayed his collection in London at the Egyptian Hall, Piccadilly, where it remained on and off for the next five years. Always in search of an audience, he next went to Paris. There in 1845, after being received at the Tuileries with accompanying members of the Iowa tribe, he was eventually offered a commission from Louis Philippe for fifteen copies of Indian Gallery subjects. Although the artist had hoped the French government might buy his entire collection, he had to satisfy himself with this commission and one the following year, also from the king, for a series of twenty-nine paintings commemorating the voyages of LaSalle in North America. For these he expected to be paid $100 each. By February 1848, however, with political turmoil besieging the country, the king and queen fled. Catlin, consequently, was never paid what he had been promised, although he did retrieve the LaSalle paintings and probably some of the later commissions before hastily making his way back to London.[9]

Once Catlin was back in England, Sir Thomas Phillips, the wealthy and eccentric collector, became one of his primary patrons. Phillips acquired an enormous number of paintings: 155 watercolors and oils, some of which may have been taken as security for a loan.[10] Catlin's financial situation by this time had become precarious. Curiosity about his collections had begun to wane. Despite occasional sales in the next few years,[11] he incurred chronic indebtedness by mortgaging his collections many times over. He had hoped that his condition would be eased by the sale of the Indian Gallery to the U.S. or British governments, but this never materialized. When Catlin had offered his collection to the Smithsonian in 1846, some sentiment against Congress appropriating funds for such a purpose was particularly hostile. The comments of James D. Westcott, a congressman from Florida, represent the point of view Catlin was never able to overcome:

I am opposed to purchasing the portraits of savages. What great moral lessons are they intended to inculcate? I would rather see the portraits of numerous citizens who have been murdered by the Indians. I would not vote a cent for a portrait of an Indian.[12]

By 1852 Catlin's creditors caught up with him and he was thrown in jail. One of those to whom Catlin owed money was Joseph Harrison (1810–1874), head of the world's largest locomotive manufacturer. Harrison interceded on Catlin's behalf, paid his major creditors, and took possession of the collections for about $40,000.[13] He had them shipped to Philadelphia, where they remained in storage for the next twenty-seven years. Although, like William Walters, Harrison was a noted art collector, he presumably viewed Catlin's works as primarily of ethnographic or documentary importance and he chose to ignore them. On June 17, 1861, Harrison wrote to his son that he felt he had greatly neglected the collections and wanted to save them from further destruction. He instructed him to hang some of the pictures on the walls of the room in which they were stored.[14] In 1879, five years after Harrison's death, Smithsonian officials appealed to his executors, hoping to acquire the collection. Later that year their wish was granted and on May 15, in a national climate that had finally begun to awaken to the uniqueness of Catlin's efforts, Mrs. Harrison announced the gift of the collection to the nation.[15]

9. Ibid., pp. 49, 53.

10. Ibid., pp. 131–132.

11. For example, he did benefit from sales, such as fifty drawings heightened in watercolor, which he called his "Album Unique," that sold for £75 to the Duke of Portland in 1859 (see Hirschl and Adler Galleries, Inc., *A Festival of Western American Art at Hirschl and Adler* [1984], p. 7).

12. Nicholas B. Wainwright, "Joseph Harrison, Jr., a Forgotten Art Collector," *Antiques* 102 (October 1972): 668.

13. Ibid., p. 665.

14. Ibid.

15. Ibid., p. 668.

The visibility that Catlin achieved in the early years of his Indian Gallery lured others to follow in his footsteps. Paul Kane (1810–1871), a Canadian, was one of these. In 1845 he gained the support of Sir George Simpson (ca. 1787–1860), a Scot who was general superintendent of the Hudson's Bay Company, who gave him permission to make use of the company's network of trails and outposts. Kane traveled as far as Fort Vancouver, Vancouver Island, British Columbia, and then returned to Toronto. There he completed fourteen canvases for Simpson, who wrote to the artist in 1847 that they would be "hung up in a room I design as a museum for Indian curiosities."[16] Like Catlin, Kane hoped to interest his government in the purchase of works derived from his travels. The Canadian government did, in 1851, commission a dozen pictures from him for £500, but his greatest supporter was a private patron, George William Allan (1822–1901) of Toronto. For $20,000 Kane sold Allan a cycle of one hundred paintings that he had intended for the government. Allan was a Renaissance man: lawyer, statesman, fellow of the Royal Geographic Society. He installed Kane's collection along with Indian artifacts and stuffed birds in a large room known as "the museum" in his stately Georgian house, Moss Park.[17] Like other western artists of his generation, Kane supplemented his income by writing about his travels in the 1859 book *Wanderings of an Artist among the Indians of North America.*

Naturalist artists like John James Audubon (1785–1851) were attracted to the animals and birds of the West with the same intense zeal that had sustained Catlin and Kane. And like these two other artists, Audubon went west without government or private patronage. While Catlin anticipated that the exhibition of his works would pro-

vide an income, Audubon went with the expectation that a lavishly illustrated compendium of his studies would do the same. His greatest accomplishment is his masterful survey, *The Birds of America* (1826–1838), which was compiled as the result of six years (1820–1826) of travel east of the Mississippi. He had used specimens brought back by other explorers for the western birds included. In 1843, however, after beginning work on *The Viviparous Quadrupeds of North America* (1845–1846), he began his own western travels by making a six-month journey to the Upper Missouri and the Yellowstone.[18]

Another breed of artist set somewhat apart from the expedition artists or those who set out with a plan for publication about their travels were the painters of panoramas. These artists, such as J. J. Banvard, Leon Pomarede, Henry Lewis, and John R. Smith, derived more immediate profits from their travels by painting and exhibiting elaborate panoramas of the Mississippi and the Missouri.[19] They did not require major patrons but were sustained, like the proprietors of "Indian Galleries," by the admission fees paid by audiences eager to be transported visually to the western wilds.

During the 1840s easterners had, out of curiosity, flocked to places like Catlin's Indian Gallery. This interest also extended to some degree to other western subjects. It was this national phenomenon that encouraged artists to continue to explore western themes: the landscape, trappers and traders, settlers, and, above all, Indians. At the same time a steady stream of settlers made their way west over the Oregon, Santa Fe, and California trails. But, although artists found that western subjects attracted attention at exhibitions, there were fewer buyers for such works. Historian Henry T. Tuckerman remarked in his *Book of the Artists* (1867) how strange it was that more American art-

16. J. Russell Harper, *Paul Kane's Frontier, Including "Wanderings of an Artist among the Indians of North America" by Paul Kane,* pp. 16, 33, 330.

17. This collection was later acquired by the Royal Ontario Museum.

18. George Dock, Jr., *Audubon's Birds of America,* pp. 1–22; John Francis McDermott, ed., *Audubon in the West,* pp. 3–19.

19. Lillian B. Miller, *Patrons and Patriotism,* p. 184.

ists did not pursue "native American subjects" since this was what particularly fascinated European collectors.[20] Earlier, this lament had been taken even one step further by a critic of the Cincinnati-based Western Art Union. He complained in 1848 that art in Cincinnati was in danger of becoming too imitative of the east when what was really needed was views of "rocky mountains which 'eye hath not seen.'"[21]

Yet, in the list of major private American collections cited by Tuckerman at the end of his book, few western subjects are listed and no single collection included more than a handful of this type.[22] Some artists, like William Ranney (1813–1857), included western genre subjects in their repertoire. Few, however, were ready to devote their time exclusively to western subjects.

A few of the artists who made their reputation in part with western subjects, such as Ranney, were based on the east coast. However, several of the best-known artists whose names are associated with the West in the first half of the nineteenth century were easterners who after traveling in the West remained there. Some of these artists, like John Mix Stanley (1814–1872) and Seth Eastman (1808–1875), found that their patronage continued to be centered in the East. Others, like Charles Wimar (1829–1863), Charles Deas (1818–1867), and George Caleb Bingham (1811–1879), had success in St. Louis. By the 1850s and 1860s Charles Christian Nahl (1818–1878), William Keith (1839–1911), and Thomas A. Ayres (1820–1858) were sustained by patronage in California.

By 1847 Ranney was painting western genre subjects devoted to the lives of trappers and pioneer settlers. Although his studio was in New Jersey, the inspiration for these pictures came from a stint in Texas in 1836. Details of this trip and possibly a second trip to Texas are sparse. In any event, by the last decade of his life Ranney painted several dozen western genre paintings, although out of necessity he supplemented these with historical subjects and sporting pictures, which had a broader appeal. Enthusiasts of his work included Marshall O. Roberts (1814–1880), a New York financier and major art collector, who owned Ranney's *Wild Horses.*

In 1842, Stanley visited Fort Snelling, Minnesota, and Fort Gibson, Arkansas Territory, now Oklahoma, where he painted portraits of Indians and frontiersmen. In 1846, by which time he had already visited the New Mexico Territory, he had exhibited his Indian portraits in Cincinnati and five years later displayed his Catlin-like North American Indian Gallery in eastern cities. In 1852 he placed over 150 of his Indian portraits on view at the Smithsonian. Thirteen years later, after his offer to sell them to the government for just over $19,000 was rejected, they too were destroyed in the Smithsonian fire of 1865. Fate seemed to plague Stanley and further of his paintings were destroyed in a fire at P. T. Barnum's American Museum in New York. His greatest success came in 1848 from touring his painting *The Trial of Red Jacket,* which is said to have earned him over $8,000 from admissions.[23]

Eastman, however, succeeded by virtue of his position as a professional soldier and illustrator for the Office of Indian Affairs. As a result of his position he was not dependent on his paintings as the sole means of support. Eastman first went west in 1829 to serve in topographical reconnaissance at Fort Crawford, Wisconsin. He later served twice at Fort Snelling, Minnesota, and had a tour of duty in Texas. In 1853 he also served on the Isaac Stevens Expedition to survey a rail route from Saint Paul to Puget Sound.[24]

20. Henry T. Tuckerman, *Book of the Artists,* p. 424.

21. T. W. Whitley, *Reflections on the Government of the Western Art Union, and a Review of the Works of Art on Its Walls* (Cincinnati: 1848), p. 5, as quoted in Miller, *Patrons and Patriotism,* p. 208.

22. Tuckerman's list included five collections containing art that could be construed as western: W. W. Corcoran of Washington, D.C.; J. C. McGuire of Baltimore; and R. L. Stuart, Marshall O. Roberts, and J. Lennox of New York.

23. *John Mix Stanley: A Traveller in the West,* p. 13.

24. Patricia Trenton and Peter H. Hassrick, *The Rocky Mountains: A Vision for Artists in the Nineteenth Century,* p. 78.

During these years his wife wrote several books on Indian life to which he contributed illustrations. Because of all his western experience he was invited in the early 1850s to become one of the primary illustrators for Henry Schoolcraft's voluminous *Historical and Statistical Information Respecting . . . the Indian Tribes of the United States* (6 vols., Washington, D.C., 1851–1857). In addition he had nineteen of his paintings purchased and distributed by the American Art Union, 1848–1851, and *The Tamer* was sold to the Western Art Union in 1849.[25]

Eastman received patronage from private collectors, including William Wilson Corcoran (1798–1888), a Washington banker and founder of the Corcoran Gallery of Art, who purchased *Lacrosse Playing among the Sioux Indians*. Eastman's work was also sought by collectors from St. Louis, a city that prior to the Civil War seemed to have the greatest concentration of western art devotees. In 1848 he painted *Indian Spearing Fish* (now lost) for E. R. Mason, an attorney, who later acquired his *Landscape and Indians*.[26] An even more prominent Eastman supporter was James C. Yeatman (1818–1901), a noted banker, philanthropist, and civic leader. Yeatman, who was a founder and treasurer of St. Louis' first prominent arts organization, the Western Academy of Art, owned Eastman's painting *Chasing Buffalo*. After the Civil War, in 1867, the government once again turned to Eastman and commissioned him to paint scenes of Indian life for the House Committee on Indian Affairs room at the Capitol and three years later he received a similar request for seventeen pictures of frontier forts for the House Committee on Military Affairs room.

St. Louis citizens were quick to reward those artists who could capture the flavor of western life. According to his considerable local following, one of the most able was Charles Wimar, a German-born and -trained artist. By 1858, Wimar, who had been painting in St. Louis for only two years since his return there from study in Dusseldorf, had begun to attract local attention. By this date he had sold several paintings, including *Jolly Flatboatmen by Moonlight* (Amon Carter Museum, Fort Worth) and *The Captive Charger* (St. Louis Art Museum; Fig. 4), as well as a series of four paintings of the abduction of the daughter of Daniel Boone. The purchaser in each case was John A. Brownlee (1819–?), president of the Merchant's Bank and president of Millers and Manufacturers Insurance Company.[27] By the following year three of Wimar's latest pictures — *Buffalo Crossing the Yellowstone* (present location unknown, formerly Washington University, St. Louis), *The Wounded Buffalo* (Washington University), and *Indians Approaching Fort Union* (Washington University) — were purchased and then proudly exhibited at the St. Louis Agricultural and Mechanical Fair by Dr. William Van Zandt (1800–1878).[28] Van Zandt was a wealthy physician and oculist who is credited with introducing the use of artificial eyes in the West.[29] He also acquired Wimar's *The Buffalo Hunt* (Thomas Gilcrease Institute of History and Art, Tulsa), a second version of which is said to have been commissioned in 1861 by Lord Lyons, British ambassador to the United States, when he visited St. Louis.[30]

Another successful businessman who admired Wimar's work was Henry T. Blow (1817–1875), president of Collier White Lead oil company as well as a founder and president of the Western Academy of Art, which Wimar had helped organize two years earlier. Blow commissioned Wimar to paint two large hunting scenes for his house in Caron-

4. Charles Wimar, *The Captive Charger*, 1854, oil on canvas, 30 × 41 inches. (Courtesy St. Louis Art Museum. Gift of Miss Lillie B. Randell.)

25. John Francis McDermott, *Seth Eastman, Pictorial Historian of the Indian*, p. 48.

26. Ibid., pp. 48, 62.

27. William Tod Helmuth, ed., *Arts in St. Louis*, p. 40; Perry T. Rathbone, *Charles Wimar*, pp. 26, 27.

28. Rathbone, *Charles Wimar*, p. 27.

29. *Missouri Republican*, May 2, 1878, p. 4.

30. Another version of Wimar's British commission is that in 1859 the Prince of Wales visited St. Louis, accompanied by the Duke of Newcastle, who commissioned a second version of *The Buffalo Hunt* (see W. R. Hodges, "Charles Ferdinand Wimar," *American Art Review* 2:177).

delet (now within the St. Louis city limits). But Wimar, who died of tuberculosis in 1862, only lived long enough to complete the first painting, *Indian Hunting Buffalo* (Missouri Historical Society), the largest work of his career. Before his death Wimar received additional recognition by being awarded a major public commission. The new dome on the Old St. Louis Courthouse was just being completed and Wimar was selected to paint four large lunette panels for it. For this he chose appropriate local themes, including *The Indian Attack on St. Louis, May 26, 1780*. Clearly, in St. Louis, at least by the late 1850s, there was a significant market for local subjects painted by European-trained painters of skill.

Unfortunately, the degree of patronage for other St. Louis–based painters, like Charles Deas, is less well known. Deas was capable of dramatic subjects, such as *The Death Struggle* (1845, Shelburne Museum, Shelburne, Vermont), which was owned in the late 1850s by R. B. A. Hewling of Philadelphia. Tuckerman observed that while in St. Louis Deas "found all that a painter can desire in the patronage of friends."[31] These apparently included James Yeatman, who in addition to paintings by Eastman and Bingham, owned Deas' *Canadian Voyageurs* (possibly *The Voyageurs,* 1846, now at the Museum of Fine Arts, Boston).[32] But despite his success, none of Deas' other St. Louis patrons can be identified with any confidence and, since few of his paintings survive, it is conceivable that some were lost in the 1849 St. Louis fire.

Beginning in 1845 Bingham, who had returned to Missouri the previous year from an extended stay in Washington, D.C., began a decade of genre images that included Mississippi boatmen, trappers, fur traders, and Indians. He seems to have been aware that work of this type would have a popular appeal, and, consequently, most of his works of this type were purchased by the New York–based American Art Union as part of its lottery award program and were distributed nationally. The only St. Louis patrons known to have owned his western subjects were Yeatman, who in 1847 purchased his *Lighter Relieving a Steamboat Aground* (present location unknown) for $250, and Charles Derby, who in 1859 owned *Captured by Indians* (St. Louis Art Museum).[33]

The organization of the American Art Union in 1839 and its subsequent twelve years of activity had a profound impact on the national exposure of American artists and among them were champions of western themes, such as Bingham, Ranney, and Eastman. Their works, like hundreds of others, after being purchased by the Art Union, were seen by thousands in New York and then distributed to winners in the Art Union's annual lottery. Of even greater benefit was the reproduction of work by Bingham and Ranney as prints that were distributed to the thousands of Art Union members. Although few of the prints distributed had overtly western themes, the Art Union, as later noted by Worthington Whittredge, certainly had encouraged native ones:

It was the Union that gave impetus to [genre] not so much by merely buying them . . . as by the encouragement it gave to native art, and the consequent spur to the artists to look for subjects at their own doors.[34]

Art Union officials realized that this kind of subject may have been more likely to appeal to Americans who were not bothered by the conventions of eastern art circles, with great pretensions of history, mythology, and the Bible. Most Americans simply wanted to ac-

31. Tuckerman, *Book of the Artists,* p. 429.
32. *Catalogue of the First Annual Exhibition of the Western Academy of Art, St. Louis, 1860,* no. 131, "Canadian Voyageurs, J. E. Yeatman Esquire."

33. E. Maurice Bloch, *George Caleb Bingham: The Evolution of an Artist,* 2:58.
34. Worthington Whittredge, "The American Art Union," *Magazine of History* 7 (February 1908): 66.

quire works that they liked and that had a quality of real America about them. This is confirmed by one letter of advice from the corresponding secretary of the Art Union to an artist, indicating they were more inclined toward pictures "taken from the everyday scenes of life, those that are not suggestive of, or create painful emotions. . . . Anything, however, that illustrates our country, history or its poetry."[35] Also, as westward settlement grew in the decades of the 1850s and 1860s, an increasing number of paintings appeared that dealt with this theme. It had appealed to Ranney as early as the 1840s and had received national attention when Emanuel Leutze painted *Westward the Course of Empire Takes Its Way* for the United States Capitol in 1862. Subsequently, even more artists found inspiration in subjects that depicted the settlers crossing the plains.[36]

On the West Coast few artists were active during the life of the American Art Union, but with statehood (1850) and the Gold Rush, California began to attract numerous artists of note. These artists, such as Charles Christian Nahl and Thomas A. Ayres, were more akin to Charles Wimar than to George Caleb Bingham, in that their patronage was highly localized. They were part of a steadily growing artistic community that eventually included William Hahn (1829–1887) and William Keith, all of whom painted a number of western genre subjects. Nahl ended up in San Francisco, where he painted portraits and genre subjects, including *Saturday Evening in the Mines* (1850s, Stanford University), which first hung in a Sacramento barroom, and *Sunday Morning in the Mines* (1872, E. B. Crocker Art Gallery, Sacramento), which he painted for Judge E. B. Crocker (1818–1875), brother of Charles Crocker, one of the Big Four railroad builders, whose house had one of the first art galleries in the West.[37]

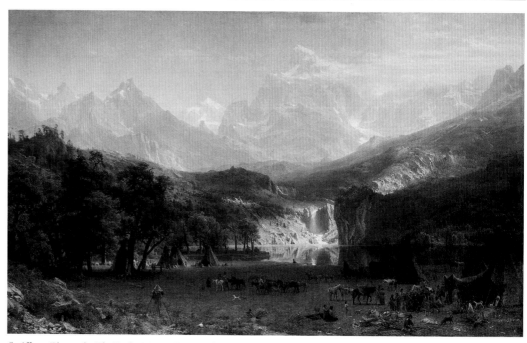

5. Albert Bierstadt, *The Rocky Mountains, Lander's Peak,* 1863, oil on canvas, 73½ × 120¾ inches. (Courtesy Metropolitan Museum of Art, Rogers Fund, 1907.)

Ayres, a landscape painter, was the first artist to paint a panoramic view of Yosemite, which he exhibited in Sacramento, and he might well have become, like Albert Bierstadt and Thomas Hill, well known for such subjects had his death in 1858 not prevented it.[38] Hahn, too, had intermittent periods of success, selling Judge Crocker his *Market Scene, Sansome Street, San Francisco* (1872) for $2,500.[39]

35. A. Warner to Frederick E. Cohen, New York, August 12, 1848 (Collection New York Historical Society), as quoted in Bloch, *George Caleb Bingham,* 1:81.

36. See, for example, Bierstadt's *Emigrants Crossing the Plains* (1867, National Cowboy Hall of Fame and Western Heritage Center, Oklahoma City) and Andrew Melrose's *Westward the Star of Empire Takes Its Way—Near Council Bluffs, Iowa* (ca. 1867, Collection of American Stanhope Hotel, New York).

37. John C. Ewers, *Artists of the Old West,* pp. 146–147; Raymond L. Wilson, "Painters of California's Silver Era," *American Art Journal* 16, no. 4 (Autumn 1984): 75.

38. Ewers, *Artists of the Old West,* p. 153.

39. Marjorie Arkelian, "William Hahn: German-American Painter of the California Scene," *American Art Review* 4, no. 2 (August 1977): 109.

Since the largest number of America's art patrons in the second half of the nineteenth century favored landscape over other forms of painting, it is not surprising that landscapes tended to predominate when they selected western themes to add to their collections. Landscape had a great measure of respectability and could be more clearly related to international art trends. In April 1860, Albert Bierstadt (1830–1902), just thirty and having returned the preceding year from a trip to the Rocky Mountains in Wyoming, exhibited his first western landscape, *The Base of the Rocky Mountains, Laramie Peak,* at the National Academy of Design. The painting, now lost, went unsold.[40] Two months before, however, Bierstadt sold *Wind River Country* (Britt Brown, Wichita, Kansas), painted that year, to Gardner Brewer (1806–1874), a millionaire textile merchant from Boston, making it the earliest surviving western landscape sold by the artist. Bierstadt wrote to his patron:

I have at last completed your picture, and in a few days shall send it to you. I have taken the liberty of having a frame made for it, and hope it will please you. The scene I have chosen for the picture is among the Rocky Mountains. In the distance is seen a part of the Mountains called the Wind River Chain, prominent among which rises Fremonts Peak. The range is covered with snow the entire season. The low hills are covered with pine forrests, and along the River, Sweetwater its name, we find the Willow, Aspen, Cottonwood, and Spruce. A very picturesque variety of pine, found only among the Rocky Mountains, I have introduced into the foreground, and also a Grizzley bear, feeding on an Antelope. . . . Should this picture not prove satisfactory, I will try again. Should you come to New York at any time I shall be most happy to see you, at the Studio Building, 15 Tenth Street.[41]

Bierstadt's early success was soon dwarfed by his sale in 1864 of *The Rocky Mountains, Lander's Peak* (Fig. 5), his largest picture to date, to James McHenry (1817–1891), an American railroad entrepreneur living in London. The painting was sold for $25,000, which at the time at least equaled the highest price ever paid for an American painting.[42] Despite this success Bierstadt was foiled in his attempt to secure a government commission for two large paintings of the Rocky Mountains and Yosemite to decorate the House of Representatives, for which he had hoped to be paid $30,000 and $40,000, respectively. But he soon thereafter sold for $25,000 the impressive *Domes of Yosemite* to Wall Street financier Legrand Lockwood for his Norwalk, Connecticut, house. Eventually Bierstadt even topped this with the sale of *Last of the Buffalo* (Whitney Gallery of Western Art, Cody, Wyoming) for $50,000 to J. T. North, the nitrate king.[43]

Aside from similar fees paid to Bierstadt's colleague Frederic Edwin Church, these high prices were unparalleled in American art. The effect they had on an interest in western landscape was phenomenal. By the time Tuckerman published his assessment of American artists in 1867, Bierstadt had surpassed Church as the country's leading landscape painter. Bierstadt was by then represented in many of the major private collections in the country, including those of James Lennox (1800–1880), New York bibliophile and philanthropist, and Marshall O. Roberts. One painting had also been acquired by the Buffalo Fine Arts Academy.[44] Two years later he joined the ranks of Americans whose work was admired by the British when he sold, reportedly for $20,000, his controversial early picture *Storm in the Rocky Mountains* (Brooklyn Museum) to Thomas William Kennard (1825–1893). In 1876 the Earl of Dunraven (1841–1926),

40. Gordon Hendricks, *Albert Bierstadt: Painter of the American West,* p. 94.
41. Ibid., p. 20.
42. Ibid., p. 154.
43. Ibid., p. 292.
44. Tuckerman, *Book of the Artists,* p. 393.

Irish sportsman, traveler, and collector, commissioned *Long's Peak, Estes Park Colorado* (Denver Public Library) for $15,000 at the same time he was building a hotel at Whyte's Lake, California.[45]

Several California commissions followed. In 1871 Colis P. Huntington (1821–1900), the Central and Pacific Railroad baron, commissioned *Donner Lake from the Summit* (New York Historical Society), while Leland Stanford is said to have requested two pictures.[46] Also, Alvin Adams, who pioneered an express route through the mining camps of California,[47] purchased *Among the Sierra Nevada Mountains,* and D. O. Mills (1825–1910), San Francisco financier, purchased *Yosemite Winter Scene* (University of California Art Museum, Berkeley). Clearly, Bierstadt's western pictures had made him a national and international phenomenon.

But even as late as the 1870s, no American art collectors specialized exclusively in western subjects. Rather, the pattern was for a paintings collector, whose primary concern was ostensibly aesthetic quality, to acquire one or more western subjects as part of a more broadly based art collection. A good example of this approach is the collection formed in the late 1860s and the 1870s by Horace Fairbanks, the president of E. and T. Fairbanks and Company of St. Johnsbury, Vermont, manufacturers of platform scales on which to weigh loaded wagons. His eclectic collection ranged from copies of sixteenth- and seventeenth-century European paintings and sculpture, inspired by if not copied from the antique, to nineteenth-century American and European paintings. To this varied group Fairbanks had added three western landscapes: Samuel Colman's *The Emigrant Train, Colorado,* Worthington Whittredge's *On the Plains, Colorado,* and Bierstadt's colossal *Domes of the Yosemite,* sold earlier to Lockwood.[48] Collectors like Fairbanks may

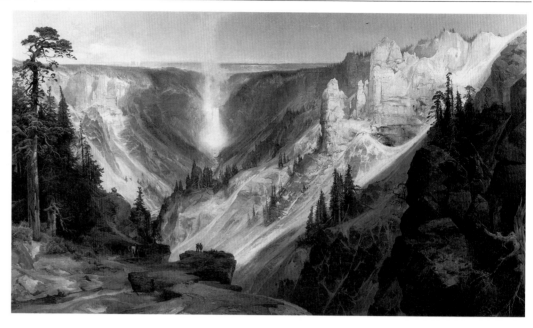

6. Thomas Moran, *The Grand Canyon of the Yellowstone,* 1872, oil on canvas, 84 × 144¼ inches. (Courtesy National Museum of American Art, Smithsonian Institution; painting on loan from the U.S. Department of the Interior, National Park Service.)

have hesitated to acquire works by such artists as Eastman, Deas, or Stanley because they may have shared the opinion expressed in 1880 by S. G. W. Benjamin that "it is greatly to be regretted that the work of these pioneers in western *genre* was not of more aesthetic value."[49]

Bierstadt's success as a painter, however, gave inspiration to a number of other painters of western landscape, including Whittredge (1820–1910), Henry Arthur Elkins (1847–1884), Ransome Gillet Holdredge (1836–1899), and Frederick Schafer (1841–1917).[50] But among the most successful were Thomas Moran (1837–1926) and Thomas Hill (1829–1908). As a result of having joined Ferdinand V. Hayden's survey expedition to the Grand Canyon of the Yellowstone, Moran returned east with sketches that enabled him to paint huge western landscapes. Within two years he sold two of his

45. Hendricks, *Albert Bierstadt*, pp. 179, 250.

46. Ibid., p. 206.

47. Julie Schimmel, *Stark Museum of Art: The Western Collection, 1978*, p. 22.

48. Patricia C. F. Mandel, "American Paintings at the St. Johnsbury Athenaeum in Vermont," *Antiques* 117 (April 1980): 868–871.

49. S. G. W. Benjamin, *Art in America: A Critical and Historical Sketch*, p. 88.

50. Trenton and Hassrick, *The Rocky Mountains,* pp. 149–153.

most important paintings, *The Chasm of the Colorado* (U.S. Department of the Interior) and *The Grand Canyon of the Yellowstone* (U.S. Department of the Interior; Fig. 6), to the federal government for $10,000 each to hang in the Senate Lobby. His paintings had been instrumental in persuading Congress in 1872 to establish Yellowstone as the first national park.

As might be expected, his private patrons were also those whose interests were linked to western development. They included William A. Bell of Manitou, Colorado, vice-president of the Denver and Rio Grande Railroad, whose wife persuaded him to buy the 1875 painting *Mountain of the Holy Cross* (National Cowboy Hall of Fame and Western Heritage Center, Oklahoma City).[51]

During the 1870s, in addition to his easel paintings, Moran produced many illustrations for popular periodicals, such as *Scribner's, Harper's Weekly,* and Appleton's *Picturesque America.* In a statement to George Sheldon, Moran disparaged the commercial qualities of art making and the making of copies in particular:

If a man's studio is simply a manufactory of paintings, which shall tickle the ignorant in art; if he is continually repeating himself in order to sell his pictures more rapidly or easily, this fact will convey itself to every intelligent mind. The pleasure a man feels will go into his work, and he cannot have pleasure in being a mere copyist of himself — in producing paintings which are not the offspring of his own glowing impressions of nature.[52]

But Moran was also quick to repeat his Yellowstone subjects in watercolor, often in sets, when the opportunity arose. Patrons for his watercolors, which cost less than his oils, included William Blackmore, a British industrialist who had accompanied the Hayden expedition; Jay Cooke (1821–1905) of the Northern Pacific Railroad, who had helped to underwrite the costs of Moran's 1871 trip;[53] Louis Prang (1824–1909), the entrepreneur who built an enormous lithographic business; and Ferdinand Hayden himself, who had led the 1871 survey expedition. As Carol Clark has observed, Moran's watercolor patrons all "shared an important attribute — they were all adventurers. Some were actual western explorers, others were armchair travelers, and a few were fellow artists."[54] To this group may be added Alexander W. Drake, art editor for *Scribner's;* Richard W. Gilder, Moran's friend and *Scribner's* editor; James Stevenson, an officer on the 1871 expedition; Mrs. George Franklin Edmonds, wife of the senator from Vermont who advocated passage of the Yellowstone bill; Russell Sturgis, American architect and author; and photographer William Henry Jackson.[55] William Henry Holmes, geologist, anthropologist, and noted mountaineer who accompanied several of Hayden's expeditions, also commissioned watercolors from Moran. These works were extremely popular with patrons and at one point Moran wrote to Holmes, "I am indeed awfully busy. . . . I have now over a hundred drawings to make for various parties."[56]

By the 1880s Moran's popularity was adversely affected by changing artistic tastes. His highly detailed, realistic site-specific paintings were being overshadowed by artists like George Inness, who painted more atmospheric, emotionally charged canvases that did not depend on glorifying a specific natural site. Moran complained bitterly in 1892:

I prefer to paint Western scenes but Eastern people don't appreciate the grand scenery of the Rockies. They are not familiar with its effects, and it is much easier to sell a picture of a Long Island swamp than the grandest picture of Colorado.[57]

51. Ibid., p. 200.
52. George William Sheldon, *American Painters,* pp. 124–125.
53. Goetzmann and Porter, *The West as Romantic Horizon,* p. 98.
54. Carol Clark, *Thomas Moran: Watercolors of the American West,* p. 41.

55. Ibid., p. 43.
56. Moran to William Henry Holmes, undated [probably 1892], Bushnell Collection, Peabody Museum, as quoted in ibid., p. 43.
57. Thurman Wilkins, *Thomas Moran,* p. 120, from *Rocky Mountain News,* June 18, 1862.

While both Moran and Bierstadt were exceptional artists with varied talents, Thomas Hill, whose success rests largely on his ability to paint the Yosemite Valley, is indicative of the great demand for western landscapes by the 1870s. Hill specialized in portraits in the late 1860s but by 1868 felt confident enough to ask $10,000 for *The Yo-semite Valley* (unlocated). His most significant commission came in 1875 when, according to his accounts, he was asked by Leland Stanford, former governor of California and president of the Central Pacific Railroad, to paint several scenes along the right-of-way of the railroad, such as *Donner Lake.* Stanford also requested a colossal depiction of *The Driving of the Last Spike* (California State Railroad Museum, Sacramento), the precise moment when the coasts were linked by rail. Hill was provided with a railroad pass that enabled him to meet with many of the persons Stanford wanted depicted. Before he was finished with the canvas it included over four hundred figures and he was subjected by Stanford to repeated demands for changes. Nearly completed, the painting was seen by Charles Crocker, who had supervised the building of the railroad over the Sierra and who groused upon seeing it, "What damn nonsense is that?" His outcry was apparently prompted by Stanford's conceit of having himself depicted at the focal point of the composition. This hostility led to Stanford's own rejection of the painting and Hill spending the rest of his life vainly trying to sell it.[58]

Hill spent the succeeding decades in San Francisco and built himself a studio at Yosemite. Until the demand for Hill's style of landscape subsided in the late 1880s he sold literally several thousand views of Yosemite and other picturesque California sites, many of them to moneyed tourists.

Despite the success of Bierstadt, Moran, and Hill, they did not have a significant impact on the number of American artists in the 1870s who chose to represent types of western subjects other than landscapes. Even as late as 1876 the painter of western subjects was not, unless his subject was landscape, in the mainstream of American painting. At the Centennial International Exhibition held in Philadelphia, for example, which included 760 paintings by Americans and 162 sculptures, only one of the most talked about works, Bierstadt's *Western Kansas,* had anything to do with the American West.[59] Conversely, the Centennial did provide a showcase in which to display models and photographs by William Holmes and William Jackson of the cliff dwellings discovered at Mesa Verde. Anthropological exhibits at major expositions and displays of artifacts continued to increase during the 1880s, at the Columbian Exposition in 1893, and culminating in a dramatic display at the 1904 Louisiana Purchase Exposition in St. Louis.[60]

In fact, it was only as a series of prophetic conditions began to unfold that a new age for the western artist emerged. With the rise of the cowboy and the cattle industry, beginning in 1866, the "Great Surveys," the four government-sponsored geological and geographical surveys conducted between 1869 and 1879, and the completion of the first transcontinental railroad, the Union Pacific and Central Pacific's line through Colorado, Utah, and Nevada to California, the West appeared in the American consciousness in ways not seen before. As the pace of western travel quickened and the cavalry pushed Indians onto increasingly restricted lands, the press was there to justify these actions and inform the public of the more lurid details. Particularly after 1876 and Custer's debacle

58. Wilson, "Painters of California's Silver Era," pp. 81, 83.

59. E. Strahan [Earl Shinn], *The Masterpieces of the Centennial International Exhibition,* vol. 1, *Fine Arts,* pp. 39–40.

60. Charles C. Eldredge, Julie Schimmel, and William H. Truettner, *Art in New Mexico, 1900–1945: Paths to Taos and Santa Fe,* pp. 25–26.

at Little Bighorn, the image of unspeakable Indian savagery was firmly implanted in the American mind. Although illustrations accompanying western stories appeared sporadically from 1867 to 1882, their number and quality grew dramatically after this date. For it was during 1883 that Frederic Remington (1861–1909), a gifted artist, contributed what was the first of dozens of illustrations for *Harper's Weekly* and other periodicals. Within five years he had been joined by Henry Farny, Rufus Zogbaum, Charles Russell, and others. By 1888 *Harper's Weekly* was occasionally featuring western subjects on its cover and occasionally devoting large, double-page spreads to single images by western artists. The impetus for this was in part a result of the West's increased accessibility. During the 1880s three more transcontinental rail lines were completed: the Southern Pacific (1882) through Texas, southern New Mexico, and southern Arizona; the Atchison, Topeka and Santa Fe (1883) through New Mexico and northern Arizona; and the Northern Pacific (1883) through the Dakota Territory, Montana, Idaho, and Washington. Such events as the Oklahoma land rush of 1889 suggested the degree to which massive western settlement had become a reality. Quite simply, the West could not be ignored.

In 1890, with the surrender of Sitting Bull at the Battle of Wounded Knee, the Indian ceased to be the official enemy of the United States. As other writers have observed, once the Indian was no longer the rational object of fear and terror, he was either reduced to educational curiosity or became rapidly romanticized.[61] So too were the cavalry and the cowboy. Such periodicals as *Harper's Weekly* and *Leslie's* glorified their escapades, a phenomenon that lasted until 1898 when the Spanish-American War displaced western imagery in the popular press. Buffalo Bill's Wild West performed from 1882 to 1916 in America and Europe, frequently to capacity crowds. It is estimated that by 1893 there were fifty wild west troupes touring the United States regaling audiences with riding and shooting acts and reenactments of Indian battles.[62]

A heightened awareness that the West was being forever transformed began almost simultaneously with the end to Indian hostilities and the explosion of western travel. Part of this awareness manifested itself in an increased sensitivity to Indian cultures. National acknowledgment of this came in 1879 with the creation of both the Bureau of American Ethnology and the Archaeological Institute of America. From this point on there was an intense desire by John Wesley Powell (1834–1902), Frank Cushing (1857–1900), Edward S. Curtis (1868–1962), and others to explore, photograph, and analyze the settlements of the West. And even to many Americans unmoved by scientific questions, there was also a sense that they were witnessing a great American tragedy: the decimation of traditonal Indian cultures. It was this latter sensibility, particularly after 1881, when Helen Hunt Jackson published *A Century of Dishonor,* her indictment of America's treatment of its own natives, that provided a generation of western artists with a nostalgic, idealized focus for their subjects and a clientele that sought them.

Artists like Henry Farny (1847–1916) and George de Forest Brush (1855–1941) catered to a new clientele. These collectors sought nostalgic images of the American Indian as noble, dignified, and in harmony with nature; theirs were Rousseauean images for urban dwellers confronted by industrialization and rapid population growth. For them, Farny, Brush, and others painted images in which the figure, and not the landscape, is of primary importance.

61. Ellwood Parry, *The Image of the Indian and the Black Man in American Art,* p. 172; Patricia Janis Broder, *Bronzes of the American West,* p. 20.

62. Lonn Taylor and Ingrid Marr, *The American Cowboy,* p. 93.

Farny, who specialized in pastoral studies of Indian life, was trained in France and spent time based in his home, Cincinnati, working as a free-lance illustrator for such periodicals as *Harper's Weekly* and *Century,* where in 1885 he came to the attention of eastern art patrons. That year Farny exhibited an enormous gouache, *The Captive* (Cincinnati Art Museum), in the American Art Association's exhibition of watercolors. It was an unusually grim subject for the artist, but it won a $250 prize and was later said to have been sold to an unnamed New York millionaire for $2,000.[63] Despite this occasional patronage from the East, it is revealing of American regional preferences that Farny's success was secured in his home city. Cincinnati at the time was a burgeoning commercial center being transformed by rapid growth and experiencing the creation of considerable private wealth. As a result Farny found ready patrons in W. C. Proctor, founder of Proctor and Gamble; Howard Hinkle, a publisher; Gen. (Judge) M. F. Force; and Rudolph Wurlitzer, owner of the Cincinnati-based music store chain.[64]

In the years after 1900 Farny had a seemingly endless line of patrons for his work. Some clients sent photographs of subjects they thought might inspire Farny to paint. Farny was besieged by so many requests that he was forced to return checks, and on one occasion responded heatedly, "I am not a house painter. I can paint only when the spirit moves me."[65]

Like Farny, George de Forest Brush found a ready market in the 1880s for his idealized depictions of the American Indian. His pursuit of Indian subjects resulted from his familiarity with Indian settlements in Wyoming, Montana, and Canada between 1881 and 1885. Beginning in 1882, while still in the West, Brush began painting such dramatic scenes as *The Escape* (1882, Philadelphia Museum of Art; Fig. 7), also known as *The Revenge,* and *Mourning Her Brave* (1883, private collection).

Brush's painting at this point recalls the work of Valentine Walter Bromley (1848–1877), a little-known British artist who painted during the preceding decade. Bromley was a special artist for the *Illustrated London News,* but his great opportunity came when he completed the illustrations for the Earl of Dunraven's book *The Great Divide,* after they traveled together for six months in 1874. Dunraven then commissioned him to paint twenty large-scale oils. Only five were completed before the artist's death, but among them was *Pahauzatanka, the Great Scalper* (Fig. 8), exhibited at the Royal Academy in 1876. It possesses the same majestic figurative power for which Brush became known and had Bromley lived he might well have achieved the level of recognition attained by his American colleague.

By 1890 Brush had painted at least twenty-five large canvases with Indian themes. The positive response to Brush's early work is probably in part attributable to his background. Unlike some of his contemporaries, who began as illustrators of western subjects and then gravitated to easel paintings, Brush, who did on occasion in the 1880s sell Indian illustrations to *Harper's Weekly* and *Century,*[66] from the start trained to be a professional painter. Certainly, his training with Jean-Léon Gérôme in Paris at the École des Beaux-Arts made him a more likely candidate for acceptance by peers and critics who placed a premium on French training. His style was fluid and polished and he brought to his subjects a sophistication not seen in some work by his predecessors and contem-

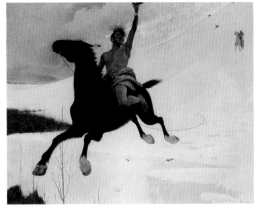

7. George de Forest Brush, *The Escape,* 1882, oil on canvas, 15½ × 19½ inches. (Courtesy Philadelphia Museum of Art, Alex Simpson, Jr., Collection.)

63. Carolyn M. Appleton and Natasha S. Bartalini, *Henry Farny,* p. 14.

64. Ibid., pp. 15–16.

65. Ibid., p. 16.

66. Nancy Douglass Bowditch, *George de Forest Brush: Recollections of a Joyous Painter,* p. 23.

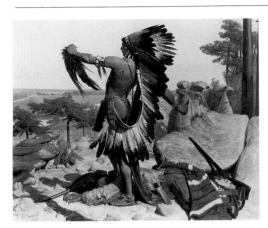

8. Valentine Walter Bromley, *Pahauzatanka, the Great Scalper*, 1876, oil on canvas, 48 × 72 inches. (Courtesy Warner Collection of Gulf States Paper Corporation, Tuscaloosa, Alabama.)

poraries. Perhaps because of this sophistication and positive critical reviews, Brush found ready buyers and one writer observed that his deliberately nonrealistic Indian subjects were "eagerly sought by collectors."[67] Among those who owned his work were Thomas B. Clarke (1848–1931), New York collector; William T. Evans (1843–1918), New Jersey art patron; and George G. Heye (1874–1957), founder of the Museum of the American Indian. Clarke, who was among the most significant patrons of American artists between 1883 and 1899, owned three paintings by Brush: *The Revenge, The Aztec Sculptor* (location unknown), and *Mourning Her Brave,* the latter two of which Clarke sold for $2,550 and $475, respectively.[68]

Evans, who lived in Montclair, New Jersey, and who later owned western works by Thomas Moran, Albert Groll (1866–1952), and Frederic Remington,[69] had purchased *Mourning Her Brave,*[70] *Before the Battle* (1884, location unknown), and *The Moose Chase* (1888, National Museum of American Art). Evans bought the latter painting through Knoedler Gallery for $2,500 in 1908.[71] One measure of Brush's acceptance by his peers is his receipt of the Hallgarten Prize (1888) from the National Academy of Design for his painting *The Sculptor and the King* (1888, Portland Art Museum, Portland, Oregon). The painting was subsequently sold to Henry Failing of Portland for $1,300, a considerable price increase over Brush's fee for *The Picture Writer's Story* (Canajoharie, New York, Library and Art Gallery), a painting of similar size that had been sold four years earlier for $200.[72] Despite these prices Brush largely abandoned painting Indian subjects after 1890. According to Brush's daughter, the artist's affinity for the Indians made him extremely sensitive to the federal government's inhospitable treatment of them. Con-

sequently, Indian subjects gave way to portraits and idealized studies of mothers and children inspired by Italian Renaissance precedents. Certainly, Brush was also becoming well known as a society portrait painter and by the 1920s, during the twilight years of the glamorous society portrait, he charged $12,000 for a full-length portrait of a mother and child and $10,000 for a half-length.[73]

It is revealing about the success of both Farny and Brush that each artist in his own way was less concerned with the reality of Indian life in America than with portraying positive but fictionalized and idealized images. While the public wanted to believe that Indian life was still as they depicted it, this was a belief accepted out of ignorance. Reality was otherwise and the images of proud, independent Indian families living unfettered on the plains that populate their paintings bear little resemblance to the photographs of the period, which depict Indian life as it was: organized around the reservation, dependent upon government handouts, and utterly controlled by the often ruthless federal government.

Brush readily admitted that his depictions of Indian life were idealized. This admission reflects the attitude of Americans in the 1880s and subsequent decades. In describing his work critics have repeatedly referred to the poetic quality of his style. One critic, writing in 1922, remarked that his Indian subjects "delivered original messages of truth and sincerity, with realism tempered by poetry to a marked degree. They do not resemble those latter day Indian pictures that classify in the art trade as 'best sellers.'"[74]

Remington, unlike Farny and Brush, was initially, at least, less interested in the idealization of the American Indian than he was

67. Minna C. Smith, "George de Forest Brush," *International Studio* 34, no. 134 (April 1908): 54.

68. H. Barbara Weinberg, "Thomas B. Clarke: Foremost Patron of American Art from 1872 to 1899," *American Art Journal* 8, no. 1 (May 1976): 72.

69. William H. Truettner, "William T. Evans, Collector of American Paintings," *American Art Journal* 3 (Fall 1971): 50–79.

70. George William Sheldon, *Recent Ideals of American Art*, 6, p. 80.

71. M. Knoedler and Company, Commission Book No. 2, April 1903–August 1927, no. 3311.

72. Joan B. Morgan, "The Indian Paintings of George de Forest Brush," *American Art Journal* 15, no. 2 (Spring 1983): 70.

73. *George de Forest Brush, 1855–1941: Master of the American Renaissance*, p. 30.

74. Lula Merrick, "Brush's Indian Pictures," *International Studio* 76, no. 307 (December 1922): 187.

in four elements: (*a*) life-and-death confrontations, (*b*) hostile antagonists (the Indians), (*c*) hard-driving heroes (the cavalry), and (*d*) rugged independents (the cowboys). For the first time the American public was confronted by an artist who could capture all the associations they had with the West: a hard life, constant struggle, and a recognition of good over evil. His vivid manner of illustration brought a fervor to western illustration that was previously unknown. His maturation as an illustrator also fortuitously coincided with a publishing explosion that brought about ten thousand new magazines between 1890 and 1940.[75]

Since it was Remington's practice to sketch in oil works that would reproduce in *Harper's Weekly* as wood engravings, it was not long before Remington sought to establish himself as an easel painter as well. This he did in 1888 when he exhibited *Return of a Blackfoot War Party* (Anschutz Collection, Denver) at the National Academy of Design. The fact that George de Forest Brush was awarded the Hallgarten Prize this same year suggests that Indian subjects were beginning to enter a brief period of prominence in the conservative world of the National Academy and the New York salon. Remington unabashedly asked $1,000 for his painting, which was four times his normal price. Although the painting was sold the following year to an unnamed buyer, it was sold again in the 1890s to T. H. Mastin, a Kansas City collector, for $250.[76]

Most of Remington's success, and his income, before 1900 came as a result of the demand for illustrations. These he was shrewd enough to loan to the publisher and then have returned so they could be sold to private collectors.[77] Occasionally, Remington received commissions. In 1889 a large painting, *A Dash for the Timber* (Amon Carter Museum, Fort Worth) was commissioned by New York industrialist Edmund Cogswell

Converse (1849–1921), inventor of the lock-joint for tubing, who was celebrating his appointment as general manager of his father's company, National Tube Works. But of the $11,000 Remington earned that year most of it came as a result of illustration.[78]

Having exhibited two years in a row at the National Academy of Design and also having been given an award at the 1889 Paris International Exposition for his painting *The Last Lull in the Fight,* Remington found his work becoming more popular. The following year he was given his first one-man exhibition in New York, at the American Art Galleries. Of the twenty-one paintings exhibited, six were already in private collections. Some of Remington's patrons were military men, like Gen. Nelson Miles (1839–1925), prominent in the Indian campaigns of the 1870s and 1880s, who would barter with the artist. For example, during the period Miles was commander of the army's division of the Pacific, he would invite Remington to be his guest in California, in exchange for paintings.[79] This Remington gladly did for the opportunity to gain new material.

Despite increasing patronage and a rapidly rising star, western artists were for the most part ignored by most serious art collectors and critics. For example, in George W. Sheldon's lavish work, *Recent Ideals of American Art* (1888), only Brush and Remington among the painters of western subjects were mentioned. All the other American art illustrated was closely aligned to the European taste for classical figures, brooding landscapes, or peasant genre scenes. The state of affairs, however, changed significantly over the next twenty years.

75. James K. Ballinger and Susan P. Gordon, "The Popular West," *American West* 19, no. 4 (July–August 1982): 42.

76. Peggy and Harold Samuels, *Frederic Remington,* p. 97.

77. Ibid., p. 139.

78. Peter H. Hassrick, *Frederic Remington: Paintings, Drawings, and Sculpture in the Amon Carter Museum and the Sid Richardson Foundation Collections,* p. 68; Registrar's Files, Amon Carter Museum: Remington, *A Dash for the Timber;* Samuels, *Frederic Remington,* p. 126.

79. Samuels, *Frederic Remington,* p. 141.

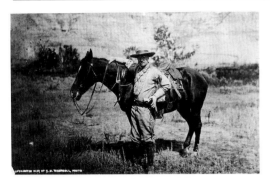

9. T. W. Ingersoll, *Teddy Roosevelt*, ca. 1895. (Courtesy Presidential File, Prints and Photographs Division, Library of Congress.)

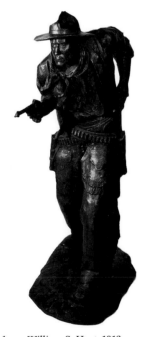

10. Charles C. Cristadoro, *William S. Hart*, 1912, bronze, Gorham Co. Founders, Providence, Rhode Island. (Courtesy University Gallery, University of Delaware, Newark.)

In September 1901, when William McKinley was assassinated, he was succeeded as president by Theodore Roosevelt, who Mark Hanna, a senator from Ohio, had described as "that damned cowboy." Roosevelt's presidency could not have come at a more propitious time for the artists of the West. Aside from Remington, there was probably no greater spokesman for the west than Roosevelt (Fig. 9). Although he was a wealthy New Yorker from a prominent family, Roosevelt aspired to a rugged lifestyle. During the 1880s Roosevelt briefly owned a cattle ranch in South Dakota and in 1887, when he decided to publish *Ranch Life and Hunting-Trail* (1888), he sought out Remington to do the illustrations. This collaborative effort was the first of several that added luster to Remington's stature by linking him with a rising political figure. Roosevelt's presidency now gave Remington a platform that extended all the way to the seat of government.

The following year, Owen Wister, a Harvard classmate of Roosevelt, published *The Virginian,* the most widely read piece of fiction of its day. It had come on the heels of dozens of western dime novels published in the 1880s and 1890s by Edward Wheeler, Thomas "Captain Howard Holmes" Harbaugh, and others.[80] The book, which ostensibly gave an account of the life of a Wyoming cowboy, became the written text to accompany Remington's paintings. Although it was a highly romanticized view, it was the one the American public wanted to believe. It is not surprising then that Wister acquired works by Remington, such as *The Last Cavalier,* which the artist gave him, and *What an Unbranded Cow Has Cost,* which Wister bought for $255 at an 1893 sale of the artist's work.[81]

Roosevelt extolled Remington's virtues, writing in 1893 that

I never so wished to be a millionaire or indeed any person other than a literary man with a large family of small children and taste for practical politics and bear hunting, as when you have pictures to sell.[82]

Curiously, however, this endorsement of Remington did not lead to the formation of a personal collection of western art. He did, however, commission sculptor A. Phimster Proctor (1862–1950) to model two bison heads for the White House to replace British lions that had long decorated one of the fireplaces.[83] He also received as gifts Remington's bronze *The Bronco Buster,* a gift from his regiment; a small bronze grizzly bear given him by artist Edwin Deming (1860–1942); and Proctor's *Charging Panther,* a gift from his cabinet.

The popularity of western subject matter was further enhanced in 1902 when Edwin S. Porter made the first western film, *The Great Train Robbery.* In succeeding decades the number of celluloid cowboys multiplied. They could be divided into two types: the strong silent man of action played by people like William S. Hart (Fig. 10) and the "hard-driving, crack shooting cowboy of the Wild West show played by actors like Tom Mix."[84] Hart in many ways became the incarnation of Zane Grey's "good-bad" hero played out repeatedly for over twelve years in such films as *Two-Gun Hicks, The Narrow Trail, Tumbleweeds,* and others.[85]

One might argue that, just as the western films and dime novels were designed to entertain, much of the western art of the era was popular with its devotees because it, too, entertained. It is probably no accident that the success of Remington and his fol-

80. Russell Nye, *The Unembarrassed Muse: The Popular Arts in America,* p. 286.

81. Ben Merchant Vorpahl, *My Dear Wister,* p. 167; Samuels, *Frederic Remington,* p. 235.

82. Samuels, *Frederic Remington,* p. 235.

83. Wayne Craven, *Sculpture in America,* p. 522.

84. Archives of American Art, Film NOR 1, Theodore Roosevelt to Frederic Remington, June 29, 1908; Edwin Deming Papers, University of Oregon Library, Theodore Roosevelt to Edwin Deming, November 3, 1916.

85. Nye, *The Unembarrassed Muse,* pp. 368, 374. The popularity of Mix and Hart is suggested by their astronomical salaries: Mix was paid $19,000 per week in 1926; Hart drew $2.25 million for nine films in two years.

lowers was based on a highly calculated narrative appeal and tremendous sense of place, the same elements that contributed to other forms of western entertainment, namely films and novels.

Despite the fact that Americans were being bombarded in the early 1900s by images of "Indians, cowboys, sheriffs, dudes, outlaws, miners, judges, dance-hall girls, scouts, soldiers, gamblers . . . Wells Fargo, the Pony Express, the railroad, the Oregon Trail, the covered wagon, Custer's Last Fight, the pursuit of Geronimo, range wars, the gold rush"[86] coming at them in books, magazines, and the paintings of western artists, not all segments of American society were willing to give in aesthetically to this barrage. As one might expect, in bastions of conservative taste, such as Boston, Remington was dismissed as a rube. In fact, Remington's own "popularity" contributed to a coolness in some artistic circles. Phillip Hale, a fashionable Boston artist reviewing an 1897 show of Remington's work there, remarked that "Remington's indifference to beauty of form, his unfeeling realism, and his poverty of color are formidable handicaps."[87] Clearly, there was a fine line in American society between those who fancied themselves arbiters of taste and those like Remington with populist appeal.

But despite pockets of criticism, these were banner years for Remington. In 1909 he received considerable distinction when William Evans purchased his painting *Fired On* (National Museum of American Art; Fig. 11) for $1,000 and Remington's dealer, Knoedler's, notified the artist it was to be a gift to the National Museum in Washington.[88] Two years earlier, while the painting was on exhibition at Knoedler's, Royal Cortissoz, the art reviewer for the *New York Tribune* and one who was frequently reserved about Remington, described the painting as "one of the

11. Frederic Remington, *Fired On,* ca. 1907, oil on canvas, 27⅛ × 40 inches. (Courtesy National Museum of American Art, Smithsonian Institution; gift of William T. Evans.)

most truly dramatic compositions he has ever put to his credit."[89]

Remington's paintings were acquired by knowledgeable collectors like Evans, but more frequently his work was purchased by people who were not prominent art connoisseurs. These enthusiasts were attracted to Remington's subjects by the qualities in American life they represented. Professionals of all types—bankers, lawyers, physicians, newspapermen—were fond of Remington's work. In 1909, for example, he sold two large works for $500 each to Robert Dudley Winthrop, an investment banker from Long Island. The same year one of the artist's Connecticut neighbors, A. Barton Hepburn (1846–1922), a lawyer, politician, and president of Chase Bank in New York, purchased *The War Bridle* for $600 at Rem-

86. Ibid., p. 288.
87. Samuels, *Frederic Remington,* pp. 256–257.
88. Ibid., p. 433.

89. Peter H. Hassrick, *Frederic Remington: An Essay and Catalogue,* p. 37.

12. After Frederic Remington, *The Fight for the Water Hole*, photogravure, 12¼ × 18⅜ inches, *Collier's*, December 5, 1903. (Courtesy Amon Carter Museum, Fort Worth.)

ington's exhibition at Knoedler's.[90] Nine years later the officers of the bank also presented Hepburn with a gift of Remington's bronze *Coming Through the Rye*.[91] Even William Randolph Hearst, the newspaper publisher, who had sent Remington to Cuba in 1896 and who bought a little of everything in his life, purchased a small, early Remington, *The Mexican Major*, at auction in 1909 and also owned his large 1893 oil *Coming to the Rodeo* (R. W. Norton Art Gallery, Shreveport).

During the artist's lifetime, close friends and acquaintances of Remington who may well have had personal and sentimental reasons for their choices also acquired his work. These collectors included Wister, Miles, artist Howard Pyle, and John Howard, the president of a coal company in Remington's home-

town of Ogdensburg, New York. Howard had been willing to pay $2,500 for Remington's painting *The Cowboy* (Amon Carter Museum, Fort Worth), two and one-half times the going rate. When he inquired why Remington had not deposited his check, Remington, lighting a cigar with it, replied, "There you are, John. Now I've deposited your d___ check."[92]

But the biggest patron Remington ever had for his easel paintings was *Collier's Magazine*. Beginning in 1903 the editors agreed to pay him $12,000 annually for the rights to twelve easel paintings. These were reproduced as two-page color spreads (Fig. 12). Not only did they give Remington national exposure in color, but the works were returned to him and many were later sold through Knoedler's for $1,000 each.

Competing instincts governed Remington's willingness to accept commissions. On the one hand he enjoyed the money all commissions brought, and some collectors sought his work precisely because he was a great illustrator,[93] but after 1900 he increasingly wanted to leave a legacy as an easel painter and cast off the shackles of the commercial illustrator. This made him cautious about accepting commissions to illustrate text.

Another type of commission that came Remington's way was the opportunity to paint a work for a commercial setting. One example of this occurred in 1906 when he was apparently asked to paint *A Cavalry Scrap* (Fig. 13), his largest painting, for the grill room of the recently opened Knickerbocker Hotel in New York.[94] While the exact circumstances of the commission are not now known, the hotel that same year is known to have paid $5,000 to Maxfield Parrish for his mural *Old King Cole*.[95]

At the same time a whole new world of opportunities for western images was being

90. Samuels, *Frederic Remington*, pp. 434–435. After the purchase Hepburn wrote to Remington: "The number of pictures sold [at Remington's Knoedler exhibition] and the rapidity with which they went was most gratifying and the best part of it is the character of the people who bought them. I congratulate you."

91. Registrar's Files "Remington *Coming Through the Rye*," Amon Carter Museum, Fort Worth.

92. Samuels, *Frederic Remington*, p. 322.

93. *Catalogue of the Collier Collection of Original Drawings and Paintings by Distinguished American Painters and Illustrators*.

94. Carolyn Appleton and Jan Huebner, "Nineteenth-Century American Art at the University of Texas at Austin," *Antiques* 126, no. 5 (November 1984): 1234.

95. Virginia Reed Colby, "Stephen and Maxfield Parrish in New Hampshire," *Antiques* 115 (June 1979): 1295.

made possible by manufacturing companies that sought images for advertising. Remington, although hesitant about the repercussions, did paintings for advertisements for such companies as Winchester Repeating Arms Company.[96] These opportunities were lucrative, but Remington accepted them reluctantly and eventually not at all.

The success of western specialists like Remington was not lost on fellow artists. Charles Schreyvogel (1861–1912), whose specialty was cavalry subjects, was one who attempted to duplicate it. Initially, in the 1890s, Schreyvogel, the son of German immigrants, found only local recognition. While his paintings would not sell to New York dealers, across the Hudson River in Hoboken where Schreyvogel lived, a small group of wealthy German American industrialists, such as John Linde, William L. Keuffel, Adolf Ludwig, Henry Lambelet, and Carl Willenborg, Sr., purchased his work.[97] These men, who gathered each week at the Deutscher Club, invited Schreyvogel to bring his paintings to their fashionable houses in the Castle Point section of Hoboken. John Linde, who purchased Schreyvogel's paintings *Breaking through the Circle* (p. 174) and *Standing Them Off,* was a wealthy paper manufacturer and patron of the arts whose collection eventually included western works by Edwin Deming, Carl Rungius, August Schwabe, and Remington. Linde was the driving force behind an exhibition held in April 1908 at the Free Public Library in Hoboken. This little-known exhibition was unusual for its date as it brought together numerous works from private collections devoted to the American West. Exhibited paintings included *Making Medicine* by Erving I. Couse, *The Toilers of the Plains* by Deming, *Arizona* by Albert Groll, *An Old Timer* by Will Ritschel, *Wanderers of the North (Caribou, Yukon Territory)* by Rungius,

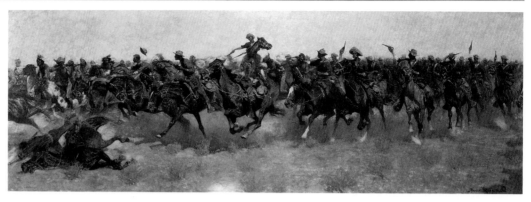

13. Frederic Remington, *A Cavalry Scrap,* 1906, oil on canvas, 41 inches × 13 feet 2 inches. (Courtesy Archer M. Huntington Art Gallery, The University of Texas at Austin; gift of Ima Hogg, 1943.)

and *A Bit of Acoma* by Mathias Sandor. The exhibition also included four paintings by Schreyvogel. Among them were Linde's *Breaking Through the Circle, My Bunkie* (Metropolitan Museum of Art), contributed by the artist, and *Protecting the Emigrants,* in addition to bronzes by Deming, Rungius, and Schreyvogel.[98]

Schreyvogel's *Protecting the Emigrants* had been painted as a commission for Adolf Ludwig, who had invited the artist to his home. Pointing to a large space above the fireplace, he said, "Charlie, I've been thinking for a long time that this spot is just the right place to hang one of your great western paintings. Can you do one that big?"[99]

Schreyvogel's *My Bunkie* (Fig. 14) had nine years earlier established his reputation as an artist. In 1899 it was hanging in an out-of-the-way location at Luchow's restaurant in Manhattan when Schreyvogel reclaimed it for exhibition at the National Academy of Design. There it won the Clarke Prize and was later acquired by the Metropolitan when a group of Schreyvogel's Hoboken admirers raised the money for it, purchased it from the artist's widow, and presented it to the museum.[100]

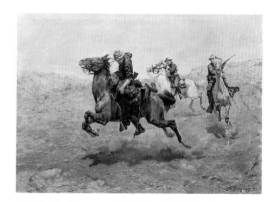

14. Charles Schreyvogel, *My Bunkie,* 1899, oil on canvas, 25³⁄₁₆ × 34 inches. (Courtesy Metropolitan Museum of Art; gift of Friends of the Artist, 1912.)

96. *Frederic Remington (1861–1909), Paintings, Drawings, and Sculpture: In the Collection of the R. W. Norton Art Gallery,* no. 6.

97. James D. Horan, *The Life and Art of Charles Schreyvogel,* p. 21.

98. *Oil Paintings by Contemporary American Artists Exhibited in the Free Public Library . . .*

99. Horan, *The Life and Art of Charles Schreyvogel,* p. 21.

100. Doreen Bolger Burke, *American Paintings in the Metropolitan Museum of Art: Volume III, A Catalogue of Works by Artists Born between 1846 and 1864,* pp. 402–403.

15. Living Room, Pawnee Bill's "Bungalow," Pawnee, Oklahoma. (Courtesy *Oklahoma Today* magazine; photo by Fred W. Marvel.)

Like Remington, Schreyvogel benefited from reproductions after his work. In 1905, Moffat, Yard & Company began to issue platinum prints of twenty-eight of Schreyvogel's works.[102] As Schreyvogel's popularity spread he was approached in 1910 by "Pawnee Bill" (Gordon W. Lillie, 1863–1942), an old western friend who the preceding year had combined his western show with that of Buffalo Bill to form "Buffalo Bill's Wild West and Pawnee Bill's Great Far East." Schreyvogel was asked, along with at least five other western artists, to do paintings for Pawnee Bill's "bungalow," a house said to have cost over $75,000, being built on his buffalo ranch in Pawnee, Oklahoma. The house opened the following year with elaborate furnishings and paintings valued at between $100,000 and $200,000.[103]

In August 1910, Schreyvogel, who seems to have orchestrated all the painting commissions, wrote Edwin Deming about the panel he was asked to do. He noted:

I will make one 5 [feet] 3⅛ × 3 ft. I wrote to Lenders [E. W. Lenders, ?–1934] and he will see Stevens [Charles S. Stephens, 1855–1931]. I hope we will all be able to go out to the Majors this late fall. I am very glad & took such liking to him. When you know him better you will be delighted with him. He is just splendid.[104]

The following year a pamphlet described the interior (Fig. 15):

The walls of the living room are decorated with the most artistic and appropriate hangings and paintings, every niche and corner having something specially designed for it, and what is more rare and unique is a series of original scenes painted by renowned artists as Schreyvogel, Stephens, Demming [*sic*], Lenders, Cross [H. H. Cross, 1837–1918] and others, each picture being drawn to fit a certain space, conveying a sentiment or to illustrate an era in the life and career of the owners and all these priceless paintings

After 1899 Schreyvogel's success steadily increased. In 1902 *Rescue at Summit Springs,* commissioned by Buffalo Bill Cody in exchange for some mining stock, was the showpiece of the Irma Hotel, Cody, Wyoming, when it opened that November.[101] That same year Mayor Herman L. Timken of Hoboken, owner of the well-known Meyers Hotel, bought the original bust of Schreyvogel's portrait sculpture, *White Eagle.* The following year *Custer's Demand* (Thomas Gilcrease Institute of American History and Art, Tulsa) was exhibited at Knoedler's, then it was at the Corcoran Gallery of Art, and eventually it was bought by Fred Crane and given to the Berkshire Museum (Pittsfield, Massachusetts), which his family had founded.

101. It hung at the hotel with work by other western artists, including Henry R. Lewis (1819–1904) and Charles S. Stobie (1845–1931) (see Don Russell, *The Lives and Legends of Buffalo Bill,* p. 427).

102. Horan, *The Life and Art of Charles Schreyvogel,* p. 45.

103. Ibid., p. 51.

104. Edwin Deming Papers, University of Oregon Library, Charles Schreyvogel to Edwin Deming, August 26, 1910.

were brought to the Bungalow by the artists themselves and presented to Mr. and Mrs. Lillie with their compliments, a token of honor and esteem such as never before recorded.[105]

At virtually the same time Schreyvogel was becoming well known, Charles Russell (1864–1926) was discovered in Montana and brought to the attention of collectors in New York. Although Russell had had *Caught in the Act* reproduced in *Harper's Weekly* as early as 1888, in the 1890s he painted primarily for his own enjoyment. He did not sell his first painting until 1899 when S. A. "Sid" Willis, the proprietor of the Mint Saloon in Great Falls, Montana, purchased *The Hold Up* (Amon Carter Museum, Fort Worth). Over the course of the next seven years Willis acquired a number of Russells, which he used to decorate the saloon (Fig. 16).

Russell's career took a dramatic turn in 1903 when he went to New York and agreed to provide illustrations for W. T. Hamilton's *My Sixty Years on the Plains* and magazines, such as *McClure's, Leslie's Illustrated Weekly*, and *Outing*.[106] His primary message was the honest, rugged lifestyle of those who inhabited Montana, and as his biographer stated, "there was no place in the pioneer environment for weaklings or sissies, and above all no place for mediocrity."[107] These were sentiments to which Russell's well-heeled admirers could easily relate.

In succeeding years, particularly after the death of Remington (1909) and Schreyvogel (1912), Russell became the most prominent of the western artists. As the result of an exhibition in Calgary, Alberta, in 1912, Russell sold five works, including *In without Knocking* (Amon Carter Museum, Fort Worth), to Sir Henry Mill Pellat (1860–1939), commander of the Queen's Own Rifles. This was followed two years later by the exhibition of his work in London at Dore Galleries on

16. Interior of the Mint Saloon depicting Charles Russell paintings in Sid Willis' Collection, ca. 1920, Great Falls, Montana. (Courtesy of C. M. Russell Museum, Great Falls, Montana.)

New Bond Street where a number of works sold five works, including *In without Knocking* (Amon Carter Museum, Fort Worth), Russell's *When Law Dulls the Edge of Chance* (1915) by public subscription and presented it to the Prince of Wales when he attended the Calgary Stampede.[109]

But like so many western artists Russell had a following among wealthy businessmen. Among them were William Mellen, a former official with the Northern Pacific Railroad,[110] and Sen. William A. Clark (1877–1934), Montana's richest mining magnate who built a mansion on Fifth Avenue in

105. Louis E. Cooke, "Buffalo Ranch and the Beautiful Bungalow Home of Pawnee Bill," *Souvenir of the Buffalo Ranch and Its Owners*, pp. 11–12.

106. Frederic G. Renner, *Charles M. Russell*, rev. ed., p. 26.

107. Ibid., p. 8.

108. Ibid., p. 28.

109. Peter Hassrick, *The Way West: Art of Frontier America*, p. 157.

110. Mellen owned Russell's *Piegan Indians Hunting Buffalo* (The Inter North Art Foundation/Joslyn Art Museum, Omaha).

New York and wanted a few watercolors to decorate it.

Stories about Russell abound. Russell's wife, Nancy, was known as the business person in the family. Robert Vose, Sr. (1873–1964), a Boston art dealer who himself gave Russell's work a number of exhibitions in both Boston and Los Angeles, recounted the story of Russell's first New York show:

Nancy would never let Charlie in the room when she had a customer. He was sitting out of sight, just outside the gallery door with a friend, and listening to the conversation. "How much is this picture Mrs. Russell?" "That is $5,000." Sir Charles whispered to his chum, "No damn picture is worth $5,000."[111]

By the early 1900s the pattern of success for artists of the western subjects was established. The artists catered to the American need to visualize the drama that had taken place over the preceding century. To do this they sought as a steady source of income illustrations for books and articles about the west. Occasionally, as in the case of Remington and others, they provided the texts as well. An important form of recognition was evidence of training abroad and membership in the National Academy of Design. These two factors provided a rite of passage for the artist of western subjects, whose topics were otherwise ridiculed by some critics who wanted American art to bear the mark of European influence. The artists who overcame these hurdles, such as Brush and Farny, or received some form of critical acclaim, such as Schreyvogel, Remington, and Russell, among others, were then fortunate to receive public exhibitions and private patronage without which an artist had little chance to succeed.

The situation for sculptors was somewhat different than for painters. By the nature of their craft, sculptors, whether interested in western subjects or not, were frequently dependent upon large-scale commissions, which were often all-consuming of the artist's time. They did, however, frequently provide a large fee to the artist.

Before the Columbian Exposition, western themes, most of which focused on the Indian, had appeared only a few times in American sculpture. Henry Kirke Brown (1814–1886), for example, had sculpted in bronze twenty copies of a statuette titled *Aboriginal Hunter,* which were distributed as premiums by the American Art Union. By 1850 the organization had paid over $2,000 to him for these bronzes.[112] Other Indian subjects, such as Shobal Vail Clevenger's *Indian Chief* (1841–1842) and Erastus Dow Palmer's *Indian Girl* (1855), were roundly praised by Tuckerman for their American theme.

In 1860 John Quincy Adams Ward (1830–1910) was commissioned by interested New York citizens to sculpt *The Indian Hunter* for Central Park. Similarly, fifteen years later Theodore Bauer was commissioned by the Meriden Britannia Company, the predecessor to International Silver Company, to sculpt *The Buffalo Hunt* (Fig. 17) to be shown at the Centennial Exposition in Philadelphia.[113] In fact, many of the best known examples of western subjects sculpted in the late nineteenth century were commissioned for city parks or for celebrations, such as the Columbian Exposition. Included in this group are John Boyle's (1851–1917) *The Alarm,* commissioned in 1884 by Martin Ryerson for Chicago's Lincoln Park, as well as Cyrus Dallin's (1861–1944) *The Medicine Man* (1900), commissioned by the Fairmount Park Association for its Philadelphia park. The Columbian Exposition gave rise to a number of

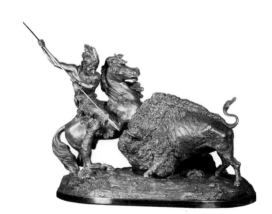

17. Theodore Bauer, *The Buffalo Hunt,* ca. 1875, bronze, H. 22¾ inches. (Courtesy Frederic Remington Art Museum, Ogdensburg, New York.)

111. Amon Carter Archives, Amon Carter Museum, Fort Worth, Robert C. Vose to Amon G. Carter, November 5, 1954. The same letter described Vose's own relationship with Nancy Russell: "During my ten exhibitions at Los Angeles, I saw much of Nancy; she would dine with me at the Biltmore and then I would dine with her and spend the evening before the great fireplace while she told me wonderful stories about Charlie and his friends. It was a large handsome room, lined with his best pictures, between which were nitches [*sic*] filled with his sculpture. Charlie had left her very comfortably situated; she had a fine Packard car and chauffeur. One delightful trip on which she took me was to call on Bill Hart [William S. Hart] on his ranch. Finally I asked her to bring that room full of Russell art to Boston and exhibit with us. She did. I deeply regret that we have no photograph of the gallery at that time. I doubt if there has ever been such a fine exhibition of Russells, for this consisted of their favorite pictures and sculpture."

112. Craven, *Sculpture in America,* pp. 148, 516.

113. Broder, *Bronzes of the American West,* p. 256.

western sculptures, among them Henry Kirke Bush-Brown's (1857–1935) *Indian Hunting Buffalo* and A. Phimster Proctor's equestrian composition of a mounted cowboy and an Indian scout. It also provided a forum in which were exhibited such sculptures as Dallin's *The Signal of Peace,* which in turn was purchased by Judge Lambert Tree of Chicago and installed in Lincoln Park.[114] Judge Tree may have spoken for many devotees of western art when, upon donating the statue, he wrote the commissioners of Lincoln Park this often-quoted statement:

I fear the time is not far distant when our descendants will only know through the chisel and brush of the artist these simple, untutored children of nature who were, little more than a century ago, the sole human occupants and proprietors of the vast northwestern empire of which Chicago is now the proud metropolis. Pilfered by the advance-guards of the whites, oppressed and robbed by government agents, deprived of their land by the government itself, with only scant compensation, shot down by soldiery in wars fomented for the purpose of plundering and destroying their race, and finally drawn by the ever westward tide of population, it is evident there is no future for them except as they may exist as a memory in the sculptor's bronze or stone and the painter's canvas.[115]

Another sculptor of western themes to benefit from the Columbian Exposition was Hermon MacNeil (1866–1947). After several years of study in France he had returned to America in 1891 to assist with sculptural decorations for the fair. The best known of his Indian subjects is his bronze *The Sun Vow* (1898), in which an Indian seated by his adolescent boy has just watched him shoot an arrow toward the sun. It is marked by an ethnological accuracy and naturalism that characterized the best western subjects of this period. While on exhibit at the Art Institute of Chicago it was purchased by architect

Howard Shaw for the grounds of his Lake Forest, Illinois, home, and soon thereafter a replica was ordered by New Jersey collector William T. Evans for his Montclair estate.[116]

Exhibitions in the early part of the century gave continued prominence to western subjects. In 1904, at the Louisiana Purchase Exposition in St. Louis, a life-size version in plaster of Remington's bronze *Coming Through the Rye* was exhibited. A large version of Adolph Weinman's *Destiny of the Red Man* was exhibited there, as was a heroic-size plaster version of James Earl Fraser's *Cheyenne Chief.*[117] Also exhibited were figural groups by Solon H. Borglum (1868–1922), including *The Blizzard* and *The Sioux Indian Buffalo Dance.*[118] As late as 1915, one of the greatest of all western theme sculptures, Fraser's *The End of the Trail,* was commissioned for exhibition at the Panama-Pacific International Exposition in San Francisco.[119]

The tradition of large-scale outdoor western sculptures in bronze continued steadily into the 1920s and sporadically thereafter. Numerous commissions for large, oudoor sculptures came to Proctor. These included *Buckaroo* (1914), for the plaza of the Denver Civic Center; *Circuit Rider* (1919–1922), for the State House grounds, Salem, Oregon; *Pioneer,* at the University of Oregon; and *Teddy Roosevelt as a Rough Rider* (1922), presented to the city of Portland by Joseph Teal, a long-time friend of the president.[120] In 1923 Gertrude Vanderbilt Whitney (1875–1942) did her large bronze equestrian monument *Buffalo Bill* for Cody, Wyoming, and eight years later Cyrus Dallin's *The Passing of the Buffalo* or *The Last Arrow* (1929) was purchased by Geraldine Rockefeller Dodge (1882–1973), the sculptor's best friend and patron, for her estate.[121] And as late as 1948 the University of Texas at Austin unveiled *Mustangs,* the last major commission of A. Phimster Proctor.

114. Ibid., p. 95.
115. William Howe Downes, "Mr. Dallin's Indian Sculptures," *Scribner's Magazine* 57 (June 1915): 781, as quoted in ibid., pp. 95, 97.
116. Craven, *Sculpture in America,* p. 518.
117. Broder, *Bronzes of the American West,* pp. 186, 197.
118. *Two Hundred Years of American Sculpture,* p. 261.

119. Fraser also received the government commission to design the new five-cent piece, the "Buffalo" or "Indian head" nickel, minted 1913–1939.
120. Craven, *Sculpture in America,* p. 523.
121. Patricia Janis Broder, "The Geraldine Rockefeller Dodge Collection of American Western Bronzes," *American Art Review* 3, no. 2 (March–April 1976): 112, 115.

Another avenue of income open to the sculptor was the production of multiple bronze castings of an individual sculpture. Occasionally these would be reduced-size replicas made after a large-scale work, such as the seventeen-inch replicas made after Cyrus Dallin's life-size work or the replicas of Fraser's *The End of the Trail,* sparked by its exhibition at the Panama-Pacific Exposition. Other times they would be less-than-life-size bronzes cast in small numbers. An early example of this is Randolph Rogers' (1825–1892) one and only true western subject, *The Last Arrow* (1879–1880). Rogers, whose fame as a sculptor was achieved in the 1850s and who was later commissioned to do the bronze Columbus Doors for the United States Capitol, sold this forty-three-inch grouping of an Indian shooting a bow and arrow in 1881 for $1,500 to O. J. Wilson of Cincinnati.[122]

The making of small-scale bronzes, suitable for exhibition in the parlor or drawing room, had been perfected in Paris in the mid-nineteenth century. Frequently, the American-modeled sculptures were cast either in Parisian foundries or in America by European-trained craftsmen, such as at the Roman Bronze Works, Brooklyn, New York. A number of American artists, such as Remington, Schreyvogel, Russell, and Deming, capitalized on the American interest in the medium and derived considerable income from the sale of bronzes. Many of these could be seen in the windows of Tiffany's on Union Square in New York, the leading dealer of bronze statuettes.[123] Here, beginning in October 1895, Remington began selling casts of his bronzes. The first was *The Bronco Buster,* which sold for $250, and prices ranged up to $2,000 for his four-figure composition, *Coming Through the Rye.*[124]

Remington, when in New York, would frequently stop at Tiffany's to see Henry W. S. Pell (active 1887–1919), the representative for Remington's sculpture.[125] His sculpture *The Bronco Buster* sold at a fast clip, approximately twenty-five per year, and brought Remington a steady income. At one point, Remington wrote an exasperated note to Riccardo Bertelli, the owner of the Roman Bronze Works, observing that the demand for his sculpture was considerable:

Tiffany is going to be out of bronzes especially Bronco Busters long before Xmas. . . . We ought to have made 20 Bronco B — this summer. I told you so.[126]

Remington bronzes found their way into houses all across America from that of the newspaper publisher Hearst (*The Bronco Buster*) and A. Barton Hepburn (*Coming Through the Rye*) to French Devereux, the young son of an executive with the Lakeshore and Michigan Southern Railroad, for whom Remington made to order in 1904 his unique cast of *The Buffalo Signal.*[127] The fifteen-year-old boy wrote to Remington that "the bronze is fine. It was the best present I got not counting an army saddle and a bridle. Papa told me what it was meant to represent. Guess I will have to feed now. Hope you have a happy year."[128]

Russell, too, heightened his national exposure with the exhibition and sale in 1904 and 1905 of his first bronzes: *The Buffalo Hunt, The Scalp Dance,* and *Counting Coup.* Because of their complex detail, these works sold for $450, or more, while Remington's single-figure bronzes sold for $250–300.[129]

The success that Remington bronzes had with the public was followed by an appreciation of them by several museums as well. In

122. Millard F. Rogers, Jr., *Randolph Rogers: American Sculptor in Rome,* p. 225.

123. Remington's work was also sold at Spaulding's in Chicago (see Michael Edward Shapiro, *Cast and Recast: The Sculpture of Frederic Remington,* p. 57).

124. Samuels, *Frederic Remington,* pp. 226, 327.

125. Shapiro, *Cast and Recast,* p. 57.

126. Remington to Bertilli (ca. late 1907), Norton Gallery, Shreveport, as quoted in ibid., p. 58.

127. Patricia Broder, "The Buffalo Signal, the Lost Remington Bronze," *Southwest Art* 8, no. 12 (May 1979): 70.

128. Samuels, *Frederic Remington,* p. 318.

129. Broder, *Bronzes of the American West,* p. 160.

1905 the Corcoran Gallery of Art purchased casts of *Coming Through the Rye* and *The Mountain Man.*[130] Two years later Daniel Chester French, chairman of the Metropolitan Museum of Art's committee on sculpture, informed Remington that they had decided to purchase four of his sculptures.[131]

Remington's small-scale bronzes eventually generated what he considered his most significant sculptural commission: *The Cowboy* (Fig. 18), cast in 1908 for the Fairmount Park Art Association in Philadelphia. The statue, which stands in the park today, joined Cyrus Dallin's *The Medicine Man,* an earlier work of a western theme. Remington was paid $20,000 for his efforts and this dwarfed the $10,000 that Solon Borglum had received for an equestrian statue in Prescott, Arizona, and the $6,000 paid Dallin.[132] Still, because of the complicated nature of the process, Remington made no money on the commission.

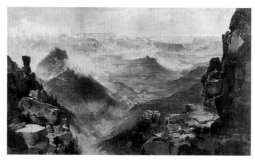

19. After Thomas Moran, *The Grand Canyon of the Colorado River, Arizona,* 1892, lithograph, published for the Santa Fe Railway. (Courtesy Arizona Historical Society, Tucson.)

20. Bertha Dressler, *San Francisco Peaks,* 1900, oil on canvas, 30 × 40 inches. (Courtesy Santa Fe Collection of Southwestern Art.)

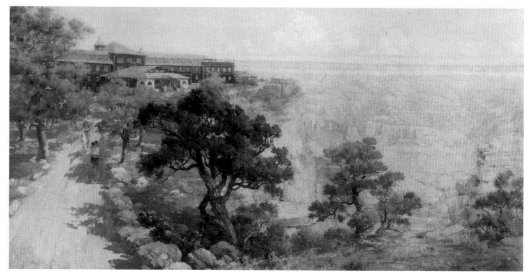

21. Louis Akin, *El Tovar Hotel, Grand Canyon,* 1904, oil on canvas, 25 × 50 inches. (Courtesy Santa Fe Collection of Southwestern Art.)

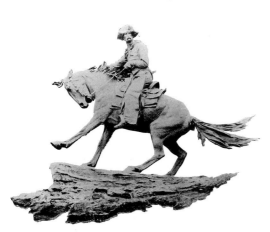

18. Frederic Remington, *The Cowboy,* 1908, bronze. (Courtesy Remington Art Museum, Ogdensburg, New York.)

130. Ibid., pp. 328, 258.
131. Samuels, *Frederic Remington,* p. 383; the museum purchased *The Old Dragoons of 1850, The Bronco Buster, The Mountain Man,* and *The Cheyenne.*
132. Samuels, *Frederic Remington,* p. 367.

In the years after the train's essential role in western settlement, the railroads began to look for ways to make their routes more profitable. As early as 1887, Thomas Moran had been invited by the Baltimore and Ohio, an eastern railroad, to supply upward of seventy views illustrating their scenic route.[133] The idea was simply that once the public became more familiar with the scenic advantages of a particular route the more likely they were to pick it over a competitor. But even in 1900 most easterners perceived the West as unduly rugged and exotic. Intense competition ensued among the western railroads, specifically the Northern Pacific, the Union Pacific and Central Pacific, the Southern Pacific, the Denver and Rio Grande, and the Atchison, Topeka and Santa Fe (ATSF). The railroads realized that one of the best ways to promote themselves was to solicit artists to travel, courtesy of the railroad, and paint subjects that highlighted the exotic beauty and quaint inhabitants that passengers would encounter by traveling and visiting sites accessible by that route. For example, Moran received a commission from the *Colorado Tourist,* a monthly sponsored by railroad interests, such as the Union Pacific and the Denver and Rio Grande, to produce illustrations for them.[134] Also, Oscar Berninghaus (1874–1952) was commissioned in 1899 to prepare a series of watercolors for Denver and Rio Grande pamphlets.[135] But the railroad that established the most aggressive campaign to promote itself was the ATSF. Since the ATSF went through scenic mountain areas of northern New Mexico and Arizona, by such sites as the Grand Canyon, Taos, and Santa Fe, it sought to promote them. Like the Union Pacific it hired Moran in 1892 and provided him complimentary travel in exchange for a painting of the Grand Canyon, to which they were given single-use copyright. The painting, which is among Moran's most spectacular late works, was produced in a six-color lithograph (Fig. 19) by the railroad and thousands of copies were distributed.[136]

The success of this venture encouraged ATSF to continue to expand promotion. By 1895 ATSF had developed the policy of utilizing western paintings in company advertising, and artist trips organized by William Simpson, chief of the railway's advertising department, became annual affairs. As the railway expanded after the turn of the century, it built new stations and passenger offices. Simpson suggested using western art as a decorative theme and the railway agreed. In 1903 the railroad purchased its first painting, *San Francisco Peaks* (Fig. 20), the mountain range in northern Arizona, by the little-known artist Bertha Dressler.[137] Over the course of the next ten years the railway, at Simpson's direction, purchased 262 paintings, and beginning in 1907 some were selected for the famous Santa Fe Railway Calendar, which could be found in over 300,000 homes nationwide. Simpson also wrote articles praising such artists as Moran, whose work took a positive view of the western landscape.[138] In 1906 the railway provided transportation to William R. Leigh (1866–1955) for his western trip and subsequently bought five of his paintings of the Grand Canyon to decorate its recently constructed Canyon and El Tovar Hotel and Bright Angel Lodge located on the rim (Fig. 21).[139] And by 1909, the Fred Harvey Company, the innovative and tremendously successful firm that ran the restaurants and hotels along the ATSF route, had opened sales rooms at El Tovar Hotel that offered native American Indian crafts and works by contemporary

133. Wilkins, *Thomas Moran,* p. 146.

134. Ibid., p. 152.

135. Patricia Janis Broder, *Taos: A Painter's Dream,* p. 117.

136. Keith L. Bryant, Jr., "The Atchison, Topeka and Santa Fe Railway and the Development of the Taos and Santa Fe Art Colonies," *Western Historical Quarterly* 9,

no. 4 (October 1978): 439. The painting authorized for use by the ATSF hung for a number of years at the Geological Survey in Washington. In 1908 Moran was invited as a guest of ATSF to repaint the work, after which it hung in El Tovar Hotel on the Grand Canyon rim. Eleven years later it was purchased by George Horace Lorimer of the *Saturday Evening Post* to hang in the

magazine's Philadelphia offices (see Wilkins, *Thomas Moran,* pp. 205–206).

137. Ibid., p. 442.

138. William H. Simpson, "Thomas Moran—the Man," *Fine Arts Journal* 20, no. 1 (January 1909): 18–25.

139. Bryant, "The Atchison, Topeka and Santa Fe Railway and the Development of the Taos and Santa Fe Art Colonies," p. 441.

painters of western subjects (Fig. 22), such as Moran, Couse, Leigh, Joseph Sharp, and Warren Rollins, among others.[140]

Other railroads followed suit. In 1906 Maynard Dixon (1875–1946) was commissioned to paint a series of murals (Fig. 23) for the Tucson office of the Southern Pacific Railroad. Dixon received another railway commission in 1917 when Louis W. Hill, president of the Great Northern, invited him to do a group of paintings featuring Glacier National Park and the Blackfoot Indians, the railway's principal tourist attractions.[141] Other artists, like John Fery (1865–1934), were commissioned by the Burlington Northern Railroad to show scenic views along their route.[142]

In addition to having artists promote the landscape, the ATSF soon "discovered the value of Indians of Arizona and New Mexico" as tourist attractions.[143] This development coincided with the arrival in Taos of artists mesmerized by its climate and scenery. The first to settle permanently in Taos was Bert Geer Phillips (1868–1956), who arrived in 1898. In the next two decades he was joined, at least for summers, by Joseph Henry Sharp (1902), Victor Higgins (1914), Ernest Blumenschein (1908), Oscar Berninghaus (1899), Erving Couse (1902), W. Herbert Dunton (1912), and Walter Ufer (1914). By 1915 this group had formed the Taos Society of Artists, and over the next twenty years they individually sold literally dozens of works to the ATSF. The work of Couse, for example, who had won the National Academy's First Hallgarten prize in 1902, appeared on twenty-two ATSF calendars between 1923 and 1938. During these years he is said to have saved $20,000 per year from this railroad work, while Ufer was paid up to $5,000 for large works sold to the line.[144]

22. Art Room, El Tovar Hotel, Grand Canyon, New Mexico, ca. 1909. (Courtesy Fred Harvey Archives, Special Collections, University of Arizona Library, Tucson.)

23. Maynard Dixon, *Cowboy on Horseback,* 1907, oil on canvas, 33¼ × 75 inches. (Courtesy Arizona Historical Society, Tucson.)

The railway purchased such paintings as Victor Higgins' remarkable *Pueblo of Taos* (ca. 1927, Anschutz Collection, Denver; Fig. 24), acquired in 1929. It favored pictures of the inhabitants of the Southwest, Indians and their homes, their way of life, and native crafts. In June 1911, for example, Simpson wrote to Blumenschein, who was then dividing his time between New Mexico and New York:

If you go out to Taos this summer will be glad to buy painting of you. On looking over what is left

140. "Just beyond the office are the Art Rooms, devoted to the sale of paintings and photographs. On the walls hang paintings of southwest scenery from the brushes of noted American artists, perhaps, including one of Thomas Moran's masterpieces, also canvases by Sauerwen, Couse, Sharpe, Leigh, Jorgensen, Burdoff, Wachtel, and Rollins" (*El Tovar, Grand Canyon of Arizona*).

141. Donald J. Hagerty et al., *Maynard Dixon,* pp. 21, 24.

142. *A Century of American Landscapes, 1812–1912,* no. 16.

143. Bryant, "The Atchison, Topeka and Santa Fe Railway and the Development of the Taos and Santa Fe Art Colonies," p. 441.

144. Ted Schwarz, "The Santa Fe Railway and Early Southwest Artists," *American West* 19, no. 5 (September–October 1982): 39.

24. Victor Higgins, *Pueblo of Taos*, before 1927, oil on canvas, 43½ × 53½ inches. (Courtesy Anschutz Collection, Denver; photo by Milmoe.)

of our small art fund, find it will be impossible to spend more than $400. We doubt you can give us something worthwhile for that amount. Prefer an Indian subject with Taos pueblo in background if such a thing is possible. Such a picture would have an advertising value apart from its art quality.[145]

To an eastern audience increasingly besieged by technological change and a fast-paced lifestyle these images were intended to suggest a soothing, restful alternative world, only a train ride away. The message worked, tourism grew, and many of the Taos artists gained income and national reputations as well.[146]

Before about 1920, patrons of western artists were of four types: (*a*) art collectors who on occasion happened to purchase a work that was of western topical interest;[147] (*b*) patrons, both private and institutional, who commissioned or otherwise purchased western works, particularly with great narrative quality, but who otherwise were not art collectors; (*c*) thematic collectors, who sought specific works, such as those by American illustrators; and (*d*) those persons or institutions whose primary interest was ethnology and who may or may not have been moved by the artistic merits of the works. By 1920 these four types of collectors were still in evidence but, increasingly, patrons, who commissioned works directly from artists, were succeeded by collectors, who for the most part bought historic works indirectly from dealers. Some of these collectors, who on occasion were also patrons, sought to furnish a "western room" in their residence or acquired works with such fervor that their collections soon exceeded available space.

One collector of this latter type was William C. Hogg (1875–1930), son of Texas Governor Stephen Hogg and a partner in the Houston oil and real estate firm, Hogg Brothers. In a ten-year span, beginning in 1920, Hogg acquired sixty-seven oils, watercolors, drawings, and bronzes by Remington. The main executive office for the firm was a big, high-ceilinged room with flat-topped desks and armchairs on the top floor of a Houston office building. Around the walls were hung Remington paintings—*The Herd Boy, The Cry for Help,* and *The Fight for the Waterhole.*[148] In an adjoining room were other western works, including *A Cavalry Scrap* (Fig. 25). Hogg began collecting in a big way, in the first year alone spending over $30,000. He bought works from numerous dealers in New York and Chicago, including *The Emigrants,* purchased for $7,000 from the John Levy

25. Offices of Hogg Brothers, Houston, Texas, ca. 1925–1930; on the left is Remington's *The Bronco Buster* and on the right is his painting *A Cavalry Scrap.* (Courtesy Barker Texas History Center, University of Texas at Austin.)

145. Ibid., p. 37.

146. "The Spell of Indian for Artists," *Literary Digest* 102 (July 13, 1929): 18. E. I. Couse is quoted by Rose Henderson of the *New York Herald Tribune* as saying that more and more Indian pictures are sold in Taos every year: "It would seem that people are realizing that with the fast disappearance of the Indians pictures representing their life in the wilder state will prove valuable in the future."

147. A twentieth-century example of this type is Jacob Ruppert (1867–1939), president of Ruppert's brewery, owner of the New York Yankees, and reputed to be among the wealthiest men in America. He had a large art collection, but the only western art in it was a group of over a dozen bronzes, ten by Remington (see Preston Remington, "The Bequest of Jacob Ruppert: Sculpture," *Bulletin of the Metropolitan Museum of Art* 34 [July 1939]: 169–172).

148. John A. Lomax, *Will Hogg, Texan,* p. 10.

Galleries, New York, and *The Parley,* purchased for $10,000 from the Howard Young Gallery, New York.[149] Other purchases included twelve drawings and a cast of *The Bronco Buster,* bought from the Ainslie Galleries, New York.[150] The Hogg Collection was successfully courted by the Museum of Fine Arts, Houston, on whose board Hogg sat and where his collection was first exhibited in 1925.

Another collector, who operated on an even grander scale, was Philip G. Cole (1883–1941). Cole was a Montana-born Princeton graduate (1906) who studied medicine only to have his father press him into service in the family automobile parts business in Brooklyn. This was a fortuitous event for the automotive industry as Cole came to invent the valve for the tube tire. Upon his marriage in 1919 his father, who knew and had collected the works of Charles Russell,[151] gave him Russell's *The Buffalo Hunt* (Fig. 26), which was the younger Cole's first acquisition of western art. During the next two decades, he bought over five hundred paintings and sixty pieces of sculpture, all by western artists.[152] These he installed in his Tarrytown, New York, house Zeeview (Fig. 27). During his lifetime he amassed what was generally regarded as the largest collection of work by Remington and Russell. Cole also befriended Danish-born artist Olaf Seltzer (1877–1957), whom in 1930 he commissioned to paint a series of miniatures devoted to Montana history.

The very same year that Cole acquired his first Russell painting, the artist, who by this time had no financial worries, began to spend part of each winter in California. He did this partly to get away from the savage Montana winters but also because his wife, who had promoted her husband throughout his ca-

reer, had found an excellent market for her husband's work among members of the movie colony. During these years a number of Russell's important paintings and bronzes were acquired by William S. Hart, Douglas Fairbanks, Noah Beery, Harry Carey, and his old friend Will Rogers. Rogers, who, like Dr. Philip G. Cole, owned one of the many versions of Russell's *The Buffalo Hunt* (Amon Carter Museum, Fort Worth), displayed it prominently in his Pacific Palisades home (Fig. 28) along with Indian blankets and saddles. It was Will Rogers' favorite painting and was said to have been selected for him by the artist.[153]

Just as Rogers converted his California coastal home into a rustic retreat, so did other collectors. This idea, to create a western environment in which to hang western subjects, dates back at least to the 1850s when William Ranney set up his New Jersey studio in a similar fashion.[154] In any event, collectors who lived in urban environments, or outside the West, took comfort in creating for themselves a setting that had a rustic air. A similar impulse led Malcolm S. Mackay (1881–1932), a New York businessman, to create in 1921 his own "Russell Room" in his Tenafly, New Jersey, home. Here in his log-lined room (Fig. 29) he surrounded himself with Russell paintings, Indian rugs, and bleached animal skulls. Mackay had vacationed out west as a young man in 1901, had been part owner of a ranch near Billings, Montana, and in 1925 had published *Cow Range and Hunting Trail,* a book on his adventures in the West. He began collecting Russells in 1911, most likely after seeing them at a Russell exhibition at the Folsom Galleries in New York. Over the next twenty years he formed what was considered the finest Russell collection at the time of the artist's death.[155]

26. Charles Russell, *The Buffalo Hunt,* 1900, oil on canvas, 48 × 72 inches. (Courtesy Thomas Gilcrease Institute of American History and Art, Tulsa.)

27. Interior of Zeeview, home of Philip G. Cole, Tarrytown, New York, ca. 1930–1940. (Courtesy Thomas Gilcrease Institute of History and Art, Tulsa.)

149. Registrar's Files, Museum of Fine Arts, Houston, "Frederic Remington."

150. Virginia Bernard, *Ima Hogg,* p. 62, diary entry for September 21, 1920. Two years later, in November 1922, Hogg bought Remington's *The Scouting Party* for $800 from the Abbe Collection, Springfield, Massachusetts (see William C. Hogg Papers HC 5/58 "Paintings

and photographs," Barker Texas History Center, University of Texas at Austin).

151. Dean Krakel, "Visions of Today," *American Scene* 5, no. 4 (1964): 58.

152. David C. Hunt, "The Old West Revisited: The Private World of Dr. Cole," *American Scene* 8, no. 4 (1967): [2].

153. "Russell Painting File," Amon Carter Archives, Amon Carter Museum, Fort Worth.

154. Francis S. Grubar, *William Ranney, Painter of the Early West,* p. 10.

155. Brian W. Dippie, *"Paper Talk": Charlie Russell's American West,* pp. 58, 100.

28. Interior of Will Rogers home, Pacific Palisades, California, ca. 1935. (Courtesy Amon Carter Museum, Fort Worth, and California Department of Parks and Recreation.)

29. "Russell Room" in Malcolm S. Mackay home, Tenafly, New Jersey, ca. 1925–1930. (Courtesy William R. Mackay, Sr., Roscoe, Montana.)

To many Americans these images of the American West may have served to illustrate the pageant of American life. Industrial strife and a flood of immigrants from Europe led some Americans to associate positive wholesome American values with the struggle of the pioneer, the life of the cowboy, and the subjugation of the Indian. The cowboy could be seen to represent "unrestrained personal freedom, practical ability, modesty, and when called for, reckless courage."[156] The cavalry officer could be seen as the government bringing to conclusion the tragic, though just, events of Manifest Destiny, and the Indian, a vanquished enemy no longer despicable, treacherous, and contemptible, could be admired for his nobility, familial values, traditions, honors, and native crafts. An extension of this thesis might be that many of the collectors of western art have seen in western paintings and sculpture characteristics and a philosophy of life they value. In so doing they may have reflected the values of social and political conservative Owen Wister, who thought he saw the aristocratic America he loved disappearing in a flood of immigrants. To Wister, "the Knight and the Cowboy are nothing but the same Saxon of different environments, the nobleman in London and the nobleman in Texas."[157] To some collectors, particularly first-generation Americans, western art may have also provided an instant heritage. By surrounding themselves with images that were distinctly and unmistakably American, they helped to solidify their own sense of place and contributed to their notion of American nationalism.

156. Taylor and Marr, *The American Cowboy*, p. 98.
157. Nye, *The Unembarrassed Muse*, p. 290.

The concern that had been expressed nationally with the creation of the Bureau of American Ethnology was manifested in succeeding decades in different ways that provided artists with patronage. One opportunity came in 1890 when the government commissioned a lengthy analysis of Indian affairs, the *Report on Indians Taxed and Indians Not Taxed.*[158] This illustrated document also provided an isolated opportunity for a handful of artists to depict Indian subjects. A group of five established, but far from well known, artists took this opportunity to visit Indian reservations and prepare written reports accompanied by sketches of their observations. The group consisted of William Gilbert Gaul (1855–1919), Walter Shirlaw (1838–1909), Julian Scott (1846–1901), Henry Rankin Poore (1859–1940), and Peter Moran (1841–1914). The artists may have seen this as an opportunity to participate in the increasing interest in western subjects, although, aside from Gaul, none of them was able to take much advantage of the trip to subsequently paint western subjects.

Some patrons, as in the nineteenth century, supported the work of particular western artists because they recognized and admired the ethnological importance of their work. In 1895, for example, Edward Ayer (1841–1927), of Chicago, a railway lumberman, bibliophile, and founder of the Ayer Indian Collection, commissioned his nephew Elbridge Ayer Burbank (1858–1949) to paint a series of portraits of American Indians, which was to become his life's work. In succeeding years he painted over 1,200 portraits of the leaders of about 125 tribes.[159]

Another artist to benefit in this way was Joseph Henry Sharp (1859–1953). Sharp, a latter-day George Catlin from Cincinnati, by 1901 had sold a major painting, *The Harvest Dance,* to the Cincinnati Art Museum and had another work, *Spotted Bird That Sings,* purchased by Andrew Carnegie.[160] That year, however, after an exhibition of his work in Washington's Cosmos Club, he was singled out for recognition by the U.S. government. As a result of seeing his work at the exhibition, William Henry Holmes, who was on the staff of the Smithsonian, purchased eleven portraits for the institution.[161] Roosevelt, too, became interested in Sharp's work to record the lives of Indians in Montana and he directed the Indian Commission to build and furnish a small cabin and studio for Sharp. At about the same time, Phoebe Apperson Hearst, the mother of William Randolph Hearst, paid $6,500 for seventy-nine of Sharp's Indian portraits and scenes of Indian life, seventy-seven of which she donated in 1902 to the Robert H. Lowie Museum of Anthropology at the University of California, Berkeley. To this group Mrs. Hearst added fifteen additional works by Sharp. This gesture enabled Sharp to resign his teaching position at the Art Academy of Cincinnati and devote full time to painting.[162] In a subsequent year fifteen more of his Indian portraits were purchased by Joseph G. Butler, Jr. (1840–1927), the steel industry pioneer from Youngstown, Ohio, and eventually given to the Butler Institute of American Art (1919), which he founded.[163]

While some citizens were concerned primarily with the fate of the Indians, others were preoccupied with the disappearance of certain forms of western wildlife. As the passenger pigeon was netted to extinction and

158. Department of the Interior Census Office, *Report on Indians Taxed and Indians Not Taxed in the United States (Except Alaska) at the Eleventh Census: 1890.*

159. Peggy and Harold Samuels, *Encyclopedia of Artists of the American West,* p. 75.

160. Forrest Fenn, "The Early Years in Taos, Joseph Henry Sharp (1859–1953)," *Southwest Art* 10, no. 3 (August 1980): 52, 54.

161. Broder, *Taos: A Painter's Dream,* p. 44.

162. Accession Record, Registrar's Office, Robert H. Lowie Museum of Anthropology, University of California, Berkeley, entry 37: January 2, 1902. Nineteen more

paintings were given between 1905 and 1916; see also Broder, *Taos: A Painter's Dream,* p. 45.

163. Letter to the author from Clyde Singer, Associate Director, Butler Institute of American Art, Youngstown, June 27, 1985.

30. Billy Beach's trophy room at his home, Great Neck, Long Island, ca. 1925–1935. (Courtesy Shelburne Museum, Shelburne, Vermont.)

ciety's Gallery of Wild Animals.[164] Private citizens, such as Theodore Roosevelt, who were appalled at the disastrous effects of market hunters, began to establish guidelines for conservation in the same way that the Congress had acted to create the first national park at Yellowstone in 1872. In 1897 Roosevelt was instrumental in the formation of the Boone and Crockett Club, which numbered among its one hundred members Hornaday, Sen. Henry Cabot Lodge, historian Francis Parkman, former Secretary of the Interior Carl Schurz, Owen Wister, and Albert Bierstadt. One of its primary objectives was the preservation of the big game of North America.[165]

Perhaps typical of the kind of private patronage that Rungius received is that of William N. "Billy" Beach. A New Yorker who had amassed a fortune supplying concrete for construction of New York subways, he, like Rungius, was a member of a preservation group, the Camp Fire Club. During the winter months the Rungiuses were frequent guests in the Beaches' Great Neck, Long Island, home and Beach's trophy room exhibited the largest collection of Rungius' animal portraits and landscapes anywhere (Fig. 30).[166]

A similar fascination with the animal kingdom led to a market for sculpture by American animaliers, sculptors who did animal subjects exclusively. These artists included Edward Kemeys (1843–1907), who did for the fauna of the West what Remington and Dallin had done for the cowboy and the Indian. His commissions included *Wolves,* for the Fairmount Park Association; *Still Hunt,* a crouching American mountain lion, for New York's Central Park; and the Union Pacific's commission of a bison head to decorate its railroad bridge at Omaha, Nebraska.[167]

the bison was almost there, as well, individual artists, writers, and photographers set about documenting a way of life and unspoiled natural environment before it was totally transformed. Private institutions, such as the New York Zoological Society, led by William T. Hornaday, commissioned such artists as Carl Rungius to record as artists, like Audubon had done earlier in the century, the big game animals of the northwest before they became extinct. Between 1914 and 1934 Rungius painted each year at least one "threatened" animal species for the so-

164. Jon Whyte and E. J. Hart, *Carl Rungius: Painter of the Western Wilderness,* p. 89.
165. Ibid., p. 43.
166. Ibid., pp. 114–115.
167. Craven, *Sculpture in America,* p. 539.

Throughout the first decades of this century most successful painters and sculptors of western subjects had their work exhibited and/or sold in New York. Western works were also sold at O'Brien's, the J. W. Young Gallery, and Carson, Pirie & Scott in Chicago; by William Findlay and George Niedringhaus in St. Louis; and at the Closson Gallery in Cincinnati, Biltmore Salon in Los Angeles, Vose Gallery in Boston, and elsewhere. But most of the western artists who achieved national recognition got a significant boost to their careers by having their work seen in New York. Clausen's (1901), Noe (1903–1905), and Knoedler's (1905–1909, 1914, 1918) all exhibited the work of Remington; Folsom Galleries (1911) exhibited the work of Russell; Keppel & Co. exhibited the work of Edward Borein (1917); Milch Gallery exhibited the work of Berninghaus (1919), Moran (1927), Deming (1928), and Frank Tenney Johnson (1929); while MacBeth Gallery gave Dixon (1923) an exhibition. Elsewhere in the country one-artist museum exhibitions were given to Frank Reaugh (Detroit Institute of Arts, 1909; Art Institute of Chicago, 1909); Joseph Sharp (Cincinnati Museum Association, 1900; Herron Art Institute, Indianapolis, 1908); Henry Farny (Cincinnati Museum Association, 1915); Edwin Deming (Brooklyn Museum, 1923); Russell (Corcoran Gallery of Art, 1925); and Blumenschein (Buffalo Fine Arts Academy, 1927).

These events happened despite what must be characterized as the relatively low station of western artists in the eyes of critics and writers about American art. Samuel Isham (1855–1914), an influential if conservative authority on American art, wasted no time in dismissing Remington, Schreyvogel, and Couse as illustrators rather than painters.

To Isham their sin was they were more interested in the "subject" rather "than the purely artistic qualities displayed in its representation." [168]

Some artists largely forsook the glamour of easel painting and instead turned to illustration. One example of this phenomenon is William Leigh, who was patronized by such international celebrities as the Duke of Windsor and King Leopold of Belgium [169] but is best known for illustrations in *Saturday Evening Post.* Like others of his generation, Leigh for the most part avoided the unpredictable demands of private or institutional patrons. While it was potentially more lucrative to paint easel paintings or murals, it was also more risky. Some artists, like Harvey Dunn (1884–1952), Edward Borein (1872–1945), and W. H. D. Koerner (1878–1938), devoted themselves primarily to commercial illustration and thereby avoided some of the disappointment experienced by their colleagues. Far better in their eyes to commit to a safe and steady relationship with *Collier's, Harper's, Saturday Evening Post, Scribner's,* or some other publisher than to be left to the vagaries of the critics and private patrons.

At the same time some western artists satisfied their need for patronage by carving out careers as illustrators, other artists found opportunities painting decorative panels and murals. As early as 1899 Oscar Berninghaus had painted an Indian for a decorative panel in the studio of St. Louis photographer J. C. Strauss. [170] The following year California artist Alexander Harmer (1856–1925) received the unusual request from then Attorney General Philander Knox (1853–1921) to execute a series of fifty painted leather panels for the library in his house. The subject was "The Passing of the Nations" and Harmer depicted representative scenes for different American Indian tribes (Fig. 31). [171]

31. Alexander Harmer, *Travois,* ca. 1900, oil on leather, 35 × 36 inches. (Courtesy Hood Museum of Art, Dartmouth College, Hanover, New Hampshire; gift of James Knox Tindle, Class of 1936.)

168. Samuel Isham and Royal Cortissoz, *The History of American Painting,* p. 501.

169. "[William Leigh] Natural Painter," *Time* 37 (March 10, 1941): 66.

170. Broder, *Taos: A Painter's Dream,* p. 258.

171. *Alexander F. Harmer, 1856–1925,* pl. 38.

By the teens and 1920s, the heyday of decorative murals, artists like Edwin Deming, Maynard Dixon, and Edward Borein were being commissioned to paint them for institutions and palatial homes in New York and elsewhere. Deming did a series of historical panels for the Fifth Avenue New York offices of the Great Northern Railroad and between 1913 and 1916 produced a series of mural panels for the Plains Indian Hall at the American Museum of Natural History in New York. His private patrons included Mrs. E. H. Harriman of New York for whom he did several Indian murals.[172] Similar commissions were received by Dixon, who in 1912 decorated with murals of Indian subjects the Pasadena, California, home of Anita Baldwin McClaughry, daughter of Nevada silver millionaire E. J. "Lucky" Baldwin.[173] In the late 1920s Borein painted a frieze depicting a variety of western ranching scenes for the Bighorn, Wyoming, home of New York businessman Bradford Brinton (1880–1936).

Russell, too, was invited to paint murals. In 1911 he was commissioned by the state of Montana to paint the mural *Lewis and Clark Meeting Indians at Ross' Hole* for the state capitol.[174] For this he was paid $5,000. Later, in 1926, he was commissioned by Edward L. Doheny (1856–1935), the oil producer who had been implicated in the Teapot Dome oil scandal of 1923–1924, to complete a series of mural-size paintings for the stair hall of his Chester Place, Los Angeles, home. Doheny, who owned Remington's oil *The Navajo Raid,* W. R. Leigh's *The Happy Hunting Ground,* and Russell's *The Snow Trail,* had the year before engaged a European artist, Detlief Sammann, to paint a mural in the large, center hall of his house. Doheny wished it to be a panorama of American history from the landing of the Pilgrim fathers to the discovery of oil in California. All proceeded smoothly until Sammann reached the point at which he was to paint Indians pursuing buffalo. He balked at this and ceased painting. It was then that Doheny called upon Russell, whom he knew. Russell continued where Sammann had left off and painted his way around the second floor to the third. To Doheny's great disappointment, Russell only got to the scene of the Gold Rush days and ran out of space before he could paint the discovery of oil.[175] For the panels Russell charged $30,000, the highest fee of his career and among the highest prices paid to that date for work by a painter of American western subjects.[176]

As far as most of the Taos Society artists were concerned, the railroads were their primary patrons. But others began to emerge. Among the most notable was Carter H. Harrison, Jr. (1860–1953), the mayor of Chicago, who along with Oscar Mayer (1859–1955), the founder of the meat-packing dynasty, and other Chicago businessmen supported stays in Taos for young artists. Those who benefited most were Victor Higgins, Walter Ufer, and E. Martin Hennings. Their patrons, Harrison and Mayer, had hunted in the Taos area and had visited the art colony.[177] Shortly after the Armory Show came to Chicago, Harrison, who had seen Ufer's work, offered him a trip to Taos. In his own words, he "organized a syndicate to finance a New Mexican trip by taking eight 25 × 30 canvases, and giving him the agreed price in advance."[178] They did this for each of three years and later made the same arrangements with Higgins. As Ufer later observed of his travels to Taos:

Carter Harrison sent me. He had been out here, loved the country and advised me to come. He

172. Therese O. Deming, *Edwin Willard Deming,* p. 7.

173. Hagerty, *Maynard Dixon,* p. 21.

174. Frank Bird Linderman, *Recollections of Charley Russell,* pp. 97–98.

175. Lucille V. Miller, "Edward and Estelle Doheny," *Ventura County Historical Society Quarterly* 6, no. 1 (November 1960): 17.

176. Frederic G. Renner, *Charles M. Russell: Paintings, Drawings and Sculpture in the Amon G. Carter Collection,* p. 28.

177. Broder, *Taos: A Painter's Dream,* p. 258.

178. Carter H. Harrison, *Growing Up with Chicago,* p. 329.

did more than advise me, he made it possible for me to come and stay by buying my work and persuading his friends to buy. He just told them they had to and they did. . . . Carter Harrison has done more for American art, for Taos art, New Mexico art, than any other man I know. He has always been a "booster" and a buyer which is the best kind of "booster" and has made it possible for a number of outstanding artists to succeed.[179]

Harrison was equally generous to Hennings. In 1917 he convinced a group of businessmen, including Mayer, to underwrite a season in Taos and guaranteed that he and Mayer would purchase the New Mexico paintings that resulted.

In 1916 Mr. and Mrs. Burt Harwood moved to Taos from Europe and began to befriend local artists. Upon Mr. Harwood's death in 1923 their home, willed to the University of New Mexico, became the Harwood Foundation. As such it provided an art gallery, only the second in New Mexico, a public library, a small museum, and a temporary place of residence for recently arrived artists. The Taos Society of Artists (1915–1927) occasionally met at the Harwood Foundation for its monthly dinner.[180]

The era in which the Taos Society flourished also saw the Southwest come to the attention of a range of American artists as diverse as John Sloan and Marsden Hartley. For the most part, these artists, with a few major exceptions, such as Andrew Dasburg and Georgia O'Keeffe, were stimulated by the Southwest for relatively short periods of time. Their styles also lacked the narrative qualities of the Taos Society artists and for this reason, as well as the avant-garde nature of much of their work, had little appeal to the collectors of western art. For example,

the major collectors of western art during this period, like Philip Cole and Will Hogg, had no interest in such work. In fact, it was not until decades later, particularly after the formation of institutions like the Amon Carter Museum (1961), that a serious effort was made by art historians to reduce the aesthetic canyon that divided these two groups, to exhibit their works together, and to interpret their respective differences.[181]

The 1920s was a period of considerable acclaim for the Taos Society painters. Examples of their work had been purchased by numerous museums, among them the Detroit Institute of Arts (Couse), the Art Institute of Chicago (Ufer, Higgins), the Museum of Fine Arts, Houston (Hennings), the Art Gallery of Toronto (Blumenschein), and the City Art Museum of St. Louis (Berninghaus). And Walter Ufer had the distinction of having his work sell for the highest prices paid for contemporary paintings of the American West.[182]

179. Broder, *Taos: A Painter's Dream*, p. 221.
180. Ibid., p. 12.

181. The most thorough treatment of this to date is Eldredge et al., *Art in New Mexico, 1900–1945*.
182. Broder, *Taos: A Painter's Dream*, p. 228.

The Great Depression and
the 1940s

32. *Left to right,* Will Rogers, Amon Carter, and Tris Speaker, November 12, 1925, Fort Worth, Texas. (Courtesy Amon Carter Museum, Fort Worth.)

The Great Depression had a deadening effect on the market for western art, just as it did on practically every other aspect of American life in the 1930s. While some artists, like Couse, remained partially insulated from the Depression by their railroad patronage, others, like Ufer, were in poor financial straits. Since collectors no longer flooded Taos, some artists made prints, which could be sold for considerably less than paintings, to support themselves.[183] Artists like Higgins were lucky and found specific admirers. In his case San Antonio collector and philanthropist Marion Koogler McNay (1883–1950) provided financial support to him, and they were eventually married, albeit briefly.[184] Some artists became more dependent upon public commissions. For example, Dunton's last work was a series of three mural lunettes for the capitol at Jefferson City, Missouri.[185] Younger artists, too, like Tom Lea (1907–), turned to public commissions. As part of a broadly based Works Progress Administration, initiated in 1935, artists were commissioned to create decorative programs for government buildings. Lea, for example, was commissioned to paint murals, such as *Pass of the North* (1937) for the courthouse in El Paso, Texas, and later painted *Stampede* (1940) (p. 144) for the post office in Odessa, Texas.

The account books of M. K. Knoedler, one of the leading art dealers in America, document the chilling effect this national malaise had on the art market in 1932 when the stockmarket had hit its lowest point and the economy was at a standstill. Throughout the 1920s works by western artists, such as Remington, were being taken on consignment and being sold quickly by the gallery for the asking price. By 1933, however, works were either being sold much below the asking price or, as was more frequently the case, returned to the owner.[186] This dramatic rever-

sal of fortunes had the effect of depressing prices and forced many collectors to attempt to sell works.

This misfortune, however, opened the western art market to beginning collectors who would have otherwise been unable to buy. For example, collectors like George Rentschler (1892–1972), a New York ship builder and manufacturer of railroad equipment, armaments, and heavy machinery, began collecting the work of Henry Farny in 1933. As his former wife explained, he focused on the Cincinnati artist's paintings because they "had been treasured by their owners for decades, and it was only the financial pressure of the Depression that forced these owners to decide to sell."[187] Over the next twenty-five years he acquired twelve Farnys, all purchased from the artist's original dealer, Closson Gallery of Cincinnati, which he later left to the University of Wyoming.

A similar opportunity confronted Texan Amon G. Carter (1879–1955), publisher of the *Fort Worth Star-Telegram* (Fig. 32). Carter began collecting in 1935 by purchasing with borrowed funds nine Russell watercolors from Bertram Newhouse of the Ehrich-Newhouse, Inc., Galleries in New York.[188] His interest in western art, particularly the work of Russell, had been stimulated by his good friend Will Rogers.[189] Two months after his first purchase he bought from Newhouse Remington's oil painting *His First Lesson* and shortly thereafter two additional works by Russell. All of these were acquired at prices greatly depressed from what they would have brought a few years before. As another dealer observed in 1939 with regard to Carter's purchases,

183. Ibid., p. 287.
184. Ibid., p. 202.
185. Ibid., p. 175.
186. Commission Book No. 3, M. K. Knoedler Gallery, New York.

187. Letter to the author from Mrs. Allerton Cushman, June 6, 1986.
188. "Charles Russell Miscellaneous," Amon Carter Archives, Amon Carter Museum, Fort Worth.
189. Amon Carter to Louis Leighton, March 20, 1948, "1948," Amon Carter Archives, Amon Carter Museum, Fort Worth.

the fact that you got yours very cheaply seems to indicate that you have purchased them during the last ten years when all prices, land, pictures, and everything else have been low and people have had to sell.[190]

Just how low is made clear by Remington's *His First Lesson*. The painting had changed hands in 1929, when it was sold by Gov. Ernest Marland of Oklahoma to W. L. Moody III of Galveston, Texas, for $12,500. Six years later Carter paid $5,000 for the painting. Rogers is said to have offered $10,000 for the painting but Carter simply would not sell, even to a friend.[191]

With the discovery of oil in the gigantic Wasson Pool in West Texas in 1937, where Carter owned oil rights, his ability to acquire western art increased dramatically.[192] During the next eighteen years his collection grew to include over a thousand paintings, sculptures, and prints by other western artists or works devoted to western themes. As his daughter has said, he collected because "the art of the West was to him a documentation of the history of a people and of a time with which he identified himself."[193] He also bought selectively, rejecting many possible acquisitions that were of insufficient quality. He was also eager, like other serious collectors, to acquire collections already formed by others.

Carter bought steadily in the late 1930s and 1940s, primarily from Bertram Newhouse, David Findlay, and William Davidson of Knoedler Gallery. The latter was the agent for Carter's most expensive purchase, the Sid Willis Collection of Russells in Great Falls, Montana. Throughout the 1940s much of Carter's collection hung in the Fort Worth Club and the Fort Worth Public Library, but in 1949 he wrote of an even greater vision:

It is my intention to establish a Will Rogers–Charlie Russell Museum at a later date in Fort Worth on our Centennial grounds, where the City of Fort Worth has built a beautiful coliseum seating 6500 people, and an auditorium seating 3500, both of which have been named Will Rogers Coliseum and Auditorium.[194]

This dream was not to become a reality until six years after Carter's death when the Amon Carter Museum opened in Fort Worth in January 1961.

Carter's enthusiasm for western art was contagious and it was not long before other Texas colleagues, notably Sid Richardson (1891–1959) and C. R. Smith (1899–), followed suit. Richardson was a cattleman and oil producer who like Amon Carter became interested in western art. He purchased his first painting, a Russell, in April 1942, and as his collection grew he focused primarily on Remington and Russell. At one point he approached Bertram Newhouse and asked whether he could form a collection of western pictures for him.[195] This they did and over the course of the next six years the bulk of the Richardson collection was brought together. After the collector's death the paintings were exhibited throughout Texas and then later at the Amon Carter Museum. In 1982 they were installed in their own gallery space in downtown Fort Worth.

190. Dalzell Hayfield to Amon Carter, November 16, 1939, "1939," Amon Carter Archives, Amon Carter Museum, Fort Worth.

191. Jerry Flemmons, *Amon: The Life of Amon Carter, Sr., of Texas,* p. 491.

192. Samuel E. Kinch, Jr., "Amon Carter, Publisher-Salesman," M.A. Thesis, University of Texas, 1965, p. 157.

193. Ruth Carter Johnson, Foreword, in Renner, *Charles M. Russell,* p. v.

194. Amon G. Carter to Louis D. Leighton, January 14, 1949, Amon Carter Archives, Amon Carter Museum, Fort Worth.

195. Brian W. Dippie, *Remington & Russell: The Sid Richardson Collection,* p. 7.

33. Living room of C. R. Smith's New York apartment as illustrated in the *Saturday Evening Post,* February 1, 1941. (Courtesy Barker Texas History Center, University of Texas at Austin.)

Frank Tenney Johnson, and Ufer, among others.[197] This purchase was followed by two small Remingtons, but his major acquisitions came as a result of his friendship with Will Rogers, who, as he had done for Amon Carter, encouraged Smith to buy works by Charles Russell. Eventually Smith acquired one-half of the Russell estate: thirty-two oils, thirty-nine watercolors, and a number of small bronzes.[198] This he bought for $40,000, his most expensive purchase, while Charles S. Jones, chairman of the Richfield Oil Company (now Atlantic Richfield Company), acquired the remaining two hundred works.[199]

By 1943 Smith had acquired so many works that he could not exhibit them all. He wrote to Amon Carter:

I hear that Sid Richardson is interested in acquiring some good western pictures and bronzes. As you know, I started out to collect Remingtons and Russells some years ago. I now have so many pictures and bronzes that I will never find a place for them and have decided to sell the Remington things I have, keeping all the Russells, Schreyvogels and Leighs that I have.[200]

Two years later this lack of exhibition space induced Smith to sell Carter his entire collection of Russell bronzes. It was the only complete collection in existence and Smith observed somewhat wryly that Carter would need to "hire a hall" to exhibit them.[201] A discerning eye also led Smith to appreciate Henry Farny in the 1950s well before general interest in his work had spread outside his native Ohio. Over the next few years he acquired a dozen Farnys, all through the Closson Gallery of Cincinnati and most for a few hundred dollars.[202]

Like Amon Carter, C. R. Smith began collecting western art in the 1930s when he was in New York. Smith had joined the Dallas-based freight carrier Southern Air Transport, which in 1929 was bought out by Aviation Corporation. After a series of mergers American Airlines was founded and shortly thereafter Smith became its president.[196] When American Airlines transferred its offices to New York, Smith took a bachelor apartment and, as earlier collectors had done, surrounded himself with mementos of the Old West (Fig. 33). His first purchase, William Leigh's *The Roping,* may well have been made through Erwin Barrie (1886–1983), who as director of the Grand Central Gallery played an influential role in promoting western art by giving shows to Leigh, Russell,

196. *Time* 72, no. 20 (November 17, 1959): 87.

197. Dean Krakel, *Adventures in Western Art,* p. 245.

198. List of art works owned by C. R. Smith, May 14, 1941, "C R. Smith," Amon Carter Archives, Amon Carter Museum, Fort Worth.

199. The Jones Collection is now owned by the National Cowboy Hall of Fame and Western Heritage Center, Oklahoma City.

200. C. R. Smith to Amon Carter, undated, "C. R. Smith – 1943," Amon Carter Archives, Amon Carter Museum, Fort Worth.

201. Amon Carter Archives, Amon Carter Museum, Fort Worth.

202. Author interview with C. R. Smith, May 16, 1982.

Smith was a passionate collector with a critical eye, an infatuation with the West, and a belief in honest, righteous dealing. His goal was less to form an encyclopedic collection than to acquire works he truly enjoyed. This fact may have been the single most important factor governing the collection's growth, although in later years he mentioned that in forming the collection he did not have at hand the resources available to some of his colleagues.[203] Fellow collectors, such as Carter, benefited from his generous advice and he was always willing to express an opinion on a work offered through a dealer or to alert him to a painting that he felt should be part of Carter's collection.[204] His sensitivity to a state's heritage was also quite evident. For example, when the Montana Historical Society was offered the Mackay collection of Russell paintings for a fraction of their market value, he was quick to contribute to their purchase and to write to Amon Carter urging him to do the same.[205]

Of all the collectors who began in the 1930s Thomas Gilcrease (1890–1962; Fig. 34) was perhaps the most energetic and catholic in his tastes. Gilcrease was a native Oklahoman and one-sixteenth part Creek Indian, a heritage of which he was particularly proud. Like other entrepreneurs of his generation, he made much of his wealth as an oil producer, founding the Gilcrease Oil Company in 1922. By 1931 Gilcrease had decided he wanted to found a museum. His long-time friend Robert Lee Humber, later attorney for Gilcrease Oil Company, suggested he focus on American art. At approximately the same time Gilcrease began visiting New York and making purchases of western subjects. Unlike some of his contemporaries, who developed narrowly focused art collections, Gilcrease collected everything to do with the West: books and manuscripts, as well as paintings and sculpture, and broadened his interest to include anything related to the American Indian, the American West, and early American history. He was also a collector of collections, estates, and studios. Among his most important purchases were the collection of Dr. Philip Cole, acquired between 1944 and 1946 at a cost of about $250,000; the watercolors of Thomas Moran; and the studio of William R. Leigh.

Instrumental in the formation of Gilcrease's collection were a number of dealers, including Rudolf Wunderlich (1920–), then of Kennedy Galleries, and William Davidson (1905–1973) of Knoedler Gallery. Davidson (Fig. 35) played a major role in selling Amon Carter the Sid Willis Collection and, prior to its opening in 1959, in developing the Whitney Gallery of Western Art, Cody, Wyoming.[206] Typical of Gilcrease's pattern of collecting was the time in 1948 when he visited Knoedler's to discuss the purchase of the watercolors in the Moran estate. According to one account, the conversation went as follows:

WILLIAM DAVIDSON:
"Tom, let's quit fooling around. Here is the entire list of the Moran estate collection."
THOMAS GILCREASE:
"Hmm. Let's see. 100 – 200 – 300 – 400 items. I'll buy them all. I have to go now, Bill."[207]

34. Thomas Gilcrease, *left,* with Mr. and Mrs. Westbrook Pegler in the Gilcrease galleries, 1960. (Courtesy Thomas Gilcrease Institute of History and Art, Tulsa.)

203. Ibid.
204. C. R. Smith to Amon Carter, January 23, 1952, Amon Carter Archives, Amon Carter Museum, Fort Worth.
205. C. R. Smith to Amon Carter, May 19, 1952, Amon Carter Archives, Amon Carter Museum, Fort Worth.

206. Krakel, *Adventures in Western Art,* p. 243.
207. Ibid., p. 29.

35. William Davidson, observing the painting *Penn's Treaty*. (Courtesy M. Knoedler & Co., Inc., New York.)

Although he was a native Oklahoman, in 1943 Gilcrease chose to first open his museum in San Antonio at the Casino Club. In part this may have been done to alert Oklahomans that there was a great collection in their midst that, without local support, could conceivably be lost to them. Later, in 1947, the San Antonio museum closed and Gilcrease reopened it in Tulsa, in May 1949.[208]

As major collectors, Gilcrease, Carter, and their colleagues were rivals for major collections, such as that owned by Sid Willis. Despite this they admired each other's abilities and realized they shared a common love for the West. It was Carter, for example, who was among the first to provide financial support when the Gilcrease collection was being threatened in the early 1950s with removal from Oklahoma to the University of Texas at Austin, or elsewhere.[209] Surviving correspon-

dence also documents that C. R. Smith frequently wrote to Carter with recommendations and leads of possible purchases, such as the Russell estate when it became available. In short, there was a great deal of respect and camaraderie among this group of collectors. Correspondence passed regularly among Carter, Richardson, and Smith, and interspersed with observations about particular artists or available works were bits of humor, such as Smith's note to Carter in 1954:

> You can tell this one to Richardson:
> "Did you hear the one about the flea from Texas?"
> "No, what did he do?"
> "Bought himself a dog."[210]

Initially, for these collectors, like their predecessors and contemporaries, the financial reward of collecting western art was limited if not inconsequential. Also, compared to collecting Old Masters or nineteenth-century French painting, collecting western art was not necessarily a sign of status. These collectors, in reality, epitomize collecting in its purest form; people drawn to objects for their sheer delight. As C. R. Smith once said of his own reasons for collecting, and so doing surely spoke for his contemporaries as well,

Paintings should be acquired, owned and preserved by those who have a deep affection for them. You do not have an affection for a painting unless you understand its significance. It has to bring back some pleasant memory, it has to rekindle some earlier ambition or it has to tell about a time and a people dear to you.[211]

208. David R. Milsten, *Thomas Gilcrease*, p. 173.

209. Estil Vance, President, Fort Worth National Bank, to William Davidson, December 4, 1953, Amon Carter Archives, Amon Carter Museum, Fort Worth.

210. C. R. Smith to Amon G. Carter, July 12, 1954, Amon Carter Archives, Amon Carter Museum, Fort Worth.

211. *Inaugural Exhibition: Selected Works, Frederic Remington and Charles Russell*, Preface.

Postscript

Since 1950 collecting western art has become a national pastime. The consolidation of a number of fortunes in the years after the Second World War led to keen competition for major works and resulted in a rapid escalation of prices. Typical of the explosion was the sale at auction of Remington's masterpiece, *A Dash for the Timber,* for $23,000 in 1945, an event that was noteworthy enough to be mentioned by *Time* magazine.[212]

Aside from the memorial museums to Buffalo Bill (1921) in Golden, Colorado, and Frederic Remington (1923) in Ogdensburg, New York, and Frank Phillips' (1873–1950) Woolaroc Museum (1929) in Bartlesville, Oklahoma, a kind of Smithsonian Institution of the American West, the first art museum devoted to American western art was that opened permanently in 1949 by Gilcrease. But in the last thirty-five years many collections formed in the 1940s and 1950s have entered the public domain and the number of museums devoted to the American West has multiplied dramatically. Museums dedicated to exploring western art can now be found from New York to Wyoming and include the Charles Russell Museum (1953), Great Falls, Montana; the National Cowboy Hall of Fame and Western Heritage Center (1954), Oklahoma City, Oklahoma; the Whitney Gallery of Western Art (1959), Cody, Wyoming; the Amon Carter Museum (1961), Fort Worth, Texas; the Bradford Brinton Memorial (1961), Bighorn, Wyoming; the Stark Museum of Art (1976), Orange, Texas; the Rockwell Museum (1982), Corning, New York; the Museum of Western Art (1983), Denver, Colorado; and the Gene Autry Heritage Museum, scheduled to open in California in 1988. They are but a few of the more prominent institutions that have sought to keep alive the culture and traditions of the American West.

The number of private collections has grown rapidly as well and, at least since the 1950s, corporations have begun to form collections of western art. Important private collections include those of Fred Renner, Harrison Eiteljorg, Philip F. Anschutz, William and Dorothy Harmsen, Carl Dentzel, and numerous others. Corporate collecting of American art in general has grown rapidly since the Second World War and some corporations, such as Northern National Gas Company, now Enron, have acquired large holdings of western art. Between 1962 and 1976 Enron, then known as Inter North, made three important acquisitions: the Maximilian-Bodmer collection of diaries, journals, aquatints, correspondence, and 427 watercolors and sketches from the 1832–1834 expedition; 100 Alfred Jacob Miller watercolors amassed by Mae Reed Porter and acquired in 1964; and 86 works by thirty-six western artists.[213] These collections have either now been given to or placed on loan at the nearby Joslyn Art Museum in Omaha. Another important corporate collection is owned by the Gulf States Paper Corporation, which since 1969 has acquired seventeen portraits by Charles Bird King.

This national awareness for western art has also spawned a wealth of publications and exhibitions. Notable among the early publications are Robert Taft, *Artists and Illustrators of the Old West, 1850–1900* (1953); Harold McCracken, *Frederic Remington — Artist of the Old West* (1947) and *The Charles M. Russell Book* (1957); and John C. Ewers, *Artists of the Old West* (1965). Exhibitions have ranged from individual retrospectives

212. *Time* 45, no. 20 (May 14, 1945): 114.

213. Goetzmann, *The West as Romantic Horizon,* Introduction.

to thematic shows, such as Westward the Way (1954), at the City Art Museum of St. Louis; Taos and Santa Fe: The Artists' Environment, 1882–1942 (1963) at the Amon Carter Museum; The American West (1972) at the Los Angeles County Museum; The American Frontier: Images and Myths (1973) at the Whitney Museum; Frontier America: The Far West (1975) at the Museum of Fine Arts, Boston; and, most recently, Art in New Mexico, 1900–1945: Paths to Taos and Santa Fe (1986), which opened at the National Museum of American Art.

This activity has suggested that after many years the best western artists are being integrated into the mainstream of American art. The stigma of the artist-illustrator, which haunted Remington and others, or the denigration of those preoccupied with subject matter as artists hopelessly out of sync with more avant-garde art currents is slowly being reconsidered. Some art historians and museum curators who grew up in the 1940s and 1950s on a Saturday diet of Hopalong Cassidy, Roy Rogers, and the Lone Ranger may associate related subjects in art with the naïveté of their own youth that may contribute to a subliminal uneasiness with any evaluation of western art. Despite this, the additional passage of time will undoubtedly precipitate increasingly thoughtful evaluations of western artists, their subjects, and their context in the cultural life of America.

The demand for western works has had a predictable effect on the price of works by western artists as well. Major works by Remington, for example, sell for over a million dollars, while bronzes by Remington and Russell routinely bring $50,000 — and much more. Demand has exceeded supply and has encouraged the creation of replicas of Remington bronzes, such as those sponsored by the Buffalo Bill Historical Society, Cody, Wyoming.[214] Also, living artists continue the subjects codified almost one hundred years ago. The Cowboy Artists Hall of Fame in Oklahoma City and the Cowboy Artists of America Museum in Kerrville, Texas, have been founded to celebrate these traditions. More recently, periodicals, like *Southwest* magazine, have emerged with a focus primarily on living artists who paint and sculpt western subjects. These artists, such as John Clymer, Robert Pummill, Don Spaulding, and Harry Jackson, whose works sell in excess of $50,000, frequently rework western themes inspired by turn-of-the-century prototypes.[215] As long as there are devotees of the American West and patrons to nurture the romantic spirit of another age, images of the American West will endure.

214. William Gardner Bell, "A Rebirth of Classic Western Art," *Southwest Art* 11, no. 9 (February 1982): 82–84.

215. J. Skow, "In Arizona: A Million Dollar Sale of Cowboy Art," *Time* 116 (November 24, 1980): 6.

Catalogue of the C. R. Smith Collection

Contributors

C. A.	Carolyn Appleton
S. A.	Susan Arthur
N. B.	Natasha Bartalini
K. B.	Karen Bearor
F. C.	Francine Carraro
P. D. H.	Patricia Dannelley Hendricks
J. H.	Jan Huebner
L. L.	Lamar Lentz
A. O.	Amy Oakland
L. W.	Lisa Ward

Artists

Oscar E. Berninghaus
Albert Bierstadt
Solon H. Borglum
J. M. Boundy
Ernest Chiriacka
Dean Cornwell
Maynard Dixon
Nick Eggenhofer
Henry Farny
William Gilbert Gaul
Herman Wendelborg Hansen
Alexander Francis Harmer
Thomas Hill
Ransome Gillet Holdredge
Peter Hurd
Frank Tenney Johnson
Tom Lea
William Robinson Leigh
Peter McIntyre
Alfred Jacob Miller
Thomas Moran

Ernest Étienne Narjot de Franceville
William Ranney
Hugo Robus
Charles M. Russell
Charles Schreyvogel
Joseph Henry Sharp
Joshua Shaw
Walter Shirlaw
Arthur Fitzwilliam Tait
Walter Ufer
Unknown Artist
Harold Von Schmidt
Thomas Worthington Whittredge
Harry Wickey

Oscar E. Berninghaus

b. 1874, St. Louis, Missouri; d. 1952, Taos, New Mexico

Morning in the Mining Camp, painted by Oscar Berninghaus in 1950, two years before his death, recalls a scene the artist may have observed in 1899, when he was hired by the Denver and Rio Grande Railroad to record the mountain scenery and the life in the mining camps. These images were published in travel pamphlets to entice travelers and settlers to come to Colorado and New Mexico via the railroad. It was on this eventful trip that Berninghaus first visited Taos, New Mexico, where, in 1912, he became a founding member of the Taos Society of Artists.

Berninghaus often painted horses — working in the field, grazing, pulling covered wagons, or merely standing at hitching posts. In fact, this last subject seems to have been particularly pleasing to him. Perhaps the significance of this subject for Berninghaus is underscored by his recollection of his first impressions of Taos. In a letter of 1950, he recalled the village as "a barren plaza with hitching rail around it, . . . cow and Indian ponies hitched to it."[1]

In some paintings, the horses play a relatively insignificant role in the overall composition. In such instances, they merely animate otherwise uninhabited adobe villages. In other works, such as this one, the horses become the major participants in a scene played out before the viewer. Here, five mounts stand quietly, huddled together for warmth in the falling snow, while their owners pass the hours in the Canon Club. They have been forgotten, as the title of a similar painting suggests.[2]

However, the narrative content of the scene was not all-important to Berninghaus late in his career,[3] despite his early training as an illustrator. He believed that "the painter must first see his picture as *paint — as color — as form —* and not as a landscape or a figure."[4] He became interested in exploring various light effects while retaining a consistent subject. Much as Monet had painted his haystacks and church façades, Berninghaus painted his stationary horses in various seasons and locations, in various types of weather, and at differing times of day.

Nevertheless, Berninghaus's light was not always observed light, for, despite the convincing dreariness of the cold winter's day depicted in *Morning in the Mining Camp,* the painting was conceived in the artist's Taos studio.[5] The grayed colors are almost monochromatic, which allows the artist to concentrate on the arrangement of elements and the interaction of form. Rather than being an interesting painting of neglected horses standing in a mining camp, the canvas becomes an experiment in design, an interpretation consistent with the artist's avowed purpose. K. B.

1. Patricia Janis Broder, *Taos: A Painter's Dream,* p. 119.
2. A painting of a similar subject, entitled *Forgotten,* is reproduced in ibid., p. 110.
3. Ibid., p. 126.
4. Berninghaus, quoted in ibid., p. 126.
5. Broder states that Berninghaus never left Taos following his honeymoon trip in 1932 (ibid., p. 128).

Oil on canvas
25¼ × 30¼ inches
Inscription: signed lower right "O. E. Berninghaus -50-"
Gift of C. R. Smith
1985.80

Morning in the Mining Camp
1950

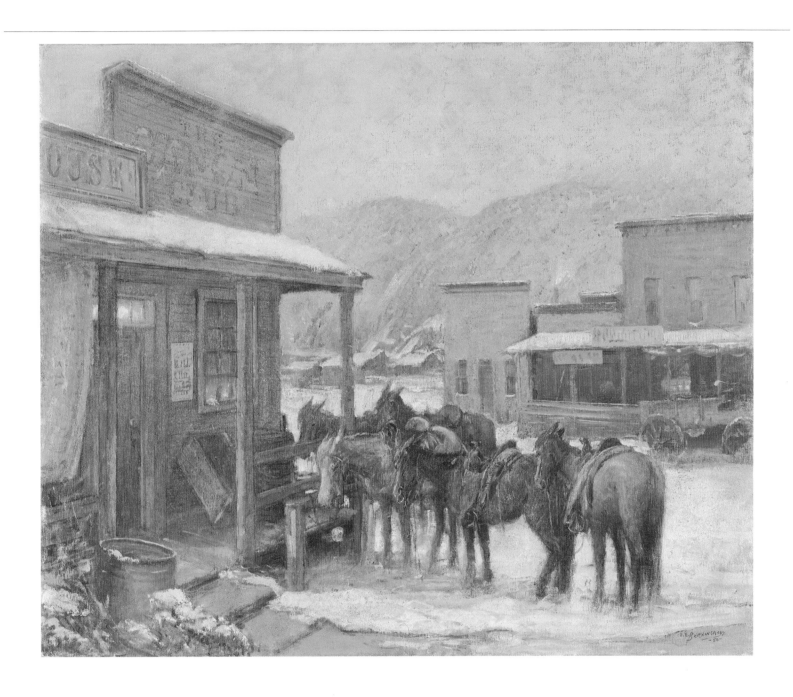

Oscar E. Berninghaus

b. 1874, St. Louis, Missouri; d. 1952, Taos, New Mexico

In *Oregon Trail* Oscar Berninghaus returned to a subject with which he was thoroughly familiar. In 1911, he was commissioned by the Anheuser-Busch Brewing Company of St. Louis to paint a series of canvases showing the growth and expansion of America. Among these works were paintings of prairie schooners heading west. Eight paintings from this series were reproduced in a booklet entitled *Epoch Making Events of American History,* distributed to St. Louis school children in 1914.[1]

In this painting, Berninghaus depicted a large wagon train of horse-drawn Conestogas — "The Cadillac of the Oregon Trail"[2] — snaking its way across the prairie. Although much of the painting is brushy and undefined in technique, the artist has painted the harnesses and riding gear of the lead wagon with great detail and accuracy.

Despite this attention to detail, Berninghaus has presented the viewer with a romanticized vision of the trek to the West. There is little suggestion of the hardships encountered en route to Oregon across the difficult terrain of the present-day states of Kansas, Nebraska, Wyoming, and Idaho. Nor is this scene entirely accurate in its conception. One of the best guidebooks for travel on the Oregon Trail, written by Joel Palmer, who made the trip in 1845 and 1846, provides the following information and advice:

For burthen [*sic*] wagons, light four-horse or heavy two-horse wagons are the size commonly used. . . . Ox teams are more extensively used than any others. Oxen stand the trip much better and are not so liable to be stolen by the Indians, and are much less trouble. . . . For those who set out with one wagon, it is not safe to set out with less than four yoke of oxen, as they are liable to get lame, get sore necks, or stray away. . . . Persons should recollect that everything in the outfit should be as light as required strength will permit; no useless trumpery should be taken. . . . The time usually occupied in making the trip from Missouri to Oregon City is about five months; but with the aid of a person who has traveled the route with an emigrating company, the trip can be performed in about four months. . . . From 10 to 25 wagons is a sufficient number to travel with safety.[3]

Travel on the Oregon Trail was immortalized in Francis Parkman's classic account *The Oregon Trail,* first published in 1849. Numerous artists, including Frederic Remington and Maynard Dixon, were commissioned to illustrate various editions of this book. Although there is no evidence to suggest that Berninghaus painted this canvas for such a purpose, he certainly would have been familiar with these works.

During his lifetime, Berninghaus won numerous prizes and honors for his paintings. In addition, he was elected an Associate of the National Academy of Design in 1926, although he never completed the required steps to become a full member. For a time, he taught illustration at the School of Fine Arts of Washington University in St. Louis. K. B.

1. Mary Kimbrough, "Oscar Berninghaus: St. Louis Portrayer of the West," *Sunday Magazine St. Louis Globe-Democrat,* February 27, 1977, p. 7.

2. Gregory M. Franzwa, *The Oregon Trail Revisited,* p. 31.

3. Ibid., pp. 30–34.

Oil on canvas
30⅛ × 40⅜ inches
Inscription: signed lower left "O. E. Berninghaus -51-"
Gift of C. R. Smith
G1976.21.1P

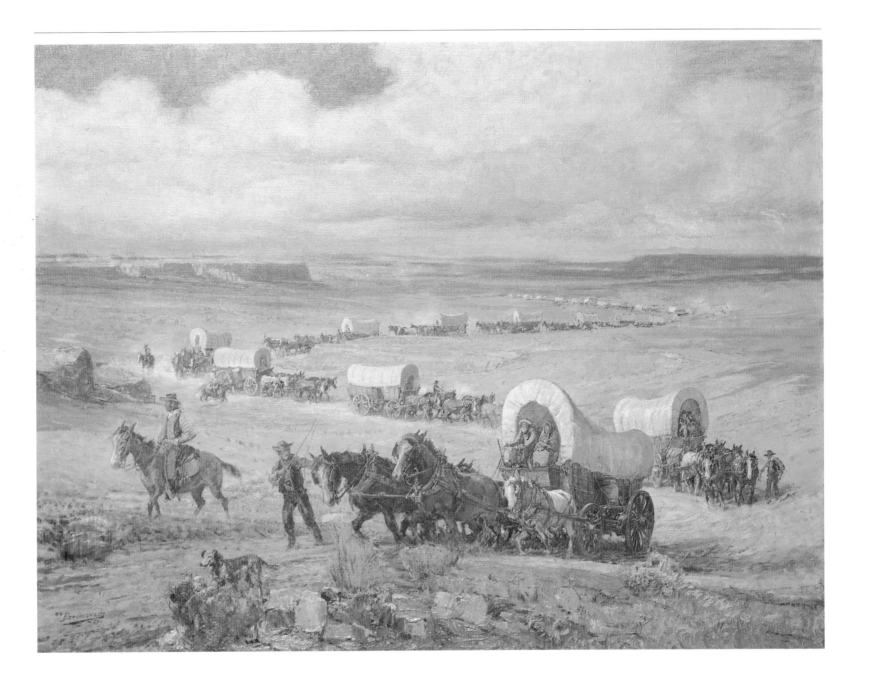

Oscar E. Berninghaus

b. 1874, St. Louis, Missouri; d. 1952, Taos, New Mexico

The mountain man, who played a significant role in the trailblazing and subsequent settling of the West, has become a romantic symbol of independence and self-reliance. Although their heyday was brief,[1] such men as Jim Bridger, Jedediah Smith, and Kit Carson became heroes in nineteenth-century novels and tales of adventure. The mountain man's rugged individualism continues to be popular with modern audiences as well: witness the popularity of Robert Redford's *Jeremiah Johnson.*[2] The character of the independent, adventurous trapper who sought to make his fortune in the wild, uncivilized land of the Rocky Mountains appealed to C. R. Smith, who in 1951 commissioned Oscar Berninghaus to paint *The Unsung Hero, the Mountain Man.*

In this painting, Berninghaus followed a lengthy pictorial tradition of depicting these reclusive hunters. Alfred Jacob Miller in 1837 was perhaps the first artist to record the mountain man's way of life. Later, such artists as William Ranney, Frederic Remington, Charles Russell, and Maynard Dixon painted him in his role as explorer or trapper. He generally appears as a somewhat unkempt, bearded man wearing buckskin clothes and hat. The tools of his trade, his knife, powderhorn, and rifle, are always at hand. In Berninghaus's painting, the mountain man has descended from the Rocky Mountains, appearing in the background, after a successful season of beaver trapping. His pelts are loaded on the mule following him. Mounted, he rides with his rifle sheathed yet poised for use should Indians attack.

The mountain man figured prominently in the history of St. Louis, Berninghaus's home prior to his permanent move to Taos in 1925.[3] It was in the *St. Louis Gazette and Public Advertiser* of February 13, 1822, that Gen. William Henry Ashley, lieutenant-governor of Missouri, first advertised for "enterprising young men" to accompany his fur company's expedition of explorer-trappers and -hunters up the Missouri River.[4] St. Louis was also a launching site for wagon trains, guided by mountain men after the fur trade subsided in the early 1840s.

Berninghaus was thoroughly familiar with the history of both St. Louis and the state of Missouri, partly as a result of a commission to paint historical subjects for lunettes in the capitol in Jefferson City, Missouri, dedicated in 1917.[5] This fact, coupled with his stature as a founding member of the Taos Society of Artists and his reputation as a painter of scenes of the westward expansion of American civilization, undoubtedly led to this commission.

A year after Berninghaus completed this painting, he died. In honor of his contribution to Taos, businesses were closed during the funeral services held in his studio.[6]
<div align="right">K. B.</div>

1. William H. Goetzmann has placed the heyday of the mountain man between the years 1820 and 1840 ("Lords at the Creation: The Mountain Man and the World," in *The Mountain Man,* p. 10).

2. *Jeremiah Johnson* is a Joe Wizan-Sanford Production, distributed by Warner Brothers, from the novel *Mountain Man* by Vardis Fisher and the story "Crow Killer" by Raymond W. Thorp and Robert Bunker; screenplay by John Millius and Edward Anhalt; directed by Sidney Pollack; released in 1972 (Milton Krims, "Jeremiah Johnson: Mountain Man," *Saturday Evening Post* 244 [Winter 1972]: 128).

3. Between 1914 and 1925 Berninghaus spent half the year in Taos and the other half in St. Louis, his childhood home. In St. Louis he had been an active member of artists' associations, such as the St. Louis Artists Guild and the Society of Western Artists. He also designed costumes and floats for the annual pageant and ball of the Society of the Veiled Prophet (Patricia Janis Broder, *Taos: A Painter's Dream,* pp. 120, 122).

4. William H. Goetzmann, *Exploration and Empire,* p. 105.

5. He painted three lunettes in the main building: *Early Lead Mining in Washington County, Old Ste. Genevieve; First Permanent Settlement, Herculaneum;* and *Where Shot Making Was an Industry;* he also painted two lunettes in the Soldiers' and Sailors' Museum: *The Attack on the Village of St. Louis in 1780* and *Surrender of the Miamis to General Dodge, 1814* (Broder, *Taos,* p. 125).

6. Ibid., p. 128.

Oil on canvas
25¼ × 30³⁄₁₆ inches
Inscription: signed lower right "O. E. Berninghaus -51-"
Gift of C. R. Smith
G1976.21.2P

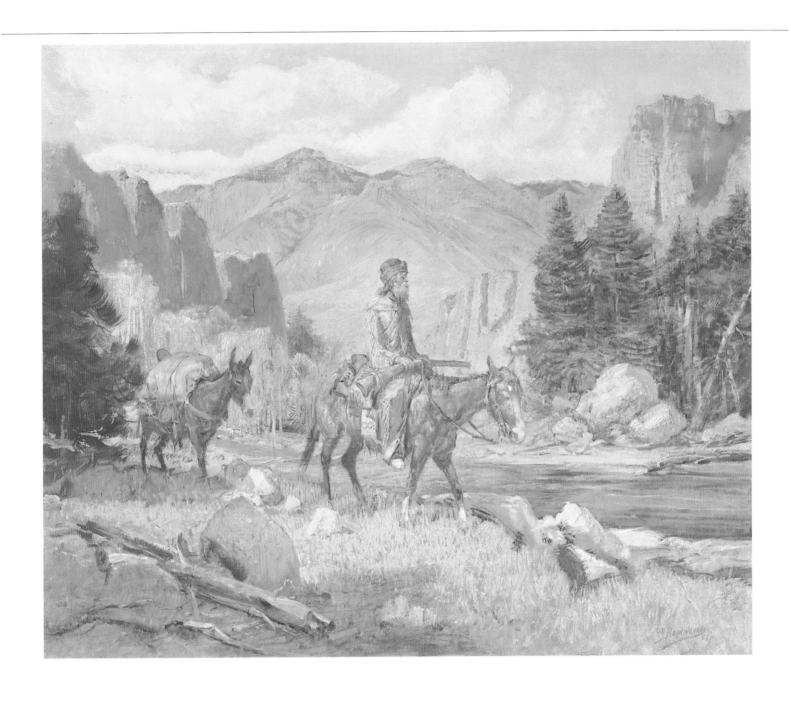

Albert Bierstadt

b. 1830, Solingen, Germany; d. 1902, New York, New York

During the 1860s Albert Bierstadt became America's preeminent painter of the West. *Sioux Village near Fort Laramie,*[1] one of the few canvases resulting from his first journey across the continent in 1859, stands at the beginning of the artist's illustrious career. Yet, unlike the panoramic visions of mountainous western terrain for which Bierstadt later earned his fame, this early painting presents a relatively intimate scene of an Indian riverbank encampment.

In 1859 Bierstadt traveled with Col. Frederick Lander's army expedition to map and improve what would later be called the Oregon Trail. The artist reported to *The Crayon,* July 10, 1859, that he found the Indians enticing and picturesque adjuncts to the western landscape. Yet he added cautiously, ". . . they have always been kindly disposed to us and we to them; but it is a little *risky,* because being very superstitious and naturally distrustful, their friendship may turn into hate at any moment."[2]

Throughout the 1859 journey Bierstadt avidly recorded in oil and pencil sketches as well as stereographs the environments and likenesses of the various Indian tribes he encountered. In this practice of painstakingly sketching and photographing images for future artistic reference, Bierstadt revealed his ties to the eastern landscape tradition as well as to that of Dusseldorf, where he had trained in the mid 1850s. Once safely back in his New York studio, the artist incorporated his first-hand sources, such as a sketch of a tripod amulet (private collection), which appears in the left foreground of this work, into his finished paintings.[3] Bierstadt also relied on stereographs taken during the 1859 journey to refresh his memory. *Sioux Village near Fort Laramie, Na.* [Nebraska], depicting an Indian with a child standing before an encampment, probably served the artist as a compositional aid in creating the painting.

Bierstadt composed at least two other scenes of specifically Sioux Indian encampments during this period, as well as a scene of unidentified Indians on the move across the Laramie plain.[4] These works, like *Sioux Village near Fort Laramie,* were thoughtfully culled from Bierstadt's first-hand sketches and stereographs taken during his first journey west. Later in the artist's career this practice was abandoned, as Bierstadt began to rely more frequently on memory when composing his works. C. A.

Albert Bierstadt, *Sioux Village near Fort Laramie, Na.* [Nebraska], 1859, photograph. (Courtesy Robert Dennis Collection of Stereoscopic Views, New York Public Library.)

1. The title of this work was shortened by Mr. Smith to *Sioux Village,* which is how it is catalogued by the Archer M. Huntington Art Gallery. The full title, however, is *Sioux Village near Fort Laramie,* as noted on the reverse of the painting.
2. Albert Bierstadt, letter to *The Crayon* 6, no. 9 (September 1859): 287.
3. Gordon Hendricks discusses the amulet in greater detail in *Albert Bierstadt,* pp. 16–18.

4. The two other Sioux encampment scenes are *Chimney Rock, Ogallilah. Sioux Village in the Foreground* of 1860, reproduced as an engraving in *Ladies Repository* 26 (January 1866), one of two frontispieces; and *A Sioux Camp near Laramie Peak,* which was illustrated in A. Pendarves Vivian, *Wanderings in a Western Land,* 213. These are known only through the above illustrations. The unidentified Indians on the move across the Laramie plain may be seen in *Indians near Fort Laramie* of 1860 (private

collection), which is reproduced in Alexander Gallery, *Albert Bierstadt: An Exhibition of Forty Paintings,* cat. no. 3.

Oil on wood panel
12½ × 19⅜ inches
Inscription: lower left, "AB 59"; verso, lower right, "Sioux Village Near Ft. Laramie from Nature for [undecipherable], A. Bierstadt, Studio Building, 15 Tenth St., N.Y."

Label (upside-down) verso, center: "Winsor & Newton, Artist's Colourmen to Her Majesty and His Royal Highness Prince Albert, 38 Rathbone Place, London"; torn label *over* above label, "Sioux" / AB Lent by C. R. Smith

Sioux Village near Fort Laramie
1859

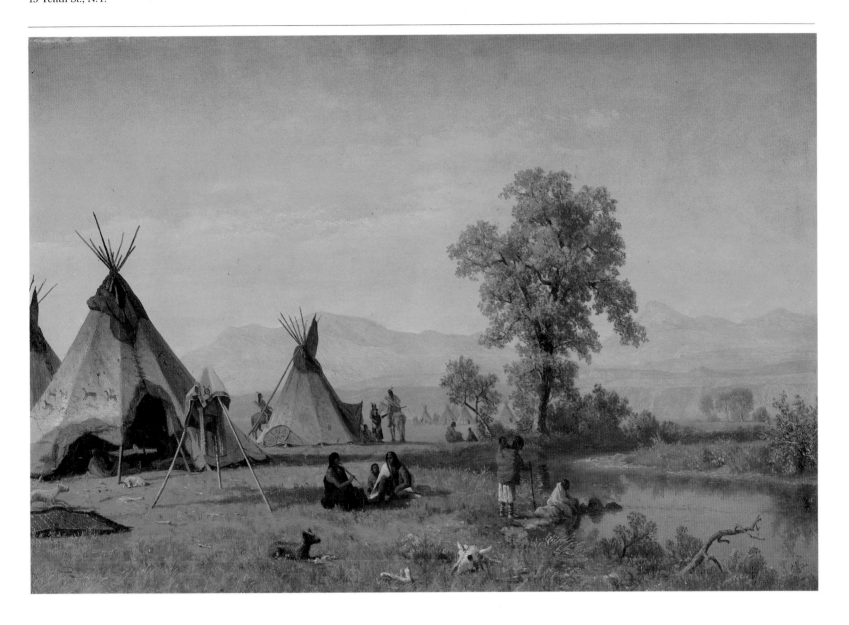

Albert Bierstadt

b. 1830, Solingen, Germany; d. 1902, New York, New York

Although *Indian Canoe*[1] does not illustrate a specific passage in Henry Wadsworth Longfellow's *The Song of Hiawatha* (1855), it seems likely that Bierstadt had the popular poem in mind when he composed this painting. Longfellow described a sunset similar to that portrayed in *Indian Canoe* when he wrote:

And the evening sun descending
Set the clouds on fire with redness,
Burned the broad sky, like a prairie . . .[2]

During an 1868 dinner honoring the poet in London, Bierstadt had in fact presented Longfellow with a small oil sketch depicting Hiawatha's departure, demonstrating early on his interest in the poem.[3] *Indian Canoe* probably was painted later in the artist's career, after he had visited the Lake Superior region in 1886.[4]

The painting depicts a lone Indian paddling silently to shore in what appears to be a birchbark canoe. The unusually weathered rocks in the distance suggest the sandstone bluffs extending along the shore of Lake Superior, called the "Pictured Rocks." John Foster and Josiah Whitney, in their *Report on the Geology of the Lake Superior Land District,* cited at length in the appendix to *The Song of Hiawatha,* report: ". . . in the Pictured Rocks there are two features which communicate to the scenery a wonderful and almost unique character. These are, first, the curious manner in which the cliffs have been excavated and worn away by the action of the lake, which for centuries has dashed an ocean-like surf against their base . . ."[5]

Indian Canoe is typical of Bierstadt's late work by virtue of its simplified subject matter and the dramatic light effects, which have in themselves become the subject of the work. This differs from the artist's earlier, panoramic yet intricately detailed canvases with circumscribed compositions, like *The Rocky Mountains* (1863, Metropolitan Museum of Art), where our eyes are arrested by the busy Indian camp at the foot of the mountain before being led upward and halted by a dazzling central mountain peak. *Indian Canoe* is an evocative image that allows our eyes to drift rhythmically into the distance, obstructed only briefly by the Indian and the hollowed cliff.

Indian Canoe not only recalls Longfellow's poem but also comments nostalgically on the state of the Indian at the end of the nineteenth century. The setting sun combined with the lone Indian in his canoe suggest the tragic end of our native Americans. Perhaps a cliché in our time, this suggestion was not one in Bierstadt's own. C. A.

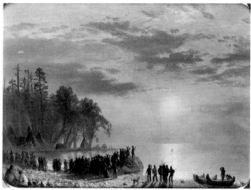

Albert Bierstadt, *Departure of Hiawatha,* ca. 1868, oil on copper. (Courtesy U.S. Department of the Interior, National Park Service, Longfellow National Historic Site, Cambridge, Massachusetts.)

1. According to the file on this painting in the Archer M. Huntington Art Gallery, *Indian Canoe* is the short and probably original title of *Filled with the Face of Heaven,* the title by which the painting has come to be known. It is possible, although not mentioned in the files, that Mr. Smith altered the title in favor of the more romantic version.
2. Henry Wadsworth Longfellow, *The Song of Hiawatha,* p. 244.
3. Cynthia D. Nickerson, "Artistic Interpretations of Henry Wadsworth Longfellow's *The Song of Hiawatha,* 1855–1900," *American Art Journal* 16, no. 3 (Summer 1984): 54–55.
4. Gordon Hendricks, *Albert Bierstadt: Painter of the American West,* p. 280.
5. Longfellow's quote in *The Song of Hiawatha* concerning the sandstone bluffs of Lake Superior is found on p. 260; the report by Foster and Whitney comes from the second volume of *Report on the Geology of the Lake Superior District,* p. 124.

Oil on canvas
21⅝ × 30 inches
Inscription: lower right "ABierstadt"
Gift of C. R. Smith
G1976.21.3P

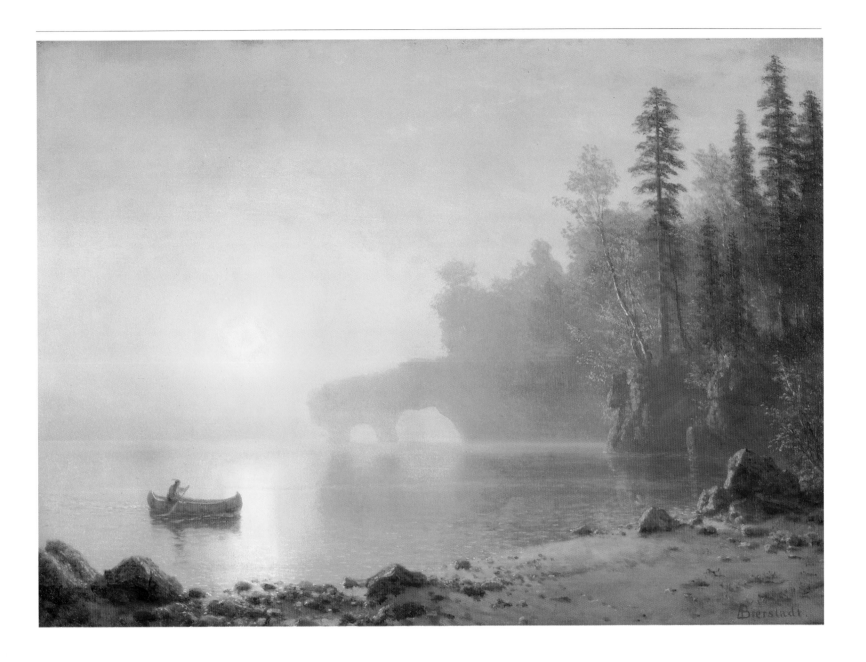

Solon H. Borglum

b. 1868, Ogden, Utah; d. 1922, Stamford, Connecticut

Solon Borglum, the cowboy sculptor, created in bronze the wild beauty and rugged life of the American cowboy. A contemporary of Frederic Remington, Borglum specialized in equestrian action scenes that recalled his early life as a working cowboy in Nebraska. *Lassoing Wild Horses* was Borglum's first work completed in Paris as well as also one of his first two works (along with *In the Wind*) to be accepted and honored in the Paris Salon of 1898. *Lassoing Wild Horses* was modeled out of Borglum's homesickness for the prairie and the free life of a cowboy.

The exotic American subject matter of *Lassoing Wild Horses* fascinated the Parisians, who flocked to see Buffalo Bill's Wild West Show in the summer of 1897 when Borglum arrived in Paris. At age twenty-nine Borglum traveled there to seek the instruction and approval of French sculptors, never expecting the overwhelming response to his work on western themes. Seventeen French newspapers carried favorable remarks about the Salon debut of *Lassoing Wild Horses* by this unknown American artist whom they called the "sculptor of the prairie."[1] The work was praised for its startling realism and irresistible authenticity.

Less then five years before Borglum arrived in Paris he had been a cowboy on his father's ranch in Nebraska. Born in Ogden, Utah, son of Danish immigrants, Borglum spent the greater part of his childhood in the frontier towns of Nebraska, where his father served as the country doctor. He was not fond of the regimentation of public school and at age fifteen he was sent with his brother Gutzon to work on a ranch in California. There Solon learned the daily routine and roping and riding skills of a cowboy.

Upon returning from California, Solon maintained his father's six-thousand-acre ranch on the Loop River in Nebraska. In that vast, isolated stretch of prairie, Solon developed his appreciation of the forces of nature, the beauty of animals, and the difficulties of cowboy life. With no thought of becoming an artist, he began to sketch horses and model portraits of hired hands in clay. In 1890 Solon showed his art work to his older brother Gutzon, who had studied art abroad and was establishing a career as an artist in California. Gutzon encouraged Solon to become an artist and offered to give him art instruction. A short time later Solon sold the ranch to the first bidder

and joined Gutzon in the Sierra Madre of California, where he spent a couple of years as an itinerant artist.

With the proceeds from his art sales, Solon went to Cincinnati to enter art classes at the Cincinnati Art School. He not only attended day and night classes but also sketched the horses at the U.S. Mail stable and learned anatomy through dissecting dead animals at a veterinary school. His sculptures of horses won Cincinnati Art School prizes and attracted the attention of Louis Rebisso, his instructor, who encouraged Solon to study art in Paris and arranged a small scholarship for him from the school.

Borglum arrived in Paris with a Nebraska oil stove and Indian blanket but without introductions or an understanding of the language. He wandered through the Louvre and the Luxembourg Gardens admiring the masterpieces of sculpture. He attended classes at the Académie Julian but found the instruction and drawing from plaster casts uninspiring. After locating the city's largest stable, Borglum gained permission to sketch the horses on a daily basis. Borglum later wrote, "When I got there I was suddenly dismayed. I saw that the most any artist can do is to live and work with nature, and I said to myself, 'that is what I must do at home. Why have I come?' And the whole time I stayed, I struggled not to let my work lose its stamp of American life."[2] Borglum lived in a small room that he rented for four dollars a month and began working on *Lassoing Wild Horses.*

In Paris Borglum met the American sculptors Augustus Saint-Gaudens and Frederick MacMonnies and their circle of artist friends, including Emmanuel Fremiet, the French sculptor of exotic animal allegories. Fremiet is reported to have praised Borglum, "You are lucky, sir. Many young men go to art school, and come out polished with nothing to say. You lived, you had something to say, then you studied art."[3] These academic artists encouraged Borglum to stay in Paris and to submit his work to the 1898 Spring Salon.

Lassoing Wild Horses is an exciting view of the rough treatment involved in the capturing and taming of wild horses on the western frontier. Both cowboys and their horses exert enormous strength in the effort to lasso and restrain an unseen bronco. One cowboy has pulled his horse to

a tense seated position as an anchor while the other cowboy aims another lasso. This remarkable composition allows one horse to have all four legs off the ground. Originally, the cast included such detailing as bridles, lariats, and cinches, which augmented the realism of the subject. Borglum completed other western sculptures, including *The Rough Rider, The Bucking Bronco,* and *Blizzard.* These small, parlor sculptures, which were very popular at the turn of the century, brought Borglum immediate success. *Lassoing Wild Horses* set the standard for Borglum's later work. Its refinement of detail, embodiment of energy, and liberation of form rivaled Remington's 1895 bronze, *The Bronco Buster.*

When Borglum returned to the United States in 1901 to open a studio in New York his success as a sculptor was established. His work won a silver medal at the Pan-American Exposition of 1901, the same year he was elected to the National Sculpture Society. *Lassoing Wild Horses* was exhibited and awarded a silver medal in 1910 at the Exposición Internacional in Buenos Aires. Eight casts of *Lassoing Wild Horses* were made at the Susse Foundry in Paris in 1898 and at the Roman Bronze Works in New York in 1906.[4]

By 1911 Borglum was an associate member of the National Academy of Design. Borglum's western themes caught the imagination of the public and won such critical praise as this by Arthur Goodrich: "His art is an expression of the man who felt the fierce epic of the West beating in his heart . . . the great West itself, the history of a picturesque century, its rough tenderness, its rugged rhythm. The swinging rush of the stampeded herd is there, the sway of the wind in the prairie grass, the mystical union of all with the horse and its rider . . ."[5] F. C.

1. "A Nebraska Sculptor—World Famous," *World Herald* (Omaha, Nebraska), April 12, 1903, Archives of American Art, microfilm #N69–98, frame 685.
2. Alfred Mervyn Davies, *Solon Borglum: A Man Who Stands Alone,* p. 48.
3. Arthur Goodrich, "The Frontier in Sculpture," *World's Work,* March 1902, p. 1873; *Lassoing Wild Horses* is illustrated on p. 1864.
4. Casts of *Lassoing Wild Horses* are in the following collections: (#3 stamped on sculpture) the C. R. Smith Collection; (#4 stamped on sculpture) the R. W. Norton Art Gallery, Shreveport; (#8 stamped on sculpture) the Art Institute of Chicago; ("Roman Bronze Works N.Y." stamped on sculpture) the Detroit Institute of Arts; the Thomas Gilcrease Institute of American History and Art, Tulsa; the National Cowboy Hall of Fame and Western Heritage Center, Oklahoma City. One cast was sold at auction to a New York collector in December 1981.
5. Goodrich, "The Frontier in Sculpture," p. 1874.

Bronze (Roman Bronze Works, New York; Susse
Foundry, Paris)
Height: 31½ inches; base: 32 × 17 inches
Inscription: signed on base "Solon Borglum"; stamped, 3
Gift of C. R. Smith
G1972.5S

Lassoing Wild Horses
1898

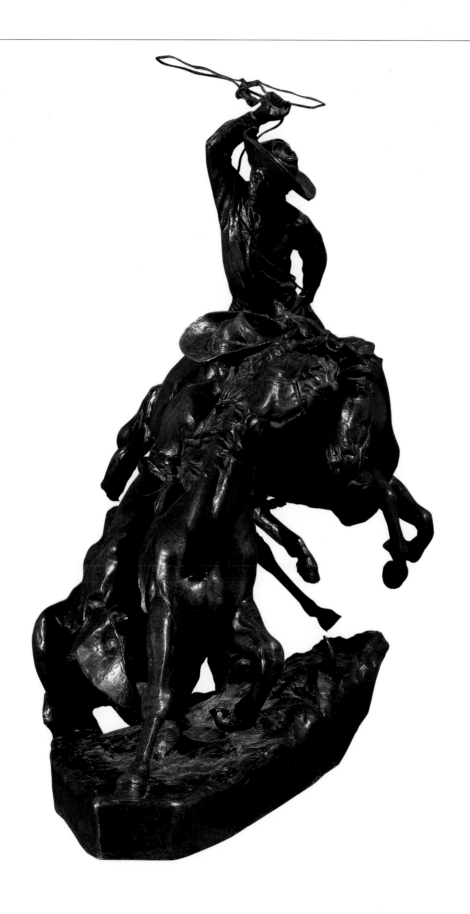

J. M. Boundy

On October 19, 1861, J. M. Boundy, a now forgotten artist, completed his painting *The Weak Never Started*.[1] Although Boundy's work reproduced Charles Ferdinand Wimar's (1828–1862) painting *The Attack on an Emigrant Train,* rendered five years earlier, this copyist most likely worked from a widely circulated color lithograph, *On the Prairie*.[2] Around 1860 Wimar's painting may have been sent to be sold in Boston. While it was there, Leopold Grozelier rendered it on stone for J. H. Bufford and Sons, a well-known company specializing in color reproductions after paintings.[3] Because nineteenth-century America witnessed a heavy demand for inexpensive art objects, copies after paintings were extremely popular. Published in 1860, *On the Prairie* reached thousands of Americans, of whom Boundy was apparently one. That both a lithographer and a painter set themselves to produce copies indicates the appeal that Wimar's image held in the mid-nineteenth century.

The style of Wimar's *The Attack on an Emigrant Train,* composed while the artist was a student at the prestigious and widely acclaimed Dusseldorf Academy, recommended it to contemporary Americans. Wimar carefully grouped monumental figures within a relatively shallow stagelike space, creating the character of a sculptural battle relief. The work is dramatic in tone and highly finished, both characteristics that mid-nineteenth-century patrons had come to expect in painting.

Moreover, Americans of the 1850s and 1860s welcomed images of westward expansion, and the wagon train symbolized this progress. *The Attack on an Emigrant Train* referred to the contemporary expansion of white culture but at the same time it afforded assurance to a white audience that pioneers could, indeed, dominate the wild. The Indian, as a symbol of the untamed, challenges the symbol of eastern civilization, the wagon train. However, there is little doubt the latter will triumph. By the 1840s the Indians had adopted the use of the rifle, but Wimar depicted them brandishing primitive weapons, no match for the white man's superior technology. The imagery assuaged the fears of many Americans who, imbued with the patriotic ideals of Manifest Destiny, agreed with distinguished Missouri Sen. Thomas Hart Benton, "It is the genius of our people to go ahead, [those] . . . bold pioneers who open the way to new countries and subdue the wilderness for their country."[4]

At the same time, *The Attack on an Emigrant Train* lamented the passing of an era. The buffalo skull and bones in the right foreground, symbols of the destruction of the wilderness, together with the sympathetic treatment of the heroically dying Indians express the dark assessment that "civilization" and pristine, inviolate nature could not coexist.[5] Thus, the painting depicts two conflicting attitudes: optimism for the future and regret for the changes necessarily wrought by "progress." N. B.

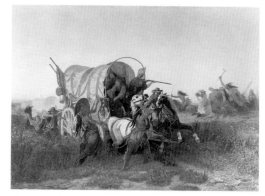

Charles Wimar, *The Attack on an Emigrant Train,* 1856, oil on canvas, 55¼ × 79 inches. (Courtesy University of Michigan Museum of Art; bequest of Henry C. Lewis.)

Leopold Grozelier after Charles Wimar, *On the Prairie,* 1861, lithograph, 17¼ × 25¾ inches. (Courtesy Joslyn Art Museum, Omaha.)

1. An extensive search through bibliographic and biographical indexes and books yields no information on the artist. The Inventory of American Paintings of the Smithsonian Institution likewise has no record of a J. M. Boundy in its artists' files.

2. *Attack on an Emigrant Train* was Wimar's second version of this theme. The first, painted in Dusseldorf in 1854, differed significantly in terms of iconography and composition (see Dawn Glanz, *How the West Was Drawn*, pp. 70–72, 178, n. 53). Style and details indicate that Boundy worked after a copy of the lithograph rather than after Wimar's painting itself. For example, Boundy's schematic shading is closer in character to that of the print, and the flowers in the right foreground of Boundy's painting are much closer in size and type to the flowers in the print.

3. Wimar's first version of *The Attack on an Emigrant Train* was sent to be sold in Boston (see William Tod Helmuth, *Arts in St. Louis,* p. 40). Similarly, the second version may have been sent to be sold there. Between 1856 when the painting was finished and 1860 when the lithograph was made, Grozelier was living and working in Boston, suggesting that sometime during these four years Wimar's painting was in that city (see Harry T. Peters, *America on Stone,* p. 200).

4. *Congressional Globe,* 28th Congress, 1st Session, 1844, p. 637. This quote was taken from Glanz, *How the West Was Drawn,* p. 56, p. 174, n. 8; see also pp. 52, 63–66, 70–72.

5. Glanz, *How the West Was Drawn,* pp. 101–102.

Oil on canvas
35¾ × 52⅝ inches
Inscription: signed and dated lower left corner "J. M.
Boundy Oct. 19, 1861"
Lent by C. R. Smith

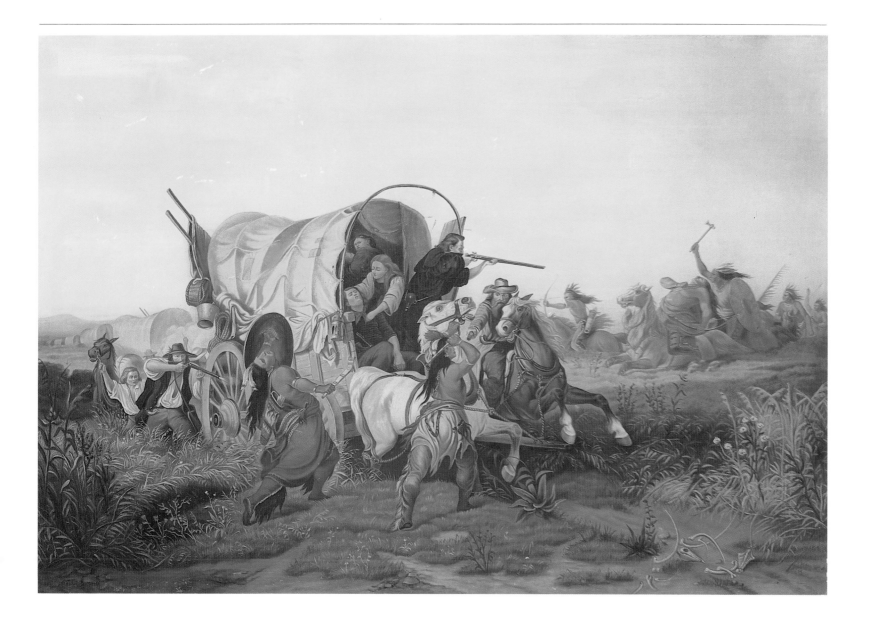

Ernest Chiriacka

b. 1920, New York, New York

The Captive is characteristic of the style and much of the subject matter[1] of Ernest Chiriacka's work, both in its depiction of Indians and in its use of stylistic devices for the enhancement of the narrative. Thus, a degree of spatial discrepancy exists because Chiriacka employed aerial perspective as much for mood as to create a realistic space. Recession into space of the three lead figures is more rapid than that of the other figures, resulting in an increasingly indistinct delineation of the three lead figures, which strengthens the sense of myth. Typically, though the essence of the narrative is defined, loosely applied paint obscures minute detail. Chiriacka also arbitrarily controlled the use of tonalities in the composition, recognizable in the heads of the three center horses, to create a lively pattern of light and dark across the surface of the painting.

The artist's whitened palette is reminiscent of the light-filled colors of the impressionist painters, as is his method of building dark tones onto light ground. The sketchiness of his stroke may reflect the influence of such American artists as Robert Henri and Frank Duvenek, who painted in a style enlivened by rapid brush strokes. Remnants of their styles were alive during the period of Chiriacka's study, perhaps in the teaching Chiriacka found at the Art Student's League. It is also possible that Chiriacka's stylistic preferences were formed as a youth when he spent time looking at and copying paintings at the Metropolitan Museum of Art.

Chiriacka was born in New York City and presently lives in upstate New York, where he maintains a studio and works as a painter and sculptor. He has painted a variety of subjects, although the majority have been linked to American history. These focus on the challenges faced in the past by the men of this country and refer to life on the frontier when the cowboy, Indian, and horse held an active place in the day-to-day consciousness of the American public. As a result of his interest in the history of the Indian, Chiriacka has sought a greater understanding of the Native American's heritage, frequently visiting Indian reservations on his travels.[2]

Chiriacka studied illustration in New York, first at the Art Student's League and later at the National Academy of Design and the Grand Central School of Art, where he studied with Harvey Dunn. He later traveled and sketched in the western United States during repeated trips to that region, recording images and expanding his knowledge of frontier history. Much of his earlier work was done under contract, and for a time he did art work for Warner Brothers, Paramount, and Twentieth Century-Fox studios, as well as a number of portraits of film celebrities.[3]

Chiriacka also worked as an illustrator for national magazines. Over the years his illustrations have frequently appeared in such periodicals as the *Saturday Evening Post, Esquire,* and *Cosmopolitan.* P. D. H.

1. Malcolm Preston, "Art Review / The Old West Rides Again," *Newsday,* December 8, 1984 (photocopy provided by the Country Art Gallery, Birch Hill Square, Locust Valley, Long Island, New York).
2. Telephone conversation with Catherine Chiriacka (Mrs. Ernest), May and August 1986.
3. Ibid.

Oil on masonite
24³⁄₁₆ × 36⅛ inches
Inscription: signed lower left corner "E. Chiriacka"
Lent by C. R. Smith

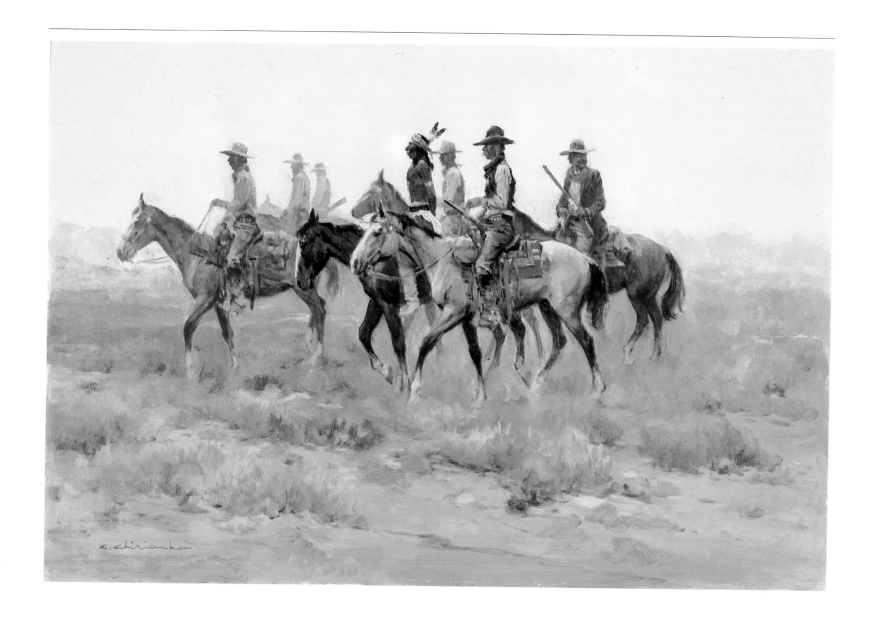

Dean Cornwell

b. 1892, Louisville, Kentucky; d. 1960, New York, New York

Wealth of 1849 was probably painted about 1949 in recognition of the centenary year of the California Gold Rush; it is typical of Cornwell's style of that period. Earlier, Cornwell had also dealt with the theme of the forty-niners in the mural he produced for the Los Angeles Public Library.

In this later painting, the foreground figures pan for gold and tend a sluicing operation. The background figures are involved in preparation for the gold retrieval process and stand in front of evidence of domestic life at camp. Between the foreground and background figures, Cornwell chose to use a forced linear perspective to compress the distance separating them. The resulting spatial manipulation, done for purposes of dramatic intensity, allows the action of the enlarged foreground figures to dominate the composition. In its clear visual definition of an idea, the ethics of industry and enterprise, this painting exemplifies the traditional subject matter and mode of presentation found in American mural painting and adventure illustration during Cornwell's lifetime.

Cornwell did considerable research for his painting commissions. He frequently traveled to a related site or museum and recorded in detailed drawings the elements relevant to his subject. This was followed by an index-card-size ink-and-wash sketch, preliminary figure studies with a model, and as many as four oil sketches of the projected painting. Occasionally, those sketches were painted on top of photostats of an acceptable drawing. For the finished work, the final sketch was traced on the canvas with a black pencil. Tones were established with a varnish wash before the figures were modeled.[1] For *Wealth of 1849,* the outline of each figure and object was also drawn in oil, possibly using burnt sienna. Most of those outlines were, as in other of his works, purposely left visible by the artist in order to delineate his subject clearly.

Dean Cornwell's career as an illustrator and muralist was long and successful. His commissions included many illustrations for major publications and a number of murals for both public and private sector buildings. As an illustrator, Cornwell was not a specialist in western themes, painting such scenes only when the story line required them. Early in his career, however, he shared exhibition space with the western artists Charles Russell and Ed Borein in the Biltmore Salon at the Los Angeles Biltmore Hotel, a gallery that had been founded by the western artists Frank Tenney Johnson and Clyde Forsythe. Throughout his career, Cornwell maintained friendly ties with these four artists and with other artists who specialized in subjects of the American West, often visiting with them in their studios.

Cornwell studied at the Art Institute of Chicago, then in New York with Charles S. Chapman and the influential illustrator and teacher Harvey Dunn. By the age of thirty, Cornwell was president of the American Society of Illustrators. He also studied mural painting with the English artist Frank Brangwyn. After 1929, when he competed for and won his first mural commission, the decoration of the rotunda of the Los Angeles Public Library, Cornwell continued to receive commissions for murals, and in 1953 he became president of the National Mural Painters Society. He was also elected academician of the National Academy of Design and taught at the Art Student's League in New York. P. D. H.

1. Peggy and Harold Samuels, *The Illustrated Biographical Encyclopedia of Artists of the American West,* p. 107.

Oil on canvas
36½ × 30⅜ inches (sight)
Inscription: signed lower left "DEAN CORNWELL";
verso, pencil, "Wealth of 1849"
Lent by C. R. Smith

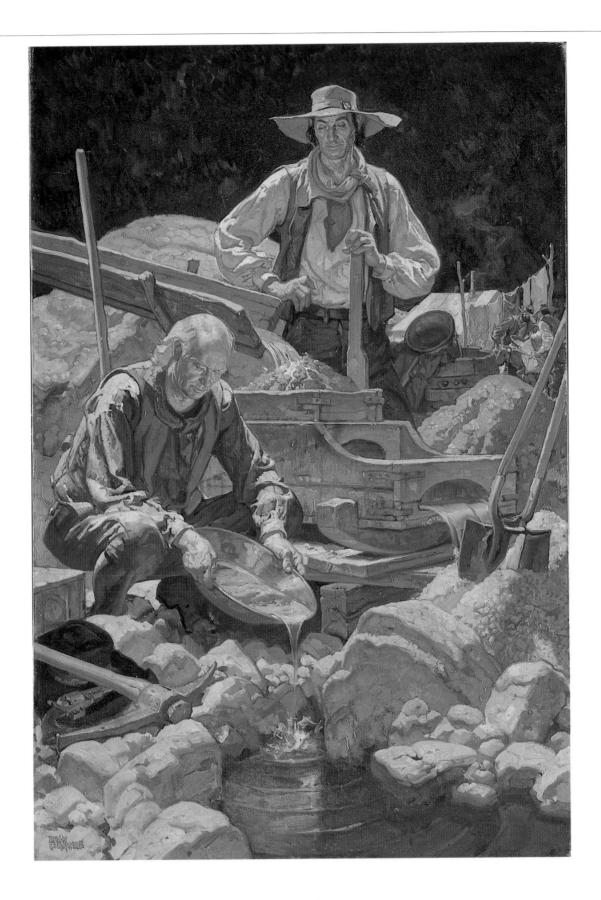

Maynard Dixon

b. 1875, Fresno, California; d. 1946, Tucson, Arizona

The painting of Namoki is one of at least three portraits by Maynard Dixon of the Hopi snake priest, whom the artist first met in 1922.[1] In 1923, Dixon and his second wife, photographer Dorothea Lange, accompanied Anita Baldwin McClaughry, millionaire daughter of mining tycoon E. J. "Lucky" Baldwin, to Walpi, in northern Arizona. The purpose of the expedition was to study the Hopi Indian culture and music, for McClaughry intended to compose an opera about Indian life.[2] While at Walpi, Dixon painted *Namoki, Hopi Snake Priest* and more than thirty additional paintings and sketches, most of which were exhibited at the Macbeth Gallery in New York City during the fall of that year.[3]

Dixon remained for four months among the Hopi. During that time, he developed a friendship with Namoki and his blind brother, Loma Hinma, a medicine man. When the artist was struck by a severe attack of rheumatism, Loma Hinma treated his ailments by massages with sacred herbs and ritual prayers to the sun. As a result, Dixon became convinced of the curative powers of Indian medicine, and he developed a lifelong interest in Hopi spiritualism.[4]

Dixon had first encountered the Hopi Indians in 1902 on his second trip to the Southwest, a trip inspired by his friendship with Charles Lummis.[5] At this time, Dixon began to collect Indian artifacts.[6] He also made illustrations of Indians, which were published in such periodicals as *Century, Scribner's, McClure's,* and *Munsey's* during the early 1900s. However, it was not until 1912 that he received his first major commission to paint an Indian subject. In that year, he painted two murals for Anita Baldwin McClaughry at Sierra Madre, near Pasadena.

Although he painted relatively few formal portraits, Dixon did make a number of portrait sketches. He held the wealthy in low regard and, consequently, he did not paint successful San Francisco businessmen or society matrons. His passion was for the people of the Southwest, its Indian, Mexican, pioneer, and rural residents.[7] In contrast to his wife's relatively unknown photographic portraits of this period, which are generally soft-focused and romantic in mood, Dixon's portrait of Namoki is boldly painted and sharply delineated.[8] Seen in profile against the yellow adobe wall, the Indian's features appear almost as if they were chiseled from stone. The female figure in the background is hardly noticeable. She pauses in a doorway as if she might disrupt the stillness of the room's interior.

The suggestion of silence and timelessness evoked by the portrait is intentional. On several occasions, Dixon commented on the Indians' characteristic silence. In an unpublished letter from 1945, Dixon wrote: "And there is the Indian who can withdraw into himself and be as silent and unresponsive as a stone. You cannot argue with silence. It returns your question to you, to your own inner silence which becomes aware — a mystical something that is neither reason nor intelligence nor intuition, a recognition of some nameless truth that may not be denied."[9]

The Hopi had no expression for time, and they had no concept of past or future. Their time was not linear. It was told in days, moons, and eternity.[10] It was a circulating space where past, present, and future are always together.[11] This concept profoundly affected Dixon's art and his attitude toward the Indian. For him, the Indian was a remnant of the Stone Age living in the midst of the Industrial Age. Thus, in the American Southwest, past and present are one, and they remain eternally linked in the artist's works.

Dixon's debt to the Indian is symbolically recognized in his adoption of the Navajo thunderbird as part of his professional signature, as it appears in this painting.

K. B.

1. Wesley Burnside lists two other paintings of Namoki in his inventory of Dixon's work. One, a canvas 16″ × 20″, signed and dated 1922, is listed as stolen, presumably in the burglary of Dixon's studio in 1922. Yet it is also listed as being exhibited in 1928. A second painting, 12″ × 29″, signed and dated 1923, is in the collection of the Southwest Museum at Los Angeles (*Maynard Dixon: Artist of the West,* pp. 166, 156).

2. Milton Meltzer, *Dorothea Lange: A Photographer's Life,* p. 58. Meltzer describes the group as traveling on "a private railway car with two chefs, two stewards, and Anita's bodyguard. . . . The windows were kept shut and the blinds drawn because they were traveling incognito [reason undetermined]. . . . Waiting for them [at Flagstaff] was a mountain of packing boxes with AB stamped on them and two trucks to move them to the campsite. . . . The boxes were full of elaborate equipment never used in the wilderness and the food was mostly tinned delicacies, including caviar. There were tents, shaped like Chinese pagodas."

3. *California Art Research,* volume 8, first series, WPA Project, San Francisco, 1937, p. 46, Archives of American Art, roll NDA/Cal 1. The Macbeth Gallery was also known for its support of Robert Henri's "Ash Can School" fifteen years earlier.

4. Indian mysticism found its way into the "Injun Babies" stories that Dixon published in 1923; although *Injun Babies* was

Oil on canvasboard
19¾ × 16 inches
Inscription: signed lower right in black "M. D. Walpi
Ariz. Sep. 1923," with thunderbird logo in red
Gift of C. R. Smith
G1976.21.6P

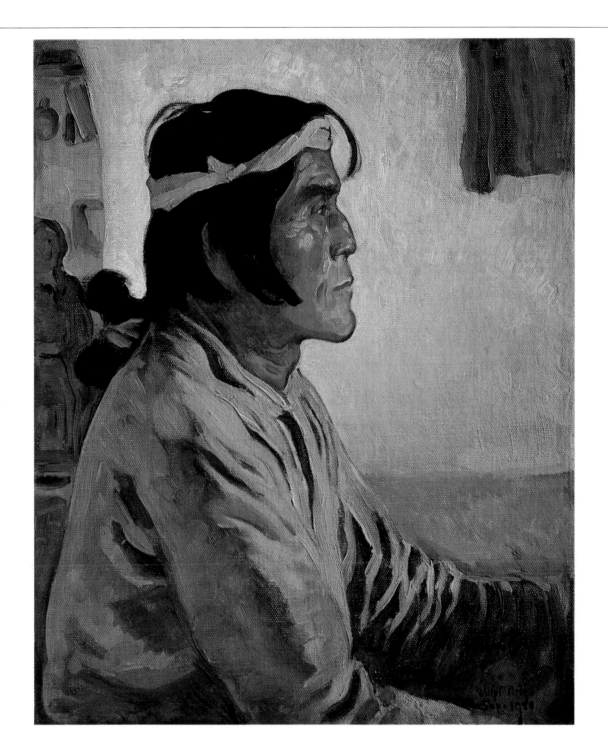

a children's book, son John Dixon recalled the stories as being "scary to young people" (*Maynard Dixon: Images of the Native American,* p. 72).

5. Lummis was founder of the Southwest Museum in Los Angeles, first city editor of the *Los Angeles Times,* and editor of *Land of Sunshine,* a San Francisco–based periodical to which Dixon contributed illustrations in the 1890s.

6. This collection was stolen from his studio in 1922.

7. Letter to K. B. from Edith Hamlin, August 6, 1984.

8. It is unknown whether Lange photographed Namoki or any members of his family.

9. *Maynard Dixon,* p. 36.

10. According to Dixon, ibid., p. 48.

11. Peter Matthiessen, "Native Earth: Man's Harmony with His Surroundings," *American West* 19 (May–June 1982): 46.

Maynard Dixon

b. 1875, Fresno California; d. 1946, Tucson, Arizona

In its emphasis on two-dimensional design, *Top of the Ridge* is close in style to Maynard Dixon's mural designs, most of which were painted during the 1920s, the heyday of private mural commissions and a decade before the more familiar period of government patronage of muralists. In order for murals to "read" at a great distance, compositions must be simplified and reduced in detail, and important figures are silhouetted against simplified backgrounds. This painting, the second version of an earlier *Top of the Ridge*,[1] exhibits these characteristics.

In this painting, Dixon's experience in commercial art was reinforced by his exposure to certain ideas of the avant garde. After his trip to Taos in 1931, where he met artist Emil Bisttram, a disciple of Jay Hambidge's Dynamic Symmetry,[2] Dixon's work took on a more "modern" appearance characterized by bolder, more simplified shapes and by a rejection of traditional illusionistic space. His work exhibited a concern with rhythm, clarity, and flatness. However, Dixon seems to have been conditioned to accept these avant-garde ideas not because he was a student of their formal development, although he did dabble in abstraction following his visit to the Panama-Pacific International Exposition of 1915.[3] On the contrary, it seems that his love of the Hopi culture led him to be open to these developments. The Hopi believed in nonattachment to preconceived forms and ideas. They sought to break down the appearances of things to reveal the essence within. These beliefs influenced their own art and the art of Dixon as well.[4]

Top of the Ridge is distinguished by its emphasis on a two-dimensional pattern of simplified shapes. The branches of the nearly dead pine tree stretch out and form an umbrella over the slowly drifting cattle and the lone cowboy herdsman. The branches parallel the curved horizon. The backs of the cattle are silhouetted in a steplike continuous line against the cloudless western sky.

There is a certain timelessness associated with the almost frozen figures and the lonely pine that seems to stand as a sentinel, a guardian of the cowboy way of life. This composition stands in marked contrast to the action-packed, bronco-busting subjects favored by Russell and Remington. In fact, Dixon left New York and his life as an illustrator in the East because, as he wrote, "I am being paid to lie about the West, the country I know and care about. I'm going back home where I can do honest work."[5] He also remarked that his work, "outside the limits of illustration, is not the regulation 'Wild West' type of painting. It aims rather to interpret the sense of freedom this country inspires and the vastness and loneliness of the land. I want my paintings to show the people as a part of that."[6]

In *Top of the Ridge,* one senses Dixon's continued concern to fuse the past and present — the past represented by a traditional subject — the present, by a more "modern" style based in part on contemporary theories of art but reinforced by a knowledge of Hopi culture. 　　　　K. B.

1. Wesley Burnside listed a canvas of the same title, 30″ × 40″, signed and dated 1925, current location unknown (*Maynard Dixon: Artist of the West*), p. 167.
2. Hambidge's Dynamic Symmetry presented a mathematical system of proportion and design based on his study of Greek vases, Egyptian bas-reliefs, and nature. Although his theories were popular among American artists, especially in the 1920s, few could understand the mathematics involved. Most artists, including Dixon, adapted the theories of proportion and unity of design to their own needs and disregarded the mathematics.
3. *Images of the Native American,* p. 21.
4. Peter Matthiessen, "Native Earth: Man's Harmony with His Surroundings," *American West* 19 (May–June 1982): 46.
5. Edith Hamlin, "Maynard Dixon: Painter of the West," *American West* 19 (November–December 1982): 54.
6. Ibid.

Oil on canvas
36 × 48 inches
Inscription: signed lower right "Maynard Dixon 1933"
Gift of C. R. Smith
G1976.21.7P

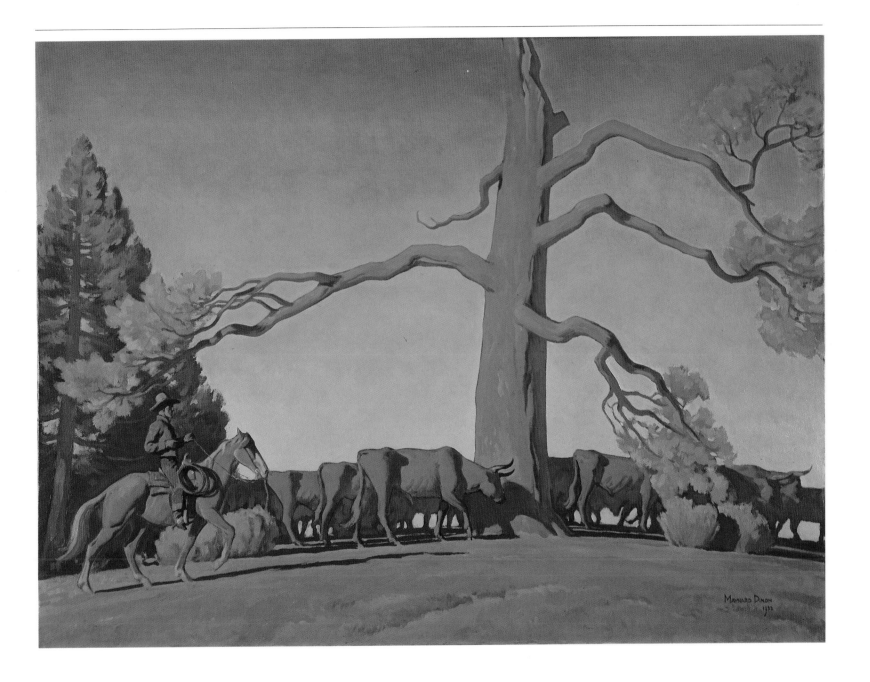

Maynard Dixon

b. 1875, Fresno, California; d. 1946, Tucson, Arizona

Although small in size, *Zion Park, Utah* is bold and powerful in design. The massive boulders, which dwarf the cottonwood trees at their base, fill the canvas such that only a glimpse of the sky overhead is visible. The commanding presence of the rock formations recalls Timothy O'Sullivan's photographs of Canyon de Chelly, a Navajo cliff dwelling in northwestern New Mexico.[1] In fact, Dixon had painted Canyon de Chelly early in his career, and he had visited the cliff dwellings of Oraibi, Walpi, Mishongnovi, Shipolovi, and Betatakin as well.[2] He was reminded of Canyon de Chelly when he first viewed Zion Park: Zion Park "was not so beautiful as Canyon de Chelly but grander — a new world to us — magnificent and awesome by moonlight."[3]

Accompanied by his second wife, Dorothea Lange, Dixon made his first visit to Zion Park during the summer of 1933. This summer's work resulted in over forty canvases, including *Zion Park, Utah.*

After Dixon's divorce from Lange and his subsequent marriage to Edith Hamlin, he left his long-time home of San Francisco for the drier and healthier climate of Tucson.[4] Yet, his love of Zion Park was so strong that he and his wife took refuge from the summer heat of Tucson by establishing a second home in Mt. Carmel outside Zion Park from 1939 until the artist's death in 1946. In 1940, they built a log-and-stone house on ten acres of land at Mt. Carmel, a site that Edith Hamlin has described as "a painter's paradise."[5] It is here that Dixon's ashes were buried beneath a bronze memorial on a ridge overlooking his home. K. B.

1. Accompanying the Lt. George M. Wheeler survey of the Colorado River, Timothy O'Sullivan photographed Canyon de Chelly in 1871–1872.

2. Edward Maddin Ainsworth, *Painters of the Desert,* p. 20.

3. Wesley M. Burnside, *Maynard Dixon: Artist of the West,* p. 107.

4. Dixon suffered from various respiratory ailments most of his life.

5. *Maynard Dixon: Images of the Native American,* p. 89. Son John Dixon described the cabin as lying "within a sheltered cove at the base of a range of juniper-studded hills. A small irrigation ditch followed the contours of the hills and gave rise to the usual stand of thirsty cottonwoods, silver maples, and Lombardy poplars. A gently curving gravelled driveway skirted the edge of a small meadow. Sagebrush surrounded all. The house contained a living room, kitchen, bath, bedroom, and sleeping loft. It had plenty of windows and up-to-date conveniences and was built of notched logs, the spaces between chinked with a coral clay plaster. There was a grape arbor built of poles at the rear of the house, and a garage nearby. There was a 'real' one-room log cabin. Beyond the cabin was the Blackfoot tepee which Dad had brought back from Montana in 1917" (ibid., p. 73).

Oil on canvas
21³⁄₁₆ × 17¼ inches
Inscription: signed lower left "MD Zion Park Utah
Aug 1933"
Gift of C. R. Smith
G1976.21.8P

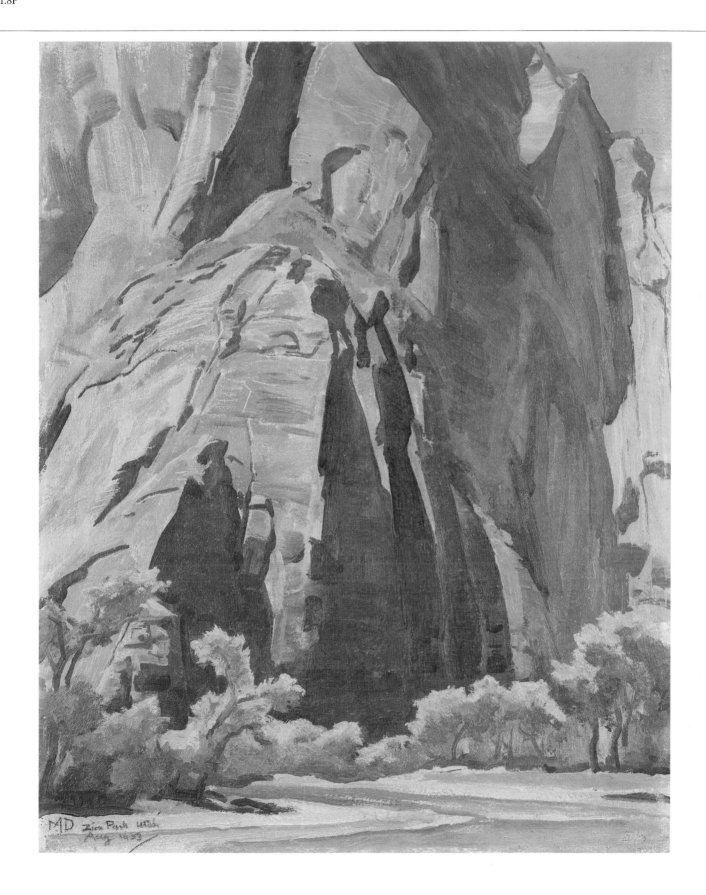

Maynard Dixon

b. 1875, Fresno, California; d. 1946, Tucson, Arizona

Of Maynard Dixon's paintings in the C. R. Smith Collection, *Desert Ranges* best illustrates the principle of "space division" that he learned from Emil Bisttram.[1] As described by Edith Hamlin, Dixon's "space division" was a means by which the artist brought into line the most dominant diagonals, horizontals, or verticals of his work.[2] In this painting, Dixon has aligned the diagonals of the descending slopes of the distant mountains with the angle formed by the pale dirt road in the foreground. The almost rectilinear clouds, too, seem to be extensions of the diagonal contours of the desert mountains. These abstract cloud and land arrangements seem nearly symmetrical, as if Dixon were painting an illustration corresponding to Willa Cather's description of the desert Southwest: "Every mesa was duplicated by a cloud mesa, like a reflection, which lay motionless above it or moved slowly up from behind it. These cloud formations always seemed to be there, however hot and blue the sky. Sometimes they were flat terraces, ledges of vapor; . . ."[3]

Desert Ranges is relieved of its geometric angularity by the rhythmically undulating dry creekbed in the foreground and by the gently curved horizontal band of brown at the base of the mountains. The browns of the mountains and vegetation in the painting are saved from monotony by the bright orange bushes and by the strong blue shadows in the foreground.

According to Edith Hamlin, who considers *Desert Ranges* one of Dixon's outstanding works of the period, the canvas was painted on location in the Salton Sea area near Indio, California.[4] For Dixon, such desert ranges were like the backbone of the earth exposed to humans. In his poem "My Country," written in 1922, he saw such rock formations as "the world's skeleton protruding in lonely places."[5] This love of the desert Southwest he shared with his friends Ansel Adams and J. Frank Dobie. K. B.

1. Bisttram, who came to Taos in 1930 and 1931, had studied Hambidge's theory under Howard Giles at the New York School of Fine and Applied Art. As he described it, Dynamic Symmetry "is a Law of Space division of immeasurable use in the solution of space problems. . . . I find it releases the imaginative powers, liberating the creative forces toward a final unquestionable order" (Bisttram, quoted in Sharyn Rohlfsen Udall, *Modernist Painting in New Mexico, 1913–1935*, p. 197). Bisttram, who maintained a lifelong interest in mysticism as a result of his association with Nicholas Roerich, may have reinforced Dixon's own mysticism and its applications to his art.
2. Edith Hamlin, "Maynard Dixon: Painter of the West," *American West* 19 (November–December 1982): 57.
3. From *Death Comes for the Archbishop*, as quoted in Una E. Johnson, *American Prints and Printmakers*, p. 29.
4. Edith Hamlin, in letter to K. B., August 6, 1984.
5. Dixon, as quoted in Kevin Starr, "Painterly Poet, Poetic Painter: The Dual Art of Maynard Dixon," *California Historical Quarterly* 56 (Winter 1977): 298.

Oil on canvas
25⅛ × 30⅛ inches
Inscription: signed lower right in pencil "Maynard
Dixon" over which is signed in brown paint "Maynard
Dixon © E.H.D. 1940"; on reverse, *Desert Ranges* /
copyright 1946 Edith H. Dixon. Reproduction Rights
Reserved / Maynard Dixon / Tucson Ariz."

Gift of C. R. Smith
G1975.6.1P

Desert Ranges
1940

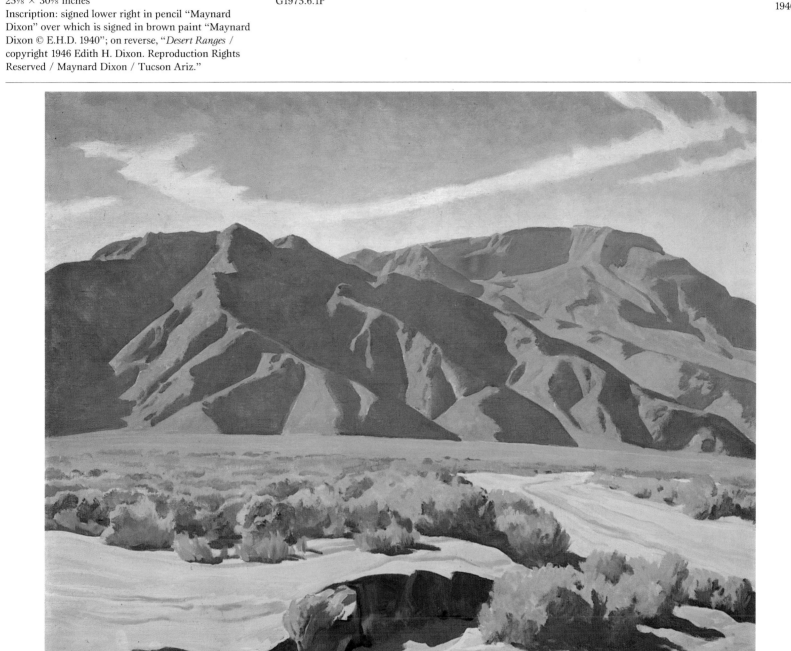

Maynard Dixon

b. 1875, Fresno, California; d. 1946, Tucson, Arizona

Randsburg, California, located seventy-five miles east of Bakersfield, on the western edge of the Mojave Desert, was a virtual ghost town in May 1940 when sixty-five-year-old Maynard Dixon recorded the scenery there. A boom town founded in the late 1890s, after gold was discovered in the area, Randsburg had once boasted a population of twenty-five hundred people and was known for such landmarks as the Yellow Aster Saloon and the Last Outpost, where local miners played poker. But prosperity was short-lived, and most of the town's inhabitants had vacated the area by the beginning of World War II.[1] Three of the remaining buildings, standing on the edge of town, appear in the foreground of Dixon's painting.

Its small size, loose brushwork, and penciled inscription suggest that *Randsburg* is an oil sketch painted on the site. This is confirmed by the artist's third wife, San Francisco artist Edith Hamlin, whom Dixon married in 1937.[2] Hamlin accompanied her husband on this expedition, one of several annual trips he made throughout southern California, Arizona, Utah, and New Mexico.

Dixon drew direct inspiration from the desert Southwest, but he avoided illusionistic replications of nature in his paintings. He believed that reality existed outside the limits of our perception and that the artist was obligated to paint this subconscious truth.[3] He rarely painted without rearranging elements to enliven the composition. This practice extended to his sketches, as Edith Hamlin recalled, "In his field sketches, coping with sun, time, and weather, he approached his subject creatively — discarding unessential detail, rearranging the composition instinctively, and memorizing the ephemeral elements he wished to keep. The fresh spontaneity of these smaller drawings and paintings is one of their great charms."[4]

Even among Dixon's field sketches, the juxtaposition of symbols of urbanization against the expanse of the desert landscape is unusual. The artist regretted the intrusion of "Tin Lizzies," gas stations, and other evidence of white "civilization" into the primitive Southwest. He believed that this region and its native Indian inhabitants were doomed to destruction by the influx of settlers who had little respect for the earth and the spirit of the people who lived in harmony with the land. These sentiments were not unlike those expressed by his friend Charles Russell and the earlier painters who sought to record the vanishing West. It is possible that Dixon was attracted to deserted Randsburg because in this area, at least, Nature seemed to be reclaiming the desert landscape. K. B.

1. Donald C. Miller, *Ghost Towns of California*, p. 138.
2. Edith Hamlin, letter to K. B., August 6, 1984; Hamlin also painted at this site.
3. Archives of American Art, microfilm 838, frame 270.
4. Edith Hamlin, "Maynard Dixon: Artist of the West," *California Historical Quarterly* 53 (Winter 1974): 374.

Oil on board
12 × 16 inches
Inscription: signed lower right "MD Randsburg Cal.
May 1940"
Lent by C. R. Smith

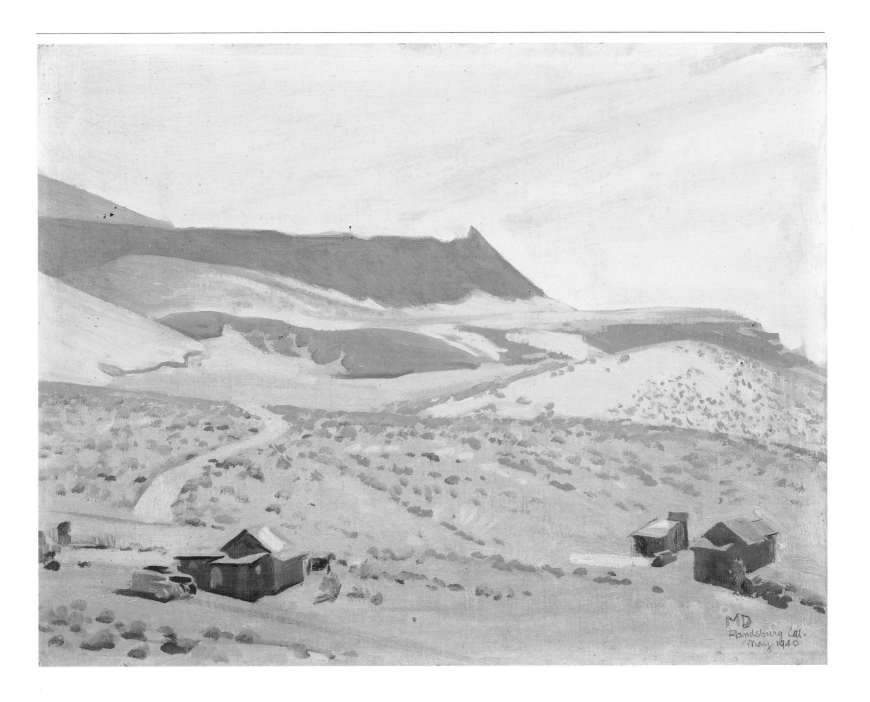

Nick Eggenhofer

b. 1897, Gauting, Germany

One of the events anticipated with relish by cowboys of the open range was the roundup. Twice a year, spring and fall, ranchers and hired hands met to sort out cattle, which were allowed to graze and breed in the open territory. Calves were branded and cattle were gathered for shipment to market. Stockmen worked together, hiring men and furnishing horses, wagons, and supplies, which would travel often thousands of miles.[1] For the cowboy this was a time of proving his skills, exhibiting his courage, living on the range, and renewing old acquaintances. All his personal gear, his ropes, straps, and clothes were softened and put into working order.

Enroute to the Roundup depicts the activity and excitement of the movement of the roundup camp. Moments before preparations had been secured, "saddle hosses were caught and saddled, and the rest of the hosses left to graze nearby. The rope corral was coiled and put into the wagon, beds rolled and piled into it, and ever' hand found somethin' to do or he wasn't a cowhand."[2] Now, wagons packed, the mule teams are hurrying to the new camp a half day's ride away.

Working wagons and early systems of transportation are of particular interest to the illustrator Nick Eggenhofer, who has written, "with my wagons, I struck an entirely different note in Western Art . . . I have a definite purpose: to record a segment of Western history which was neglected to a large extent by the old artists."[3] If the "old artists" were perhaps closer in time to the period depicted, Eggenhofer carefully researched the remains of western life in photographs, diaries, letters, paintings, and drawings and in the objects themselves.

Born in Gauting, a small Bavarian town, he observed as a youth many activities conducted with the aid of horse-drawn wagons. In the United States at the age of sixteen he was excited by the visits of traveling rodeos, especially the visit to New York of the noted wrangler Guy Weadick and his Stampede Cowboys. Eggenhofer recalled the continuing pageant of roping cowboys, bucking broncos, and chuckwagons rolling across the stage above his front row seat. This low vantage point is one almost always used in his work and is clearly visible in *Enroute to the Roundup,* where mules and wagons, horses and riders seemingly roll across the paper.

Working as an illustrator for early pulp magazines and later for books and novels concerning western life, Eggenhofer contributed to hundreds of magazine articles and nearly forty books.[4] His own *Wagons, Mules, and Men: How the Frontier Moved West* is a classic reference describing and illustrating transportation and equipment used in the nineteenth-century West.[5] In 1971, it was said that Eggenhofer had made thirty thousand western illustrations.[6]

A. O.

1. Ramon F. Adams, *Old-time Cowhand*, pp. 245–256.
2. Ibid., p. 251.
3. James K. Howard, *Ten Years with the Cowboy Artists of America*, p. 174.
4. Ibid.
5. Nick Eggenhofer, *Wagons, Mules, and Men: How the Frontier Moved West.*
6. Peggy and Harold Samuels, *The Illustrated Biographical Encyclopedia of Artists of the American West*, p. 154.

Gouache on paper
15⅜ × 25⅜ inches
Inscription: signed lower right "N. EGGENHOFER"
Gift of C. R. Smith
G1976.21.10P

Enroute to the Roundup
ca. 1957–1958

Henry Farny

b. 1847, Ribeauville, Alsace, France; d. 1916, Cincinnati, Ohio

Henry Farny achieved international recognition for his sensitive paintings of the American Indian. Farny studied in Dusseldorf and Munich during the late 1860s and early 1870s and developed a meticulous style in which figures and landscapes were carefully rendered. On his return to America, Farny focused on the American Indian while his contemporaries Frederic Remington and Charles Russell, who also catered to the intense interest in the American West, concentrated on the life of the cowboy. During the 1870s and the 1880s Farny worked as an illustrator for *Harper's Weekly, Century Magazine,* and *Harper's Young People* and applied his skills to the quick-drying medium of gouache, an opaque watercolor, which allowed him to capture subtle details of the western landscape and its native inhabitants.

On November 1881 the *Cincinnati Daily Gazette* reported that "Mr. Farny returned on Saturday from Dakota, where he has been making a series of studies for an Indian painting for which he is collecting material. He was the guest of Col. Gilbert of the 17th Cavalry at Fort Yates and enjoyed every facility for enlarging his acquaintance with the Sioux . . . He brings back with him a great quantity of Indian loot, and a chat with him gives one some entirely new ideas of the Sioux."[1]

While at Fort Yates, North Dakota, Farny was supposedly given a Sioux name as well as an emblem, a circle with a dot in the middle, by which the Sioux would know his paintings.[2] This symbol appears in the lower right corner of this work and from this time became part of the artist's customary signature.

Farny's observations at the Standing Rock Reservation led to his gouache entitled *Issue Day at Standing Rock.* It was executed in preparation for a *Harper's Weekly* engraving, published July 28, 1883 (pp. 472–473), with the title *Ration Day at Standing Rock Agency* and is one of only a few preparatory grisailles by him to survive. At least one illustration of this subject appeared earlier in *Harper's Weekly.*[3]

Farny pictures the large assembly of Indians who came every two weeks from throughout the reservation to receive rations of coffee, sugar, flour, and meat from the government agency.[4] As the U.S. Indian agent at Standing Rock later reported, "The Sioux are almost all ration Indians which condition is due chiefly to the bad lands of their reservations. There has been considerable change in the condition of the Indian since the disappearance of game. . . . The rations are their main dependence and form two-thirds of their support."[5]

The report describes the Indians of Standing Rock as having "been in the past the terror of the west and northwest but are now far from the warlike savage they were . . ."[6] In a quiet scene with little action, Farny interprets this change in the Indian culture, contrasting the elegant costume and proud stance of the brave with the poverty and despair of those waiting for rations. There is an attempt to capture a candid moment, yet the work becomes more than a document because of its quiet drama and studied composition.

F. C.

Henry Farny, *Ration Day at Standing Rock Agency,* engraving, *Harper's Weekly* 27 (July 28, 1883): 472–473. (Courtesy Amon Carter Museum, Fort Worth.)

1. "Mr. Farny among the Sioux," *Cincinnati Daily Gazette,* November 8, 1881, p. 8.
2. See J. F. Earhart, "Henry Farny," *Cincinnati Commercial Tribune,* magazine section, January 21, 1917, microfilm 973, frame 282; Denny Carter, *Henry Farny,* p. 24.
3. Paul Frenzeny's illustration *Muster-Day on an Indian Reservation, Harper's Weekly* 24 (July 24, 1880): 476.
4. See John C. Ewers, "Food Rationing — from Buffalo to Beef," in *Indian Life on the Upper Missouri,* pp. 168–174.
5. Department of the Interior Census Office, *Report on Indians Taxed and Indians Not Taxed in the United States (Except Alaska) at the Eleventh Census: 1890,* pp. 509, 520.
6. Ibid., p. 510.

Gouache and watercolor
16³⁄₁₆ × 24⁷⁄₈ inches
Inscription: signed lower right "Farny"
Gift of C. R. Smith
G1972.8(1)P

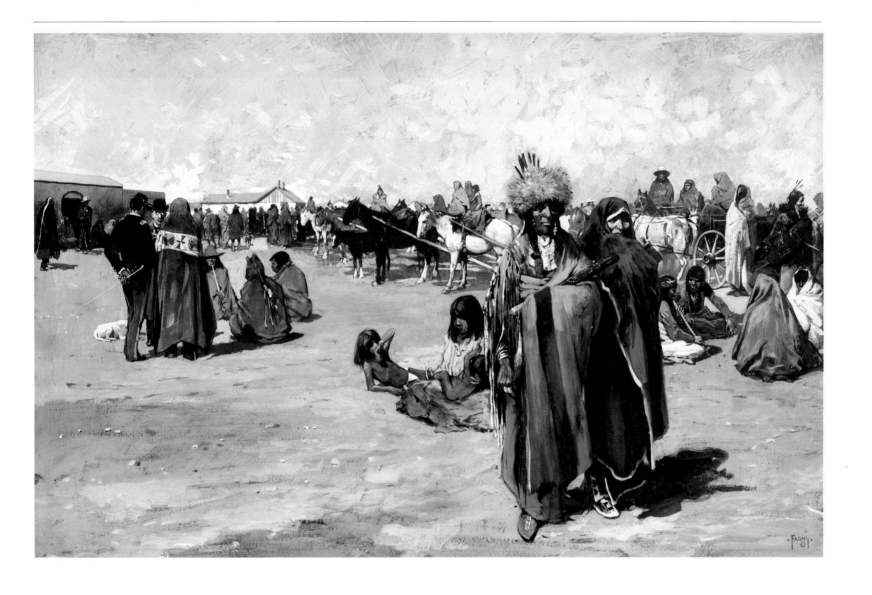

Henry Farny

b. 1847, Ribeauville, Alsace, France; d. 1916, Cincinnati, Ohio

This portrait of a frontiersman as he stands with his hands on his hips is unusual, for, unlike Frederic Remington, Farny largely ignored the cowboy to concentrate on the Indian as subject matter in his paintings and illustrations. Although Farny painted many watercolor portraits of both identifiable and unknown Indians, only two other small portraits of cowboys exist, an undated bust titled *Cowboy* and a portrait of ca. 1882 entitled *Mouiseau. An "Old-Timer"* may have inspired the rendition of a cowboy in an undated book illustration[1]. Farny's hand is so sure in the delicate application of watercolor in precise detail that he used no pencil to delineate forms. F. C.

Henry Farny, *Cowboy with the Letter "H,"* engraving. (Courtesy collection of Mr. James E. Walter, Toledo.)

1. For the illustration see Archives of American Art, microfilm 973, frame 75.

Gouache and watercolor
13¹⁄₁₆ × 7¹⁄₁₆ inches
Inscription: signed, dated, and titled, middle right "An
'Old-Timer' Farny 1886"
Gift of C. R. Smith
G1972.8(11)P

Henry Farny

b. 1847, Ribeauville, Alsace, France; d. 1916, Cincinnati, Ohio

Peace Be with You first appeared in *Harper's Young People* in 1886 as an engraved illustration for the twenty-eighth chapter of an action-packed adventure serial called "Two Arrows: A Story of Red and White," by William O. Stoddard. A tall, lean Indian with his hand raised in peace approaches the viewer while a band of his armed comrades watch from their natural rock fortress. With the caption "His right hand with the palm up to show that he was peaceful," the picture closely chronicles a tense episode of the story just before a betrayal.

Peace Be with You is similar to Farny's award-winning painting *Danger,* painted in 1888. Both use a sloping hillside to create a high horizon line and emphasize the verticality of the composition. The subject also looks directly at the viewer in a way that actively solicits a response. From this time the full-length portrait of a lone Indian in the landscape became a recurring theme for Farny.

F. C.

Henry Farny, *His Right Hand with the Palm Up to Show That He Was Peaceful,* engraving, *Harper's Young People* 7 (January 5, 1886): 152. (Photo by George Holmes.)

Gouache and watercolor
20¹⁵⁄₁₆ × 13¹¹⁄₁₆ inches
Inscription: signed and dated lower right "Farny / 89"
Gift of C. R. Smith
G1972.8(13)P

Peace Be with You

1889

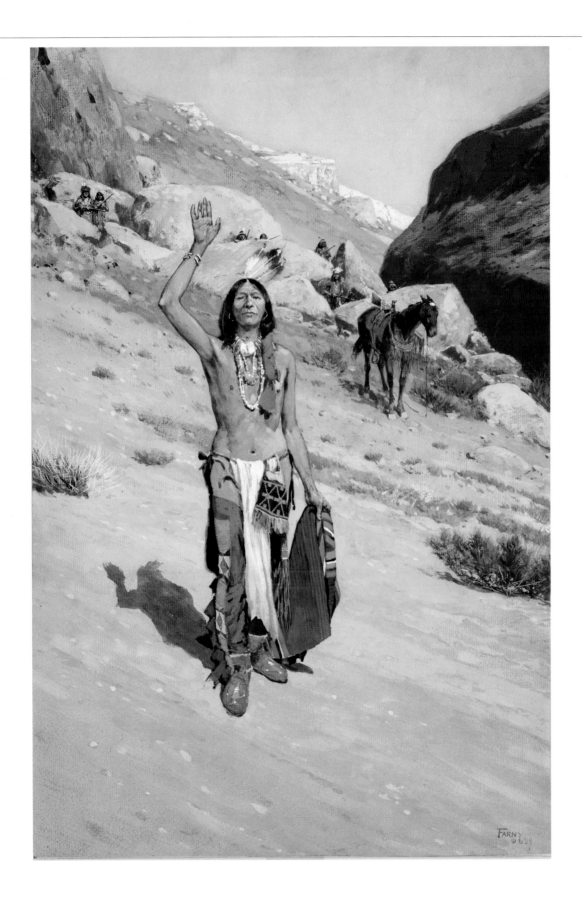

Henry Farny

b. 1847, Ribeauville, Alsace, France; d. 1916, Cincinnati, Ohio

By 1891 when *Breaking Camp* was painted, Farny had received international recognition for his work and major awards in New York and Paris. From this time Farny concentrated more on his paintings and less on illustrations. His paintings, in turn, became less narrative. Of the many scenes of Indian camps Farny painted during his career, *Breaking Camp* is one of the earliest. The subject is handled without overt sentiment or symbol.

In *Breaking Camp* the combination of adroit technique, skillful organization of composition, and sensitive attention to color and light establishes the benchmarks of his style of the 1890s. For such works as this, contemporary critics gave Farny glowing praise: "Whether in oil or aquarelle, detail is painted with the fidelity to detail of a Meissonier and the broad sweep of a Gérôme."[1] This recognition is based on a European standard, which Farny emulated, American patrons demanded, and critics applauded. F. C.

1. Edward Flynn, "The Paintings of H. F. Farny," *Cincinnati Commercial Gazette,* March 14, 1893, Archives of American Art, microfilm 973, frame 247.

Gouache and watercolor
9⅞⁄₁₆ × 16¾ inches
Inscription: signed lower right "H. F. Farny" 1891
Gift of C. R. Smith
G1972.8(8)P

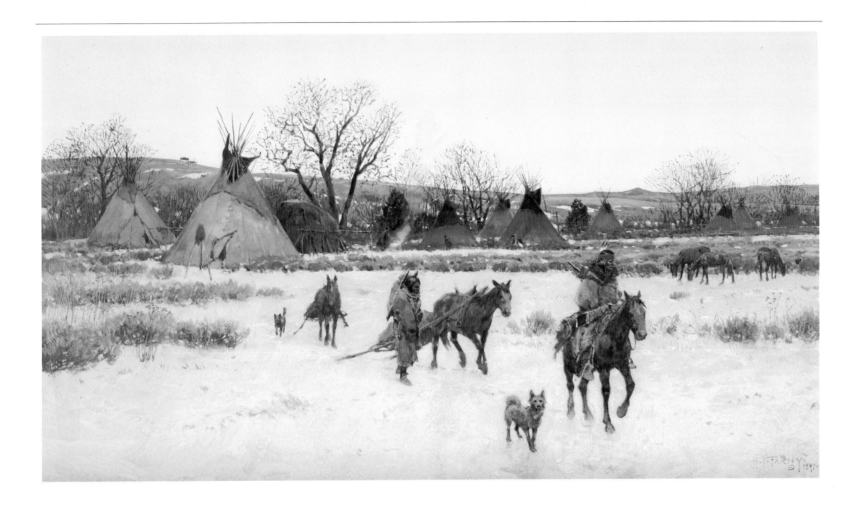

Henry Farny

b. 1847, Ribeauville, Alsace, France; d. 1916, Cincinnati, Ohio

Council of the Chiefs is among Farny's most comprehensive studies of an Indian encampment. Clustered groups of tipis, grazing horses, and distant rugged mountains are woven into an imaginative, balanced composition. Mountains, rivers, rocks, and trees are arranged to reinforce the tranquility of the scene.

Farny's works reflect a romantic, fictional view of the Indians at a time before subjugation by white "civilization." Here some Indian garb, such as that of the mounted Indian who wears a manufactured white shirt, reflects the intrusion of white culture. Yet the dominant image shows the Indians continuing an earlier life style. Women prepare deer hides for tipis and dry meats for the coming winter. Paradoxically, almost all of Farny's tipis bear no painted battle scenes, which suggests that in 1896 his resources were limited to photographs of Indian reservations, where cloth was given by the government to construct homes.[1]

Farny's paintings exclude the obvious evidences of reservation life, such as covered wagons, log houses, and corrals of ration cattle for the Indians, recorded in photographs for the 1890 Census *Report on Indians Taxed and Indians Not Taxed*. An 1894 interview with the artist reveals the ironic side of reservation life that he avoided altogether in his artwork: "It is indescribably funny to listen to Farny's description of the incongruities encountered in Indian Territory. Many of the Kiowas and Comanches are quite wealthy from money received for their lands, and they purchase the products of the white man's skill, and then have very little idea of the use for which they were intended. One squaw came along pushing an ornate baby buggy filled with firewood, while on her back was strapped a healthy, screaming papoose."[2] Farny's romantic sensibility and his sensitivity to the Indian's plight may have influenced his omission of these details. S. A.

1. Department of the Interior Census Office, *Report on Indians Taxed and Indians Not Taxed in the United States (Except Alaska) at the Eleventh Census: 1890,* p. 367.
2. Typed transcript from "Farny in the West," *Cincinnati Commercial Tribune,* 1894, Archives of American Art, microfilm 1233, frame 534.

Gouache and watercolor
17⅛ × 28⅛ inches
Inscription: signed and dated lower right "H. F.
Farny / 96"
Gift of C. R. Smith
G1972.8(14)P

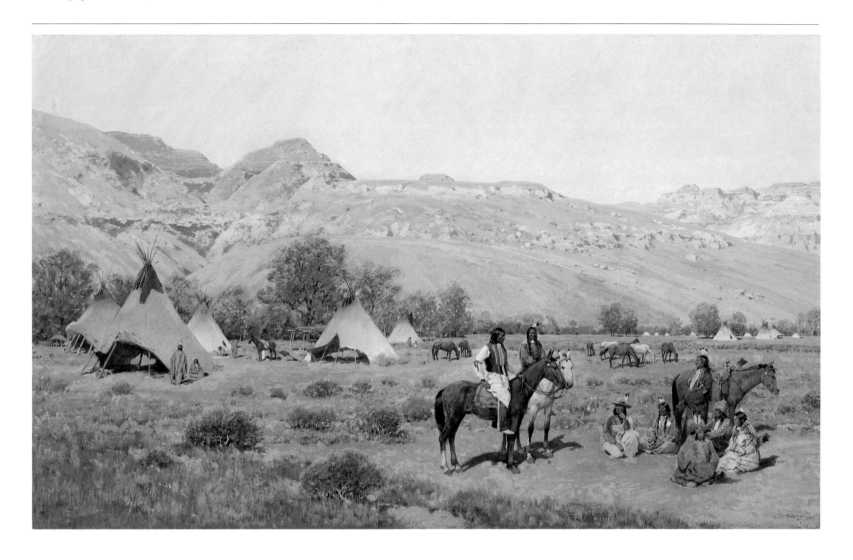

Henry Farny

b. 1847, Ribeauville, Alsace, France; d. 1916, Cincinnati, Ohio

The figure in *Sioux Indian* is from a time, perhaps twenty years earlier, when the Indians still subsisted primarily on hunted game and battled with the cavalry on the plains. The public wanted to believe that Indian life was still the way Farny depicts it; as one critic wrote, "the evidence of absolute fidelity and truth and unpretentious study of genuine Indians and real frontier life with which Farny's canvases fairly reek, give them a value that is not meretricious and altogether frank."[1] Here Farny displays the Indian artifacts that gave his depictions such wide appeal. In the distant campsite, the tribe members are protected by the warrior's shield, which, when not being used in battle, was displayed amid the tipis to ward off evil spirits. The warrior is armed with a rifle protected by a decoratively fringed case and wears the regalia that by 1898 was largely ceremonial.

Farny usually chose to paint the fierce warring tribes of the Northern Plains, such as the Sioux, Apaches, and Crows, rather than the agrarian tribes of the Southwest. In the individual portraits Farny showed the Indian hunting, waiting in ambush, or posed with his horse. The elegance of Farny's Indians, clothed in brilliant, colorfully patterned dress, contrasts sharply with contemporary photographs, such as *Lame Dog and His Horse.* Whereas Farny's brush describes an Indian on parade, the camera records the less glorious remnants of a now fettered tribe. S. A.

John A. Anderson, *Lame Dog and His Horse,* ca. 1893; from *Sioux of the Rosebud: A History in Pictures,* by Henry W. Hamilton and Jean Tyree Hamilton. (Copyright © 1971 by the University of Oklahoma Press.)

1. Edward Flynn, "The Paintings of H. F. Farny," *Cincinnati Commercial Gazette,* March 14, 1893, Archives of American Art, microfilm 973, frame 246.

Gouache and watercolor
10³⁄₁₆ × 7³⁄₁₆ inches
Inscription: signed and dated lower right "Farny / 98"
Gift of C. R. Smith
G1972.8(10)P

Sioux Indian
1898

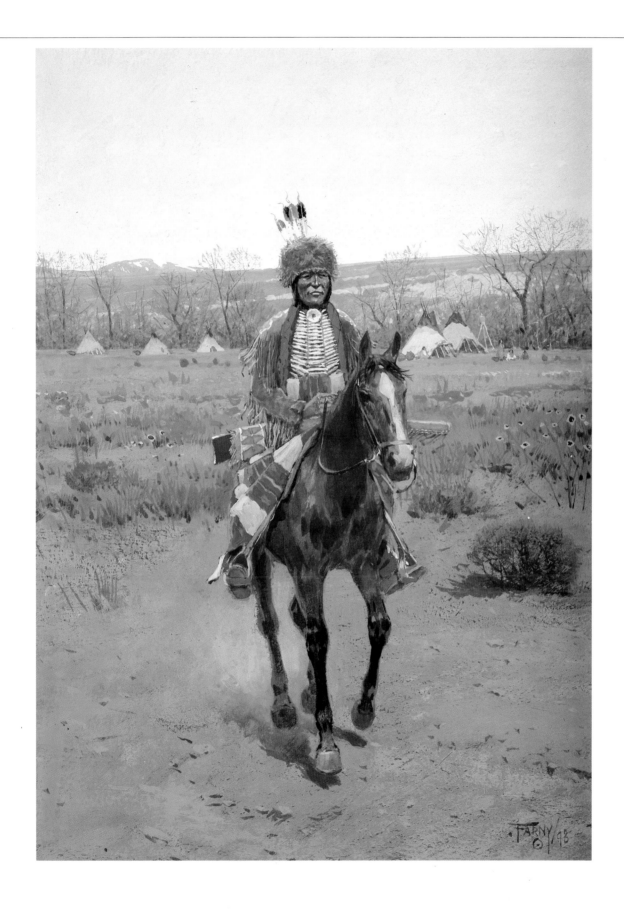

Henry Farny

b. 1847, Ribeauville, Alsace, France; d. 1916, Cincinnati, Ohio

Sitting Bull was perhaps the best-known Indian in North America at his death in 1890. Americans perceived him as the catalyst behind the Sioux and Cheyenne nations' defeat of Custer at Little Bighorn in 1876, and, as Farny reported, "Sitting Bull [is] known among all the Indians in the West . . . [and] rightly or wrongly he [was] looked upon by all the tribes as the great representative of their race."[1] In fact, at Little Bighorn, Sitting Bull "was accepted as leader of all his bands," which was an unprecedented event in North American Indian history, where authority was exercised by a council of chiefs.[2]

The whites who came into contact with Sitting Bull never really understood his mystique. A Major McLaughlin, agent of Standing Rock, said of him in 1883: "Sitting Bull is an Indian of very mediocre ability, rather dull, and much the inferior of Gall and others of his lieutenants in intelligence. I cannot understand how he held such sway over, or controlled men so eminently his superiors in every respect, unless it was by his sheer obstinacy and stubborn tenacity. He is pompous, vain and boastful, and considers himself a very important personage."[3] Sitting Bull was proud of his resistance to white subjugation, which he perpetuated even after becoming a reservation Indian, by exhibiting indifference to white authorities, such as General U. S. Grant, whom he met in Farny's company in Bismarck during the same year.[4]

Farny's posthumous portrait of Sitting Bull probably derives from a photograph, the primary medium for Indian portraiture at the time. Shown as the powerful medicine man, he wears the same bull horns and feathered headdress he had worn as part of the Buffalo Bill Wild West show during the 1880s.[5] Clutching his hatchet and peering through a masklike face at the viewer, Sitting Bull seems to confirm one description of him as "a wild and restless warrior . . . from his youth."[6]

Farny began to sketch and paint bust portraits of Indians in 1882 and continued them throughout his career. In 1894 a Cincinnati newspaper reported Farny's continuing interest in Indian portraits, claiming that "his studio now resembles a rogue's gallery composed of the prize murder[er]s of the world."[7] Since it was painted almost a decade after Sitting Bull's death, this portrait may have been a commissioned work. It may be from a series of Indian portraits exhibited in December 1900 at the Cosmos Club in Washington, D.C., which are reported to have been "so popular that the government purchased eleven of them for the National Museum."[8] S. A.

1. Typed transcript of "A Needless Cruelty," *Cincinnati Commercial Gazette,* December 18, 1890, Archives of American Art, microfilm 1233, frame 460.

2. Nelson A. Miles, *Personal Recollections and Observations,* p. 199.

3. Doane Robinson, *A History of the Dakota or Sioux Indians,* p. 452.

4. Typed transcript of "A Needless Cruelty."

5. Robert M. Utley and Wilcomb E. Washburn, *The Indian Wars,* p. 333; photograph of "Sitting Bull and Buffalo Bill before a show in 1885."

6. Miles, *Personal Recollections and Observations,* p. 194.

7. Typed transcript of "Farny in the West," *Cincinnati Commercial Tribune,* 1894, Archives of American Art, microfilm 1233, frame 535.

8. Indian Hill Historical Museum Association, *Henry F. Farny;* this group of portraits is presently unlocated.

Oil on panel
11⁷⁄₁₆ × 8½ inches
Inscription: signed and dated lower right "H. F. Farny
1899"
Gift of C. R. Smith
G1972.8(2)P

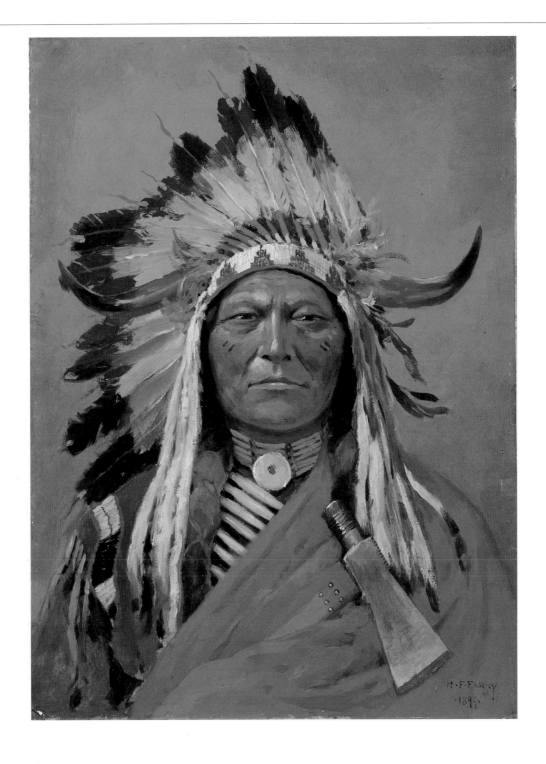

Henry Farny

b. 1847, Ribeauville, Alsace, France; d. 1916, Cincinnati, Ohio

During the 1890s Farny lightened his palette. *Early Start,* one of Farny's many snow scenes of this period, gave him the opportunity to eliminate a great variation of colors to concentrate on creating a unified mood. In this painting, Farny exhibits an understanding of color and a delicate control of the medium that was appreciated by his critics, one of whom noted: ". . . no harsh color-notes mar the harmony of his themes; there is lacking any indication of strained effort for purely color effects."[1] Another added that "he was a master of subdued coloring."[2]

This painting blends elements of Farny's early training. Its intimacy recalls his earliest genre paintings, such as *Landscape with Children* (1880), which reflect the influence of Dusseldorf painter Carl Lessing; he frames the scene in a stagelike foreground set against a background imbued with crystalline northern European light. The wiry trees that obscure the horizon recall the mystical landscapes of the German Nazarenes. S. A.

1. Edward Flynn, "The Paintings of H. F. Farny," *Cincinnati Commercial Gazette,* March 14, 1893, Archives of American Art, microfilm 973, frame 247.
2. J. F. Earhart, "Henry Farny," *Cincinnati Commercial Tribune,* January 21, 1917, magazine section, Archives of American Art, microfilm 973, frame 282.

Gouache and watercolor
8¼ × 12¼ inches
Inscription: signed and dated lower right "Farny 1900"
Gift of C. R. Smith
G1972.8(12)P

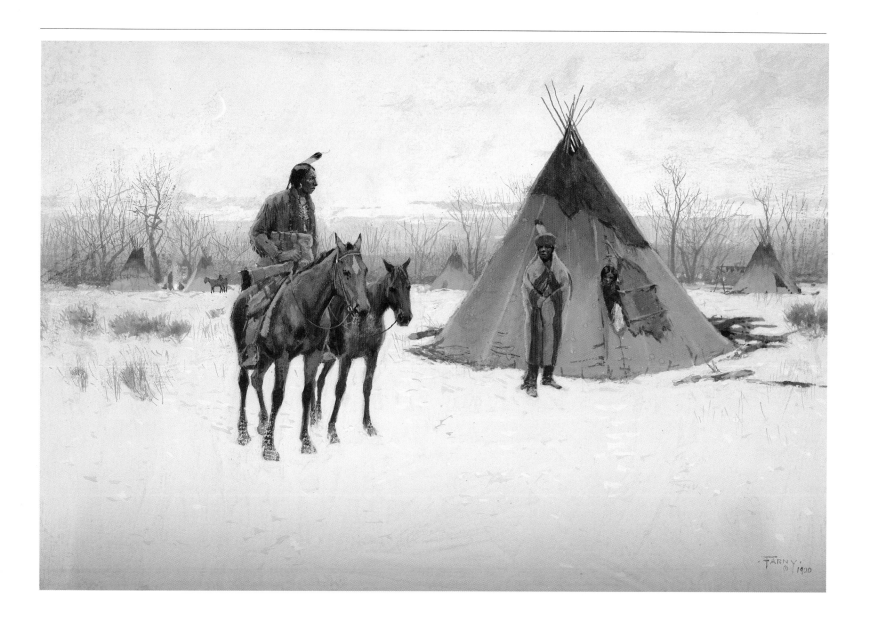

Henry Farny

b. 1847, Ribeauville, Alsace, France; d. 1916, Cincinnati, Ohio

"How wonderfully effective were his mountain pictures in which he would show a mountain peak, high up on the canvas, bathed in golden sunlight against a turquoise-tinted sky — and all of this seen across a dark canyon filled with the luminous sea of violet blue haze. And how well he represented the great depths and shadows of the chasm"[1] — so wrote a Cincinnati reporter in 1917 of Farny's mountain scenes.

After his 1884 trip down the Missouri River, Farny began to use mountainous settings for his portrayals of Indian life. Whereas his earlier illustrations for *Century Magazine* depict the mountain faces as seen by explorers from the river, his several later paintings of Indians in mountainous terrain often depict the high elevations. John K. Hillers provided photographic mountain views for *Century Magazine* engravers during the same years that Farny worked for the magazine. It seems likely that Farny was aware of these as he was of other Hillers photographs, since his compositions resemble those in Hillers' photographs of the Grand Canyon. S. A.

1. J. F. Earhart, "Henry Farny," *Cincinnati Commercial Tribune*, January 21, 1917, magazine section, Archives of American Art, microfilm 973, frame 282.

Gouache and watercolor
11³/₁₆ × 8⅛ inches
Inscription: signed and dated lower right "Farny 1900"
Gift of C. R. Smith
G1972.8(7)P

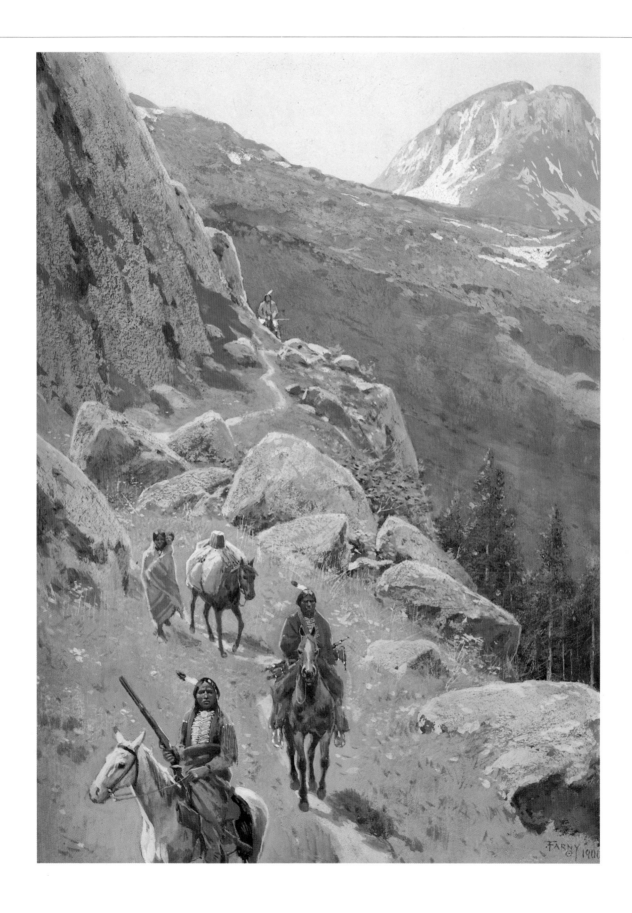

Henry Farny

b. 1847, Ribeauville, Alsace, France; d. 1916, Cincinnati, Ohio

In the late 1890s Farny developed the motif of figures smoking pipes as a means of creating evocative lighting effects. Here one can almost feel the warmth on the man's face from the small glowing flame cupped between his hands.

Farny rarely drew preliminary sketches in his later career; he preferred to work directly on canvas with the paint. *Smoke Makes Rest,* however, sketched in pencil and charcoal and tinted with gouache, is an exception. It appears to have been done in preparation for the painting *Traveling by Full Moon, Winter* painted in 1904. The figure in the sketch is the leading figure in the larger composition of Indians traveling at night by dogsled who have stopped to rest on a frozen lake.

Farny's selection of a gray-blue paper for *Smoke Makes Rest* enhances the wintery quality of the depiction. Although the majority of Farny's surviving works are painted or sketched on white paper, in many of the other works the color of the paper is not discernible. "The same equally agreeable effects are produced in the various mediums of the palette, oil, watercolor, guache [*sic*], and pen-and-ink. He uses white paper, brown paper, and blue paper with equal and unvarying skill . . . Always and ever, however, he is Farnyesque in all that that coined descriptive implies."[1] L. W.

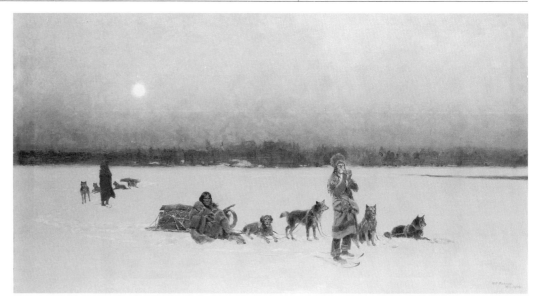

Henry Farny, *Traveling by Full Moon, Winter,* 1904, oil on canvas. (Private collection; photo courtesy Sotheby Parke Bernet, Inc., New York.)

1. Edward Flynn, "The Paintings of H. F. Farny," *Cincinnati Commercial Gazette,* March 14, 1893, Archives of American Art, microfilm 973, frame 246.

Charcoal, pencil, and gouache
13⅞ × 9⁹⁄₁₆ inches
Inscription: signed and dated lower right "Farny 1904"
Gift of C. R. Smith
G1972.8(5)P

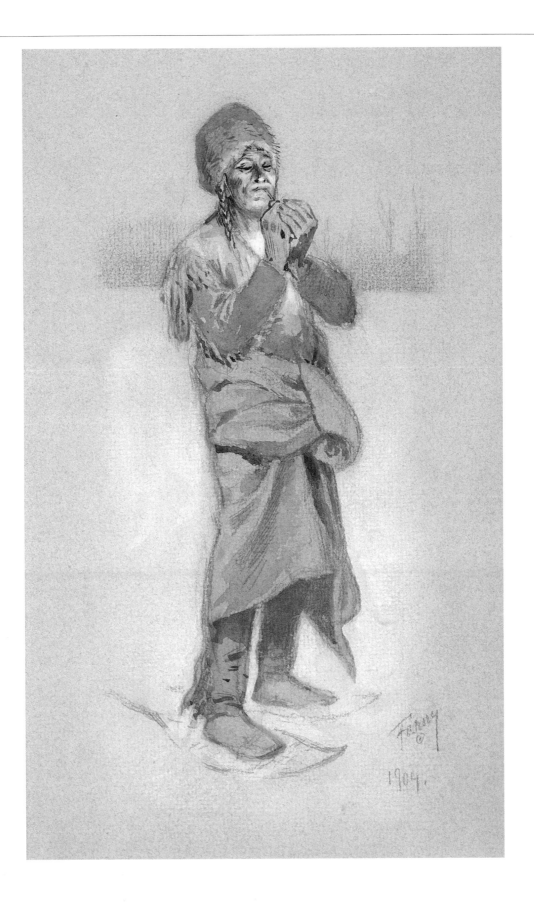

Henry Farny

b. 1847, Ribeauville, Alsace, France; d. 1916, Cincinnati, Ohio

Le Signe de Paix (The Sign of Peace) is one of the few paintings by Farny inscribed as a gift.[1] The recipient, L. de Gisbert, was a friend of the artist. He and his wife, who both came from Farny's French homeland of Alsace, were also friends of Farny's future bride, Anne Ray. "Whenever she went to the riding school on Mount Auburn as guests [*sic*] of M. and Madame de Gisbert, the instructors, Miss Ray attracted great attention."[2] In 1919 the de Gisberts proudly stated that their private collection of approximately thirty Farny works included "the first painting and the last painting Farny made," making theirs one of the largest collections of Farny's work formed in the artist's lifetime.[3]

"There [were] a number of interesting charcoal drawings in the collection. Many of these are studies of horses Farny found at the riding club."[4] Yet, "the Indian horses that Farny paints [were] the small, muscular, shaggy, uncouth mustangs of the Far West."[5] The Indian horse and rider prominently in motion in *Le Signe de Paix* may complement these sketches and reflect the de Gisberts' interest in equestrian activities.

Increasingly, after 1900 Farny painted in oil, employing it for the full range of his work from studies of single figures, as here, to complex multi-figure compositions. Farny's relatively loose technique here recalls his Munich training. L. W.

1. In an inventory of Farny's work printed in "Farny Biography," *Cincinnati Daily Times-Star,* January 27, 1925, a work entitled *The Sign of Peace* with a description suggesting that it closely resembled this painting was listed as in the possession of Mr. and Mrs. A. Howard Hinkle, prominent patrons of the arts in Cincinnati (see Archives of American Art, microfilm 973, frame 293).

2. "When He Takes His Ward for Wife," unidentified newspaper clipping, 1906[?], Archives of American Art, microfilm 973, frame 306.

3. "Stroll through a Collection of Works from Brush of Farny," unidentified Cincinnati newspaper clipping, October 6, 1919[?], Archives of American Art, microfilm 973, frame 284.

4. Ibid.

5. Edward Flynn, "The Paintings of H. F. Farny," *Cincinnati Commercial Gazette,* March 14, 1893, Archives of American Art, microfilm 973, frame 247.

Oil on panel
14¹³⁄₁₆ × 10⅝ inches
Inscription: signed and dated with inscription lower
right "L. De Gisbert de son ami H. F. Farny 1905"
Gift of C. R. Smith
G1972.8(3)P

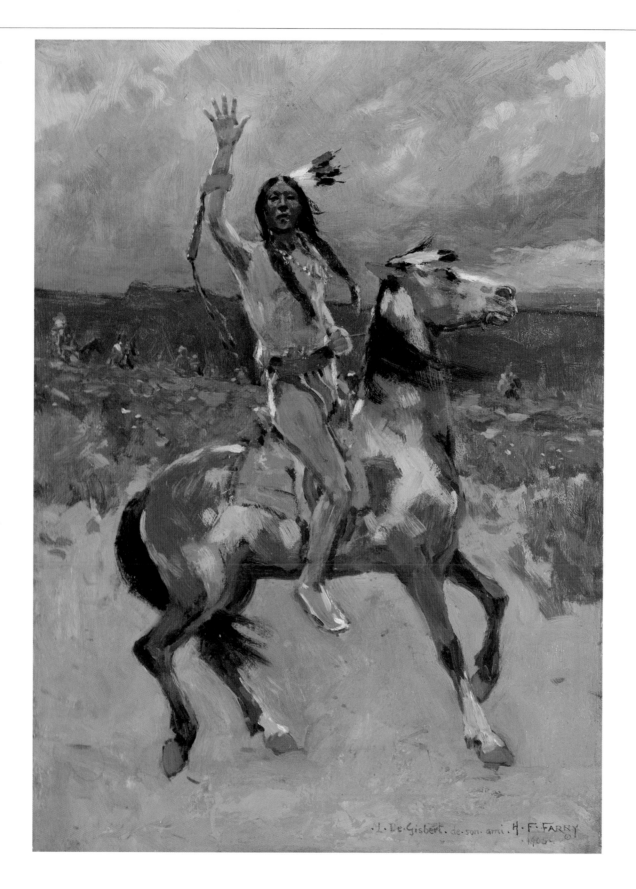

Henry Farny

b. 1847, Ribeauville, Alsace, France; d. 1916, Cincinnati, Ohio

The lone Indian, either on foot or on horseback, was one of Farny's favorite subjects. About 1900 the artist began to set this figure in a snow-covered forest, as in *On the Alert*. To highlight the background the figure is silhouetted against a sunset of brilliant violet and yellow, colors that appear with increasing frequency in Farny's paintings after 1900. To create a strong contrast Farny strengthens the dark pigments of the horse and rider by coating them with what appears to be a thin, resinous glaze not used elsewhere in the composition. L. W.

Gouache and watercolor
7¼ × 5¼ inches
Inscription: signed and dated lower right "Farny 1907"
Gift of C. R. Smith
G1972.8(9)P

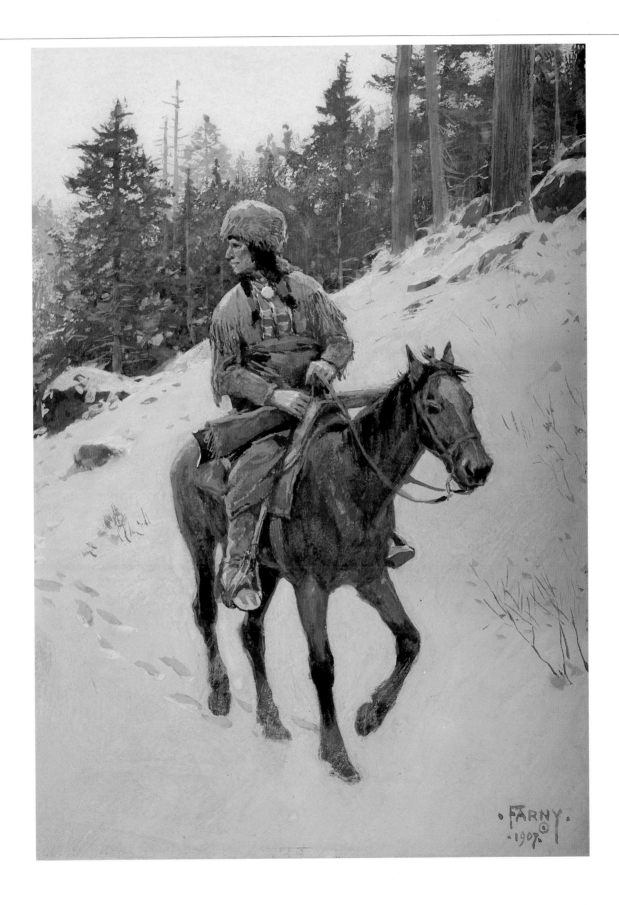

Henry Farny

b. 1847, Ribeauville, Alsace, France; d. 1916, Cincinnati, Ohio

For much of his career Farny favored covering the entire sheet of paper with thick pigment, but here, in a rare exception, he uses thin, translucent washes in the foreground and sky to permit the brightness of the paper to show through. One critic commented that "his watercolors are exquisite in feeling; clear, brilliant, and harmonious in tone."[1] Originally, these washes were probably more intense than now, as they appear to have faded.

The Crossing, like many of Farny's paintings after 1900, recalls his earlier works. Apparently Farny was pressed to meet the demand for his Indian subjects. Yet, in spite of the great number of requests, it is reported that Farny never sold a painting unless he felt the buyer understood and appreciated it. As a result, several potential patrons were unrewarded in their quest to acquire one of his works.[2] L. W.

1. Edward Flynn, "The Paintings of H. F. Farny," *Cincinnati Commercial Gazette,* March 14, 1893, Archives of American Art, microfilm 973, frame 246.
2. *World,* August 16, 1906, Archives of American Art, microfilm 973, frame 261.

Gouache and watercolor
9¹³⁄₁₆ × 17¾ inches
Inscription: signed and dated lower right "Farny 1908"
Gift of C. R. Smith, 1970
G1972.8(6)P

The Crossing
1908

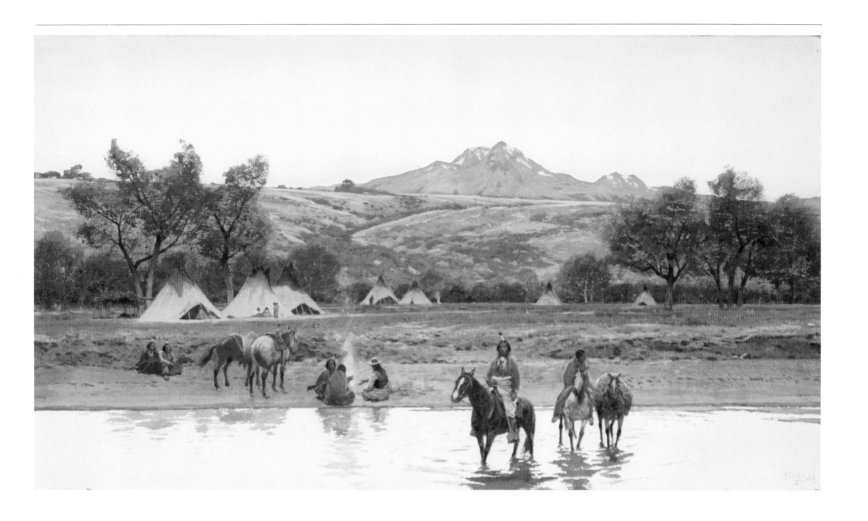

Henry Farny

b. 1847, Ribeauville, Alsace, France; d. 1916, Cincinnati, Ohio

Homeward is part of a group of Indian canoe pictures painted by Farny after 1900. Here a lone Indian paddles toward his camp after a successful hunt. A deer lies limp in the bow of the canoe, as the last rays of sunlight and the glow of a campfire flicker across the water.

By 1911, the year Farny painted *Homeward,* he was seeking new challenges and for several years had been exploring historical themes that depicted early American life. In 1908 he painted his first historical painting, *La Salle* (private collection, Atlanta). By this time Farny began losing interest in Indian subjects, but his audiences and patrons had an insatiable appetite for them. As a result, Farny continued to produce readily salable Indian paintings like *Homeward* while working on what he considered more important historical scenes. The composition of *Homeward* recalls another historical subject, *As It Was in the Beginning.* Although smaller, *Homeward* is also painted in oil. Farny has reversed the direction of the canoe without drastically changing the composition. Here is an example of how Farny, even as he explored historical subjects late in his career, continued to meet the high demand for Indian paintings of a nonhistorical nature by creatively modifying compositions. L. W.

Oil on mahogany panel
14 × 6¹¹⁄₁₆ inches
Inscription: signed and dated lower right "Farny 1911"
Gift of C. R. Smith
G1972.8(4)P

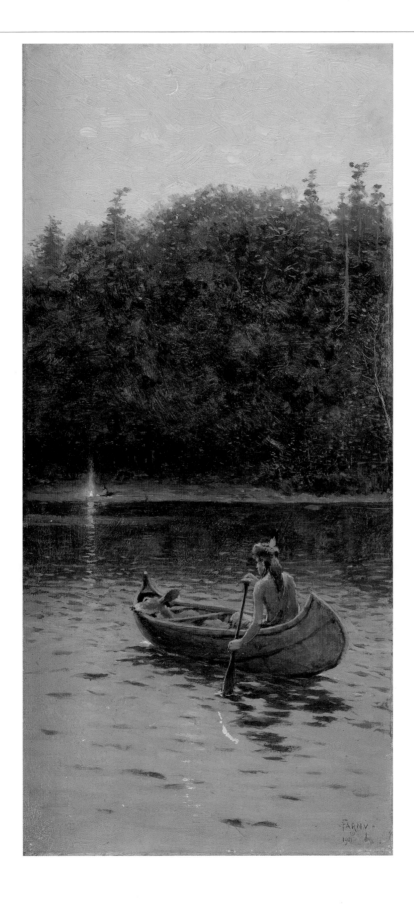

William Gilbert Gaul

b. 1855, Jersey City, New Jersey; d. 1919, New York, New York

In August 1890, Gilbert Gaul, acting as a special agent to Standing Rock Agency, Fort Yates, North Dakota, reported on the condition of the Sioux, or "Dakota" Indians, as they called themselves. Gaul's report was incorporated into the Department of the Interior's Eleventh Census. The final comprehensive volume included articles, illustrations, and photographs by several special agents assigned to Indian agencies across the continental United States. Besides Gaul — who also assessed the situation of the adjoining Cheyenne River Agency in South Dakota — Walter Shirlaw, Julian Scott, Peter Moran, and Henry R. Poore were participants in the census research. Like his counterparts, Gaul noted the climate and agriculture as well as the customs, religion, and social structure of the indigenous Sioux tribes.

Gaul was probably asked to participate in the 1890 census for two reasons: his familiarity with the Dakota region from an 1876 trip there and his distinguished career as a painter and illustrator of military scenes. In 1879 Gaul was elected an associate of the National Academy of Design; in 1882 at the age of twenty-seven he became full academician. Beginning in the 1880s, in addition to painting, Gaul began to produce illustrations of hunting and battle scenes for popular periodicals like *Harper's Weekly* and *Century Magazine.* This exposure gave him even wider recognition.

Dakota Indians, depicting a group of female figures outside a tipi, is a finished work prepared after another sketch, *Sioux Camp* (Thomas Gilcrease Institute of American History and Art, Tulsa). This sketch was the model for Gaul's census report illustration of the same title. The women appear in each just as Gaul described them, wearing "loose robes to the ankles, with flowing sleeves."[1] The tipi Gaul painted was of muslin or canvas. By 1890 the Indians' colorful buffalo skin tents "painted or decorated with whole histories of the families occupying them, or their adventures"[2] were gone. In fact, Gaul noticed that virtually all the Indians in the region lived in log huts. However, they were reluctant to give up their tipis and erected them beside their houses. Gaul added that the tipis were "very useful on their journeys to and from the agency for rations," reminding us that, because of the poor agricultural climate of the region and the confinement of the Sioux to reservations, they were dependent on government rations for subsistence.[3] Most likely, *Dakota Indians* depicts a family at the agency.[4]

A contemporary reviewer remarked in 1898 that all of Gaul's sketches were made "from life out on the frontier," adding however that "he does not paint his pictures out in the open: he uses a camera and a color-box, and makes his notes from life, but paints his picture in his studio."[5] A rough sketch, *Indian Family* (private collection) suggests that Gaul worked out the image for the census illustration *Sioux Camp* from this small first-hand study of two quickly brushed-in figures in front of a canvas tipi. *Dakota Indians* was then composed from the census illustration, adding four horses to the far right of the central tipi and an unhitched wagon to the left. The informal arrangement of the figures yet their apparent awareness of the viewer also suggest the presence of a sketcher or photographer. While no photographs relating to Dakota Indians are known, a photograph by Gaul of a Sioux couple included in the 1890 census report suggests that Gaul used photographs frequently as a studio reference.[6]

Gaul painted Sioux, or Dakota, subjects quite frequently after his 1890 journey west for the government.[7] But in contrast to his later, more romanticized subject portrayals, these early works convey a relatively objective presentation of the condition of Indian life in 1890. C. A.

William Gilbert Gaul, *Sioux Camp, Standing Rock Agency, North Dakota,* 1890, oil on canvas. (Courtesy Thomas Gilcrease Institute of American History and Art, Tulsa.)

1. Department of the Interior Census Office, *Report on Indians Taxed and Indians Not Taxed in the United States (Except Alaska) at the Eleventh Census: 1890,* p. 526.
2. Ibid., p. 524.
3. Ibid.
4. *Issuing Government Beef* (Thomas Gilcrease Institute of American History and Art, Tulsa), a painting that represents Indians waiting to receive meat rations, incorporates the left third of *Dakota Indians* in its composition, where one Indian woman walks toward the tipi. This segment is seen in turn at the right edge of *Issuing Government Beef;* given the similar terrain in both paintings, one may view these works as continuations of each other.
5. Jeannette L. Gilder, "A Painter of Soldiers," *Outlook* 59, no. 9 (July 2, 1898): 570.
6. *Report on Indians Taxed and Indians Not Taxed,* p. 518.
7. Other Sioux subjects by Gaul are *The Pow Wow* (Sid Richardson Collection, Fort Worth), *Issuing Government Beef* (Thomas Gilcrease Institute of American History and Art, Tulsa), and *Sioux Camp at Sunset* (private collection); the latter is illustrated in James F. Reeves, *Gilbert Gaul,* p. 33.

15¾ × 24³⁄₁₆ inches
Inscription: signed lower right "Gilbert Gaul —
Dakota"
Lent by C. R. Smith

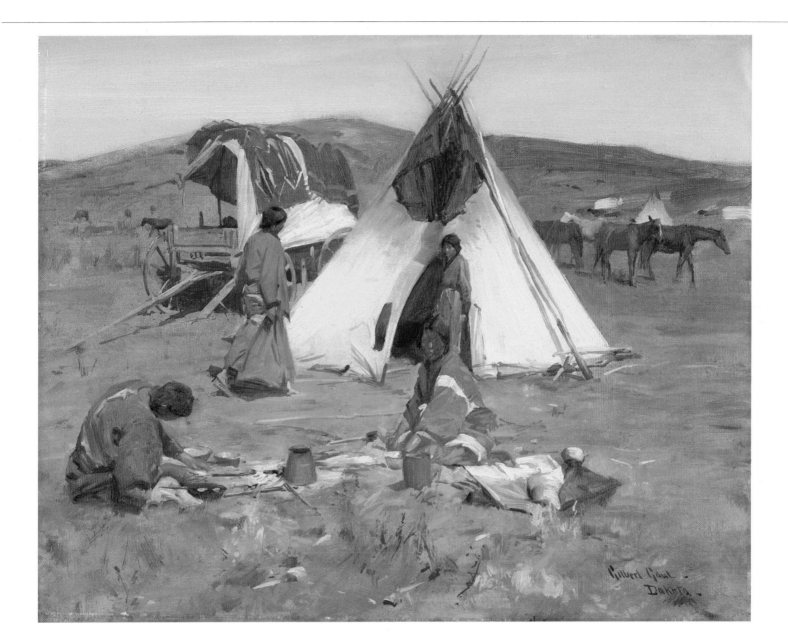

William Gilbert Gaul

b. 1855, Jersey City, New Jersey; d. 1919, New York, New York

At the turn of the century, the theme of the vanishing race recurred among images of the American Indian; this is an appropriate interpretation of Gilbert Gaul's *The Land of the Free*.[1] The painting depicts a Sioux squaw wrapped in a Navajo blanket, a very expensive article of clothing prized by the reservation Indians in the Dakotas.[2] With her fringed buckskin skirt and red-and-blue moccasins visible beneath her blanket, the solitary figure stands silently on a mountain peak, her face bearing an expression of sorrow. Gaul's use of light suggests a setting sun, an accepted poetic device that conveys the idea that this was the twilight of the Indians' separate existence from the encroaching "civilization" of the whites. This interpretation is reinforced by the snow on the ground, which indicates wintertime, the season of death and decay. Coincidentally, winter was also the season of the massacre of the Sioux at Wounded Knee Creek in December 1890, which was viewed by the popular press as the end of the Indian way of life. Gaul had spent time with this very tribe only months before the historic battle.[3]

Among illustrations of the American Indian, it was not unusual to see the profile of the solitary Indian male standing on a cliff or mountainside. However, incidents of a solitary female figure in such an environment were very rare. Where a squaw was the subject of a painting, she was generally depicted performing domestic chores or else she played a subordinate role to her visible warrior mate. Thus, the absence of the male figure in this painting is significant. One possible interpretation of this image is that the woman is in mourning, which would be consistent with the interpretation of the painting as a metaphor for the vanishing Indian race. Gaul was familiar with the funerary rites of the Sioux, upon which he commented in the report of the 1890 census.[4] The Sioux generally selected the highest places in the vicinity for the burial of their dead, and the squaw mourned alone. According to Gaul, the squaws "shed no tears, but the face is distorted by the emotions felt."[5] The artist may also have known of an earlier illustration of the subject in *Century Magazine,* for which he worked as an illustrator following 1887. In the issue dated May 1885, George de Forest Brush's illustration *Mourning Her Brave* showed a squaw standing on a snow-laden hill, the body of her husband lying behind her. In the accompanying text, Brush expressed his fear that the inclusion of the corpse made his scene too specific and detracted from the point of the painting—the universality of grief. By eliminating the presence of the male and focusing upon the silent, isolated figure of the squaw, Gaul created a timeless symbol of mourning for the vanishing Indian lifestyle, a subject that appealed to a public nostalgic for the past.

The Land of the Free was probably painted about 1900. Characteristic of his work of the 1890s,[6] Gaul applied his paint heavily and loosely in the background, but with greater precision in the figure. However, unlike his earlier paintings in which the subject was conveyed primarily through narrative content, Gaul increasingly sought to suggest meaning on a psychological level. For interpretation, the viewer was forced to identify with the emotional state of the figure portrayed. This was particularly true of the artist's work of the first decade of the twentieth century, the period in which the works of Sigmund Freud were gaining popularity. Thus, *The Land of the Free* incorporated painting techniques of the 1890s and yet presaged Gaul's interest in the psychological make-up of his subjects around 1905.

K. B.

1. It is unclear whether the title was given by Gaul or was appended to the canvas in later years. However, it is consistent with the romantic titles associated with other later paintings by Gaul.
2. Paul Dyck, *Brule the Sioux People of the Rosebud,* p. 320.
3. Gaul had served as special agent for the Eleventh Census dispatched to the Sioux reservations in the Dakotas during the summer of 1890.
4. Department of the Interior Census Office, *Report on Indians Taxed and Indians Not Taxed in the United States (Except Alaska) at the Eleventh Census: 1890,* 525.
5. Ibid.
6. James F. Reeves, *Gilbert Gaul,* 16.

Oil on canvas
29⅜ × 23½ inches
Inscription: none
Gift of C. R. Smith
G1976.21.12P

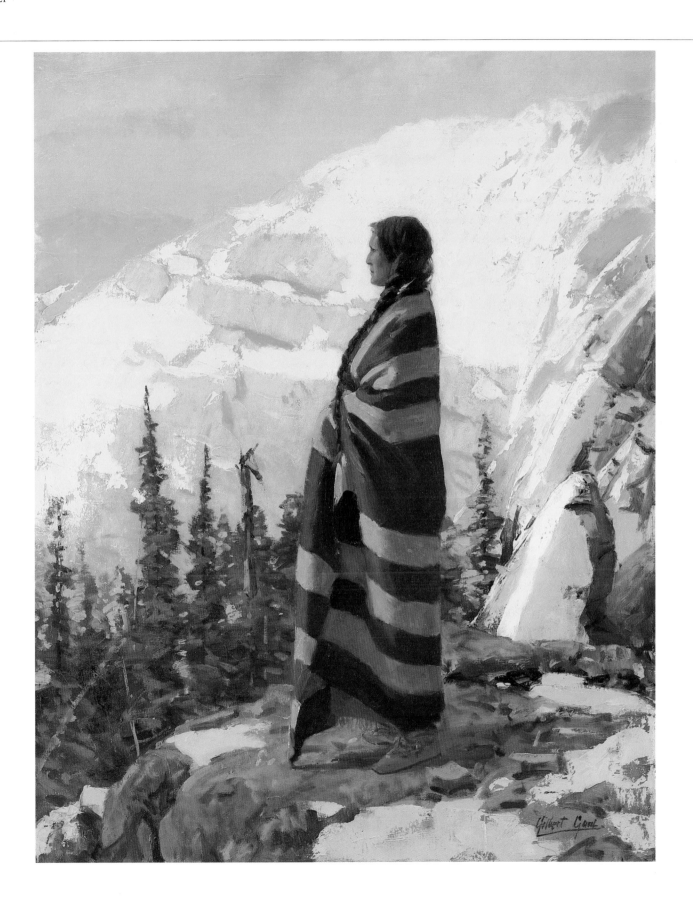

William Gilbert Gaul

b. 1855, Jersey City, New Jersey; d. 1919, New York, New York

Of all the paintings by Gaul in this collection, *Friend or Foe?* bears the closest resemblance in subject to those works that earned him the reputation as "foremost painter of battle scenes in this country."[1] Gaul, interested in the military from his school days when he studied to be a naval officer at the Claverack, New York, Military Academy, was ultimately unable to pursue a military career due to poor health. It was after his graduation in 1872 that Gaul turned to his natural artistic talent and began to study privately with John G. Brown and at the National Academy of Design with Lemuel E. Wilmarth. Both teachers were established genre painters from whom Gaul learned to study the form and to arrange figures into tight, interacting groups in dramatic compositions. Gaul combined his artistic knowledge with military subjects to create paintings of popular appeal.

Friend or Foe? presents three archetypal characters of the American West, a trapper-trader, an Indian scout, and a cavalry officer poised for action. Scattered around the figures lie remnants of their overnight camp — one unrolled and two rolled blankets, a cup, saucer, and coffee pot. While the trapper and cavalry officer crouch with rifles in hand the central Indian, his left hand raised to his mouth, cautiously calls to the unseen intruders beyond.

Few other known works by Gaul survive that combine Indians, trappers, and cavalrymen, but National Academy of Design exhibition records indicate that Gaul exhibited similar subjects in the late 1890s.[2] It is likely that Gaul preferred to concentrate on the Civil War and, later, Mexican subjects for which he was better known because the western cavalry genre was dominated by such artists as Frederic Remington and Charles Shreyvogel. Gaul was nevertheless successful with the few cavalry scenes he did paint, such as *Exchange of Prisoners*. Known only from an illustration in *Leslie's Illustrated Weekly*, December 16, 1897, the painting had been exhibited at the National Academy of Design the previous month. The reviewer enthusiastically described it as "one picture really deserving attention," adding that it represented "one of those incidents of Indian warfare that make excellent stage scenes for a dramatist."[3] This comment could easily apply to *Friend or Foe?* as well. The paintings convey a similar tone and employ figures of similar dress and physical characteristics, suggesting that they were painted about the same time. C. A.

William Gilbert Gaul, *Exchange of Prisoners,* photograph from *Frank Leslie's Illustrated Weekly,* December 16, 1897, p. 396. (Courtesy Amon Carter Museum, Fort Worth.)

1. *American Art News* 18, no. 10 (December 27, 1919): 4.
2. For instance, Gaul exhibited *U.S. Cavalryman* in 1898 and *The Indian Prisoner* in 1899 at the National Academy of Design. Earlier subjects shown there by Gaul deal with the Civil War (see Maria Naylor, ed., *The National Academy of Design Exhibition Record, 1861–1900*).

3. *Leslie's Weekly,* December 16, 1897, p. 396. This painting is not listed in the records of the National Academy of Design as presented by Maria Naylor (n. 2, above). However, the article and accompanying illustration prove its existence there in 1897.

Oil on board
18¾ × 24⅞ inches
Inscription: signed lower right "Gilbert Gaul"
Gift of C. R. Smith
G1976.21.11P

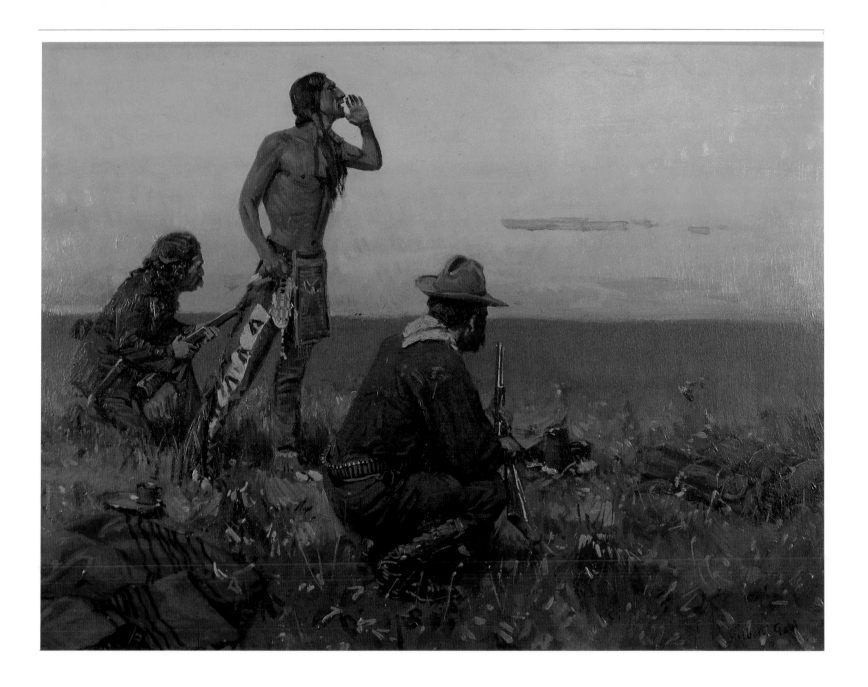

William Gilbert Gaul

b. 1855, Jersey City, New Jersey; d. 1919, New York, New York

Although Gaul was engaged primarily in painting military scenes, he composed hunting subjects on and off throughout his career. His interest matches the popularity of the hunting genre throughout the nineteenth century, as seen in the work of such artists as A. F. Tait and W. R. Ranney.

Early in his career Gaul produced two illustrations for *Harper's Weekly,* each two full-page widths in size, which must have gained him favorable notice. The first, *Hunting Wild Hogs in Arkansas* in the November 26, 1887, issue, featured hunters on horseback and their dogs clamoring after a feisty wild hog, while *Jack-Rabbit Hunting in Southern California* in the October 27, 1888, issue presented a similar scene with a jackrabbit instead. Both are characterized by brisk action and figures executed in a facile way, typical of Gaul's style in both illustration and painting at that time.

The Hunter and His Dog, however, is quite different in mood and treatment from these earlier more rambunctious scenes. Instead of those active, robust figures, he depicts a quiet scene of a man — simply dressed, hat pulled down over his ears — crouching with his dog to inspect an animal's print on the ground. The work, which focusses on the simple camaraderie between a man and his dog, is loosely brushed and incorporates subdued green and brown tones to create a quiet, introspective scene. This mood is more characteristic of works later in Gaul's oeuvre like *The Fire Is a Friend* that reject the tense action-packed scenes popular earlier in the artist's career. The loose impressionistic brushwork evident in *The Hunter and His Dog* recalls that of late paintings by Gaul of gardeners and children, for instance, in which the loosely articulated figures in outdoor environments are barely discernible from the verdant foliage surrounding them.

The Hunter and His Dog, which represents a dramatic change in style and theme by 1910, reflects a change in contemporary taste as well. This canvas most likely appealed to audiences interested in simpler subjects than the western and military themes dominating most of Gaul's oeuvre. C. A.

William Gilbert Gaul, *Hunting Wild Hogs in Arkansas,* etching, *Harper's Weekly,* November 26, 1887. (Courtesy Amon Carter Museum, Fort Worth.)

Oil on canvas
18⅛ × 24³⁄₁₆ inches
Inscription: signed lower right "Gilbert Gaul"
Gift of C. R. Smith
G1976.21.14P

William Gilbert Gaul

b. 1855, Jersey City, New Jersey; d. 1919, New York, New York

One of Gaul's more sentimental works, *The Fire Is a Friend* presents an intimate nighttime scene in which a spirited campfire illuminates the figure of a tranquil Indian and the surrounding rocks and nearby stalks of grass. The Indian, warmly dressed in a rough coat that reveals a colorful blanket underneath, gazes intently into the flames. Gaul's lively, chiplike brushstrokes incite our imaginations to hear the pop and crackle of the burning wood and to see the leap of the flames.

The treatment of the subject in *The Fire Is a Friend* lends credence to the report that Gaul, by this time, viewed the Indians as "very picturesque."[1] In contrast to earlier works like *Friend or Foe?,* there is no evidence of tension or aggression. We can readily imagine the Indian here recalling past adventures in the firelight. This vision concurs with the Department of the Interior's 1890 Census, in which Gaul played a part, where it was reported that the Indians were hardly the "warlike savages" they were once reputed to be.[2]

The Fire Is a Friend reflects a nostalgic trend evident in the late works of the artist's contemporary Frederic Remington. Remington's *Apache Medicine Song* (1908, Sid Richardson Collection, Fort Worth) presents a group of Indians dramatically silhouetted by the campfire around which they huddle. The late work of both Gaul and Remington incorporates many such evocative images that comment nostalgically on lost Indian culture.

The Fire Is a Friend can be viewed also as a precursor in theme to the works of the Taos artists as well, in particular Joseph Henry Sharp and Irving Couse. The hallmark of both of these Taos painters is the presentation of a single, withdrawn Indian, often perched beside a warm fire and lost in contemplation.[3] *The Fire Is a Friend* thus represents an important early example of the growing trend toward solemn, poetic images of a vanishing aspect of our American heritage. C. A.

1. Jeannette L. Gilder, "A Painter of Soldiers," *Outlook* 59, no. 9 (July 2, 1898): 570.
2. Department of the Interior Census Office, *Report on Indians Taxed and Indians Not Taxed in the United States (Except Alaska) at the Eleventh Census: 1890,* p. 509.
3. See, in particular, reproductions in Mary Carroll Nelson, *The Legendary Artists of Taos,* of works by Sharp and Couse.

Oil on canvas
29 × 40 inches
Inscription: signed lower left "Gilbert Gaul"
Gift of C. R. Smith
G1976.21.13P

William Gilbert Gaul

b. 1855, Jersey City, New Jersey; d. 1919, New York, New York

Columbia River[1] depicts a late spring Indian encampment in the American Northwest. Above the calm river rise mountains with scattered patches of snow. It is unknown whether or not Gaul actually visited the Columbia River in the course of his career. It is conceivable that Gaul painted the subject at a patron's request, in which case he may have employed photographs. One important contemporary source of information and photographs that may have influenced Gaul was Edward S. Curtis's twenty-volume work *The North American Indians*. Begun by Curtis in 1900 to record the activities of those Indians still retaining vestiges of their customs, the volumes covering the Indians of the Columbia River region were published in 1911.[2] None of the photographs included, however, reproduce a scene like that in *Columbia River*.

Among the Indians populating the river area and its many tributaries were the Yakima, Spokan, Flathead, Nez Perce, and Walla Walla tribes. Curtis recorded sadly that many of these Indians were ravaged by disease and alcoholism. Historically, most of the tribes ate fish in the spring and summer months in their homeland, and in the winter they moved eastward to the buffalo country of the Missouri plains.

The broad brushwork and simple composition suggest that Gaul painted *Columbia River* late in his career.[3]
C. A.

1. The title of this work has been shortened from *Columbia River Scene* to *Columbia River* to coincide with the inscription found on the verso of the canvas.
2. Edward S. Curtis, *The North American Indian*, vols. 7 & 8.

3. See reproductions in James F. Reeves, *Gilbert Gaul*. Also of note is a label on the verso of this painting indicating that *Columbia River* hung in the Department of State Diplomatic Reception Rooms in Washington, D.C., most likely when C. R. Smith was secretary of commerce, 1968–1969.

Oil on canvas
24¼ × 35⅜ inches
Inscription: lower right, "Gilbert Gaul"; verso,
"Columbia River / G.G."
Lent by C. R. Smith

Herman Wendelborg Hansen

b. 1854, Ditmarschen, Germany; d. 1924, San Francisco, California

Capt. John G. Bourke, a participant in the Apache campaigns of the 1870s and 1880s, wrote that in their battles in Arizona the U.S. Army confronted "the astutest and fiercest of all tribes encountered by the Caucasian since he crossed the Mississippi. . . . [The] history of this land of Arizona [is] one full of strange stories of all that is horrible . . . so much of it is written in blood . . ."[1] In his watercolor *News from the Front,*[2] without descending into sensational voyeurism, Herman Wendelborg Hansen captured some of this urgency and danger facing the army in Arizona. Here a U.S. soldier has ridden his horse across the blinding hot Arizona Territory to deliver news to a small U.S. Army outpost. The insistent gesture of the wounded [?] rider, the extreme fatigue of his horse, and the rapt attention of the listeners suggest that an incident of some importance has just occurred. The telegraph poles indicate that the message soon will be conveyed to the proper authorities.

Although the strong narrative character of *News from the Front* derives from illustration, Hansen was not an illustrator and his painting was never intended to illuminate a text. Hansen, instead, frequently mined popular nineteenth-century periodicals, using illustrations by Frederic Remington, the most popular western American artist of the day, as sources for the paintings he sold directly to the public. Here, Remington's March 1891 illustration for *Century Magazine, Arrival of a Courier,* probably served as inspiration. That same year an identical oil version by Remington received favorable attention when exhibited at the National Academy of Design. Entitled *Arrival of a Courier—Arizona Territory, 1890* (R. W. Norton Art Gallery, Shreveport), it was responsible for Remington's designation as an Academy associate.[3] Hansen, perhaps aware of Remington's success with this subject, modeled his exhausted horse, western-style buildings, and alert audience after the illustration. As Hansen modified the illustration he infused it with greater drama. Moreover, his mastery of watercolor and his familiarity with Arizona gained through summer sketching trips enabled him to evoke with finesse the western atmosphere. *News from the Front,* one of Hansen's first versions of this subject, is similar in style to his watercolor *Cowboy Standing by Horse Watching Indians,* signed and dated 1898, and was almost certainly painted before the more

stylized oil painting of 1905, *Cowboy Race* (Kennedy Galleries, 1976; present location unknown).

Hansen studied in 1870 at Hamburg under Professors Simmonsen and Neimerdinger, painters of battle scenes and still life. In succeeding years he was at London's Royal Academy (1876), in New York (1877), and at the Art Institute of Chicago (1878). He subsequently traveled from West Virginia to Canada and Mexico before finally settling in San Francisco in 1882. None of his youthful experiments in painting survive. Hansen's earliest known works date after 1894 and deal exclusively with the same boisterous themes that appealed to Remington. In fact, he did not achieve much notice until the vogue for western subjects arrived during the 1890s. In 1900 the artist attracted attention with his painting *Pony Express Rider* (sold Sotheby Parke Bernet, Oct. 27, 1978; present location unknown), and San Francisco newspapers began to take note of his work in 1901 with his first exhibition. By 1905 a local art critic declared him a "compeer of Remington" and in 1907 another reviewer reflected that "it is impossible to see the exhibition of paintings by H. W. Hansen without thinking of Frederick [sic] Remington . . . Hansen's subjects are almost identical and if his work lacks some of the crispness of outline and vividness of coloring seen in Remington's, he makes up for it in the greater softness and finish."[4] During the first decade of the twentieth century Hansen also exhibited in New York, London, Munich, and Paris, where at the Salon a picture of a stampede of wild horses attracted favorable attention. In 1911 he is reported to have won a Grand Prize at the St. Petersburg Exposition.[5]

After 1911 Hansen's success and output appear to have diminished. The artist presumably continued to paint pictures of the cavalry and the cowboy although few of these late works are known. Not until Hansen's death in 1924 was his work again evaluated by the local press. Writing for the *San Francisco Chronicle,* Harry Noyes Pratt acknowledged that even if Hansen's fame had declined, nevertheless, the artist "leaves in the homes of collectors and art patrons all over the country paintings which not only are valuable as art expressions but valuable historical records as well. They tell not only the story of the old days, but they speak vividly of the extraordinary ability and splendid sincerity of the man."[6] N. B.

Frederic Remington, *Arrival of a Courier,* wood engraving, *Century Magazine* 41 (March 1891): 650. (Photo by George Holmes.)

Herman Wendelborg Hansen, *Cowboy Standing by Horse Watching Indians,* 1898, watercolor. (Courtesy Bancroft Library, University of California, Berkeley.)

1. John G. Bourke, "General Crook in the Indian Country," *Century Magazine* 41 (March 1891): 650. Hansen must have known this article since it was illustrated by Remington's *Arrival of a Courier,* which served as inspiration for *News from the Front.*

2. This watercolor was sold by Sotheby Parke Bernet under the title *News from the Front* on January 24, 1951 (sale 1218, lot 6). Subsequently, the title was changed to *The Alert* and is listed

under both titles in the Archer M. Huntington Art Gallery's Registrar's files.

3. Peter H. Hassrick, *Frederic Remington: An Essay and Catalogue,* pp. 20, 23, n. 29.

4. *San Francisco Call,* April 23, 1905, February 4, 1907.

5. Gene Hailey, ed., "Herman Wendelborg Hansen," in *California Art Research,* vol. 9, pp. 98, 104.

6. Harry Noyes Pratt, "Hansen, Great Painter of Old West, Dies," *San Francisco Chronicle,* April 13, 1924.

Watercolor and gouache on paper mounted on board
16⅜ × 23⅛ inches
Inscription: signed lower right corner "H. W. Hansen"
Lent by C. R. Smith

News from the Front (The Alert)
ca. 1891–1905

Alexander Francis Harmer

b. 1856, Newark, New Jersey; d. 1925, Santa Barbara, California

At the end of the nineteenth century after great changes had been wrought on the landscape, nostalgic Californians re-created in prose and pictures the halcyon days prior to the 1848 discovery of gold. Frequently such depictions characterized the days of the cattle-ranching Mexican *dons* by a "sleepy, lazy happy-go-luckiness, dolce-far nienteness, where the spirit of mañana and poco tiempo reigned . . ."[1] Alexander F. Harmer's *Early California* shares this view. Instead of depicting Mexican *vaqueros* (cowboys) at work tending the wealth-bringing herds, Harmer portrays two of them inside a barn playing cards. Dressed in the typical costumes of the profession, the two sit on colorful blankets while their elaborate saddles lie unused in the corner. A bottle, perhaps of local wine, has been emptied and the cardplayer to the left intently scrutinizes his shifty opponent, who has stowed one of the blue-backed cards in his pocket.

Early California is not dated, but the artist's son, Douglas Harmer, believes it was executed toward the end of his father's career, around 1900–1920.[2]

Harmer's professional education, occupying three different periods at the Pennsylvania Academy of Fine Arts (1874–1876, 1883–1884, 1888) under artists including Thomas Eakins and Thomas Anshutz, provided him with a traditional and thorough academic background. Yet much of Harmer's training was unconventional by Academy standards. Attracted to the Southwest, Harmer enlisted twice in the army (1872–1874, 1881–1883) as a means to study the Indians in their native land. During his second tour of duty, spent in Arizona Territory during the Apache campaigns, Harmer became acquainted with Gen. George Crook and Capt. John G. Bourke, two of the nation's most renowned Indian fighters, and made numerous sketches of the people and events associated in the army's struggles there. These studies later became sources for illustrations published in *Harper's Weekly* and in Bourke's two volumes, *The Snake Dance of the Moquis of Arizona* (1884) and *An Apache Campaign in the Sierra Madre* (1886). Subsequent travels through Arizona (1884), Mexico (1888–1889), and California (late 1880s) provided him with additional materials for paintings and illustrations of Indians as well as landscape and architectural scenes.

With his marriage in 1893 to Felicidad A. Abadie, a member of a very old California family, Harmer ultimately settled in Santa Barbara and entered a circle of prominent Spanish-Mexican families, including the Del Valles, the De la Guerras, and Don Antonio Coronel, who were associated with a movement to preserve dying Spanish culture. Consequently, Harmer's paintings and illustrations after this time are devoted mainly to California themes. The artist's longstanding friendship with Charles Lummis, the influential writer and editor of books and periodicals celebrating Spanish culture and the Southwest, whom Harmer had known since around 1884, also encouraged this new direction. While Harmer's wife provided him with access to old costumes and chests filled with ancestral heirlooms, which the artist used in his paintings, Lummis, on occasion, gave Harmer photographs of the families in re-enacted scenes from which Harmer painted a number of oils. *Early California*, a nostalgic evocation of nineteenth-century California life, was painted during this phase in the artist's career. While the painting's narrative content was probably rooted in the artist's imagination, the artifacts and costumes were based on authentic models. For example, the sombrero of the figure on the right and the coat of the figure on the left were part of Harmer's collection of costumes and are still in his son's possession.[3]

To the end of his career Harmer continued to paint small California genre scenes as well as landscape and marine pictures in which he became increasingly interested in the poetic effects of color and light. At the same time his talents were also engaged in a variety of diverse commissions. In 1900 he designed a series of fifty panels of embossed and painted leather. Entitled *Passing of the Nations,* the work was Harmer's last devoted to the American Indian and was commissioned by Attorney-General Philander Knox, who had seen Harmer's work on a visit to Santa Barbara. In 1909 Harmer designed costumes for *Natoma,* Victor Herbert's opera of a Santa Barbara Indian legend produced in New York. In the 1900s Harmer also designed collector plates of the California missions manufactured in England by Wedgewood.

Although he was respected by his contemporaries and associated with more famous artists, including Thomas Moran, Frank Tenney Johnson, and Ed Borein, during his lifetime, Harmer did not achieve widespread success.[4] While his sensitivity for color and light rendered his depictions appealing, Harmer's mastery of the human figure was less skilled. In addition, his subject matter, appealing to local patrons interested in California themes, also served to keep his audience small. In 1899 Lummis attempted to bolster his friend's reputation in *Out West Magazine:*

The plausible suggestion that a great Master might have done still more with the marvelous art material of our Southwestern border, is, after all, impertinent; for the great Masters have not cared to risk their skins where Mr. Harmer learned his material. Nor is this invidious to Mr. Harmer. The fact that he has led an uncommon life and has taken his higher education in art where few artists would dare go, does not by any means indicate his work needs such apology. The simple fact is that it adds the rare distinction of accuracy . . . He is particularly and indisputably the artist of the Apaches and the old-time Californians . . . I know of no one else with half his talent as an artist, who has had a tenth of his touch with frontier life — one of the most picturesque the world has ever seen.[5] N. B.

1. George Wharton James, *Through Ramona's Country,* p. 385.
2. Letter from James M. Hansen to N. B., July 20, 1984.
3. Ibid.
4. Harmer established a small art colony in Santa Barbara where these artists as well as others studied (see *Alexander F. Harmer, 1856–1925*)

5. Charles F. Lummis, "A Painter of Old California, Alex F. Harmer and His Work," *Out West Magazine* 12 (December 1899): 22–23.

Oil on canvas
12½ × 17½ inches
Inscription: signed lower left corner "A. Harmer"
Gift of C. R. Smith
G1976.21.15P

Thomas Hill

b. 1829, Birmingham, England; d. 1908, Raymond, California

As the California population grew in the years after the gold rush, the area increasingly attracted artists. One of these was Thomas Hill, who arrived in 1861 and devoted much of his career to depicting the grandeur of the California landscape. *Indians of the Northwest,* previously entitled *Indian Encampment, Yosemite Valley,*[1] depicts three small groups of Indians in the Hood River Valley in Oregon, which Hill also visited. Mt. Hood, a picturesque peak visible from the Columbia River and Portland, appears in the background.

According to Samuel Bowles in his *Our New West,* published in 1869, Mt. Hood was second only to Yosemite for its natural beauty and interest to the Pacific Coast traveler. He also noted that the peak was familiar to "Eastern eyes" as a result of the exhibition of a painting of the subject by Albert Bierstadt.[2] Carleton Watkins' popular photographs of the Columbia River area in 1867 also included a distant view of Mt. Hood. Even lesser-known artists, such as F. A. Butman, received high prices in the East during the 1860s for their paintings of this peak.[3] Thus it is not surprising that Hill in his search for picturesque West Coast subjects painted the mountain as early as 1865 and returned to the subject as late as 1890.[4]

Indians of the Northwest, which resembles John Mix Stanley's *Mt. Hood* (University of Michigan), dated 1871, was possibly the *Mount Hood* listed as exhibited by Hill at the Mechanics' Institute Fair in San Francisco in the fall of 1874.[5] Although less expansive and dramatic than Hill's Yosemite views, this scene still imparts a similar message — admiration of God's work in the West, a primitive wonderland untarnished by whites. K. B.

1. The title *Indians of the Northwest* is inscribed on the back of the painting.
2. Samuel Bowles, *Our New West: Records of Travel between the Mississippi River and the Pacific Ocean,* pp. 480, 481–482.
3. "Art Beginnings on the Pacific. I," *Overland Monthly* 1 (July 1868): 34.
4. In the exhibition "Thomas Hill: The Grand View" (Oakland Museum, 1980), two dated paintings of Mt. Hood were shown. One was *Mt. Hood Erupting* (John H. Garzoli Fine Arts), dated 1865, and the other was *Mount Hood with Indian Campfire* (collection of James H. Brown), dated 1890 (Marjorie Dakin Arkelian, *Thomas Hill: The Grand View,* pp. 63, 66).
5. Ibid., p. 24.

Oil on board
15 × 21⅜ inches
Inscription: signed lower right "T. Hill"
Lent by C. R. Smith

Thomas Hill

b. 1829 Birmingham, England; d. 1908, Raymond, California

William H. Brewer, whose chronicles of his expeditions in the uncharted territories of the West helped to bring the region to public attention, provided the first known confirmation of the existence of a majestic mountain whose peak bore a cross of snow. As he recorded in a letter of 1869, he and his companions climbed to the summit of Grays Peak in Colorado and saw, in the distance, the mountain that came to be called the Mount of the Holy Cross.[1] However, it was William Henry Jackson's photograph of 1873 that proved to an unquestioning public that God had placed his unmistakable stamp of approval on this great Edenic paradise, the American West. Through the influence of Jackson's photograph, the mountain began to attract artists. Thomas Moran, for example, visited the site in 1874. An engraving after his painting *Mountain of the Holy Cross*[2] appeared in William Cullen Bryant's *Picturesque America,* published in 1874, while the painting itself won a gold medal at the Centennial Exposition in Philadelphia in 1876.[3]

In the wake of Moran's success, Thomas Hill painted his own *Mt. of the Holy Cross, Colorado.* The most probable date for this painting is 1884, when problems in his marriage and the destruction of his Yosemite studio during a storm led him to seek new subjects. In August, he traveled to the Yellowstone Park area, and by winter he was in New Orleans.[4] He must have passed through Colorado on this trip.[5] Even so, it is questionable whether Hill actually viewed the cross itself. The true "cross," visible only from high elevations or great distances, was formed by the snow-filled confluence of vertical and horizontal ravines near the top of the peak. However, in comparing the painting with photographs of the subject, one finds that the artist placed his cross somewhat lower on the mountain's face. The shape of Hill's cross, too, is highly inaccurate, although to judge by the popularity of these images, accuracy was not of overriding concern to artists or their public. As one historian has remarked, "Crude engravings that idealized the cross beyond any resemblance to reality became normal illustrations for travel articles and books."[6]

Hill's angle of vision is identical to that of Jackson in his famous photograph taken from Notch Mountain at an elevation of 12,000 feet. Yet Jackson had recorded that the climb to this point was "the toughest trial of strength I have ever experienced."[7] For the fifty-five-year-old Hill, who had already suffered serious health problems, such an ascent may have been too strenuous. It is possible that, failing to view the cross himself, Hill based his painting on Jackson's photograph or an engraving from it. In contrast to most paintings of the peak in which the format is vertical, his composition is horizontal, in accordance with the successful formula he had used in his Yosemite paintings.

K. B.

1. Mathias S. Fisch, "The Quest for the Mount of the Holy Cross," *American West* 16 (March–April 1979): 32.
2. Painted in 1873, before he visited the site; the painting was based upon Jackson's photograph.
3. Fisch, "The Quest for the Mount of the Holy Cross," p. 57.
4. Marjorie Dakin Arkelian, *Thomas Hill: The Grand View,* p. 31.
5. Hill visited Colorado prior to 1891, when he exhibited his *Grand Canyon of Colorado.*
6. Carl Abbott, *Colorado: A History of the Centennial State,* p. 176.
7. Fisch, "The Quest for the Mount of the Holy Cross," p. 57.

Oil on canvas
14 × 21¹⁄₁₆ inches
Inscription: signed lower right "T. Hill"
Lent by C. R. Smith

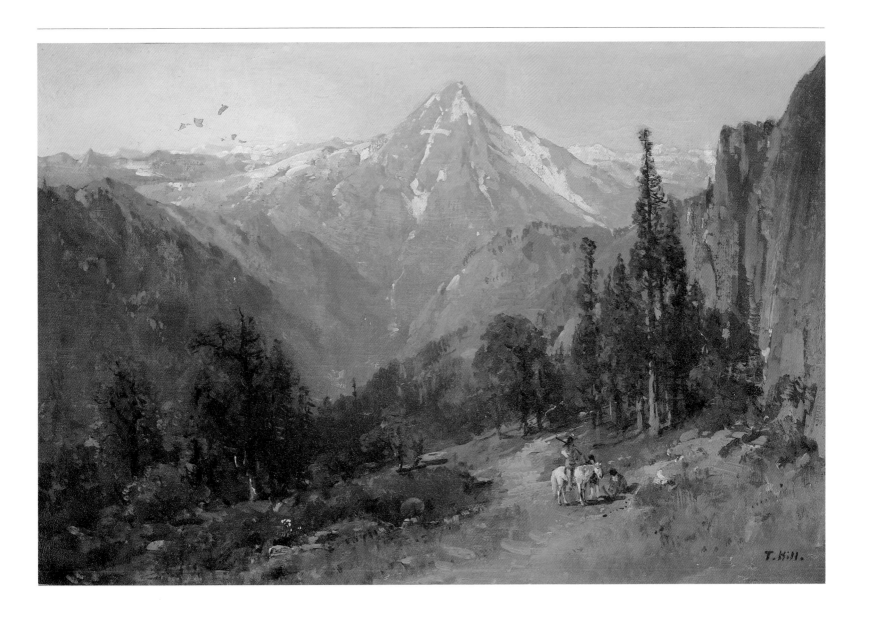

Thomas Hill

b. 1829, Birmingham, England; d. 1908, Raymond, California

In 1864, the tract of land now known as Yosemite National Park became the first area in this country protected from exploitation by miners and developers and set aside for public recreation. Leading the preservation movement, Frederick Law Olmsted consulted three experts on Yosemite in his lobbying efforts: photographer Carleton E. Watkins and artists Virgil Williams and Thomas Hill.

Thomas Hill first visited Yosemite Valley in 1862, only eleven years after the first recorded expedition by whites into the area. So enchanted was he by the primordial beauty of the massive peaks and cliffs and their tremendous cascades of water that he cut short his undistinguished career as a portraitist to specialize in scenery of the West.[1] As added incentive, the gold rush economy in California and the interest in California on the Atlantic seaboard meant patrons on either coast for scenes of the state's natural wonderland. Hill quickly established himself in San Francisco, and, much like Carleton Watkins, who once photographed an exhibition of Hill's paintings, the artist soon became noted for his Yosemite views. He exhibited a painting of Yosemite at the National Academy of Design in 1866. In 1868, after Albert Bierstadt received acclaim for his early panoramic views of Yosemite and at a time when the public eagerly anticipated the completion of the transcontinental railroad, making travel to California easier and cheaper, Hill executed in Boston his first large-scale view of Yosemite, a scene based upon earlier sketches. Within a few years, Louis Prang and Company published a chromolithograph after a *Yosemite Valley* in the *American Chromos* series; and Hill's large *Yosemite Valley* was a popular and critical success at the Philadelphia Centennial Exposition in 1876. After 1884, Hill maintained a studio in Yosemite from which he turned out the quickly executed canvases he sold to tourists.

An extremely prolific artist, he painted an estimated five thousand views of Yosemite. The loose brushwork and pink tonality of *Indians at Campfire, Yosemite Valley* were characteristic of Hill's quickly painted canvases from the 1880s. This canvas was probably painted in the mid-1880s at Hill's Yosemite studio.

Indians at Campfire, Yosemite Valley depicts the valley from Inspiration Point, a favorite vantage for artists on the Mariposa Trail because "the general view of the valley, from Inspiration Point, on this trail is the most beautiful and striking of the whole."[2] This point, on the south rim of Yosemite, rises three thousand feet above the valley floor. The view of the valley, with the peak of El Capitan to the viewer's left and Bridalveil Falls to the right, recurs often in Hill's oeuvre. The artist frequently included tiny Indian figures to suggest the scale of the massive peaks beyond them, although the Indians who once inhabited the valley had been evicted by the army years earlier. Thus, the figures also serve as romantic reminders that this primitive landscape was as yet unharmed by the advance of white "civilization."

K. B.

1. Hill continued to derive some income from portrait commissions and from the sale of sentimental genre scenes through the mid-1860s, as may be determined from the catalogue of paintings at the California Art Union in 1865.
2. J. M. Hutchings, *Scenes of Wonder and Curiosity in California*, p. 137.

Oil on canvas
29⅝ × 45½ inches
Inscription: signed lower left "T. Hill"
Gift of C. R. Smith
G1976.21.17P

Indians at Campfire, Yosemite Valley, California
ca. 1885

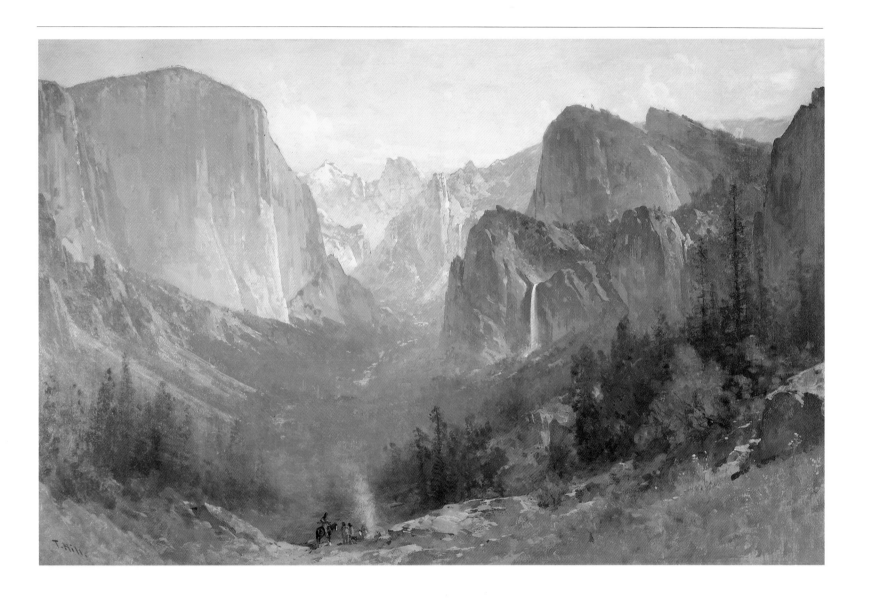

Thomas Hill

b. 1829, Birmingham, England; d. 1908, Raymond, California

After 1884, Thomas Hill maintained a studio in Yosemite from which he turned out the quickly executed canvases he sold to tourists. *The Yosemite,* painted in 1887, may have been one such work. In this painting, the recognizable landmarks of Yosemite, El Capitan on the left and Bridalveil Falls on the right, appear once more. In contrast to the other view of Yosemite in the collection, however, the vantage point here is from the floor of the valley. Two Indian figures, upon whom our attention is focused due to their location at the bottom of the "v" formed by the descending rock faces, are dwarfed by Nature's handiwork. Facing the viewer, these Indians seem to invite the traveler into the valley, in contrast to the reception that might have waited here thirty years earlier when whites were not welcome.

During the late 1880s, Hill's Yosemite summer studio at the Wawona Hotel[1] was a tourist attraction itself. Guests were attracted to his collection of war implements and specimens of mounted animals.[2] However, while he did sell paintings to the numerous travelers who visited the studio, he suffered financial difficulties. Scenery of California and the Pacific Northwest declined in popularity during the 1880s, and, as a result, commissions dwindled for those artists whose reputations were based on such views. In December 1886, Hill was forced to auction many of his works in order to meet expenses.

Hill did receive major recognition during the 1880s, however. In December 1886, he assumed the directorship of the California School of Design following the death of his friend artist Virgil Williams. He abandoned this position in 1887 when naturalist John Muir commissioned him to paint Muir Glacier in Alaska. Two paintings from this trip were among the nineteen Thomas Hill paintings in *Picturesque California,* edited by Muir and published in 1888. In addition, he designed the covers for James Hutchings' *In the Heart of the Sierras,* also published in 1888.

Thomas Hill spent much time in his later years painting and then searching for a buyer for his *Driving the Last Spike* commemorating the completion of America's transcontinental railroad in 1869. Now hanging in the California State Capitol Building, this painting, along with some of Hill's Yosemite views, was exhibited at the World's Columbian Exposition in Chicago in 1893. Hill, who was born in England in 1829 and had studied art at the Pennsylvania Academy of Fine Arts and in Paris under Paul Friedrich Meyerhein, died in 1908. K. B.

1. His winters were spent at nearby Raymond, California.
2. Arkelian, *Thomas Hill: The Grand View,* p. 32.

Oil on canvas
19½ × 25¼
Inscription: signed lower right "T. Hill 1887"
Gift of C. R. Smith
G1976.21.16P

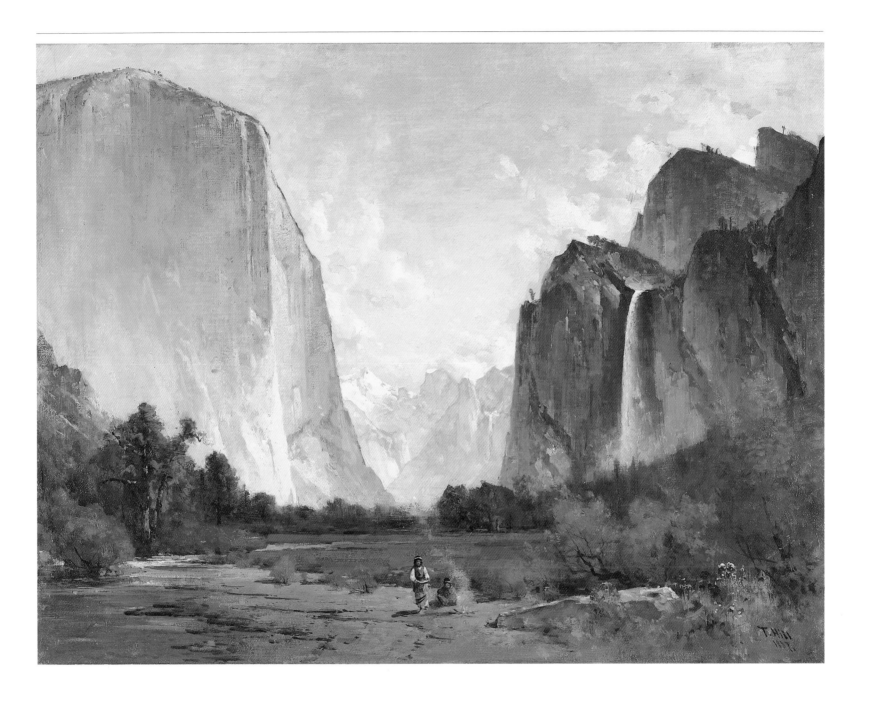

Ransome Gillet Holdredge

b. 1836 New York (or England); d. 1899, Alameda County, California

Montana Encampment is now considered to have been painted by Ransome Gillet Holdredge, although when acquired prior to 1976 by the donor, the visible signature was that of E. I. Couse (Eanger Irving Couse, 1866–1936). It was a relative of Couse who first doubted, on stylistic and historic grounds, that the work was by Couse, alerted the Huntington to this question, and proposed Holdredge as the true artist.[1] After examination under ultraviolet light and study under magnification, the Couse signature was found to rest on top of restoration. Another signature became slightly visible through examination by the infrared vidicon. Further cleaning revealed the under signature to be R. G. Holdredge, an artist whose known style, palette, and subject matter can be found in *Montana Encampment*.[2]

Holdredge, building his scene in layers, painted the landscape first, the tipis second, and the figures last. Seemingly carelessly strewn yet actually purposefully arranged, the figures are emphasized with bright local color, forming ribbonlike bands of accenting color. It is possible that some of the work on this painting was finished in Holdredge's studio, with the first portions painted plein air. It is also possible the artist used photography as an aid.

The painting has been relined in the twentieth century and retouched, particularly in the upper right. At the present time little is known of the provenance of the painting, prior to the ownership of the donor. It is known that sometime between the years 1920 and 1960 the painting was at Closson Gallery in Cincinnati.

Holdredge went to California in the 1850s as a draftsman for the Mare Island Navy Yard, San Francisco, and is reported to then have begun study with some of the few local artists living in San Francisco at the time. By 1860 he had risen to the post of head draftsman. It was about this time, when he was twenty-four, that he began to exhibit paintings of landscapes, which he first signed as "Holdridge," later changing the spelling of his signature to "Holdredge." The local press referred to him as the ranking landscape painter of the day, praising his bright Hudson River style canvases.[3]

In 1874 Holdredge and Hiram Bloomer held a joint sale of their paintings to finance European studies. In 1876 Holdredge was said to have been serving, as a field artist for *Scribner's,* with Major Reno's troop at the time of the Custer massacre. When Holdredge returned to San Francisco in 1880 he was painting a dark landscape in the style of the French Barbizon School and using a palette knife to achieve a surface with a noticeably thick and raised body of paint, an impasto finish.[4]

Holdredge is reported to have preferred portraits to landscapes. However, in a time of great demand by the buying public for views of America's wide-open spaces, the demand for his landscapes repeatedly sent Holdredge sketching scenes throughout California, the Northwest, western Canada, and the Rocky Mountains. Holdredge's abilities declined significantly during the 1890s due to continuing poor health. Upon his death, he was buried at public expense.[5] P. D. H.

Ransome Gillet Holdredge, *Montana Encampment* (detail), ca. 1865–1880. (Photo by George Holmes.)

1. Virginia Couse Leavitt to Sarah Humble, July 15, 1981, Registrar's files, Archer M. Huntington Art Gallery.

2. Compare *Flathead Squaws in Camp, Montana,* by R. G. Holdredge (*Franz R. Stenzel Collection,* Sotheby Parke Bernet Auction catalogue [Los Angeles], June 24, 1980, no. 596).

3. Peggy and Harold Samuels, *The Illustrated Biographical Encyclopedia of Artists of the American West,* p. 232.

4. Ibid.

5. Ibid.

Oil on canvas
20¼ × 36⅛ inches
Inscription: signed lower left "E. I. Couse" over "R. G.
Holdredge"
Gift of C. R. Smith
G1976.21.4P

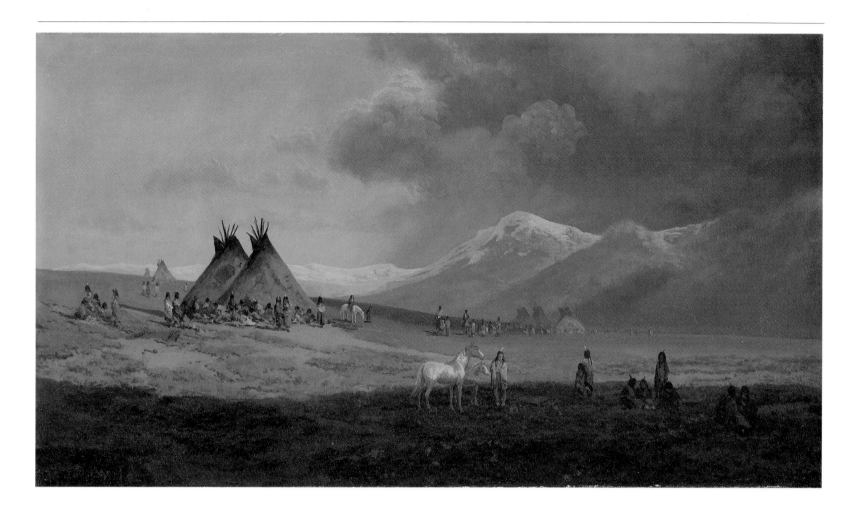

Peter Hurd

b. 1904 Roswell, New Mexico; d. 1984, San Patricio, New Mexico

Typical of Peter Hurd's mature landscape paintings, *Picacho Valley, Chavez Ranch* records a scene in New Mexico near the artist's own home at Sentinel Ranch, San Patricio. The scene is much the same today, with the house and windmill still standing.[1] It was this area of the country that most attracted Hurd as a place to live and as subject matter. Painted in egg tempera made with egg yolk from his own chickens,[2] the painting is typical of Hurd's scenes of the Southwest, both in style and in medium. In his slightly anthropomorphic treatment of nature and in his overall romantic view of the land, his landscape paintings of the Southwest can be linked to those of the American regionalists.

Peter Hurd, who was born and died in New Mexico, enjoyed a long and successful career that carried him far from that state. His career may be said to have begun in New York, with an early sale of his artwork to one of his supervisors at the military academy at West Point. The supervisor also encouraged him to resign his appointment there and study at the Pennsylvania Academy of Fine Arts. Hurd followed his advice and later became one of the few students accepted by American illustrator N. C. Wyeth. In 1929 Hurd married Wyeth's eldest child, Henriette, also a painter, and in the mid-thirties the Hurds moved to their new home, the ranch at San Patricio, New Mexico. It was after *Life* magazine did a short essay on him that broad recognition came to Hurd.[3] In 1942 he was elected to the National Academy of Design.

During World War II, *Life* had Hurd classified with the rank of captain and attached to the 8th Air Force in England, where his assignment under the additional auspices of *Life* magazine was to paint the life of Britain at war. Later he was transferred to India. There he found, under the influence of his brother-in-law Andrew Wyeth, expression in watercolor, using the medium as had Wyeth, to record the momentary scenes of wartime. The influence was a reciprocal one, for earlier both N. C. and Andrew Wyeth had learned from Hurd the essentials of tempera painting on gesso. Hurd's wartime assignment brought an increased sharpness of detail to his work. An earlier more lyrical style gave way to the less adorned, more sparse visual response that would typify his paintings of western scenes, exemplified in *Picacho Valley, Chavez Ranch*.

During the 1950s and 1960s, Hurd continued to work for the Time-Life Corporation, painting more than a dozen covers for *Time* magazine, the most notable being that of President Lyndon B. Johnson as the 1964 Man of the Year.[4] As a result, Hurd was chosen to paint Johnson's official portrait. When the portrait was completed, the president rejected it, saying the work was too large.[5] The painting was given to the National Portrait Gallery in Washington. Despite that incident, Hurd continued to paint portraits. His reputation, however, was built on murals and easel paintings of landscapes depicting the desert and foothills of the ranch country he considered home. P. D. H.

1. Telephone conversation with Diana Badger, Sentinel Ranch, New Mexico, May 1986.
2. *Life*, July 24, 1939, p. 24.
3. Ibid.
4. The painting for the 1964 Man of the Year cover was painted by Hurd jointly with his wife, Henriette.
5. "L.B.J. on Canvas," *Newsweek*, February 7, 1966, p. 19; M. S. Young, "The Ugliest Thing I Ever Saw," *Apollo* 85 (April 1967): 297.

Egg tempera on gesso on panel
24⅝ × 47¼ inches (sight)
Inscription: signed lower left "PETER HURD"; verso,
"The Chavez Ranch, San Patricio, N.M. Cleaned and
varnished with Liquitex matt varnish, 1962"
Lent by C. R. Smith

Picacho Valley, Chavez Ranch
1945

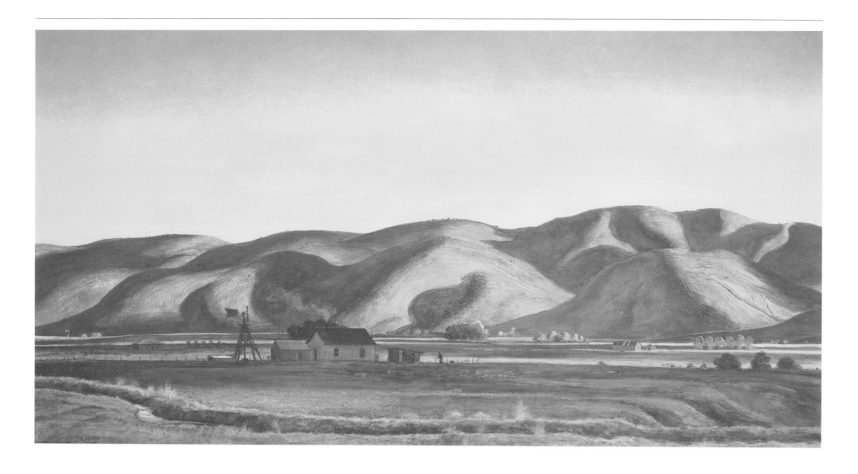

Frank Tenney Johnson

b. 1874, Big Grove (now Oakland), Iowa; d. 1939, Alhambra, California

Pursuing his interest in recording the vanishing frontier, Johnson made his first trip to the West and Southwest in 1904 on a train pass provided by *Field and Stream* in exchange for illustrations. Via train and then stagecoach Johnson traveled to Hayden, Colorado, to participate in and record a cattle roundup. His extended trip took him from Cheyenne to Santa Cruz photographing and sketching scenes he used for the rest of his career. Because of his association with cowboys, trappers, and Indians, Johnson's paintings and illustrations of frontier subjects for *Field and Stream, Cosmopolitan, Harper's,* and novels by Zane Grey were admired for their authenticity and accuracy of detail. Critics proclaimed that "his canvases will be the last painted by one who lived on a frontier that passed into history when the twentieth century began."[1]

On his first trip to the Southwest, Johnson wrote a letter to his wife in New York City describing his impressions of an exotic land: "I never saw a more beautiful night. The adobe houses shown up so clear and white in the approaching moonlight that I wanted to paint them just as I saw them."[2] Johnson developed a distinctive technique of applying a vermillion underpainting to deepen and enrich the night colors of his paintings. He became known for his depictions of moonlit night scenes of the Southwest. During the 1910s and 1920s such romantic "nocturnes" won Johnson critical praise. In 1923 a painting of a rugged Mexican traveling with a laden burro by lamplight won a $1,000.00 prize at the Salmagundi Club's annual exhibition in New York. Other paintings by Johnson of similar themes include *A Mexican Smuggler, Beneath a Southern Moon,* and *Mexican Nocturne.*

For Johnson the nostalgia for the disappearing frontier was eclipsed by the intrigue of the Mexican Revolution of 1910. Johnson used the subject to create this dramatic night scene. It presents a hushed moment with the revolutionary figures gathered on the street. Men in sombreros and sarapes are silhouetted against the green-black darkness. An acid yellow light from an open door creates mysterious shadows, which cloak the conspirators. The tension of the night colors and arrested action reinforce the clandestine nature of the scene. F. C.

1. Fred Hogue, "Nocturne Paintings Depict Frontier Days," *Los Angeles Times,* November 1, 1936, Archives of American Art, microfilm 1264, frame 821.
2. Harold McCracken, *The Frank Tenney Johnson Book,* p. 83.

Oil on canvas
24¼ × 18⅛ inches
Inscription: signed and dated lower left "Frank Tenney
Johnson 1919"
Gift of C. R. Smith
G1976.21.18P

Mexican Revolutionaries
1919

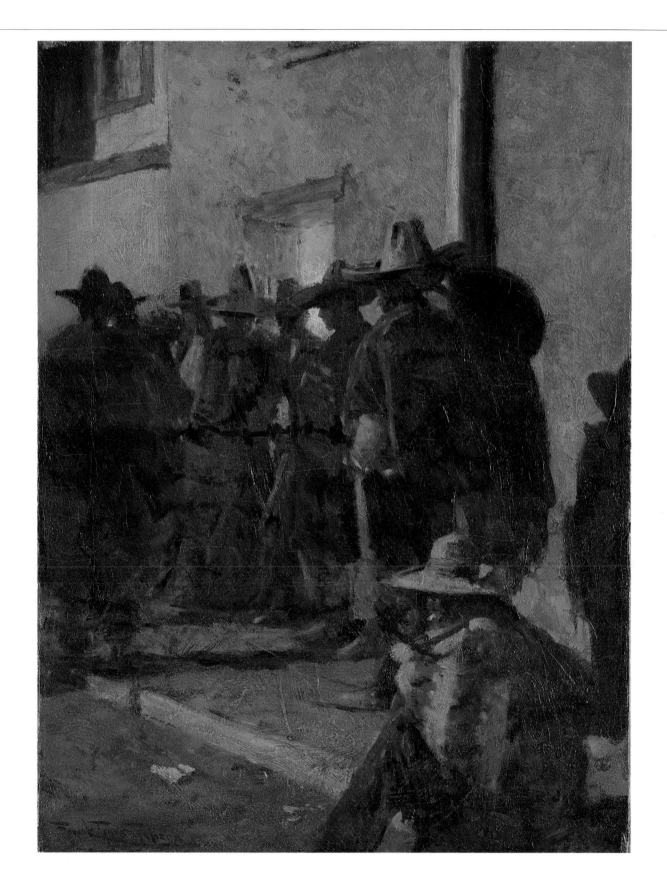

Frank Tenney Johnson

b. 1874, Big Grove (now Oakland), Iowa; d. 1939, Alhambra, California

Fifty-five years after the tragic event, painter Frank Tenney Johnson eulogized the heroism and drama of an unfortunate event in Indian-Anglo relations known as Thornburgh's Battlefield. In a scene reminiscent of an action-packed Saturday matinee, Johnson pictures the brave cavalrymen defending themselves against warring Indians at a critical moment in the battle. Attention is focused on the plight of the cavalrymen as Indians on horseback circle in the distance. A frightened horse that has lost its rider rears as a symbol of the danger and excitement of the battle. An ominous white skull reveals the grim outcome of the battle. Swirls of dust cloud the action on the battlefield, just as legend obscures the historical accuracy of the painting.

In 1879 near Milk River in Colorado, two hundred soldiers commanded by Maj. Thomas T. Thornburgh fought more than three hundred Ute Indians in a week-long struggle. The skirmish began accidentally with an ill-conceived attempt by the U.S. government to agrarianize the Utes on the White River Reservation. A contemporary newspaper engraving presented a desperate picture of the bloody battle that developed, showing Thornburgh's men firing over a barricade of dead horses and supply barrels to protect their wounded, who were huddled in a pit. Before reinforcements arrived, Thornburgh and eleven of his men were killed and forty-three were wounded; thirty-seven Utes were killed. This battle, along with the murder of the U.S. Indian agent on the reservation, became the U.S. government's final justification for banishing almost all of the Utes to a reservation in Utah.

Although Johnson had success as an illustrator of western subjects, the historical nature of the subject of this painting is unusual. Johnson typically portrayed Indians, settlers, and cowboys.[1] From his boyhood days in Iowa when he watched the westward traffic on the Missouri River, he was fascinated with frontier subjects. When his family moved to Milwaukee, he was apprenticed to panorama painter and watercolorist F. W. Heinie and later studied with Richard Lorenz, a painter of western subjects and a former Texas Ranger who encouraged Johnson to record the disappearing frontier. Johnson studied briefly at the New York Art Student's League, first with John Twachtman and later with Robert Henri.

There he acquired the painting technique of using heavy impasto and extensive overpainting that is characteristic of his mature work.

Thornburgh's Battlefield was painted in 1934 at the height of Johnson's career. The work succeeds in depicting action, excitement, and motion of battle. Unlike Remington's static figures in *The Last Stand* (in a private collection), Johnson's figures are engrossed in action. The foreground of sagebrush, the middleground of heated battle, and the background that dissolves in a swirl of dust are united in a comprehensive, dynamic whole. Despite this vortex of action, the composition is tightly controlled, anchored by the clear depiction of a strong soldier's face in the center of the canvas. The face could be modeled after John Wayne, William Boyd, Gene Autry, or any of the stars of western movies during the Golden Age of the Western in the early and mid-thirties.[2] The scene is reminiscent of the climactic shoot-outs of such films as *Sutter's Gold* (1936) or *Cavalry*. After moving permanently to Alhambra, California, in 1921, Johnson became familiar with the stylistic conventions of the cinema. His studio, which he shared with Clyde Forsythe, not only became a meeting place for such artists as Charles Russell, Ed Borein, and Eli Harvey but also was frequented by Hollywood stars. Johnson's friends and patrons included Douglas Fairbanks and James Cruze, one of Hollywood's top directors of westerns.[3]

A few years before his death, Johnson was accepted as a full member of the National Academy. He received numerous prizes for his work, which recalled the heroic days of the American frontier and presented a reassuring image of heroism and sacrifice far from the stark realities of the Depression era. F. C.

1. Harold McCracken, *The Frank Tenney Johnson Book,* p. 142.
2. George N. Fenin and William K. Everson, *The Western: From Silents to Cinerama,* p. 193.
3. McCracken, *The Frank Tenney Johnson Book,* p. 138.

Oil on canvas
40½ × 50½ inches
Inscription: signed "F. Tenney Johnson 1934 ANA"
Gift of C. R. Smith
G1976.21.19P

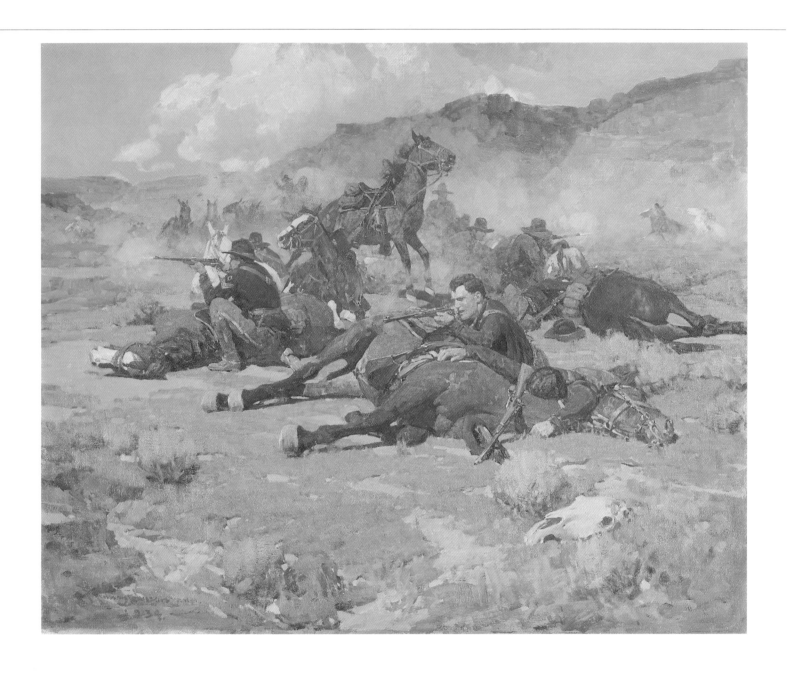

Tom Lea

b. 1907, El Paso, Texas

In the spring of 1940, after a tour through Longhorn country with noted southwestern historian and writer J. Frank Dobie, Texas artist Tom Lea designed this scale painting of the *Stampede*. Later that year it was commissioned to be reproduced as a 15½-foot mural in the Odessa, Texas, Post Office by the U.S. Treasury Department's Section of Fine Arts, an agency that encouraged wholesome national subjects for public works. Still extant, the mural is an object of civic pride. Subsequently, the *Stampede* was reproduced on the cover of Dobie's book *The Longhorns*.[1] Later, between 1955 and 1960, Lea presented the scale painting to C. R. Smith, a Texan whose friendship he treasures, as he said, "trying to make return for a gift."[2]

Lea's subject was inspired by the importance of the theme in popular Texas culture. The mythology of the stampede had its earliest expression in many nineteenth-century trail-drivers' songs. According to Lea himself, it is especially "Little Joe, the Wrangler," a song of a valiant cowboy struggling to calm nature gone wild, that describes the atmosphere and action of the painting:

We was camping on the Pecos when the wind
 began to blow,
And we doubled up the guard to hold them tight,
When the storm came roaring from the north
 with thunder and with rain,
And the herd stampeded off into the night.

'Midst the streaks of lightnin' a horse we could
 see in the lead,
'Twas Little Joe, the Wrangler, in the lead;
He was riding Old Blue Rocket with a slicker
 o'er his head,
A tryin' to check the cattle in their speed.[3]

Dobie's *The Longhorns*, a well-received volume devoted entirely to the old Texas breed for which the artist had been commissioned to design accompanying illustrations, also filled Lea's imagination with frantic, charging cattle and powerful, courageous cowhands. Lea had read the book in manuscript format while contemplating the design for the Odessa Post Office mural and decided to include a color painting of a stampede as part of the illustration commission. At the same time, he planned that the color painting would serve him well as a scale painting for the Post Office mural. The subject was obviously suitable to the

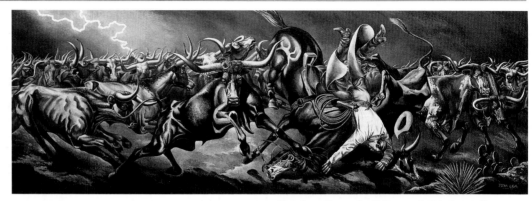

Tom Lea, *Stampede,* 1940, mural, U.S. Post Office Lobby, Odessa, Texas. (Courtesy Tom Lea.)

site—the Odessa Post Office was located some seventy miles from an old cattle crossing on the Pecos River.[4]

In the same tradition as his sources, Lea's painting not only recalls the days of the nineteenth-century cowboy but, more importantly, it also eulogizes these first Texans. Here Lea depicted the nineteenth-century Longhorn consciously evoking the "epic times of drivers on long trails . . . ,"[5] an important period in Texas history. After the Civil War, the state's financial recovery was built on the cattle industry. Between 1866 and 1890 approximately ten million Longhorns were driven over Texas borders to northern markets.[6] But the Longhorn was important for more than financial reasons. A Texan's identity was inextricably entwined with the beast he drove to market. Not only have Texans found that their state "looks somewhat like a roughly skinned cowhide spread out on the ground," but "like the cattle themselves, the early day range men and their horses were made of rawhide . . ."[7] By focusing on the stampede and thus on the wildness of the nineteenth-century Longhorn, Lea memorialized for posterity the courage of the cowboy who willingly faced death. The artist did not concentrate on the gory details but emphasized danger through the use of dramatic composition, highly stylized form, and dissonant color.

Lea's reverential attitude toward Texas history as witnessed by the *Stampede* was heavily influenced by his childhood. Born in El Paso in 1907, Lea was raised there amid important men and impressive events. As a child, he watched through a telescope the Mexican Revolution unfold across the river in Juárez. His father, a one-term reform mayor, earned the enmity of Pancho Villa, who offered a $1,000 reward for the mayor's capture— dead or alive. In such an ambience, the young man's imagination and his fascination for Texas were kindled and by the mid-1930s, after extensive training at the Art Institute of Chicago under muralist John Norton, Lea began to focus on and glorify Texas in his own murals. One of his first murals, *Pass of the North* (1937), still visible in the El Paso courthouse, foreshadows the romanticism of the *Stampede*. It celebrates the "giants" of the past—the pioneer, the missionary, the conquistador, the cowboy. Not interested in depicting human foibles, Lea has declared, "I am not much engaged by things I cannot admire. A subject doesn't interest me except by its power, the texture and quality that denotes character."[8] N. B.

1. The commission was not won in competition but was awarded as a "kind of consolation prize after my designs lost the Section's big national competitions" for the St. Louis Post Office (Tom Lea, letter to N. B., November 6, 1983). In another letter, dated April 26, 1975, to Elizabeth Roberts, Research Assistant, Archer M. Huntington Art Gallery, Lea stated the scale design occupied him from April 24 to June 3, 1940, and the mural itself

"engaged me from 13 August to 5 October 1940." In 1941 the *Stampede* appeared in color on the cover of *The Longhorns.*
2. Tom Lea, letter to N. B., November 6, 1983.
3. Tom Lea, *A Picture Gallery*, p. 35, supplies the first verse; the subsequent stanza is from John Lomax, *Cowboy Songs and Other Frontier Ballads*, pp. 167–169.

4. Lea, *A Picture Gallery*, pp. 35–39.
5. Ibid., p. 35.
6. J. Frank Dobie, *The Longhorns*, p. xvii.
7. Ibid., pp. 26, 191.
8. John O. West, *Tom Lea, Artist in Two Mediums,* p. 19.

Oil on canvas

14⅜ × 34¼ inches

Inscription: signed lower right "Tom Lea"; lower right outside picture margin, "To C. R. Smith from his friend Tom Lea"

Gift of C. R. Smith

G1976.21.20P

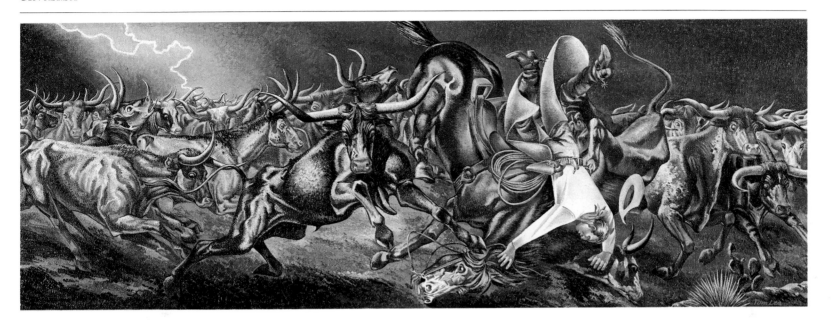

Tom Lea

b. 1907, El Paso, Texas

"A current theme grips me often, the image of a man and a horse . . . in the space of the land."[1] In such pictures land becomes symbolic of its inhabitants' characters. Lea typically emphasizes the harshness of the surroundings in order to extol the virtues of the men of rawhide who have endured in the Southwest. At first, the rosy sentiment of *The Year It Rained* seems unusual. Here Lea depicts a land of rich grasses and fattened beef and makes an obvious allusion to the pot of gold at the end of the rainbow. But the title suggests the singularity of a prosperity brought by rain. Moreover, the wizened old rancher, whom the artist describes as "a hardy survivor of many a drought and bitter hardship on dry pastures,"[2] is an emblem reminding us of a theme prevalent in Lea's later work: nature in West Texas is not usually so kind.

After World War II and his experiences as a war artist-correspondent for *Life* magazine, Lea's interests changed. He was no longer devoted to the romantic ideals investigated in his earlier, government-sponsored murals. Since the late 1940s he has explored feelings in smaller, more intimately scaled paintings and novels. *The Year It Rained* was commissioned by C. R. Smith.[3] It recalls a 1939 design, *Men of the Field,*[4] submitted in competition for the St. Louis Post Office mural. In both works figures are set in fertile landscapes with rainbows in the background. However, differences in tone reflect the change in the artist's attitude. *Men of the Field* lauds the industry of the American farmer. The broad, hearty figures, the prosperous landscape, and the rainbow that ends in a recently planted field all cheerfully promise the riches obtained through labor and agriculture. In *The Year It Rained* there is little of the younger man's romantic idealism as the old rancher in the grip of nature is controlled by exterior forces. From Lea's own novels, such as *The Wonderful Country* (1952) and *The Primal Yoke* (1960), to paintings like *A Little Shade* (1968, Texas Ranger Museum, Fort Fisher, Waco, Texas) and *The Year It Rained,* this theme dominates much of his mature work.

A subtle change in style accompanies the artist's shift in attitude. In *The Year It Rained* a more realistic approach has succeeded the stylization of earlier more heroic works like the *Stampede.* This shift betters suits Lea's aim for meaningful content. As he explained a few years ago, his pictures "are intended to be not exercises in aesthetics or performances for the sake of technique, but records and representations of experience from life."[5]

N. B.

1. Tom Lea, *A Picture Gallery,* p. 123.
2. Tom Lea, letter to N. B., November 6, 1983.
3. C. R. Smith to Donald Goodall, June 4, 1975, Registrar's files, Archer M. Huntington Art Gallery.
4. See Lea, *A Picture Gallery,* p. 33, for *Men of the Field.*
5. Ibid., p. vii.

Oil on canvas
36⁵⁄₁₆ × 28³⁄₁₆ inches
Inscription: signed lower right "Tom Lea 75"; upper
left corner: "The Year It Rained painted in the spring
of 1975 at El Paso"
Gift of C. R. Smith
G1976.21.21P

The Year It Rained
1975

William Robinson Leigh

b. 1866, Berkeley County, West Virginia; d. 1955, New York, New York

The Roping presents the ideal cowboy: rough, lean, and capable of manipulating a lariat while riding a horse at full gallop and keeping his eye on a herd of stampeding cattle. From the chaps to the Colt 45, the cowboy's costume and gear are meticulously recorded. Leigh's interest in authenticity began with his first trip west in 1906. Leigh devoted his art career to capturing and solidifying the image of the cowboy and the Indian and their special chapter in American history.

This painting was reproduced in the June 15, 1915, issue of *Mentor Magazine* with the title *The Roping* and a copyright date of 1914.[1] The *Mentor* article announced, "Mr. Leigh, who was born in West Virginia in 1866, has been well known for years as a magazine and book illustrator, and has lately come into a new renown as a painter of great western pictures."[2] Leigh's reputation had grown with exhibitions at the Snedecor Babcock Gallery and an invitation to join the Allied Artists of America in 1914 along with Frank Tenney Johnson.

From 1906 to 1914 Leigh's work was characterized predominantly by landscapes in the grand manner of Thomas Moran, who had urged Leigh when they met in 1908 to paint American subjects.[3] *The Roping,* which focuses on the figure, is a sharp departure from the early emphasis on landscape. The simplicity of the composition and immediacy of the subject matter are reminiscent of Leigh's illustrations. *The Roping* is the first of at least nine works completed between 1914 and 1943 that portray single cowboys on galloping horses. These works are similar in composition and theme, and all have titles that suggest action and adventure. F. C.

1. At some point after C. R. Smith acquired this painting the title was referred to as *Scatter Out and Head 'Em Off.* This painting may be the work entitled *The Roper* owned by Maurice Heckscher in 1933 (see William R. Leigh, *The Western Pony,* p. 115).

2. Arthur Thoeber, "Painter of Western Life," *Mentor Magazine,* June 15, 1915, p. 11.

3. D. Duane Cummins, *William Robinson Leigh: Western Artist,* p. 86.

Oil on canvas
40 × 30 ¼ inches
Inscription: None
Gift of C. R. Smith
1984.92

The Roping
1914

William Robinson Leigh

b. 1866, Berkeley County, West Virginia; d. 1955, New York, New York

Each summer between 1912 and 1927 artist William Leigh would leave his midtown Manhattan studio and travel to Indian reservations in the Southwest to study, sketch, and photograph Indian life and to collect artifacts. A critic claimed in 1917 that Leigh had "amassed a knowledge of his favorite work that no one living today uses with so much intelligence when it comes to the test of pictorial representation."[1] Accuracy of detail based on first-hand observation was considered a hallmark of authenticity. Leigh included detailed depictions of the Indian pony and burro in a majority of major paintings and in over a dozen oil studies. According to Leigh's biographer, D. Duane Cummins, in 1922 Leigh gave the Prince of Wales a small painting entitled *Navaho Pony*.[2] The C. R. Smith Collection contains three such small paintings, each presenting a single beast of burden saddled and standing in full sun with no hint of landscape and no rider. These three works could have been painted as early as 1915, as later inscriptions on the backs of the paintings suggest, or as late as 1933.

Paintings entitled *Hopi Transportation* and *Navajo Pony* in the C. R. Smith Collection were reproduced in *The Western Pony*, a 1933 book written and illustrated by Leigh. This was Leigh's second successful book, a culmination of his long interest in the Southwest and the western horse. Leigh writes from a nostalgic perspective and displays a will to preserve the values and images of the Old West: "I find in the West the truely typical and distinctively American motifs, a grandeur in natural surroundings, a dramatic simplicity in life which can be found nowhere else. In that life, in those surroundings — marvelously varied and abundant — the horse plays a major role."[3] Leigh illustrated *The Western Pony* with reproductions of eighteen drawings of riding gear and wild animals — the natural enemies of the horse — as well as six color reproductions of paintings of various types of horses. He describes the horse used by Indians as "a product of down-breeding" and "a smaller horse than the mustang; shorter in the leg and heavier in the body."[4] Leigh painted both *Hopi Transportation* and *Navajo Pony* at the Navajo Reservation at Keams Canyon, Arizona.

Hopi Transportation[5] presents a wiry gray pony standing in profile with reins "tied to the ground"[6] in Indian fashion and outfitted with a western saddle and red Navajo blanket. The horse peers wearily at the viewer with a bloodshot eye. Concerning this image, Leigh indicates his typical disdain of Indian horsemen: "An Indian pony, small, vindictive, he lugs a perpetual grouch; he has never known kindness, or justice, and all men look alike to him."[7]

Navajo Pony[8] bears the wooden, bow-shaped saddle of Indian design with a traditional Navajo blanket. In this painting of a white horse Leigh demonstrates his remarkable skill as a draftsman. Dry, thick paint is layed with authority that recalls Leigh's early training in Munich. Yet the free and energetic use of color in the purple shadows and pink highlights reveals an interest in the impressionist technique.

Navajo Burro[9] did not serve to illustrate *The Western Pony*, yet it is identical in concept and composition to the other paintings of horses. *Navajo Burro* was painted in Polassas, Arizona. Although Leigh was vocal in his disapproval of French schools of art, impressionist brushstroke and color, which define the burro's motley coat with flecks of yellows, oranges, and deep blues, are central to this work. Leigh, who often painted the docile burro, wrote with compassion, "The Navaho's burro is often seen with abbreviated ears — or no ears — they have been amputated as punishment for breaking into cornfields."[10] F. C.

1. Archives of American Art, microfilm 1264, frame 829, quotation attributed to W. B. McCormick of *The Press* in a 1917 brochure for an Exhibition of Paintings by William R. Leigh at the Mohr Art Galleries, Toledo, Ohio.
2. D. Duane Cummins, *William Robinson Leigh: Western Artist*, p. 110.
3. William R. Leigh, *The Western Pony*, p. 96.
4. Ibid.

5. *Hopi Transportation*, previously identified as *Navajo Pony*, is reproduced in the following: June Dubois, *William Robinson Leigh: Art of Frontiers*, p. 111, and Leigh, *The Western Pony*, p. 41. Curiously, the illustration in *The Western Pony* does not include a brand on the animal, whereas the illustration in *William Robinson Leigh* clearly shows a brand, as does the painting.
6. Leigh, *The Western Pony*.
7. Ibid.

8. *Navajo Pony*, previously known as *A Hot Day*, is reproduced on p. 27 of Leigh, *The Western Pony*, and p. 136 of Dubois, *William Robinson Leigh*. The reproduction in *The Western Pony*, the earlier publication, does not include a brand, but the book *William Robinson Leigh* and the actual painting both include a brand on the pony.

Oil on canvas
Inscription: signed lower right "W. R. Leigh"
Gift of C. R. Smith

13 × 16¾ inches G1976.21.23P

13⅜ × 16⅞ inches G1976.21.22P

13½ × 16¾ inches G1976.21.24P

9. *Navajo Burro,* previously known as *Hopi Burro* or *Hopi Transportation,* is reproduced in Dubois, *William Robinson Leigh,* p. 97.
10. Leigh, *The Western Pony,* p. 87.

Peter McIntyre
b. 1910, New Zealand

Peter McIntyre's landscape is painted from a bird's-eye view that singles out the Longhorn Ranch, Madison Valley, Ennis, Montana. Interrupted only by unobtrusive constructions marking the ranch, a swath of open landscape underscores the thematic presence of the Big Country. In the state of Montana, McIntyre encountered one of the few remaining areas in this country where the land can be felt to dwarf its inhabitants, and where the sense of wonder evoked by earlier frontier expanses can be revived in the mind and feelings. Alternately, under McIntyre's brush, the land, though of giant proportions, seems tame and docile, representing a settled or arcadian west.

C. R. Smith, upon seeing reproductions of McIntyre's paintings, wrote to the artist in New Zealand and, finding that McIntyre planned to paint a series of paintings on the American West, invited McIntyre to stay with him on his Longhorn Ranch near Ennis, Montana. McIntyre did stay with Smith and the two became friends. It was during this time that McIntyre painted the Longhorn Ranch.[1] In an unusual circumstance, McIntyre's involvement with the American landscape links the New Zealander to a lasting artistic tradition in this country based on a public philosophy of free will and at times pantheistic beliefs. These have found expression for the American artist in the open spaces and grandeur of the western landscape. Such tributes to the land find continuing confirmation today in the work of many artists whose sentiments are supported by equally committed collectors.

Born in New Zealand and presently living in Wellington, Peter McIntyre has spent the major part of his life in that area. However, he has traveled extensively, particularly during the period of World War II. After attending the Slade School of Art in London, he remained in that city as an artist for nine years. When war was declared in 1939, McIntyre joined a New Zealand unit composed of Londoners, which was sent to join another unit in Egypt. There he became the group's official artist, attaining the rank of major. In that capacity, he covered the battles of one military division throughout the war. In Greece, Crete, Egypt, Libya, and Italy, he developed a continuity of subject matter that provided a remarkable historical record. Painting the expected number of military portraits, McIntyre also covered many battle scenes. These were executed with a quick virtuosity, preserving action and realism. Some of his works from the war were acquired by the New Zealand government for the national collection, to be placed on permanent exhibition at the Art Museum at Waioru. McIntyre has said that he wants to emphasize that he is not prowar and, in fact, he is "dead against war" and that he hates "it as only a man who has seen it can hate it."[2] McIntyre remains an active participant in New Zealand art exhibition programs; the most recent exhibition of his work being held in Auckland at the John Leech Gallery in summer 1986. P. D. H.

1. Telephone conversation with the artist, August 1986.
2. Ibid.; "War Memories Recalled," *The Press* (Christchurch), November 24, 1981.

Oil on canvas
23⅜ × 33½ inches (sight)
Inscription: signed lower right corner "Peter McIntyre"
Gift of C. R. Smith
G1976.21.25P

Longhorn Ranch, Madison Valley, Ennis, Montana
1971

Alfred Jacob Miller

b. 1810, Baltimore, Maryland; d. 1874, Baltimore Maryland

Wind River Mountain Range Scene,[1] a romantic portrayal of a lake encircled by the Wind River Range of Wyoming, is the result of Alfred Jacob Miller's travels to the region in 1837. Earlier that year Miller left Baltimore to seek his fortune in the more adventurous city of New Orleans. He soon found it in Capt. William Drummond Stewart, a former British army officer who was then attached to the American Fur Company. The adventurer sought Miller to record visual "souvenirs" of Stewart's last fur-trading expedition into the Rocky Mountains. Enticed by the chance to gather a wealth of artistic inspiration, Miller assented. The journey lasted six months, ending on the banks of the Green River in Wyoming at the raucous annual rendezvous of fur traders.

Miller was the first artist to venture into the Wind River region and he was enchanted by the dramatic beauty of this virtually untouched western wilderness. In particular, he maintained a fondness for the mountain lakes, which he frequently incorporated into his canvases, exclaiming "they are now as fresh and beautiful as if just from the hands of the Creator."[2] *Wind River Mountain Range Scene* presents a lone Indian dressed in full regalia on horseback, dwarfed by the atmospheric mountains beyond. While the figure stands on a tiny bluff in the left foreground, another Indian races up behind him. Miller's predilection for such compositional arrangements in his landscape paintings links him to contemporaries of the early Hudson River School.

A watercolor almost identical to *Wind River Mountain Range Scene* was produced between 1858 and 1860 as one of a set of two hundred replicas of Miller's earlier western watercolor sketches at the request of a major patron, Baltimore collector William T. Walters. Unfortunately, Miller did not date the oil version. However, his habit of reworking the same scenes over the course of his later career suggests that it was also produced after the original watercolor, ca. 1858–1874.[3]

Despite such jewellike paintings as *Wind River Mountain Range Scene,* landscape was not Miller's primary concern. After he returned to Baltimore, Miller's patrons frequently requested landscape scenes. However, the artist preferred to paint the portraits and escapades of the Indians and trappers he witnessed during his first and only trip west. The artist's landscapes have been described as small and pinched by some critics in contrast to the grandiose depictions of nature by artists like Thomas Moran and Albert Bierstadt. In fact, Miller once insisted that in the case of one of his western landscapes it would have required the pencil of "a Stanfield, Turner, or Church" to provide the full effect.[4] Yet, Miller's gift to the viewer is not in portraying large, theatrical canvases or in conveying seemingly scientifically accurate scenery like his compatriots. His ability lay in depicting quiet and more gently tempered visions of the American West. C. A.

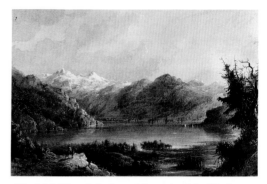

Alfred J. Miller, *Lake Scene, Mountain of the Winds,* ca. 1858–1860, watercolor, 9³⁄₁₆ × 13⁹⁄₁₆ inches. (Courtesy Walters Art Gallery, Baltimore.)

1. The title of this painting at the time it was acquired by Mr. Smith was *Wind River Mountain Range Scene;* he changed it to the more romantic *The Sirens Were Singing from the Tops of the Peaks.*
2. Ron Tyler, ed., *Alfred Jacob Miller: Artist on the Oregon Trail.* p. 9.
3. Two other small undated works by Miller, *Trappers Enroute to the Rendezvous* (Gund Collection of Western Art, Cleveland, Ohio) and *The Lake Her Bosom Expands to the Sky* (Dallas Museum of Art), were once in Mr. Smith's collection. They exhibit a similar idealized, somewhat melancholy mood as that of *Wind River Mountain Range Scene.* The artist's stylistic preference for soft, diffused light and dramatic contrasts reflects Miller's brief European training in Paris in 1833, when he copied works by Rembrandt and the more recent romantic master Delacroix.
4. Tyler, *Alfred Jacob Miller,* p. 34.

Oil on panel
10 × 16⅛ inches
Inscription: lower right, "Miller"
Lent by C. R. Smith

Wind River Mountain Range Scene

ca. 1858–1874

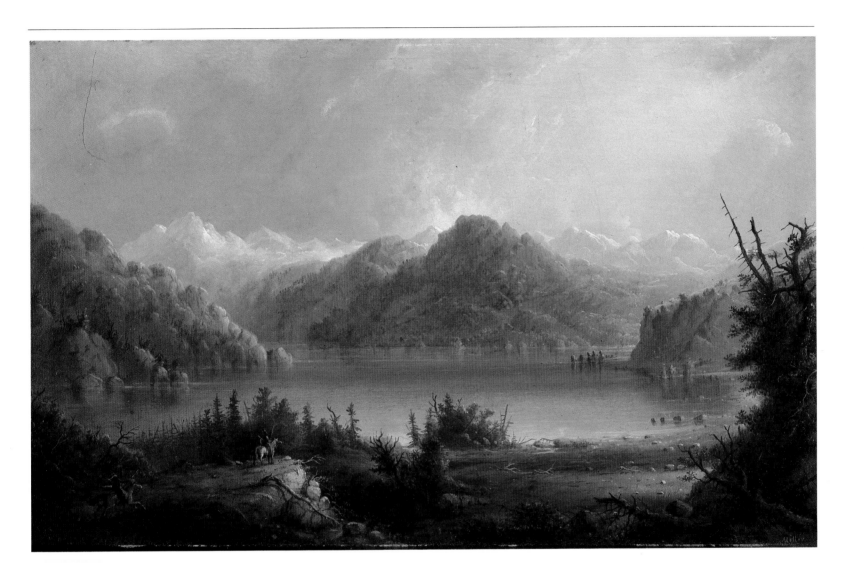

Thomas Moran

b. 1837, Bolton, Lancashire, England; d. 1926, Santa Barbara, California

When the thirty-eight-year-old Thomas Moran painted *The Golden Hour,* he was already a well-traveled and popular artist. In the preceding four years his visions of the western landscape had served to make the spectacular scenery of Wyoming, Idaho, and Montana more familiar and desirable to eastern Americans, who were initially quite skeptical of its reported features. In 1872 his first major oil, *The Grand Canyon of the Yellowstone,* made his fame when it sold to Congress for the astonishing sum of $10,000. Moreover, together with photographs taken by William Henry Jackson, *The Grand Canyon of the Yellowstone* presented the decisive evidence to Congress for establishing a national park there.

Writing in 1872 for the *New York Tribune,* critic Clarence Cook found that the success of *The Grand Canyon of the Yellowstone* stemmed from both its basis in nature and the artist's "eye of imagination [and] desire for beauty."[1] Painted three years later, his much smaller *The Golden Hour* is also an imaginative interpretation of nature. Moran depicts the towering cliffs of the Green River in southwestern Wyoming. Bereft of human presence, it is a primeval scene of majestic land forms enveloped in fiery-orange haze and surrounded by water. This painting, which is one of Moran's first versions of this particular locale, was probably based on watercolor sketches made on his trips through Wyoming in the summers of 1871 and 1872. In fact, this site held special memories for Moran as it was here in 1871 that he made his first western sketch.[2] The small size and loose brushwork of *The Golden Hour* mark it as unusual. From 1874 to 1885 Moran was busy with watercolor commissions, apparently completing very few oil paintings, most of which were large, important exhibition pieces. However, the monogram and date appear to be just as Moran used them in the mid-1870s, giving credence to the early date.[3]

Although he based his composition on studies of the geological and atmospheric phenomena of this area, Moran let his imagination filter his observations of nature. In *The Golden Hour* the cliffs have been placed closer together and lengthened to exaggerate their size and grandeur. The aristocratic forms of Moran's rocky towers seem to embody the notion of noted English aesthete and critic John Ruskin that "mountains of the earth are its natural cathedrals."[4] Similarly, Moran accentuated the glory of the western sunset. His sonorous color inspires noble feelings, an idea also found in Ruskin's writings, with which Moran must have been familiar.[5]

Art critics, similarly steeped in the values codified by Ruskin, approved this elaboration upon the raw material supplied by nature. G. W. Sheldon could have been referring to *The Golden Hour* when he wrote in 1878, "At last we have among us an artist eminently capable of interpreting the sentiment of our wilder mountain-scenery in a style commensurate with its beauty. . . . He is extremely felicitous in selecting his subjects and in bringing them within the conditions of pictorial treatment; he has a fine sense of the mysterious world of light and shade and of the color and glory of Nature. . . ."[6] N. B.

1. Clarence Cook, *New York Tribune,* May 3, 1872, Archives of American Art, microfilm N730, frame 62.

2. *Green River, Wyoming, First Sketch Made in the West* (Thomas Gilcrease Institute of History and Art, Tulsa).

3. I am indebted to Carol Clark, who made these observations (Archer M. Huntington Art Gallery, Registrar's files, Carol Clark to N. B., June 6, 1984).

4. This quote is taken from William H. Truettner, "Scenes of Majesty and Enduring Interest: Thomas Moran Goes West," *Art Bulletin* 58, no. 2 (June 1976): 225, n. 54, who in turn quotes from John Ruskin, *Modern Painters,* 4: 337, 368.

5. Ibid.; Truettner demonstrates that Moran must have been aware of Ruskin's writings from the onset of his career, well before the two met in 1882.

6. G. W. Sheldon, *American Painters,* p. 125.

Oil on canvas
9½ × 13⅝ inches
Inscription: monogram and date lower right, "TM
1875"
Lent by C. R. Smith

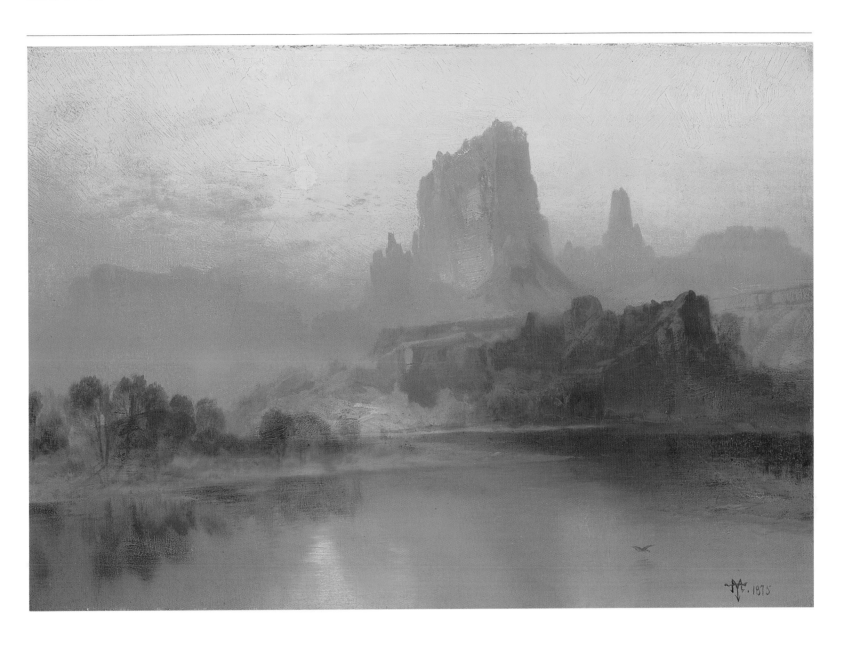

Ernest Étienne Narjot de Franceville

b. 1826, St. Malo, France; d. 1898, San Francisco, California

Partly because of its small size and lack of date, it is not clear to what purpose Ernest Narjot's painting *On the Warpath* was intended. It could be either a preliminary sketch or a completed work done as Narjot traveled into the countryside on horseback. He did make a number of such trips and, although he is reported to have sold these works often on his travels, some may have been retained as preliminary sketches for later works to be completed in his studio. He also painted sketches late in his life after he had become ill. The painting might also represent a detail from a somewhat larger work done by the artist. Painted quite thinly on a fine-thread canvas, it is mounted on millboard (as is at least one other similarly sized work by the artist).[1] It is impossible to tell from the condition of the mounting whether the work is a fragment or an independent composition. Conceivably, the painting could have been executed while Narjot was living in Mexico.

In style and in subject matter there are significant similarities between *On the Warpath* and others of Narjot's extant paintings.[2] Characteristically, the pattern of light falls down the periphery of the figures.[3] There are other important parallels, which may be found in the artistic devices of his compositions, such as the spatial treatment, the arrangement of mass, the larger patterns of light and dark, and the posture of man and horse.[4]

Ernest Étienne Narjot de Franceville was born in St. Malo, a port city on the coast of Brittany. Before he was sixteen, following the example of his parents and other family members who were artists, Narjot went to Paris to study art. At least in part due to accounts of the gold rush, he emigrated to California in the latter part of 1849, arriving in San Francisco, where he worked as an artist. After joining an 1852 mining expedition to Sonora, Mexico, Narjot stayed in Mexico for over a decade, continuing to paint. He returned to San Francisco in 1865.

Once back in San Francisco, Narjot opened a painting studio and achieved prominence in the area. In 1868 Narjot was featured in the press under the title "Art Beginnings in the Pacific," and at the notice of his death in 1898, a local paper captioned his portrait "the Oldest California Painter."[5] In 1936 he was referred to in the local press as the area's pioneer artist.[6] It is known that Narjot exhibited competitively in the San Francisco area through the state fairs, at which he was awarded medals several times for his paintings.[7] His work also was exhibited outside the California and Mexico area at least once, in Minneapolis, ca. 1892.[8] One of the first members of the Art Association, San Francisco, Narjot was a regular contributor to the association's exhibitions.[9]

His oeuvre was varied in its subject matter[10] and included portraits, images of pathos, trompe l'oeil still lifes, scenes of border life including battle scenes, men doing outdoor chores, and even swimming outings. He also painted festival and mythological scenes. In addition to easel work, Narjot did fresco painting for churches, theaters, and public institutions and some book illustrations.

He was commissioned in the early 1890s to decorate the Leland Stanford tomb on the Stanford University grounds at Palo Alto. During his work on the ceiling of the tomb, paint is reported to have fallen into his eyes.[11] When he returned home from Palo Alto he was ill and a doctor was called. His illness led to the loss of one eye, some paralysis, and progressive brain damage. For a time he continued to paint at intervals, but inevitably his abilities deteriorated. To benefit the destitute Narjot family, a sale of art work by his artist-friends was held shortly before his death. Thomas Hill was among the thirty artists who participated in that sale.

Due to the great earthquake in 1906, Narjot's work at the Stanford tomb was damaged; it was later replaced. Much of his easel work was also lost in the same catastrophe, for many of his yet unsold works had been stored at the San Francisco Art Association, where they burned in the ensuing fire. P. D. H.

1. *Placer Mining at Foster's Bar* (1851? 1854?), oil on millboard, 12³⁄₁₆″ × 14⅛″, signed and dated indistinctly, 1851 or 1854. (Joseph Armstrong Baird, *Catalogue of Original Paintings, Drawings, and Watercolors in the Robert H. Honeyman, Jr., Collection,* p. 102).

2. Additional confirmation of Narjot's use of Indian subject matter appears in the article "Art Beginnings on the Pacific," *Overland Monthly,* August 1868, which refers to Narjot's "figure compositions" of "the picturesque aboriginal and mixed races

of the coast" (Albert Dressler, *California's Pioneer Artist: Ernest Narjot, a Brief Resume of the Career of a Versatile Genius,* p. 6; also see reference to Indian subject matter in article on Narjot appearing in *The Wave,* September 12, 1891 [California State Library]).

3. Other examples include Narjot's *New Year's Festival in Chinatown, San Francisco, California,* 1888, and *The Sacrifice of a Druid Priestess,* 1881 (Dressler, *California's Pioneer Artist,* pp. 12, 14).

4. For example, see Narjot's *Wagon Train Approaching Hostile Indians* (exhibition catalogue, *California's Centennial Exhibition of Art,* section I, "Historic California," p. 42).

5. *Overland Monthly* (Dressler, *California's Pioneer Artist,* n.p.); *San Francisco Call,* August 25, 1898; *San Francisco Chronicle,* December 25, 1896.

6. Dressler, *California's Pioneer Artist,* title page.

Oil on canvas, mounted on millboard
9⅛ × 15⅜ inches
Inscription: none
Gift of C. R. Smith
G1976.21.29P

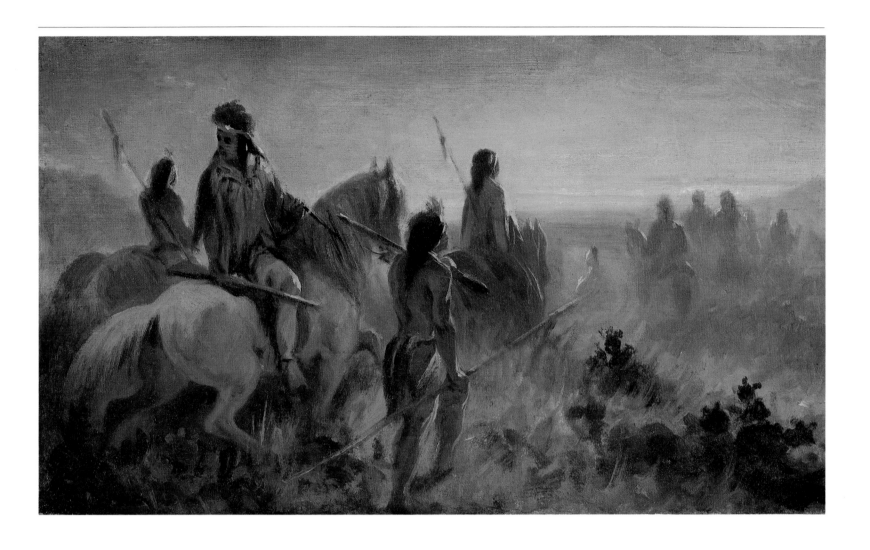

7. *Sacramento Record Union,* September 14, 15, 17, 1888, September 15, 1889; *Sacramento Bee,* September 20, 1889.

8. *The Bay of San Francisco, the Metropolis of the Pacific Coast and Its Suburban Cities: A History,* 2: 456 (reference provided by Kathleen Correia, California State Library, Sacramento).

9. "A Pathetic Case: Emil Narjot as He Is To-Day," *San Francisco Call,* January 28, 1894.

10. Dressler, *California's Pioneer Artist,* unnumbered illustra-

tions; *San Francisco Chronicle,* December 29, 1883 (*Moorish Girl*); *San Francisco Daily Evening Post,* June 18, 1881 (a reference to Narjot's painting depicting sportsmen hunting exhibited at "Morris & Kennedy's gallery"); *San Francisco Call,* December 25, 1896 (referring to Narjot's fresco work in California and Mexico); *Sacramento Union,* September 15, 1889 (illustration of Bret Harte heroine).

11. Ibid.

William Ranney

b. 1813, Middletown, Connecticut; d. 1857, West Hoboken, New Jersey

In William Ranney's *Halt on the Prairie,* two trappers en route to trade their furs are silhouetted against a brilliant yet desolate landscape. A description at the time the painting was first publicly exhibited observed of the trappers: "One is mounted: the other is standing, and engaged in adjusting his saddle-girth. The scene is the broad prairie, and the time is afternoon."[1] The mood is sedate; the figures are uncommunicative and pensive. Their isolation from civilization is heightened by the remoteness of the scenery. But Ranney admired the trappers' courage and resourcefulness in pursuing their lonely profession. These are noble, self-confident men and Ranney's admiration for them was shared by contemporary writers.

Washington Irving, for example, also used equestrian imagery to elevate the status of the contemporary trapper:

. . . "the Mountaineers," the traders and trappers that scale the vast mountain chains, and pursue their hazardous vocations amid their wild recesses . . . move from place to place on horseback. The equestrian exercises, therefore, in which they are engaged, the nature of the countries they traverse, vast plains and mountains, pure and exhilarating in atmospheric qualities, seem to make them physically and mentally a more lively and mercurial race than the fur traders of former days. . . . A man who bestrides a horse must be essentially different from a man who cowers in a canoe. . . .[2]

Halt on the Prairie is one of Ranney's first paintings dealing with the trapper theme, a subject he frequently depicted.[3] Signed and dated 1850, it was painted in the same year as such highly successful works as *The Trapper's Last Shot* (private collection). *Halt on the Prairie* was also well received. It was acquired by the American Art Union soon after its completion. Exhibited in November 1850 by the Art Union just prior to their annual distribution in December, *Halt on the Prairie* elicited the following praise: "Ranney's pictures tell their story with spirit and success. His later works bear the mark of industrious study, and all of them are favorites with the public . . . 'Halt on the Prairie,' is especially admired, not without reason . . ."[4]

By the time Ranney painted *Halt on the Prairie* the trapper's dominance in the West had been curtailed by the large numbers of settlers steadily streaming toward the Pacific. Paintings like *Halt on the Prairie,* then, did not document the western reality in 1850 but served to remind Americans of the admirable vanguard in the civilizing process.[5] The New York artist's outlook was not that of a chronicler, but that of the mid-century genre artist preoccupied with relating a romantic and idealized story to a largely urban audience for whom such subjects would have seemed exotic and remote. N. B.

1. Mary Bartlett Cowdrey, *American Academy of Fine Arts and American Art-Union,* 2: 295, no. 121.
2. Washington Irving, *Adventures of Captain Bonneville,* ed. by Edgeley W. Todd, p. 10. Dawn Glanz discusses the significance of the equestrian theme in trapper paintings by Ranney's contemporary Charles Deas and also quotes the passage from Irving (*How the West Was Drawn,* pp. 45–47; see also her discussion of Ranney, pp. 48–50).

3. Other trapper images include *The Trappers* (1851) and *Halt on the Plains* (n.d.) (see Francis S. Grubar, *William Ranney, Painter of the Early West,* p. 39, n. 57; p. 45, n. 86).
4. *New York Tribune,* November 27, 1850, p. 4. Although the work was pleasing, apparently it did not enjoy quite the same widespread attention as *Wild Duck Shooting — On the Wing.* No copies after *Halt on the Prairie* are known to have been made by Ranney or by anyone else (see Grubar, *William Ranney,*

pp. 34–35). A sale of the artist's work in 1858, shortly after his death, did include *A Sketch for Picture, Halt on the Prairie* (*Catalogue of Paintings to Be Sold for the Benefit of the Ranney Fund,* no. 93).
5. Glanz, *How the West Was Drawn,* p. 53.

Oil on canvas
37⅜ × 54⁵⁄₁₆ inches
Inscription: signed and dated lower center "W. Ranney
50"
Gift of C. R. Smith
1985.82

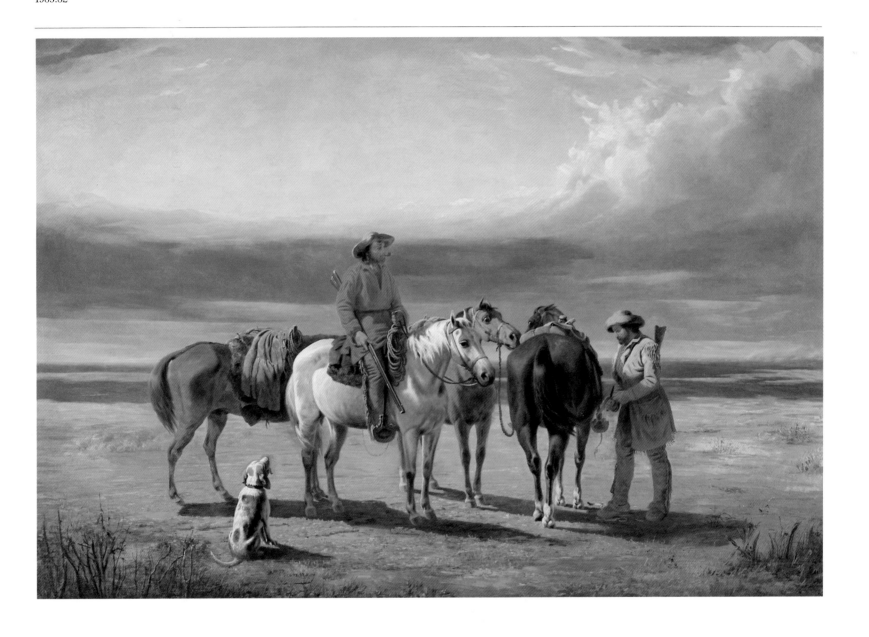

William Ranney

b. 1813, Middletown, Connecticut; d. 1857, West Hoboken, New Jersey

Wild Duck Shooting — On the Wing is one of William Ranney's better known sporting scenes.[1] The picture is neither signed nor dated, but its style is consistent with a version signed and dated 1850 and also entitled *On the Wing*, for which a pen-and-ink study is known.[2] The subject evokes a mood of tense yet frozen anticipation. As described in 1850, it depicts "a sportsman . . . waiting with his gun raised about to fire. Beside him is a boy with a powder-horn. A dog is ready to seize the bird the moment it falls."[3] In *On the Wing*, plainly dressed duck hunters dominate the shallow picture space delimited by the reeds of a marsh and invite scrutiny. Unlike their effete predecessors in eighteenth-century British sporting art, these figures are robust and strong. Their ennobling traits of simplicity and vigor were perceived as components of the national character and rendered the work appealing to contemporaries.

Like many artists of the time, Ranney frequently painted replicas of his more successful works. His first version of *On the Wing* met with immediate favor and marked the beginning of the artist's most successful period. It was exhibited in the National Academy of Design's Twenty-fifth Annual Exhibition in the spring of 1850 after Ranney's designation as an associate of the Academy that same year.[4] Subsequently, the painting was acquired by the American Art Union, which did much to publicize Ranney when Charles Burt engraved it for the October 1850 issue of the Art Union's *Bulletin*. The subject was apparently popular as Ranney also painted *Duck Shooting* (1850, Corcoran Gallery of Art) and *The Retrieve* (1852, present location unknown), both variations on the theme.[5] Copies were made after Burt's engraving by third parties and, later, Currier and Ives utilized the theme for lithographs.[6]

Ranney was known during his lifetime for sporting pictures like *On the Wing* and for romantic portrayals of the American trapper; only during the last ten years of his life did the artist explore the realms of genre and the American West. Little is known about the beginning of Ranney's training in Brooklyn in 1834. A brief trip west in 1836 to fight in Texas's struggle against Mexico is credited with enamoring him of "the picturesque in scenery and character,"[7] but upon his return to Brooklyn in 1837, Ranney supported himself with the more secure field of portraiture.

Ranney opened a studio in New York in 1843, then later in West Hoboken, where Henry T. Tuckerman visited him (during the 1850s). Tuckerman's description of Ranney's studio indicates that the artist still retained vivid memories of the West: " . . . guns, pistols, and cutlasses hung on the walls; and these, with curious saddles and primitive riding gear, might lead a visitor to imagine he had entered a pioneer's cabin or border chieftain's hut: such an idea would, however, have been at once dispelled by a glance at the many sketches and studies which proclaimed that an artist, and not a bushranger, had here found a home."[8]

It was in his Hoboken studio that Ranney began to paint genre scenes, a development no doubt encouraged by the contemporary flourishing of the American genre school. By this time, William Sidney Mount (1807–1868) had come into prominence in New York. The two artists were friends and Mount's successful venture outside the traditional realm of portraiture may have encouraged Ranney.[9]　　　　N. B.

William Ranney, *On the Wing*, 1850, oil on canvas, 29½ × 44½ inches. (Courtesy private collection.)

1. This painting was owned by the J. N. Bartfield Gallery in New York City and is catalogue number 46 in Francis S. Grubar, *William Ranney, Painter of the Early West*, p. 35. The label Grubar records in his catalogue is that on the back of Texas's painting and the measurements are virtually the same. The painting's title was changed to "Duck Shooters" by C. R. Smith when it entered his collection. It has since reverted to the name given by the artist (Registrar's file, Archer M. Huntington Art Gallery).

2. Grubar, *William Ranney*, p. 35, n. 46; p. 50, n. 129.

3. This description referred to the first version of *On the Wing* (see Mary Bartlett Cowdrey, *American Academy of Fine Arts and American Art-Union*, 2: 295, n. 224).

4. The *Bulletin* of the American Art Union, June 1850, p. 45, noted that William Ranney had been elected an Associate of the National Academy of Design (see Grubar, *William Ranney*, p. 20, n. 14).

5. Grubar, *William Ranney*, p. 35, n. 45; p. 36, n. 48; p. 40, n. 62.

6. Ibid., p. 35, n. 45; p. 54, n. 193.

7. Henry T. Tuckerman, *Book of the Artists*, p. 432.

8. Ibid., pp. 431–432.

9. Mount called Ranney "a glorious fellow," and after Ranney's death in 1857 Mount is said to have completed paintings left unfinished in Ranney's studio (see Bartlett Cowdrey and Hermann Wagner Williams, Jr., *William Sidney Mount, 1807–1868*, p. 5; Charles Lanman, *Haphazard Personalities*, p. 177 [noted in Grubar, *William Ranney*, pp. 10, 20, n. 17]).

Oil on canvas
32 × 45 inches
Inscription: none
Gift of C. R. Smith
G1973.14P

Wild Duck Shooting — On the Wing
ca. 1850

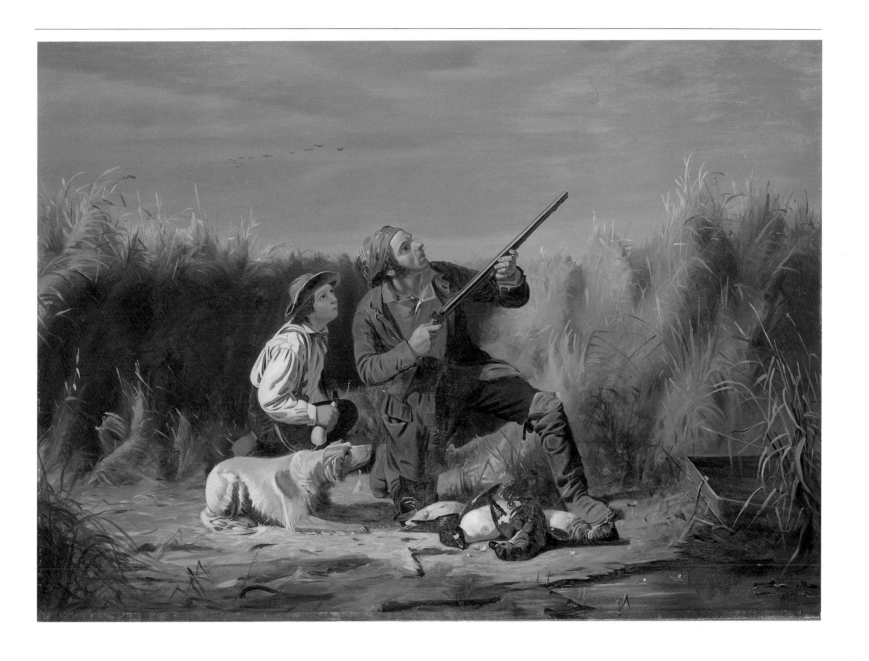

Hugo Robus

b. 1885, Cleveland, Ohio; d. 1964, New York, New York

The General, originally one of four casts,[1] was exhibited at the 1939 New York World's Fair and in 1942 at the Museum of Modern Art. It marks the beginning of Robus's long interest in the reduction of figures to geometric, curved volumes.

Born in Cleveland, Robus was first trained in the craft of jewelry. He became interested in painting, however, through his study at the Cleveland School of Art from 1904 to 1908 and later at the National Academy of Design. Typical of the time, Robus ventured to Paris where he studied painting at the Académie de la Grand Chaumière. Robus also entered the sculpture class of Antoine Bourdelle but soon rejected his French teacher's classicism and allegory for abstract form. Robus must have seen the 1912 exhibition in Paris of the works of Italian futurist Umberto Boccioni. From the time Robus returned to New York in 1915, his paintings exhibited the influence of futurist principles.

In New York, Robus found other artists, including Gaston Lachaise, Robert Laurent, and Elie Nadelman, who rejected traditional forms and embraced abstraction. At the Modern Art School, where Robus taught painting, the faculty included William Zorach and Oronzio Maldarelli, whose abstract works were grounded in the figure. The school's catalogue quoted the ideas of art critic Clive Bell in assertion that the figure is valid and substantive subject matter for modern art.[2]

In 1920 at the age of thirty-five, Robus became dissatisfied with painting and stopped exhibiting his work. He resigned from teaching painting and, with only a meager income from doing odd jobs, for a decade perfected his sculpture. He modeled clay from the near-by Hudson River, which, he said, "didn't cost me anything and I became used to it so that I felt uncomfortable trying to use ordinary modelling clay."[3]

Produced at the beginning of Robus's period of isolation and introspection, *The General* was one of the first sculptures Robus modeled in clay and cast in plaster in 1922. Like his earlier paintings, which relied on futurist's elements, *The General* emulates the avant-garde concepts of simplification of sculptural form. The work exemplifies the emergence of Robus's synthesis of organic forms and near abstractions; man and horse are one in form, expressing the dynamics of motion. *The General* was cast in brass in 1957.

After this work Robus relied exclusively on interpreting the human figure: " . . . he did not feel sufficiently god-like to create totally new, i.e. abstract designs, he felt more comfortable creating organic biological forms."[4] *The General* introduces the elements of Robus's mature style: a human theme of organic forms with formal simplicity, curved lines, and rounded planes. F. C.

1. Roberta K. Tarbell, *Hugo Robus,* p. 163.
2. Roberta K. Tarbell, "Figurative Interpretations of Vanguard Concepts," in *Vanguard American Sculpture, 1913–1939,* by Joan M. Marter, Roberta K. Tarbell, and Jeffrey Wechsler, p. 31.
3. Tarbell, *Hugo Robus,* p. 60.
4. Tarbell, "Figurative Interpretations of Vanguard Concepts," p. 30.

Brass
Height: 19 inches; base: 18 × 7⅜ inches
Inscription: stamped "HUGO ROBUS" (beneath horse)
Gift of C. R. Smith
G1975.6.3S

The General
(1922 modeled and cast in plaster) 1957 cast in brass

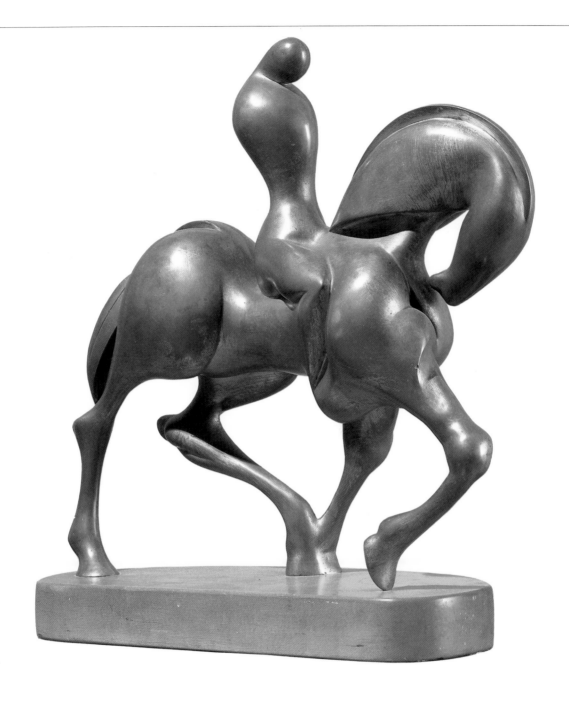

Charles M. Russell

b. 1864, St. Louis, Missouri; d. 1926, Great Falls, Montana

"Lots of cowpunchers like to play with a rope, but ropes, like guns are dangerous. All the difference is guns go off and ropes go on. So you'll savvy my meanin', I'll tell you a story." Thus, humorist and artist Charles Marion Russell began one of his Rawhide Rawlins stories. But this passage could easily preface the tale of *The Slick Ear* as well. A "slick ear," in the jargon of the cowboy, was a yearling that had been missed in the roundup of the season before, a maverick.[1] *The Slick Ear,* a story told in paint, recounts a dangerous, yet humorous, incident resulting from an ill-timed throw of the lasso. A cowboy's rope has failed to remain around the neck of its target and has slipped over the young maverick's ears, catching only on one horn. A steer is entangled in the rope and threatens to unseat the cowboy. Such herding misadventures frequently appear among the works of Russell, and, although fictional, these incidents are based upon the artist's own experiences as a Montana cattle herdsman.

Characteristically, Russell was careful to be accurate in his portrayal of the details in *The Slick Ear.* The cowboy, or "dallyman," has roped the maverick and clearly tied the rope in a half hitch, or "dally," around the horn of his saddle.[2] He then shifted his weight in his saddle to counter the pull of the rope and to help his mount keep its footing on the rocky slope. His saddle stirrups are typical of those used by Montana cattlemen, while those of the distant rider, called tapaderos, are characteristic of those used in the Texas brush country.[3] The chaps of this rear cowboy are known as "angoras," worn for warmth. The livestock brands shown are clearly recognizable and are accurate. For example, the Bar Triangle brand on the entangled steer belonged to the Greely Grum outfit, south of Judith Gap, Montana.[4] The brown-and-white short-horn steers in this painting figure prominently as the cowboys' antagonists in Russell's works. No doubt, they recall some particularly "ornery" steers with whom Russell had to contend during his night-herding days.

The Slick Ear was painted in 1914, the year that several of Russell's works were first exhibited in London. His work had already been exhibited in New York and elsewhere; his success as an artist was assured. His paintings were often reproduced on calendars and in colored prints for popular distribution. In fact, *The Slick Ear* was first published as a color lithograph. Reproductions of the painting later appeared in a book of cowboy songs and on ink blotters.[5] However, by 1914, the range that Russell had known in Montana had changed, and it is with nostalgia that the artist recalls a West that no longer existed. K. B.

1. Mitford M. Mathews, *A Dictionary of Americanisms or Historical Principles,* 2: 1566.
2. Frederic G. Renner, *Charles M. Russell: Paintings, Drawings, and Sculpture in the Amon Carter Museum,* rev. ed., p. 235.
3. Ibid., p. 169.
4. Ibid., p. 235.
5. Karl Yost and Frederic G. Renner, *A Bibliography of the Published Works of Charles M. Russell,* pp. 26, 15, 19.

Oil on canvas
30 × 33½ inches
Inscription: signed lower left "C M Russell 1914 ©"
with skull trademark
Gift of C. R. Smith
1985.83

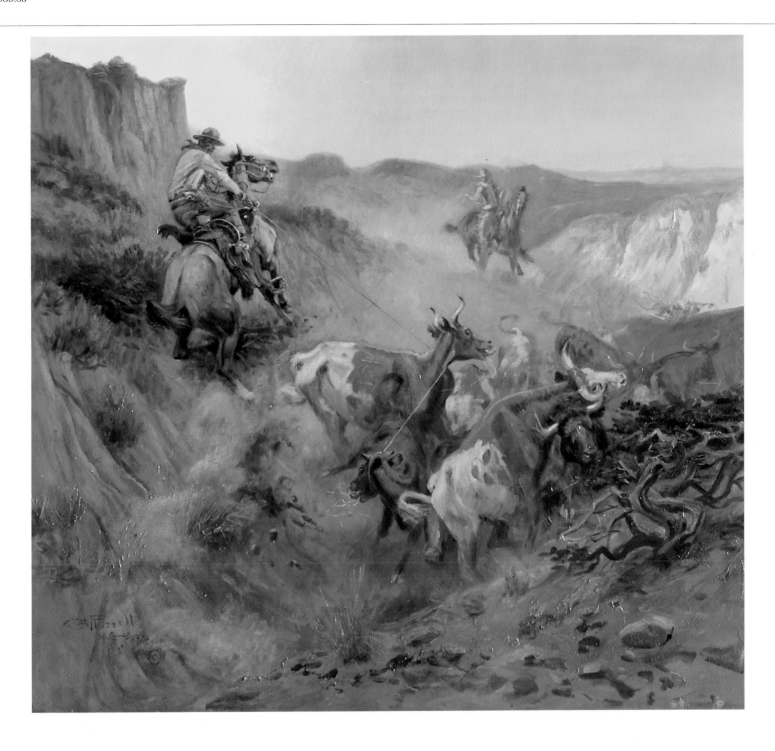

Charles M. Russell

b. 1864, St. Louis, Missouri; d. 1926, Great Falls, Montana

Charles M. Russell lived in Montana for forty-six years, eleven of which were spent in the Judith Basin area of central Montana, where he worked as a night wrangler. Lacking formal art training, he sketched, painted, and modeled clay for his own amusement, and these works frequently were given to his cowboy friends or to the owners of The Mint and the Silver Dollar saloons in Great Falls. On occasion, he might collect in payment "anything from a round of drinks for the gang to folding money of the smaller denominations."[1] He earned an early reputation as a "cowboy artist," and such paintings as the undated *Git 'Em Out of There,* alternately titled *Come Out of There,* recall life in the Montana cattle country of his early adulthood.

Before the West became criss-crossed by barbed-wire fences, the herds from the various ranches mingled with one another on the open range. Each spring, a roundup was held in which the wild cows were separated according to their brands and taken to their respective owners' corrals, where their calves were branded.[2] In *Git 'Em Out of There,* two roundup cowboys have discovered a cow and a calf who have strayed from the herd. In a familiar composition reminiscent of numerous Russell paintings, one rider has roped the cow to lead her forcibly from the dry gulch she and her calf have found, and the other man has his loop ready if assistance is needed.

This painting reveals Russell's facility with watercolor, a medium he used frequently throughout his career.[3] Many of his early watercolor paintings were gifts to friends. However, after a 1903 trip to New York, Russell began to receive commissions for book and magazine illustrations, and his watercolor paintings, like his oils, were reproduced in a variety of formats.[4]

Russell's paintings romantically recorded a way of life that was displaced by twentieth-century urbanization and mechanization. The artist resented the changes that took place on the Montana ranges during his later years. Once, during a speech, before which he had been introduced as a "pioneer," Russell stated flatly:

In my book a pioneer is a man who comes to a virgin country, traps off all the fur, kills off all the wild meat, cuts down all the trees, grazes off all the grass, plows the roots up, and strings ten million miles of bob wire. A pioneer destroys things and calls it civilization. I wish to God that this country was just like it was when I first saw it and that none of you folks were here at all.[5]

Git 'Em Out of There is a memento of this country nearer its virgin state, as Russell first encountered it and as he would have us remember it. K. B.

1. Charles M. Russell, *Rawhide Rawlins Stories.*
2. In the Judith Basin area alone, there were over twenty-eight different brands. Russell's knowledge of brands once earned him the position of "rep," "one knotch higher than a common cowboy," who was responsible for singling out the cattle belonging to the ranches he represented (Patrick T. Tucker, *Riding the High Country,* pp. 165–166).
3. One of Russell's earliest watercolors, *Roping 'Em,* ca. 1883, painted soon after the artist began to work as a herdsman, is in the Amon G. Carter Collection, Fort Worth. Although artist's materials were not readily available on the frontier, Russell was able to obtain his first watercolors through nearby Fort Benton (ibid., p. 71).
4. *Git 'Em Out of There* was probably painted in the mid-1910s, about the time Russell painted *The Slick Ear.* However, according to Yost, the work was not published until it appeared on the cover of the January 1951 issue of *Western Horsemen* (Karl Yost and Frederic G. Renner, *A Bibliography of the Published Works of Charles M. Russell,* p. 107).
5. J. Frank Dobie, "The Conservatism of Charles M. Russell," *Montana* 8 (October 1958): 59.

Watercolor on paper
18½ × 25 inches
Inscription: signed lower right "C M Russell" with
skull trademark
Gift of C. R. Smith
1985.84

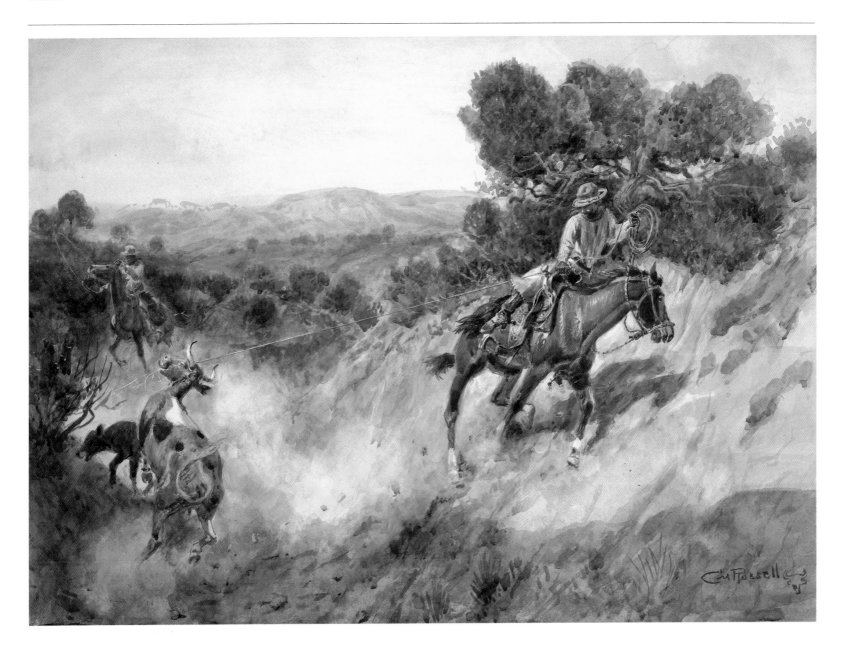

Charles M. Russell

b. 1864, St. Louis, Missouri; d. 1926, Great Falls, Montana

In 1963, when C. R. Smith allowed paintings from his private collection to appear in *Montana* magazine, the painting chosen to adorn the first cover was *Medicine Man,* alternately titled *Stoic of the Plains.* The painting was a favorite of Nancy Russell, who never allowed her husband, Charles Russell, to sell the work.[1]

Unlike many of his artist contemporaries, Russell was careful to choose those details of hair style, dress, and trappings that would make his Indian subjects recognizable by tribe. In this case, the tribe represented is Piegan, who lived in central Montana near the Judith Basin area. Even the horses his Indians ride bear distinguishing tribal markings. In this painting, the horse ridden by the medicine man has red spots encircled by blue rings on its neck. These marks are "raid marks," each of which stood for a successful raid against an enemy.[2] The red design painted on the horse's chest is identical to that appearing on the central horse in Russell's *Jumped,* 1914, in the Amon Carter Collection, Fort Worth.

Russell loved the Indian. He had spent months living among the Blackfeet in 1888, and he hated to see their way of life destroyed by the onslaught of the white "civilization." Although he painted the Indian in various activities, his favorite composition, if one may infer from its repetition in the artist's oeuvre, represented the Indian in procession, led by a noble brave, sitting erect upon his war pony, carrying a spear or staff, his stony countenance signifying his determination to conquer his enemies or die gloriously in the attempt. Such a figure, with the caption "The Knight of the Plains as He Was," adorned Russell's personal letterhead stationery for many years.[3] K. B.

1. "On the Cover," *Montana* 13 (July 1963): 1; Mr. Smith acquired the work from the Russell estate.
2. Frederic G. Renner, *Charles M. Russell: Paintings, Drawings, and Sculpture in the Amon Carter Museum,* rev. ed., p. 62.
3. Charles M. Russell, "The Horse Hunters," *Montana* 8 (October 1958): 66.

Oil on canvas
22⅛ × 17⅛ inches
Inscription: signed lower left "C M Russell 1916 ©"
with skull trademark
Gift of C. R. Smith
G1976.21.30P

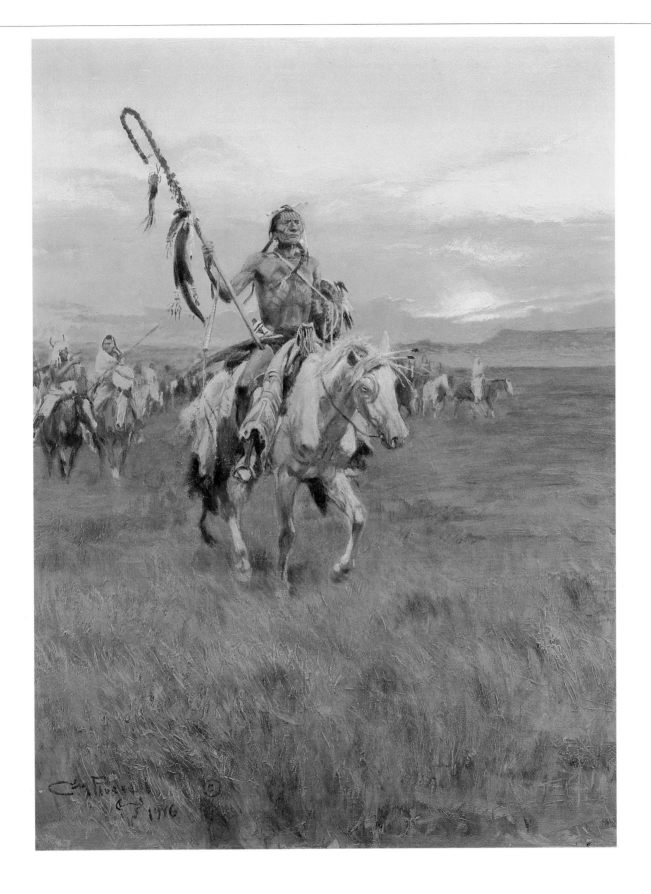

Charles Schreyvogel

b. 1861, New York, New York; d. 1912, Hoboken, New Jersey

Charles Schreyvogel, like his contemporaries Charles Russell and Frederic Remington, established his career as a painter of the western frontier in the 1890s when the Old West was rapidly disappearing. Painted in 1901 during a time of vigorous creative activity and increased commissions for Schreyvogel, *Going for Reinforcements* is typical in subject, theme, and style of the nostalgic works recalling the heroism and excitement of the Old West that brought Schreyvogel fame.

Judging from his background and early artistic career, Schreyvogel seems an unlikely candidate as a renowned painter of the dying West. A son of German immigrants, Schreyvogel was born on the East Side of New York City and made his way through public school selling newspapers and working as an office boy. His artistic ability was recognized early, and when his parents moved to Hoboken he was apprenticed to a gold engraver. His talents were channeled into the practical arts of die sinking and lithography but his ambition remained to be a fine artist. He studied at the Newark Art League in the late 1870s and worked at a lithography firm until 1876. Then, with the financial support of his two brothers, he quit his job and traveled to Munich. His study at the Munich Royal Academy with Johann F. Kirchbach and the American expatriate Carl Marr from 1886 to 1890 firmly established Schreyvogel's dedication to realism, interest in genre subjects, and technique of thick impasto. When Schreyvogel returned to New Jersey he struggled as a lithographic artist and painter of portraits, landscapes, and miniatures on ivory.

In 1893 at age thirty-two, Schreyvogel first encountered the heroic figures of the West as a spectator at the sensational Buffalo Bill's Wild West Show. When the show arrived in Brooklyn, Schreyvogel sketched the Indians and cowboys who traveled worldwide performing amazing horse stunts and rope tricks as well as reenactments of famous cavalry battles. Somehow this experience recalled one of Schreyvogel's lifelong dreams. He later told a *Cosmopolitan* writer "that as a lad his impulse was not only to draw and paint but to draw and paint Indians, cowboys, soldiers, 'I used to dream of shooting Indians and painting them,' were his words."[1] The same year that Schreyvogel saw the Wild West Show, he traveled to the Ute Reservation in southwest Colorado, where he painted the Indians, and to Arizona, where he sketched cowboys in action.

Although more than a decade had past since the grand exploits of the U.S. Cavalry, it was in the recent memory of the western frontier that Schreyvogel found exciting subject matter for his paintings. During his travels west Schreyvogel made sketches and photographs of Indians and cowboys and collected the costumes, firearms, and gear that gave his paintings accuracy in detail. Most important, Schreyvogel brought home to New Jersey stories of heroism and bravery related by former cavalry soldiers, which served as sources of inspiration for his paintings of western army life.

One such cavalry story may have been the basis of Schreyvogel's painting *My Bunkie,* which brought him national recognition in the 1900 National Academy of Design exhibition. Hardly a neophyte, Schreyvogel had exhibited *Over a Dangerous Pass* in the 1897 National Academy,[2] but he surprised everyone in 1900 when *My Bunkie* was not only accepted in the Academy but also won the coveted Clarke Prize for figure painting.[3] The following year Schreyvogel was elected an associate member of the National Academy. The tale of Schreyvogel's reluctant entry of *My Bunkie* into the Academy and its subsequent acceptance, honorary recognition, and fame was legendary long before Schreyvogel's unexpected death in 1912.

With the success of *My Bunkie,* Schreyvogel traveled in 1900 to the Dakotas to work on a number of paintings about the exploits of the western army. Works like *Going for Reinforcements, The Dispatch-Bearers, Defending the Stockade,* and about ten others produced between 1900 and 1901 portrayed the undisputed bravery of the troopers. Schreyvogel's paintings betray a sentiment underlying the age: Indians are consistently portrayed as aggressors and cavalrymen are usually shown in defensive postures. Sympathy is with the heroic cavalrymen who appear brave, generous, unselfish, and kindly toward their horses and comrades.

Going for Reinforcements isolates the human drama of two cavalrymen, one of whom is wounded, riding away from a burning fort to seek help for their fellow soldiers. The presence of threatening Indians gives a sense of urgency to the mission. The image of flight from danger is fixed with the lead horse awkwardly suspended in midair. This work was included in the 77th Annual National Academy of Design exhibition in 1902 and was widely known through a portfolio of photographic reproductions published in 1909.[4]

F. C.

1. Gustav Kobbe, "A Painter of the Western Frontier," *Cosmopolitan* 31 (October 1901): 568.
2. "From the Seventy-second Annual Exhibition of the National Academy of Design," *Harper's Weekly,* April 17, 1897, p. 380.
3. Charles H. Caffin, "Annual Exhibition of the National Academy," *Harper's Weekly,* January 13, 1900, p. 31.
4. *My Bunkie and Others: Pictures by Charles Schreyvogel.*

Oil on canvas
34⅛ × 25 inches
Inscription: signed lower right "Chas Schreyvogel";
lower left, "Copyright 1901 by Chas Schreyvogel"
Gift of C. R. Smith
1985.85

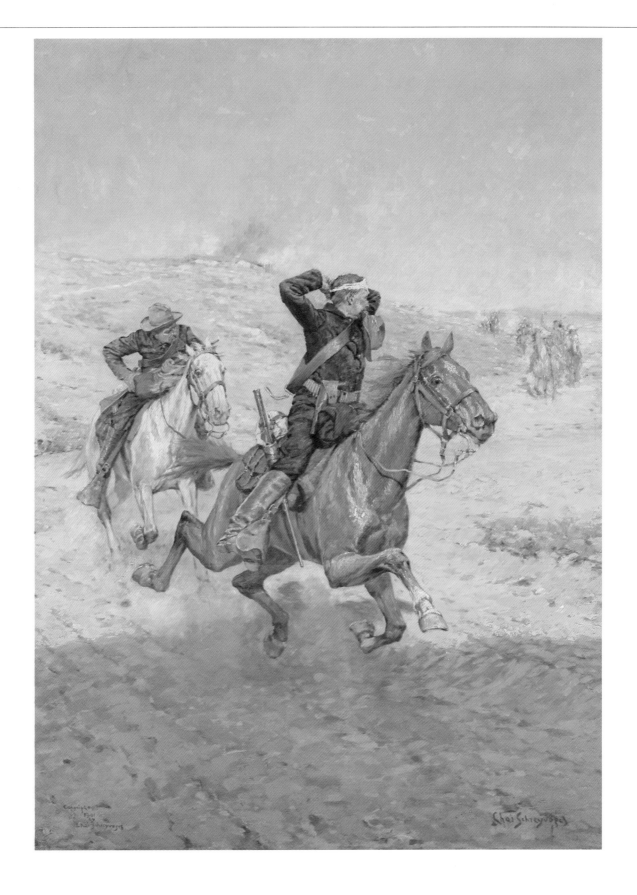

Charles Schreyvogel

b. 1861, New York, New York; d. 1912, Hoboken, New Jersey

Breaking through the Circle shows five U.S. Cavalrymen on horseback forcing their way through an encircling band of hostile Indians. As in most of Schreyvogel's western scenes, the action is arrested at a dramatic moment. Fixed on canvas are the roiling clouds of dust and gunsmoke as shots are fired and horses are suspended in full gallop. Colors vibrate in the bright light of midday. A mere suggestion of a western landscape with sagebrush and rocks serves as a stage set for the action. The danger of the moment is accentuated by the nervous energy and excitement of the horses. There is great concern for realism in the careful characterizations and studied expressions of both soldiers and Indians as well as in the authentic depiction of military accoutrements and Indian war regalia. Although the detailing is accurate, the scene is fictional and romantic in spirit.

Schreyvogel's success as a painter of western themes hinged on his ability to depict his subjects with authority. On his trips west he collected photographs, casts, and sketches of his western subjects. In his Hoboken studio, where he often painted on the roof, Schreyvogel used the material he had collected to develop his action-packed compositions. Exhaustive research into Indian and cavalry dress, manners, and life went into each painting. Schreyvogel even went to the trouble of hiring a horseman to ride toward him again and again in Hudson Park near his studio in New Jersey while he made numerous photographs and sketches.[1] This exercise allowed Schreyvogel to achieve the realistic image of the horsemen advancing toward the viewer in *Breaking through the Circle* and other works. Because of his attention to historical accuracy and careful draftsmanship, Schreyvogel produced fewer than one hundred known paintings.

One of the most successful of his western battle scenes, *Breaking through the Circle* was painted when Schreyvogel was building his reputation not only as an important genre painter but also as an accurate artist of America's recent history. In 1903, one year before *Breaking through the Circle* was painted, Schreyvogel emerged unscathed from a controversy initiated by Frederic Remington. The great illustrator of western scenes publicly criticized Schreyvogel for supposed gross inaccuracies in a painting that commemorated an actual event, *Custer's Demand.* Remington questioned the authenticity of the pistol holders, cartridge belts, Sioux war bonnets, cavalry horses, officer's boots, and leggings, among other things. No less personages than Theodore Roosevelt, the wife of Colonel Custer, and Colonel Crosby, who was present at the scene of the painting, came to Schreyvogel's defense in support of the authenticity of the details and the spirit of his painting.

After Remington's death in 1909, Schreyvogel's reputation as a painter of western themes surpassed that of his former rival. But his prominence was brief; Schreyvogel's long-awaited success ended unexpectedly when he died of blood poisoning in 1912. F. C.

1. James D. Horan, *The Life and Art of Charles Schreyvogel: Painter-Historian of the Indian-Fighting Army of the American West,* p. 56.

Oil on canvas
34¼ × 46⅜ inches
Inscription: signed lower left "Chas Schreyvogel
ANA / Copyright 1904"
Gift of C. R. Smith
1982.20

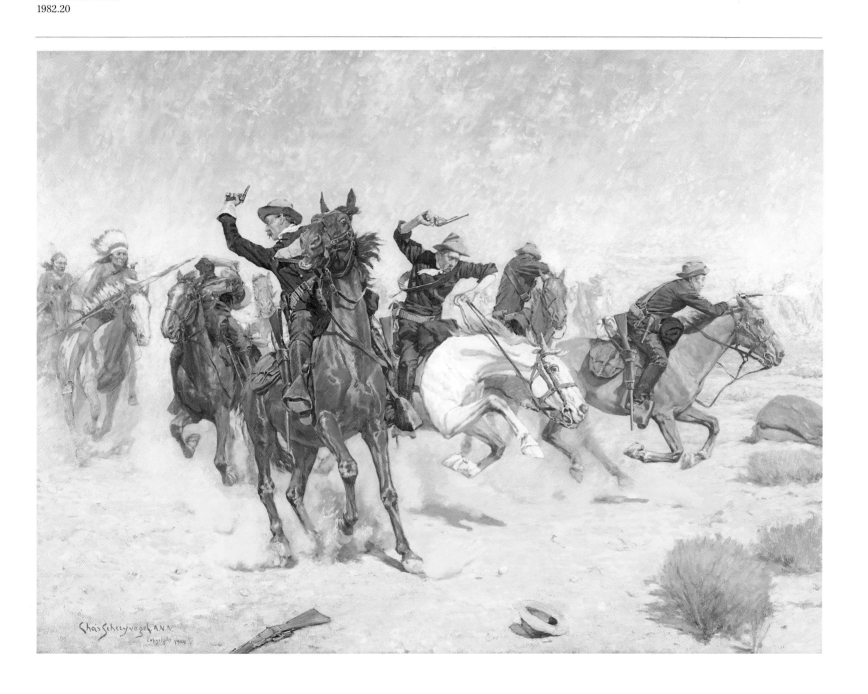

Joseph Henry Sharp

b. 1859, Bridgeport, Ohio; d. 1953, Pasadena, California

In 1902, when Phoebe Apperson Hearst gave the Robert H. Lowie Museum of Anthropology at Berkeley seventy-seven of Sharp's paintings, she gave the artist the financial independence necessary to resign his post at the Art Academy in Cincinnati and devote his full attention to painting. As a result, he was able to return to his cabin on the battlefield of the Little Bighorn, which was then part of the Crow Reservation in Montana. His Montana cabin-studio was built especially for him near the Custer battlefield by the Indian commissioners under orders from President Theodore Roosevelt, who admired Sharp's work.[1] Sharp proceeded to spend the next fifteen winters in Montana.

In 1904 Sharp painted *Winter's Coming On,* a picturesque view of a Crow Indian encampment situated near bluffs probably visible from Sharp's Montana cabin-studio. This painting may have been completed in his winter studio or later created from Montana sketches at his summer home in Taos. Nicknamed "The Anthropologist," Sharp was noted for his accuracy in depicting the lives of the Plains and Taos Pueblo Indians. In fact, Hearst donated her collection of paintings to the Museum of Anthropology at the University of California, and in 1901 the Bureau of American Ethnology of the Smithsonian Institution purchased several of his Indian portraits. In *Winter's Coming On* the composition is traditional for Plains Indian village scenes — an empty, grassy foreground, tipis in the midground, and mountains or cliffs in the distance.[2] The Montana bluffs in the background appear in several of Sharp's works, like *Sweat Lodge* and *Cheyenne Tepees — Montana* (both in the Peters Corporation, Santa Fe), while the robed figure standing by the nearest tipi was repeated in *Winter Encampment on the Plains* (Anschutz Collection, Denver).

Born in Ohio, Sharp moved to the western art center of Cincinnati at age fourteen to study art. After three trips abroad to study Old Masters and one journey west, he became an instructor at the Art Academy. While in Cincinnati Sharp maintained a studio in the same building as Henry Farny. After a bit of initial discouragement, Farny prodded Sharp to travel west again and to develop further his penchant for painting Indian portraits and scenes.[3] Thus Sharp launched his second journey westward in 1893 on the pretext of an illustration assignment for *Harper's Weekly,* this time to Taos, New Mexico, where a decade and a half later he settled.[4] K. B. & C. A.

1. Laura Bickerstaff, *Pioneer Artists of Taos,* p. 87.
2. Similar compositions are used in Bierstadt's *Sioux Village near Fort Laramie* (C. R. Smith Collection) and Farny's *Indian Encampment* (Anschutz Collection, Denver).
3. Patricia Broder, *Taos: A Painter's Dream,* p. 45.
4. Ibid., p. 37.

Oil on canvas
20¼ × 30⅜ inches
Inscription: signed lower right "J. H. Sharp 1904"
Gift of C. R. Smith
G1975.6.5P

Joseph Henry Sharp

b. 1859, Bridgeport, Ohio; d. 1953, Pasadena, California

Restlessly at Home depicts a quiet glade in which two Indian women sit outside their lone, open tipi by a campfire, engrossed in the performance of their daily routine. The comfortable intimacy of the scene indicates the rapport that Sharp was to enjoy throughout his long career with his Indian friends and subjects. They trusted his gentle presence and allowed Sharp, who had by this time gone completely deaf, to observe their camps, settlements, daily routines, and rituals at close proximity.

Sharp's close-up depiction of Indians within a forest setting is somewhat unusual, as he and other western artists more frequently chose to depict their subjects in portraits, on the open plains, or in pueblo settings. His subjects here may be Crow Indians, as they resemble figures rendered in *Crow Lodges with Sweat Tipis* (Kennedy Galleries, 1976), however, Sharp traveled widely in Wyoming, Montana, and Washington before settling in Taos and recorded numerous Indian tribes. He was keenly sensitive to the Indians' inability to cope with the invasion of white "civilization" and the resulting destruction of their own culture. At one point he somewhat boastfully remarked, "If I do not paint them no one ever will."[1]

Sharp is perhaps best remembered for his earlier Indian portraits and his later Taos pueblo scenes.[2] *Restlessly at Home* marks an intermediary period when the artist, then highly respected and financially secure, sought to observe and record not only the colorful rituals but also, in this case, the simple daily routines of this Indian family. The visual appeal of paintings such as this made Sharp popular during his lifetime. Although he never became a member of the National Academy of Design, he did win medals at the 1901 Pan-American Exposition in Buffalo and the 1915 Panama-California Exposition in San Diego. In 1912, Sharp established permanent residence in Taos and became a charter member of the Taos Society of Artists. Although he later traveled to Spain, Africa, South America, the Orient, and Hawaii, his travels had little effect on his art. Sharp moved to Pasadena during the fall of 1952 and he died there the following year. C. A. & K. B.

1. Laura Bickerstaff, *Pioneer Artists of Taos*, p. 86.
2. Sharp, between 1901 and 1916, completed over two hundred portraits of the Indian survivors of Little Bighorn in Montana; the historical significance of these works is enhanced by the brief biographical sketches he often noted on the backs of his portraits.

Oil on canvas
20 × 30¼ inches
Inscription: signed lower right "J. H. Sharp 07"
Gift of C. R. Smith
G1975.6.4P

Joshua Shaw

b. 1776 or 1777, Bellingborough, Lincolnshire, England; d. 1860, Burlington, New Jersey

The European exploration of America was an important theme in mid-nineteenth-century painting. In Joshua Shaw's *The First Ship* a group of Indians reacts with wonder and fear to the arrival of a ship in the distance, the rising sun behind it suggesting the dawn of a new era. Although regarded as a pioneer in portraying the American native, Shaw was not a serious student of Indian life. In this painting his depiction is a vision of the Indian as the noble savage and as a tragic figure, who as part of the wilderness scene is disappearing with the new age.

English born and trained, Shaw, at age forty-one, was persuaded by Benjamin West to emigrate to the United States in 1817. He was enthusiastic about the landscape of his new country and was one of the first artists to produce topographical views of American scenery for reproduction. *The First Ship,* however, is an imagined subject and one of several paintings devoted to this theme by Shaw that are almost identical in composition and size, varying only in details.[1]

There are two possible interpretations of this scene. Most frequently it is described as the arrival of Columbus. More likely, however, the subject is derived from a work by historical painter John G. Chapman, whose painting *The First Ship* was exhibited at the National Academy of Design in 1837.[2] If this is the case, Shaw's painting may allude to the popular history of Giovanni Verrazzano and his voyage in the *Dolphin,* "the first ship" to explore the coast of North America. Shaw's interpretation fits the description of Verrazzano's encounter with the natives, who "gazed with expressions of savage wonder at their strange visitants" and who were "naked, except at the waist, which was covered with skins and girdles of grass, interwoven with the tails of animals, and at the head, which some decked with garlands of feathers . . ."[3]

Shaw's vision of the landscape depicts Verrazzano's "serene sky, rarely and transiently tainted with vapors . . . [and] a smooth sea."[4] In the foreground, to the right of the awestruck Indians is a scalp. In paintings by Shaw it was a motif that represented the popular attitude that, for the Indians, scalping was natural and lawful behavior. At the same time it sensationalizes the tales of their savage attacks. L. L. & J. H.

1. Of the over two hundred paintings exhibited during Shaw's American career (see Miriam Carroll Woods, "Joshua Shaw (1776–1860): A Study of the Artist and His Paintings," M.A. Thesis, University of California, Los Angeles, 1971) only seven, produced between 1838 and 1850, are recorded as having Indian subjects. This painting is not inscribed with a date but was probably executed sometime during the late 1840s. Shaw painted at least five versions of this scene during the 1840s and in 1850. Two of these paintings, *Coming of the White Man,* 1850 (Collection of Carl Dentzel, Northridge, California), and *The First Ship,* 1846 (sold at Christie's, New York, December 3, 1882, lot no. 10), are almost identical to this painting. Other versions, also from the 1840s, differ in the number of figures or are known only through engravings or titles in exhibitions.

2. Chapman's painting was engraved and widely circulated in *The Token and Atlantic Souvenir,* p. 294.

3. Many accounts of Verrazzano's voyage appeared during the nineteenth century. The passage quoted here is from George W. Greene, "Life and Voyages of Verrazzano, Delle Navigazioni et Viaggi, raccolte da M. Giovan-Battista Ramusio," *North American Review* 45 (1837): 293–311.

4. Ibid., pp. 297–298.

Oil on canvas
25 × 36 inches
Inscription: signed lower right "J. Shaw"
Gift of C. R. Smith
G1976.21.33P

Walter Shirlaw

b. 1838, Paisley, Scotland; d. 1909, Madrid, Spain

Walter Shirlaw's vivid depiction of the *Buffalo Hunt* was most likely painted after a trip west in 1890. Rather than chronicle contemporary conditions of Indian life on the reservation, it evokes a bygone era when native Americans were free to battle the buffalo. By 1890 the American frontier had officially ceased to exist. The Indians were contained within reservations, and the buffalo, due to indiscriminate slaughter, were all but extinct. The imagery of the buffalo hunt consequently became a popular metaphor for the disappearance of the West. Shirlaw, who most likely never witnessed such a scene, probably based his painting on an engraving, *Indian Hunting Buffalo*, by the well-known illustrator F. O. C. Darley.[1] Of the many illustrations and paintings of the subject, however, Shirlaw's version is particularly notable. The brilliance of the style heightens the romantic nostalgia of the scene. A small group of Indians, their forms merely suggested by a flickering brush, assail their prey in an atmospheric, stormy landscape. Rendered insubstantial by Shirlaw's lack of interest in detail, the Indians and the buffalo become ghostly apparitions, anachronisms from the past.

Both the subject matter and the style mark the *Buffalo Hunt* as rare among Shirlaw's oeuvre. Although the artist spent six months in the Rockies in 1869, no western-inspired works from this early date are known.[2] Instead, Shirlaw's career from 1870, when he left the United States for a seven-year sojourn in Munich, to 1890, when he traveled west as a special agent for the U.S. Census Bureau, was devoted to traditional academic themes. Indeed, Shirlaw became well known among eastern circles with genre subjects, such as *Toning the Bell* (Art Institute of Chicago; 1876 medal winner at the Philadelphia Centennial Exposition) and *Sheep-Shearing in the Bavarian Highlands* (exhibited National Academy of Design 1877; present location unknown). In such works Shirlaw's technique is relatively subdued — the Munich-trained artist usually seemed to prefer a quieter mode to the other, more activated pole of the Munich school epitomized by the *Buffalo Hunt*. It is likely that Shirlaw's position as a teacher at the Art Student's League in New York and his membership in the National Academy of Design encouraged his natural inclination to paint conservatively.

F. O. C. Darley, *Indian Hunting Buffalo,* 1844, bank note engraving. (Courtesy Prints Division, New York Public Library, Astor, Lenox and Tilden Foundations.)

Walter Shirlaw, *The Race,* lithograph; from *Report on Indians Taxed and Indians Not Taxed in the United States (Except Alaska) at the Eleventh Census: 1890.* (Courtesy Harry Ransom Humanities Research Center, University of Texas at Austin.)

Like many of his late-nineteenth-century colleagues, Shirlaw became interested (albeit for a short period) in western American themes. In the summer of 1890 he traveled as a special agent for the U.S. government to Montana to prepare paintings and written reports on two Indian agencies. His efforts were published in 1894 in the extensive document *Report on Indians Taxed and Indians Not Taxed.* Two of Shirlaw's paintings, *The Race* and *Omaha Dance,* were reproduced in color in the report. They are both dated August 1890 and create a sense of drama and movement similar to that found in the *Buffalo Hunt.* It seems likely that the *Buffalo Hunt* was painted after August 1890 and probably by 1894, when Shirlaw's interest in Indian subjects appears to have waned.[3] But, while the paintings associated with the government report have a reportorial quality, the *Buffalo Hunt* was conceived in the studio, rooted in imagination, and as a result Shirlaw deliberately transformed reality into a more compelling image.　　　　N. B.

1. Darley's image had appeared in *Graham's Magazine* in 1844 and subsequently in 1856 as a bank note vignette. Shirlaw, from 1853 to 1858, had been an apprentice bank note engraver and at that time was probably exposed to Darley's work (see Rena N. Coen, "The Last of the Buffalo," *American Art Journal* 5 [November 1973]: 91–93).

2. A search has uncovered no such early works. T. H. Bartlett, "Walter Shirlaw," *American Art Review* 2 (1881): 98, mentions that on Shirlaw's trip west "the landscape impressed him. The

plain spoke in a new language and the mountains were a history. . . . The desire to reproduce his impressions was humbled by a conscious inability. . . . After making a large number of sketches he returned to Chicago . . ." This suggests that these western sketches were landscape studies.

3. Shirlaw's few known Indian paintings are close in style to *The Race,* indicating that they were all painted in the early 1890s. Shirlaw's only Indian illustrations were also published at this time. For the November 1893 issue of *Century Magazine,*

Shirlaw wrote and illustrated a short article on a personal experience while an agent for the 1890 Census Bureau ("Artist's Adventures: The Rush to Death," *Century Magazine* 47 [November 1893]: 41–45). His last known and datable Indian theme was the illustration *The Death Song,* which appeared in *Century Magazine* 47 (January 1894): 424. Although *Indian Tilting at Scalp Pole* (Images Gallery, Minneapolis), dated 1898, has been attributed to Shirlaw, this attribution is questionable.

Oil on canvas
9⅜ × 14¼ inches
Inscription: monogram lower left corner
Lent by C. R. Smith

Buffalo Hunt
ca. 1890–1894

Arthur Fitzwilliam Tait

b. 1819, near Liverpool, England; d. 1905, Yonkers, New York

In 1852, Arthur Fitzwilliam Tait traveled to the Chateaugay Lakes region in the Adirondacks and became entranced with this sportsman's paradise. Returning to the Adirondacks annually, he drew upon his own hunting experiences to paint at least sixteen frontier hunting and trapping scenes, including *Huntsman with Deer, Horse, and Rifle*. In this dramatic moment a hunter kneels, his rifle ready, and stares intently to the right. A slain deer lies at his feet; a bloody knife is nearby. The hunter's dog and horse are alert to a mysterious, unknown sound, perhaps a breaking twig that heralds the approach of another trophy. This hunter is a prototype for the man sighting game in *Still Hunting on First Snow* (Adirondack Museum, Blue Mountain Lake, New York) dated 1855, a self-portrait.[1] As the facial features of the hunters in the two paintings are similar, one might suspect that the hunter in the earlier work is also the artist himself.

Although Tait sketched on his hunting trips, most of his paintings were executed in his Broadway studio in New York City. This studio was cluttered with antlers, preserved birds, and grass samples from which he copied in order to give his paintings lively and accurate detail. This characteristic attention is seen here in the design on the rifle butt, the tassles on the horse's bridle, and the hammer mechanism on the gun.

Tait's hunting and sporting subjects were highly popular, and lithographs made after them were distributed through the American Art Union (1850–1852), Currier and Ives (1852–1864), and Louis Prang and Company (beginning in 1866).[2] Although Tait was, along with Fanny Palmer and Louis Maurer, one of Currier and Ives' most popular artists, he was never actually employed by them, and his correspondence with Currier reveals an uneasy relationship between artist and patron. Eventually, he was responsible for 28 of approximately 120 large-sized outdoor scenes that Currier and Ives published.[3]

Tait became familiar with lithography as a youth in England when he sold prints from Thomas Agnew's store in Manchester. After studying art briefly at the Royal Institute there, he found limited patronage for his lithographs of architectural subjects. His introduction to George Catlin in England in 1843 suggested perhaps a more profitable future in America,[4] but it was not until 1850 that he gave up lithography and emigrated to this country.

Tait's later paintings became sentimental and lacking in the sense of adventure evident in his sporting pictures. While this attitude was well suited to the Prang greeting cards and calendar illustrations that bore prints after his works, it did not give him lasting appeal into the twentieth century. His early hunting subjects have held the greatest interest for collectors since his death in 1905.　　　　　　　　　　　K. B. & J. H.

1. The artist's self-portrait is also seen in *Returning to Camp with Game* and in *Deer Driving: The Lakes, Northern New York* (private collection, New Jersey).

2. *Huntsman with Deer, Horse, and Rifle* was apparently never lithographed, at least no print is known by either of the titles presently associated with the painting.

3. Walter Rawls, *The Great Book of Currier and Ives' America*, p. 329.

4. Patricia C. F. Mandel, "English Influences on the Work of A. F. Tait," in *A. F. Tait: Artist in the Adirondacks*, p. 15.

Oil on canvas
30¼ × 44⅛ inches

Inscription: signed lower right "A. F. Tait N Y 1854"
Gift of C. R. Smith
G1976.21.35P

Huntsman with Deer, Horse, and Rifle
1854

Walter Ufer

b. 1876, Louisville, Kentucky; d. 1936, Santa Fe, New Mexico

On the surface, Walter Ufer's *Returning the Stray* is a painting of a Pueblo Indian herding a stray sorrel pony, whose ownership is indicated by the brand of five red slashes on the near front leg. The mounted herdsman follows his charge into Taos, characterized by its adobe buildings. The strong New Mexican sun shining from the viewer's left casts dramatic, sharply delineated shadows on the pale dirt road. One might easily dismiss this work as a typical Taos artist's study of the sunlit landscape with the obligatory presence of the Indian to add a touch of exotic romanticism. However, to do so would be to misunderstand the artist entirely.

Walter Ufer was a socialist who believed in the integrity and decency of the common man. A card-carrying member of the "Wobblies,"[1] whom Leon Trotsky, smuggled north from his exile in Mexico, allegedly visited in Taos,[2] Ufer was an active supporter of the laborer in his fight against oppression at the hands of big business.[3] Similarly, he fought against the exploitation of Indians, whom he felt were losing their own identity to "Americanization." The artist refused to clothe his Indians in the romantic garb that appealed to an aristocratic audience. He once wrote: "The Indian is not a fantastic figure. He resents being regarded as a curiosity."[4] On another occasion he wrote: "I paint the Indian as he is. In the garden digging — In the field working — Riding amongst the sage — Meeting his women in the desert — Angling for trout — In meditation."[5]

For Ufer, then, the mundane activities of daily life for the Pueblo Indian, rather than the colorful ceremonial dances and rituals, are appropriate subjects for paintings. While his figures have been criticized as being "sluggish," the critics have missed the point, according to Patricia Janis Broder, who believed that "in Ufer's paintings the contrast of the brilliant sunlit desert with the passive, lifeless figures of the Indians emphasizes the weariness of the Pueblo people and their stoic acceptance of the burdens of life in a transitional age."[6]

Although *Returning the Stray* is undated, as are most of Ufer's works, it is similar in style and color to paintings exhibited in the artist's one-person show at the Corcoran Gallery of Art, in Washington, D.C., in 1922–1923, and to paintings exhibited at the Grand Central Gallery, in New York City, in 1929. In fact, the figures of the two horses are virtual replicas of horses appearing in a painting shown in the latter exhibition.[7] Thus, the date of this work might be narrowed to the mid- to late 1920s.

1. The Industrial Workers of the World, or IWW, was a union of revolutionary socialists who sought to radicalize the labor movement through a policy of confrontation, violent if necessary. Founded in 1905, the IWW reached its greatest influence during 1912–1917.

2. Mary Carroll Nelson, *The Legendary Artists of Taos*, p. 76.

3. Ufer was once jailed for joining striking miners on their picket line in Gallup, New Mexico (Patricia Janis Broder, *Taos: A Painter's Dream*, p. 211).

4. Walter Ufer, quoted in ibid., p. 225.

5. Ibid., p. 225.

6. Ibid., p. 217.

7. *Across the Arroyo*, Art Gallery, University of Notre Dame.

Oil on canvas
20 × 25 inches
Inscription: signed lower right "W Ufer"
Gift of C. R. Smith
G1976.21.36P

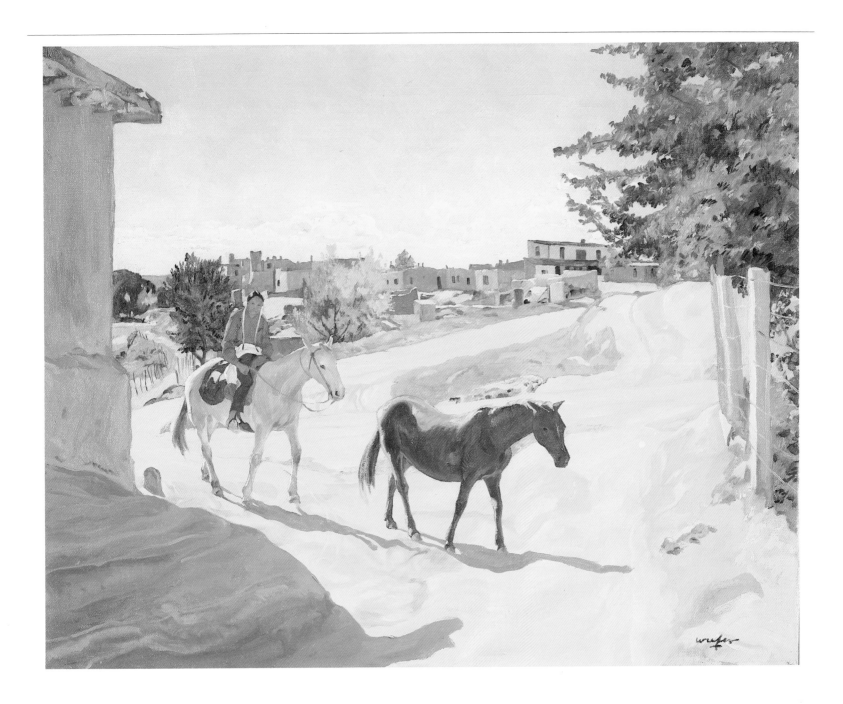

Walter Ufer

b. 1876, Louisville, Kentucky; d. 1936, Santa Fe, New Mexico

The Indian was Walter Ufer's favorite subject, and his favorite model was Jim Mirabel, a Pueblo nicknamed "Ufer's Jim."[1] *I Well Remember* is a portrait of this man, who was like a brother to Ufer and whom the artist furnished with the funds to build part of the Mirabel's adobe home in Taos.[2] Mirabel, who died in 1976, lived into his nineties. This portrait probably dates from the early 1930s when the model was in his mid-forties.

Despite Ufer's training at the Dresden Royal Academy, reinforced by studies in Munich, Paris, and Rome, the artist abandoned his academic style when he reached Taos in 1914 and joined the Taos Society of Artists in 1915. Rather than paint a more formal portrait of an obviously posed sitter, characteristic of European portraiture, the artist chose to paint Mirabel in the process of talking, perhaps reminiscing about the old days, while wrapping his hair with colorful ribbons. The model's face is unidealized, with his brow and nose wrinkled together over half-closed eyes, squinting against the strong Taos sunlight. The figure is clothed in store-bought garments rather than in traditional Indian dress. The trousers may have been part of a military uniform bought at a surplus store. Ufer himself frequently dressed in military surplus uniforms.[3] The basket and the corn shucks to the man's left are symbols of the Indian's traditional life based upon the cultivation of corn. Thus, in this portrait, the Indian's new, more "Americanized" lifestyle is contrasted with his past. Significantly, the viewer is slightly elevated with respect to the sitter. Such a position suggests an unspoken commentary on the Indians' lower status in this country, a fact acutely impressed upon the sensitivities of the artist, who might be considered an early social realist.

Ufer received numerous awards before his popularity declined as a result of the Depression and his own alcoholism. He was included in the U.S. Exhibition in Paris in 1919 and in the Venice Biennial in 1924. He died of appendicitis in 1936. Jim Mirabel, the model, was one of two close friends who scattered Ufer's ashes over the Taos Valley, in accordance with the artist's last request.[4] K. B.

1. Mary Carroll Nelson, *The Legendary Artists of Taos,* p. 79.
2. Ibid.
3. Ibid., p. 76.
4. Patricia Janis Broder, *Taos: A Painter's Dream,* p. 229.

Oil on canvas
25⅛ × 30½ inches
Inscription: signed lower right "W. Ufer"
Lent by C. R. Smith

Oil on canvas
25⅛ × 30½ inches
Inscription: signed lower right "W. Ufer"
Lent by C. R. Smith

I Well Remember
ca. 1930–1935

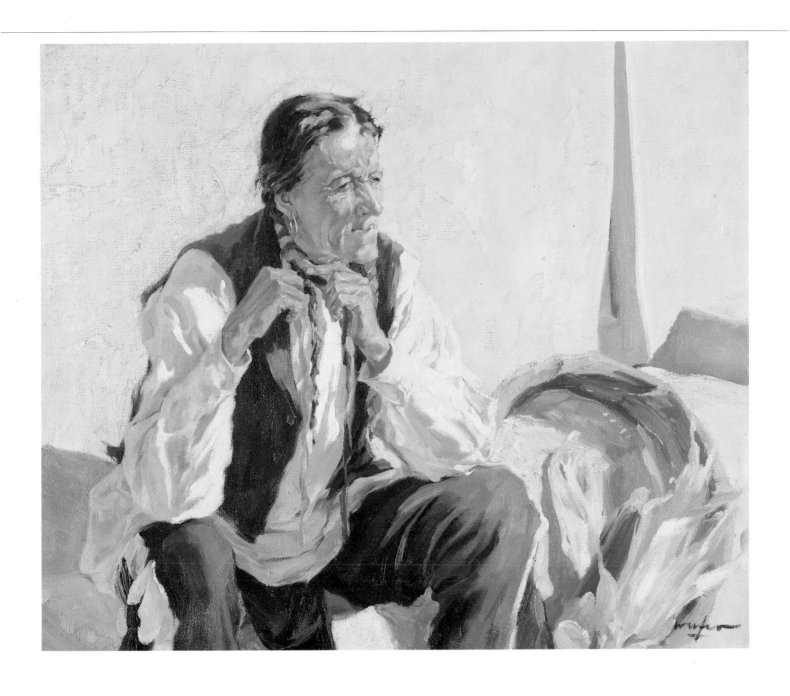

Unknown Artist

Feared by American Indians and pioneers alike, the prairie fire was a popular theme for artists and writers throughout the nineteenth century. In 1827 James Fenimore Cooper's widely read novel *The Prairie* alerted many eastern American audiences to the dramatic and dangerous potential of fire. Cooper described huge columns of smoke rolling up from the dry plains toward his protagonists, and the red glow, which "gleamed upon their volumes with the glare of the conflagration . . . leaving all behind enveloped in awful darkness."[1] But the mood of *Prairie Fire,* a painting by an unknown artist, is perhaps closer to George Catlin's 1844 description of the subject. Upon discovering a fire approaching, one of Catlin's Indian guides announced in startled surprise, " . . . see ye that small cloud lifting itself from the prairie? he rises! the hoofs of our horses have waked him! The Fire Spirit is awake — this wind is from his nostrils, and his face is this way!"[2] In *Prairie Fire* a group of Indians perched atop a hill with their horses observe from a safe distance the roaring flames of an ever-spreading fire.

Between 1825 and 1875 a number of American artists painted prairie fire scenes. Among them where John Mix Stanley, Paul Kane, George Catlin, Alfred Jacob Miller, Charles Deas, William Ranney, A. F. Tait, and Carl Wimar. The subject was also deemed of sufficient popularity to appear as a print by Currier and Ives in 1871. Some artists depicted wildlife, Indians, or fleeing pioneers, while others focused on those who chose desperately, and often ingeniously, to fight the flames. Few canvases present Indians viewing the situation cautiously from a distance as in this *Prairie Fire,* although a related example, *A Prairie on Fire,* by Paul Kane, exists. The prairie fire in fact is a backdrop to the artist's primary wish to portray Indians in their picturesque garb.

At the time the Huntington Gallery acquired *Prairie Fire* it was attributed to John Mix Stanley. Current scholarship, however, suggests that this is unlikely.[3] Stylistically, the composition and figures do bear a vague resemblance to those by Stanley, and the composition suggests it was painted ca. 1850. C. A.

Paul Kane, *A Prairie on Fire,* ca. 1846, oil on canvas. (Courtesy Royal Ontario Museum, Toronto.)

1. James Fenimore Cooper, *The Prairie,* p. 305.
2. George Catlin, *Letters and Notes on the Manners, Customs, and Conditions of the North American Indians,* vol. 2, letter 33.
3. Conversation with Julie Schimmel, Assistant to the Director of the National Museum of American Art, on July 9, 1984. Schimmel, who wrote her dissertation on John Mix Stanley, also conferred with William Truettner, who agreed that *Prairie Fire* was not the work of Stanley.

Oil on canvas
20¼ × 30¼ inches
Inscription: none
Gift of C. R. Smith
G1976.21.34P

The Prairie Fire
ca. 1850

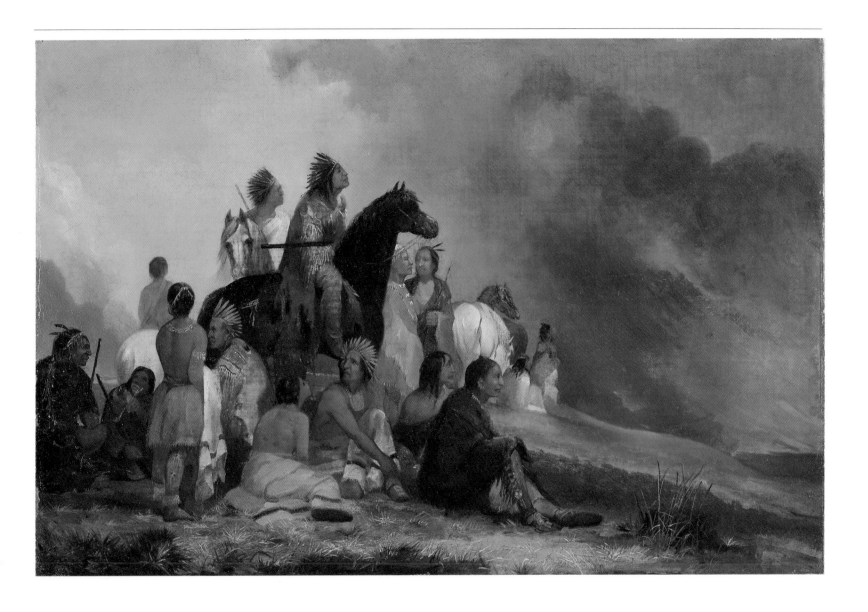

Harold Von Schmidt

b. 1893, Alameda, California; d. 1982, Westport, Connecticut

Uncle Dick Wootton — Indian Trader portrays an actual character of heroic dimensions who died in the year of Harold Von Schmidt's birth. Wootton (Richens Lacey Wootton, 1816–1893) was an Indian trader, army scout, and frontiersman. A Kentuckian born in Virginia, he left that region by his twentieth birthday for a life in the Colorado Rockies. There he traded beaver with the Sioux and became fast friends with the Arapaho. Along with other legendary scouts, such as Kit Carson, Antoine Leroux, and Tom Tobin, Wootton engaged with the army in 1848 and 1849 in rescue efforts for settlers and travelers along the Canadian River (now known as the Red River) down into Texas, in pursuit of the Utes and Jicarilla Apaches of the Raton Mountains.[1]

After marriage, Wootton first settled with his wife in Taos, then moved back to Colorado to ranch, engaging in freighting over the Santa Fe trails. Seemingly more and more domesticated by family life, in 1858 he sold all of his holdings and loaded his family for a move back to Kentucky. On the way Wootton detoured north by way of the Platte River. There he traded with the Cheyenne and Arapahoes, opened a supply store, and contributed to the development of a new settlement on Cherry Creek, which would become the city of Denver. After four years, Wootton drifted south and started a ranch at Pueblo, building a toll road over the Raton Pass and a combination house and hotel. He never returned to Kentucky. A legend in his lifetime, by 1878 he was known in the region as Uncle Dick.[2]

Harold Von Schmidt provides a good example of the western artist-illustrator as visual historian. The information included in the painting remains distant from contemporary reality; the artist, through accuracy of detail and a feeling of immediacy, has preserved for the viewer an increasingly remote situation based on history. Painted to illustrate "Blazer of Trails West" by Joseph Millard, for *True* magazine, January 1952, the work is executed in what Von Schmidt referred to as a two-color spread, based on white, black, and any second color, here an umber. The black and umber compose the two colors; the white derives from the color of the page. The donor of the Huntington's painting, C. R. Smith, enjoyed a friendly relationship with Von Schmidt and the two corresponded over the years. According to a family source, C. R. Smith commissioned the only work Von Schmidt ever produced outside a publication assignment, a 1957 painting entitled *Cavalry Charge.*[3]

Von Schmidt was born in Alameda, California. After a period in a San Mateo orphanage, he went to live with an aunt, who encouraged him to study art, and a grandfather, who, as a member of the 1849 gold rush, gave Von Schmidt the opportunity to taste adventure through recollections of those times. The facts suggest that Von Schmidt developed a highly motivated and industrious personality. Spending his summers as a cowboy and a lumberjack, he first studied at the California College of Arts and Crafts. By 1913, he had illustrated his first magazine cover (*Sunset Magazine*). During his later student days at the San Francisco Art Institute (1915–1918), he was an associate art director. Working with the already established western painter Maynard Dixon, Von Schmidt painted most of the backgrounds for Dixon's murals. During this period Dixon was also helped by the artist Charles Russell. Two years later Von Schmidt found the time to serve as a member of the American rugby team in the 1920 Olympics.[4]

A pupil of F. H. Meyers, Von Schmidt also studied with illustrator Worth Ryder. In 1924 he moved to New York for further study at the Grand Central School of Art under Harvey Dunn, whose teaching introduced Von Schmidt to the tradition of dramatic illustration, which Dunn had inherited from his own teacher, the influential American illustrator Howard Pyle.[5] The Von Schmidt family still owns a painting produced through the collaborative work of Von Schmidt, Harvey Dunn, and Dean Cornwell.[6]

As a mature artist, Von Schmidt described his admiration as a young student for English painters John Constable, Frank Brangwyn, and Joseph Mallord William Turner and how later he came to admire French painters Paul Gauguin, Camille Pissarro, and Paul Cézanne. It was during travel in Europe that Von Schmidt discovered Italian painters Giotto, Caravaggio, and, his favorite, Piero della Francesca. He also greatly admired Michelangelo and Rubens, as well as many American illustrators.[7]

Von Schmidt became a leading magazine illustrator, his work appearing many times in *Saturday Evening Post,* as well as in other publications. He also illustrated books and was best known for the illustrations he did for Willa Cather's *Death Comes for the Archbishop.* With few exceptions, Von Schmidt's illustrations were primarily tied to the West. P. D. H.

1. Howard Louis Conrad, *Uncle Dick Wootton,* ed. Milo Milton Quaife, pp. 65–67, 190–202 passim.
2. Ibid., pp. 352–359, 397–399 passim.
3. Telephone conversation with Eric Von Schmidt, son of Harold Von Schmidt, May 1985.
4. Peggy and Harold Samuels, *The Illustrated Biographical Encyclopedia of Artists of the American West,* p. 505.
5. Ibid.
6. Eric Von Schmidt.
7. Magazine article segment, autographed to C. R. Smith from Harold Von Schmidt (Von Schmidt file, Archer M. Huntington Art Gallery).

Oil on canvas
29¼ × 49½ inches
Inscription: signed and dated lower right "Harold Von
Schmidt, 1951"
Gift of C. R. Smith, 1976
G1976.21.31P

Uncle Dick Wootton — Indian Trader

1951

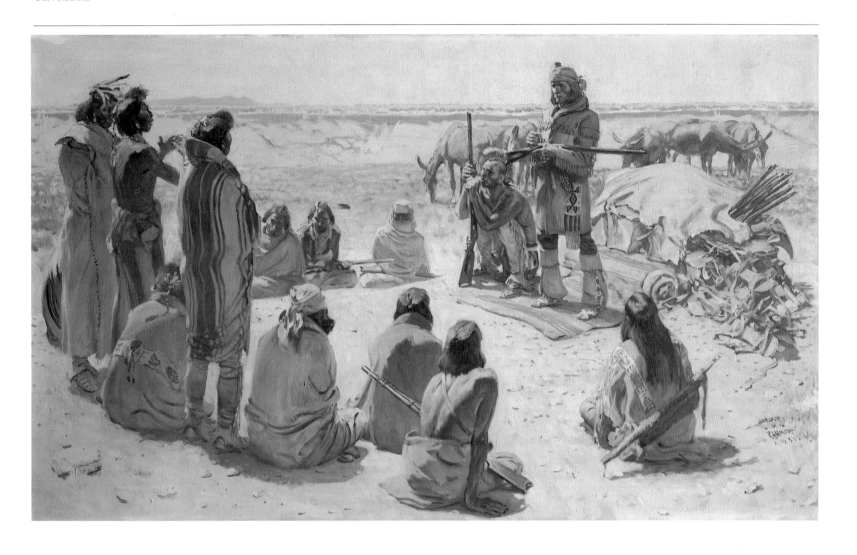

Thomas Worthington Whittredge

b. 1820, Springfield, Ohio; d. 1910, Summit, New Jersey

In 1866[1] Worthington Whittredge joined Gen. John Pope's "tour of inspection throughout the department of the Missouri, as it was then called, which embraced all the eastern portions of the Rocky Mountains and New Mexico."[2] But unlike Albert Bierstadt and Thomas Moran, whose travels resulted in highly dramatic and grandiose images of American scenery, Whittredge's trip inspired him to capture the fleeting atmospheric effects of the low rolling landscape.[3] He later observed of his journey west of the Mississippi:

I had never seen the plains or anything like them. They impressed me deeply. I cared more for them than for the mountains, and very few of my western pictures have been produced from sketches made in the mountains, but rather from those made on the plains with the mountains in the distance. Whoever crossed the plains at that period, notwithstanding its herds of buffalo and flocks of antelope, . . . could hardly fail to be impressed with its vastness and silence and the appearance everywhere of an innocent, primitive existence.[4]

His words are reflected in *Buffalo on the Platte River,* as a heavy gray mist obscures any evidence of spectacular mountain scenery and draws attention to quietly grazing buffalo.

Western landscapes were unusual in the oeuvre of this New York–based artist. In all, he produced roughly forty western oil sketches and studio paintings.[5] *Buffalo on the Platte River,* although derived from sketches done in situ, was most likely painted in his New York studio after his first western journey.[6] In this instance Whittredge distinguishes himself by what Henry Tuckerman described as his constant and loving study of nature, applying to his canvases perhaps a deeper sentiment than other more dramatically inclined artists who portrayed the vast western frontier.[7]

Before his western trip Whittredge had gained renown as a painter of eastern subjects. He had trained at Dusseldorf and Rome from 1849 to 1859,[8] returned to New York, where he was an active member of the National Academy of Design, and became one of the best-known landscape painters of his generation. C. A. & A. O.

1. Much controversy surrounds the dating of Whittredge's first trip west; however, June 1866 to September 1866 is probably correct (see Anthony F. Janson, Sr., "The Western Landscapes of Worthington Whittredge," *American Art Review,* November–December 1976, pp. 58–69; Nancy Dustin Wall Moure, "Five Eastern Artists Out West," *American Art Journal* 5, no. 2 [November 1973]: 17–19).

2. John I. Baur, ed., *The Autobiography of Worthington Whittredge, 1820–1910,* p. 45.
3. Ibid., p. 55.
4. Ibid., p. 45.
5. Janson, "The Western Landscapes of Worthington Whittredge," p. 58.

6. Ibid., p. 60.
7. Henry T. Tuckerman, *Book of the Artists,* p. 518.
8. Ibid., p. 516.

Oil on panel
13⅛ × 22⅝ inches
Inscription: signed lower left "W. Whittredge"
Gift of C. R. Smith
1985.81

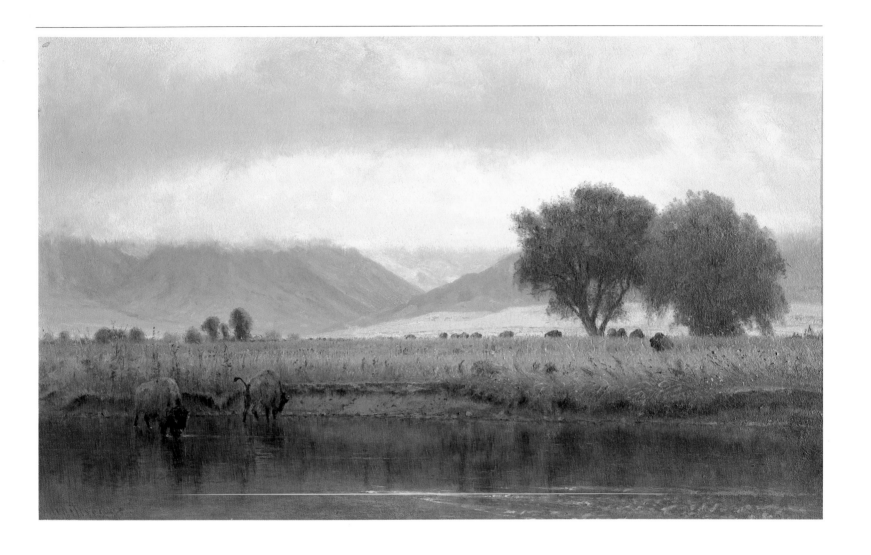

Harry Wickey

b. 1892, Stryker, Ohio; d. 1968, Cornwall, New York

In 1935, after a successful career as an etcher of New York City street life and a teacher at the Art Student's League, Harry Wickey was forced to give up etching because the close work and nitric acid affected his eyesight. Seeking solace and new inspiration, Wickey left New York City and spent two summers in his native Ohio. There in the quiet, rural environment he rediscovered his interest in nature. He wrote to his long-time friend and agent, Samuel Golden of the American Artists Group, "I cannot recall when I have had such sustained joy and interest in my work. It seems I had never actually seen this country before. I have a collection of drawings of horses, stallions, pigs, landscapes and all the other like things in and on the earth's surface that is to be found around here."[1]

Upon his return to his New York studio with these drawings, Wickey enthusiastically embraced lithography and sculpture as his artistic means of expression. His subject matter emerged from his surroundings, including both Ohio farm animals and New York street scenes. A former student of George Bellows and Robert Henri, Wickey believed that art is an expression of one's own environment. Wickey expressed his concern for art that is vital and integral: "I feel that a strong realistic sculptor is very much needed . . . we have had our fill of either weak academics or strong arm monstrosities and the time is ripe for a simple, strong expression of things as they are."[2] Like other American artists of the 1930s, Wickey began to explore nativistic themes in a style grounded in realism.

Sulking Bull was created during the time Wickey searched for new media of expression and solidified his aesthetic concerns. Regarding the piece, Wickey wrote to Golden: "I am going to get the bronze of the bull this friday and will need some cash . . . could you make out a check for me for $200.00. I am very happy at this time and I am sure the work shows it. Getting up at 6 am and plowing into it . . . This modeling may be my medium."[3] The work is muscular, earthy, and the embodiment of Wickey's realistic approach to art.

Wickey's sculptures, including *Sulking Bull, Young Boar,* and *Rearing Stallion,* were exhibited for the first time in 1938 at the Weyhe Gallery in New York. One-person shows followed at, among others, the Cincinnati Art Museum and the Associated American Artists in New York. He received a Guggenheim Fellowship in 1939. An energetic man, Wickey wrote his autobiography, entitled *Thus Far: The Growth of an American Artist,* in 1941; served as artist-in-residence at Bucknell University from 1942 to 1946; and later became curator at the Storm King Art Center, in Mountainville, New York, all the while remaining active as a sculptor. F. C.

1. Letter from Harry Wickey to Sam Golden, July 2, 1935, from Stryker, Ohio, Archives of American Art, microfilm N/Ag 12, frame 502.

2. Letter from Harry Wickey to Sam Golden, March 27, 1938, Archives of American Art, microfilm N/AG 12, frame 523.

3. Letter from Harry Wickey to Sam Golden, October 19, 1937, from Cornwall Landing, New York, Archives of American Art, microfilm N/AG 12, frame 520.

Bronze
Height: 10½ inches; base: 16⅛ × 7½ inches
Inscription: signed "Wickey 37"
Gift of C. R. Smith
G1975.6.6S

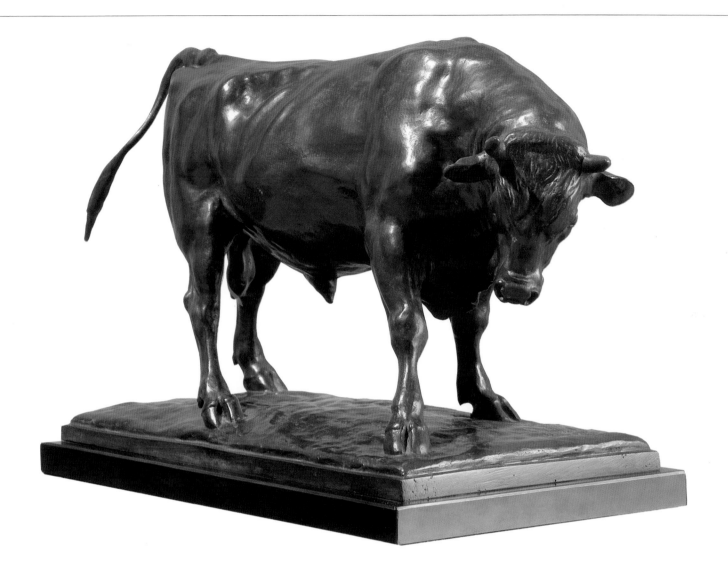

Ernest Chiriacka (1920–)

Arapahoe Camp, n.d.
Oil on masonite
24 × 36⁵⁄₁₆ inches
Loaned by C. R. Smith

George Dick

Caballos, n.d.
Oil on masonite
11½ × 15½ inches
Gift of C. R. Smith
G1976.21.5P

Nick Eggenhofer (1897–)

Missouri Freighters, n.d.
Gouache on paper
14¼ × 17 inches (sight)
Gift of C. R. Smith
G1976.21.9P

Herbert J. Gute (1907–)

Farmhouse, n.d.
Watercolor
13¾ × 19⅜ inches (sight)
Loaned by C. R. Smith

Chajo Hinajosa

Cielo y Mar, 1967
Oil on masonite
7½ × 9¾ inches
Loaned by C. R. Smith

Peter Hurd (1904–1984)

The Alamo Tree, n.d.
Watercolor
22¼ × 28⅜ inches (sight)
Loaned by C. R. Smith

Tom Lea (1907–)

The Lead Steer, 1941
32⅛ × 42⅛ inches
Gift of C. R. Smith
1985.170

E. Marenco

Campaña del Desierto: Rondin, 1879
Watercolor
9¾ × 7 inches
Loaned by C. R. Smith

Campaña del Desierto: El Centinela, 1879
Watercolor
8⁹⁄₁₆ × 5⅜ inches
Loaned by C. R. Smith

Peter McIntyre (1910–)

Antelope on Alert, Madison Valley, Montana, 1971
Oil on canvas
24 × 33⅓ inches
Loaned by C. R. Smith

Canyon de Chelly, n.d.
Oil on canvas
23½ × 32½ inches
Gift of C. R. Smith
G1976.21.26P

The Grand Canyon of the Yellowstone, n.d.
Oil on canvas
27⅛ × 31 inches
Loaned by C. R. Smith

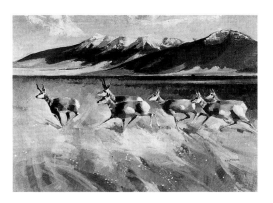

Montana Antelope, 1971
Oil on canvas
23¾ × 33¾ inches
Gift of C. R. Smith
G1976.21.27P

Gerald Mofchum

Nude, n.d.
Oil on canvas
28 × 28¼ inches
Gift of C. R. Smith
G1976.21.28P

Ogden Pleissner (1905–)

Bear River, 1977
Watercolor
6⅞ × 9⅝ inches (sight)
Loaned by C. R. Smith

How Noiseless Falls the Tread of Time, n.d.
Oil on canvas
24⅛ × 36⅛ inches
Loaned by C. R. Smith

Hugo Robus (1885–1964)

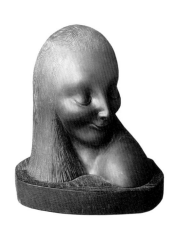

A Smile, 1936
Bronze on wood base
Height: 13½ inches; base: 12¾ × 10½ inches
Gift of C. R. Smith
G1975.6.25

Keith Shackleton

Mallards in Flight, 1958
Oil on particle board
23¾ × 29⅞ inches
Gift of C. R. Smith
G1976.21.32P

Unknown Artist

Vaqueros and Bull, 1933
Pen and ink on paper
5½ × 9⅛ inches
Loaned by C. R. Smith

Bibliography

Archival Sources

Amon Carter Museum, Fort Worth, Texas. Amon G. Carter Archives.

Archives of American Art, Washington, D.C.

Cook, Clarence. *New York Tribune,* May 3, 1872. Microfilm N370, frame 62.

Earhart, J. F. "Henry Farny." *Cincinnati Commercial Tribune,* magazine section, January 21, 1917. Microfilm 973, frame 282.

"Farny in the West." *Cincinnati Commercial Tribune,* 1894. Typed transcript. Microfilm 1233, frame 534.

Flynn, Edward. "The Paintings of H. F. Farny." *Cincinnati Commercial Gazette,* March 14, 1893. Microfilm 973, frame 246.

Frederic Remington correspondence available on microfilm Roll NOR 1.

Hogue, Fred. "Nocturne Paintings Depict Frontier Days." *Los Angeles Times,* November 1, 1936. Microfilm 1264, frame 821.

"A Nebraska Sculptor — World Famous." *World Herald* (Omaha, Nebraska), April 12, 1903. Microfilm N69–98, frame 685.

"A Needless Cruelty." *Cincinnati Commercial Gazette,* December 18, 1890. Typed transcript. Microfilm 1233, frame 460.

"Stroll through a Collection of Works from Brush of Farny." Unidentified Cincinnati newspaper clipping, October 6, 1919 [?]. Microfilm 973, frame 284.

"When He Takes His Ward for Wife." Unidentified newspaper clipping, 1906 [?]. Microfilm 973, frame 306.

Wickey, Harry, to Sam Golden. Unpublished letters March 27, 1938. Microfilm N/AG 12, frame 523. July 2, 1935, from Stryker, Ohio. Microfilm N/AG 12, frame 502. October 19, 1937, from Cornwall Landing, New York. Microfilm N/AG 12, frame 520.

World, August 16, 1906. Microfilm 973, frame 261.

Barker Texas History Center, University of Texas at Austin, Austin, Texas. William C. Hogg Papers.

M. Knoedler and Company, New York, New York. Company records.

Museum of Fine Arts, Houston, Texas. Registrar's files.

University of Oregon Library, Eugene, Oregon. Edwin Deming Papers.

Published Sources

Abbott, Carl. *Colorado: A History of the Centennial State.* Boulder: Colorado Associated University Press, 1976.

Adams, Ramon F. *Old-time Cowhand.* New York: Macmillan, 1961.

———, and Homer E. Britzman. *Charles M. Russell: The Cowboy Artist, a Biography.* Pasadena: Trail's End Publishing Co., 1948.

Ainsworth, Edward Maddin. *Painters of the Desert.* Palm Desert, Calif.: Desert Magazine, 1960.

Aldrich, Lanning. *The Western Art of Charles M. Russell.* New York: Ballantine Books, 1975.

Alexander, Jack. "Just Call me C. R." *Saturday Evening Post* 213 (February 1, 1941): 9–11.

Alexander F. Harmer, 1856–1925. Santa Barbara: James M. Hansen Gallery, 1982.

Alexander Gallery. *Albert Bierstadt: An Exhibition of Forty Paintings.* New York, 1983.

American Art News 18, no. 10 (December 27, 1919): 4.

Anderson, Roy. "E. I. Couse, 1866–1936." *Southwest Art* 4 no. 5 (November 1974): 54–59.

Appleton, Carolyn M. "Indians Taxed and Indians Not Taxed / Walter Shirlaw, Gilbert Gaul, and the 1890 Census." *Gilcrease Magazine of American History and Art* 7, no. 1 (January 1985): 28–32.

———, and Natasha S. Bartalini. *Henry Farny.* Austin, Tex.: Archer M. Huntington Art Gallery, 1983.

———, and Jan Huebner. "Nineteenth-Century American Art at the University of Texas at Austin." *Antiques* 126, no. 5 (November 1984): 1234–1243.

Arkelian, Marjorie Dakin. *The Kahn Collection of Nineteenth-Century Paintings by Artists in California.* Oakland, Calif.: Oakland Museum, 1975.

———. *Thomas Hill: The Grand View.* Oakland, Calif.: Oakland Museum, 1980.

———. "William Hahn: German-American Painter of the California Scene." *American Art Review* 4, no. 2 (August 1977): 102–115.

"Art Beginnings on the Pacific. I." *Overland Monthly* 1 (July 1868): 34.

"Artists of the Santa Fe." *American Heritage* 27, no. 2 (February 1976): 57–72.

Baird, Joseph Armstrong. *Catalogue of Original Paintings, Drawings, and Watercolors in the Robert H. Honeyman, Jr., Collection.* Berkeley: Friends of the Bancroft Library, 1968.

———. "Charles Christian Nahl: Artist of the Gold Rush, Exhibition Review." *American Art Review* 3, no. 5 (September–October 1976): 56–70.

Ballinger, James K., and Susan P. Gordon. "The Popular West." *American West* 19, no. 4 (July–August 1982): 36–45.

Bartlett, T. H. "Walter Shirlaw." *American Art Review* 2 (1881): 97–145.

Baur, John I., ed. *The Autobiography of Worthington Whittredge, 1820–1910.* New York: Arno Press, 1969.

The Bay of San Francisco, the Metropolis of the Pacific Coast and Its Suburban Cities: A History. 2 vols. Chicago: Lewis Publishing Co., 1892.

Bell, William Gardner. "A Rebirth of Classic Western Art." *Southwest Art* 11, no. 9 (February 1982): 82–87.

Benjamin, S. G. W. *Art in America: A Critical and Historical Sketch.* New York: Harper & Brothers, 1880.

Bernard, Virginia. *Ima Hogg.* Austin: Texas Monthly Press, 1984.

Berry, Rose V. S. "Walter Ufer in a One-Man Show." *American Magazine of Art* 13 (December 1922): 507–514.

Bickerstaff, Laura. *Pioneer Artists of Taos.* Denver: Sage Books, 1955.

Bierstadt, Albert. Letter. *The Crayon* 6, no. 9 (September 1859): 287.

Bloch, E. Maurice. *George Caleb Bingham: The Evolution of an Artist.* 2 vols. Berkeley and Los Angeles: University of California Press, 1967.

Bourke, John G. "General Crook in the Indian Country." *Century Magazine* 41 (March 1891): 650.

Bowditch, Nancy Douglass. *George de Forest Brush: Recollections of a Joyous Painter.* Peterborough, N.H.: Willaim L. Bauhan, 1970.

Bowles, Samuel. *Our New West: Records of Travel between the Mississippi River and the Pacific Ocean.* Hartford: Hartford Publishing Co., 1869.

Brayer, Herbert O. *William Blackmore: The Spanish-Mexican Land Grants of New Mexico and Colorado, 1863–1878.* 2 vols. Denver: Branford-Robinson, 1949.

Broder, Patricia Janis. *Bronzes of the American West.* New York: Harry N. Abrams, 1973.

———. "The Buffalo Signal, the Lost Remington Bronze." *Southwest Art* 8, no. 12 (May 1979): 68–71.

———. "The Geraldine Rockefeller Dodge Collection of American Western Bronzes." *American Art Review* 3, no. 2 (March–April, 1976): 109–121.

———. *Taos: A Painter's Dream.* Boston: Little, Brown and Co., 1980.

Broderick, Janice K. *Charles M. Russell: American Artist.* St. Louis: Jefferson National Expansion Historical Association, 1982.

Brush, George de Forest. "An Artist among the Indians." *Century Magazine* 30 (May 1885): 56–58.

Bryant, Keith L., Jr. "The Atchison, Topeka and Santa Fe Railway and the Development of the Taos and Santa Fe Art Colonies." *Western Historical Quarterly* 9, no. 4 (October 1978): 437–453.

Burke, Doreen Bolger. *American Paintings in the Metropolitan Museum of Art: Volume III, A Catalogue of Works by Artists Born between 1846 and 1864.* New York: Metropolitan Museum of Art, 1980.

Burnside, Wesley M. *Maynard Dixon: Artist of the West.* Provo, Utah: Brigham Young University Press, 1974.

Caffin, Charles H. "Annual Exhibition of the National Academy." *Harper's Weekly,* January 13, 1900, p. 31.

California Academy of Sciences. *Images of the Native American.* San Francisco, 1981.

———. *Maynard Dixon: Images of the Native American.* San Francisco, 1981.

California Art Research. Vol. 8, first series. San Francisco: WPA Project, 1937.

California's Centennial Exhibition of Art. Sect. I, "Historic California." Los Angeles: Los Angeles County Museum, 1949.

Carr, Gerald R. "Albert Bierstadt, Big Trees, and the British: A Log of Many Anglo-American Ties." *Arts Magazine* 60, no. 10 (June–Summer 1986): 60–71.

Carter, Denny. *Henry Farny.* New York: Watson-Guptil Publications, 1978.

Catalogue of Paintings to Be Sold for the Benefit of the Ranney Fund. New York, 1858.

Catalogue of the Collection, 1972. Fort Worth: Amon Carter Museum of Western Art, 1973.

Catalogue of the Collier Collection of Original Drawings and Paintings by Distinguished American Painters and Illustrators. Indianapolis: John Herron Art Institute, 1907.

Catalogue of the First Annual Exhibition of the Western Academy of Art, St. Louis, 1860. St. Louis: Printed at the Missouri Democratic Book and Job Office, 1860.

Catalogue of the Second Exhibition of Oil Paintings. Hoboken, N.J.: Free Public Library, 1909.

Catlin, George. *Letters and Notes on the Manners, Customs, and Conditions of the North American Indians,* II. 1844. Reprint, New York: Dover Publications, 1973.

A Century of American Landscapes, 1812–1912. Philadelphia: Frank S. Schwarz & Son, 1986.

Chapin, Louis. *Charles M. Russell: Painting of the Old American West.* New York: Crown Publishers, 1978.

Chapman, John G. "The First Ship." In *The Token and Atlantic Souvenir,* p. 294. Boston: D. H. Williams, 1842.

Christie, Manson, and Woods International, Inc. *Walter Ufer: Sixteen Paintings.* Houston, 1982.

Clark, Carol. *Thomas Moran: Watercolors of the American West.* Austin: University of Texas Press, published for the Amon Carter Museum of Western Art, 1980.

A Classified Catalogue of the Paintings on Exhibition at the Room of the California Art Union, No. 312 Montgomery Street, with the Constitution and By-Laws, and List of Officers. San Francisco: California Art Union, 1865.

Coen, Rena N. "The Last of the Buffalo." *American Art Journal* 5 (November 1973): 91–93.

Coke, Van Deren. *Taos and Santa Fe: The Artist's Environment, 1882–1942.* Albuquerque: University of New Mexico Press, for the Amon Carter Museum of Western Art and Art Gallery, University of New Mexico, Albuquerque, 1963.

Colby, Virginia Reed. "Stephen and Maxfield Parrish in New Hampshire." *Antiques* 115 (June 1979): 1290–1298.

Compilation of Works of Art and Other Objects in the United States Capitol. Washington, D.C.: Government Printing Office, 1965.

Conger, Clement E., with William G. Allman. "Western Art in the White House." *American West* 19, no. 2 (March–April 1982): 34–41.

Congressional Globe, 28th Congress, 1st session, 1844.

Conrad, Howard Louis. *Uncle Dick Wootton.* Ed. Milo Milton Quaife. Chicago: Lakeside Press, R. R. Donnelley & Sons Co., 1957.

Constable, W. G. *Art Collecting in the United States of America.* London: Thomas Nelson and Sons, 1964.

Cooke, Louis E. "Buffalo Ranch and the Beautiful Bungalow Home of Pawnee Bill." *Souvenir of the Buffalo Ranch and Its Owners.* [Pawnee, Okla., ca. 1911.]

Cooper, James Fenimore. *The Prairie.* Rev. ed. New York: W. A. Townsend Co., 1859.

Cortissoz, Royal. "The Academy Exhibition: Where It Stands in the Movement of American Art." *Harper's Weekly,* April 17, 1897, p. 394.

Cosentino, Andrew F. *The Paintings of Charles Bird King, 1785–1862.* Washington, D.C.: Smithsonian Institution Press, 1977.

Cowdrey, Mary Bartlett. *American Academy of Fine Arts and American Art-Union.* Vols. 2 and 6. New York: New York Historical Society, 1953.

Cowdrey, [Mary] Bartlett, and Hermann Wagner Williams, Jr. *William Sidney Mount, 1807–1868.* New York: Columbia University Press, 1944.

Craven, Wayne. *Sculpture in America.* Cranbury, N.J.: Cornwall Books and Associated University Presses, 1968, 1984.

Cummins, D. Duane. *William Robinson Leigh: Western Artist.* Norman: University of Oklahoma Press and Thomas Gilcrease Institute, Tulsa, 1986.

Cunningham, Elizabeth. "Corporate Collections, a Response to the Arts." *Artists of the Rockies and Golden West,* Summer 1984, pp. 118–125.

———. *Masterpieces of the American West: Selections from the Anschutz Collection.* Denver: Anschutz Collection, 1983.

Curry, Larry. *The American West.* New York: Viking Press, 1972.

Curtis, Edward S. *The North American Indians.* 20 vols. 1911. Reprint, New York: Johnson Reprint, 1970.

"Cyrus Rowlett Smith (1899–)." *Fortune,* January 1976, p. 125.

Davies, Alfred Mervyn. *Solon Borglum: A Man Who Stands Alone.* Chester, Conn.: Pequot Press, 1975.

Day, Donald. *Will Rogers.* New York: David McKay Co., 1962.

"Decorations in the Missouri State Capitol, Jefferson City." *American Magazine of Art* 12 (July 1921): 243–249.

Deming, Therese O. *Edwin Willard Deming.* New York: Riverside Press, 1925.

———. "Life-Long Painter of Indians." *Mentor* 14 (April 1926): 23–28.

Department of the Interior Census Office. *Report on Indians Taxed and Indians Not Taxed in the United States (Except Alaska) at the Eleventh Census: 1890.* Washington, D.C.: Government Printing Office, 1894.

Dial, Scott. "Alexander Phimster Proctor, 1860–1950." *Southwest Art* 4, no. 11 (May 1975): 60–65.

Dictionary of American Biography, ed. Dumas Malone. 20 vols. New York: Scribner's, 1928–1937. Reprint, 1964, 10 vols.

Dictionary of National Biography, ed. Leslie Stephen and Sidney Lee. 66 vols. London: 1885–1901.

Dippie, Brian W. *Remington & Russell: The Sid Richardson Collection.* Austin: University of Texas Press, 1982.

———, ed. *"Paper Talk": Charlie Russell's American West.* New York: Alfred A. Knopf, 1979.

Dobie, J. Frank. "The Conservatism of Charles M. Russell." *Montana* 8 (October 1958): 57–63.

———. *The Longhorns.* Boston: Little, Brown and Co., 1941. Reprint, Austin: University of Texas Press, 1980.

Dock, George, Jr. *Audubon's Birds of America.* New York: Harry N. Abrams, 1979.

The Drawings of Maynard Dixon. San Francisco: Fine Arts Museums of San Francisco, Achenbach Foundation for Graphic Arts, 1985.

Dressler, Albert. *California's Pioneer Artist: Ernest Narjot, a Brief Résumé of the Career of a Versatile Genius.* San Francisco: Albert Dressler, 1936.

Dubois, June. *W. R. Leigh: The Definitive Illustrated Biography.* Kansas City, Mo.: Lowell Press, 1977.

———. *William Robinson Leigh: Art of Frontiers.* Kansas City, Mo.: Lowell Press, 1977.

Dunton, Herbert. "The Painters of Taos." *American Magazine of Art* 13 (August 1922): 247–252.

Duty, Michael. "Robert F. Rockwell and the Rockwell Collection of Western Art." *Southwest Art,* March 1985, pp. 36–43.

Dyck, Paul. *Brul'e: The Sioux People of the Rosebud.* Flagstaff, Ariz.: Northland Press, 1971.

Eggenhofer, Nick. *Wagons, Mules, and Men: How the Frontier Moved West.* New York: Hastings House, 1961.

El Tovar, Grand Canyon of Arizona. 1909.

Eldredge, Charles C., Julie Schimmel, and William H. Truettner. *Art in New Mexico, 1900–1945; Paths to Taos and Santa Fe.* Washington, D.C.: National Museum of American Art, Smithsonian Institution, 1986.

Ewers, John C. *Artists of the Old West.* New York: Doubleday & Co., 1973.

———. "Food Rationing — from Buffalo to Beef." In *Indian Life on the Upper Missouri.* Norman: University of Oklahoma Press, 1968.

"Farny Biography." *Cincinnati Daily Times-Star,* January 27, 1925.

Fenin, George N., and William K. Everson. *The Western: From Silents to Cinerama.* New York: Orion Press, 1962.

Fenn, Forrest. "The Early Years in Taos, Joseph Henry Sharp (1859–1953)." *Southwest Art* 10, no. 3 (August 1980): 50–57.

A Festival of Western American Art at Hirschl and Adler. Exhibition Catalogue. New York: Hirschl & Adler Galleries, 1984.

Fisch, Mathias S. "The Quest for the Mount of the Holy Cross." *American West* 16 (1979): 32–37, 57–58.

Flemmons, Jerry. *Amon: The Life of Amon Carter, Sr., of Texas.* Austin: Jenkins Publishing, 1978.

Forrest, James T. *Bradford Brinton: His Collections and the Quarter Circle A Ranch.* Big Horn, Wyo.: 1986.

Francis, Rell G. "Spokesman in Bronze for the American Indian: Cyrus E. Dallin, 1861–1944." *Southwest Art* 11, no. 5 (October 1981): 170–175.

Franzwa, Gregory M. *The Oregon Trail Revisited.* St. Louis: Patrice Press, 1972.

Frederic Remington: The Soldier Artist. West Point: United States Military Academy, 1979.

Frederic Remington (1861–1909), Paintings, Drawings, and Sculpture. In the Collection of the R. W. Norton Art Gallery. Shreveport, [1979].

"From the Seventy-second Annual Exhibition of the National Academy of Design." *Harper's Weekly,* April 17, 1897, p. 380.

Frost, Richard I., Leo A. Platteter, and Don Hedgpeth. *The West of Buffalo Bill: Frontier Art, Indian Crafts, Memorabilia from the Buffalo Bill Historical Center.* New York: Harry N. Abrams, [1974].

Gallery Guide: Amon Carter Museum. Fort Worth: Amon Carter Museum, 1981.

Gaul, Gilbert. "Exchange of Prisoners." *Leslie's Weekly,* December 16, 1897, p. 396.

George, Hardy. "Thomas Hills's 'Driving of the Last Spike,' a Painting Commemorating the Completion of America's Transcontinental Railroad." *Art Quarterly* 27 (1964): 82–93.

George de Forest Brush, 1855–1941: Master of the American Renaissance. New York: Berry-Hill Galleries, 1985.

Gibson, Arrell M. *Santa Fe Collection of Southwestern Art.* Tulsa: Gilcrease Museum, 1983.

Gilder, Jeannette L. "A Painter of Soldiers." *Outlook* 59, no. 9 (July 2, 1898): 570–573.

Glanz, Dawn. *How the West Was Drawn: American Art and the Settling of the Frontier.* Ann Arbor, Mich.: UMI Research Press, 1982.

Goetzmann, William H. *Exploration and Empire.* New York: W. W. Norton and Co., 1966.

———. "Lords at the Creation: The Mountain Man and the World." In *The Mountain Man.* Cody, Wyo.: Buffalo Bill Historical Center, 1978.

———, and William N. Goetzmann. *The West of the Imagination.* New York: W. W. Norton, 1986.

———, and Joseph C. Porter. *The West as Romantic Horizon.* Omaha: Center for Western Studies, Joslyn Art Museum, 1981.

———, and Becky Duval Reese. *Texas Images and Visions.* Austin: Archer M. Huntington Art Gallery, University of Texas at Austin, 1983.

Goodrich, Arthur. "The Frontier in Sculpture." *World's Work,* March 1902, p. 1873.

Greene, George W. "Life and Voyages of Verrazzano, Delle Navigazioni et Viaggi, raccolte da M. Giovan-Battista Ramusio." *North American Review* 45 (1837): 293–311.

Grubar, Francis S. *William Ranney, Painter of the Early West.* Washington, D.C.: Corcoran Gallery of Art, 1962.

A Guide to the Paintings in the Permanent Collection. Chicago: Art Institute of Chicago, 1925.

Hagerty, Donald J., et al. *Maynard Dixon.* San Francisco: California Academy of Sciences, 1981.

Hailey, Gail, ed. "Herman Wendelborg Hansen." In *California Art Research.* Vol. 9. San Francisco: WPA Project 2874, 1937.

Hamilton, Henry W., and Jean Tyree Hamilton. *The Sioux of the Rosebud: A History in Pictures.* Norman: University of Oklahoma Press, 1971.

Hamlin, Edith. "Maynard Dixon: Artist of the West." *California Historical Quarterly* 53 (Winter 1974): 361–376.

———. "Maynard Dixon: Painter of the West." *American West* 19 (November-December 1982): 50–58.

Harper, J. Russell. *Painting in Canada: A History.* 2d ed. Toronto: University of Toronto Press, 1977.

———. *Paul Kane's Frontier, Including "Wanderings of an Artist among the Indians of North America" by Paul Kane.* Austin and London: University of Texas Press published for the Amon Carter Museum, Fort Worth, and the National Gallery of Canada, Ottawa, 1971.

Harrison, Carter H. *Growing Up with Chicago.* Chicago: Ralph Fletcher Seymour, 1944.

Hassrick, Peter H. *Frederic Remington: An Essay and Catalogue.* Fort Worth: Amon Carter Museum, 1973.

———. *Frederic Remington: Paintings, Drawings, and Sculpture in the Amon Carter Museum and the Sid W. Richardson Foundation Collections.* New York: Harry N. Abrams, 1973.

———. *The Way West: Art of Frontier America.* New York: Harry N. Abrams, 1977.

Helmuth, William Tod, ed. *Arts in St. Louis.* St. Louis, 1864.

Henderson, James David. *Meals by Fred Harvey.* Fort Worth: Texas Christian University Press, 1969.

Hendricks, Gordon. *Albert Bierstadt.* Fort Worth: Amon Carter Museum of Western Art, 1972.

———. *Albert Bierstadt: Painter of the American West.* New York: Harry N. Abrams, 1974.

———. "Bierstadt's *The Domes of Yosemite.*" *American Art Journal* 3 (Fall 1971): 22–31.

Hill, Gene. "Pawnee Bill and the Treasures of Blue Hawk Peak." *Oklahoma Today,* March–April 1986, pp. 14–18.

Hobbs, Susan. *1876: American Art of the Centennial.* Washington, D.C.: National Collection of Fine Arts, Smithsonian Institution, 1976.

Hodges, W. R. "Charles Ferdinand Wimar." *American Art Review.* 2 vols. Boston, 1881.

Hogarth, Paul. *Artists on Horseback: The Old West in Illustrated Journalism, 1857–1900.* New York: Watson Guptil, 1972.

Horan, James D. *The Life and Art of Charles Schreyvogel: Painter-Historian of the Indian-Fighting Army of the American West.* New York: Crown Publishers, 1969.

Howard, James K. *Ten Years with the Cowboy Artists of America.* Flagstaff, Ariz.: Northland Press, 1976.

Hunt, David C. "The Old West Revisited: The Private World of Dr. Cole." *American Scene* 8, no. 4 (1967).

Hutchings, J. M. *Scenes of Wonder and Curiosity in California.* San Francisco: Hutchings and Rosenfield, 1860.

Hutchison, William H. *The World, the Work and the West of W. H. D. Koerner.* Norman: University of Oklahoma Press, 1978.

Inaugural Exhibition: Selected Works, Frederic Remington and Charles Russell. Fort Worth: Amon Carter Museum, 1961.

Indian Hill Historical Museum Association. *Henry F. Farny.* Cincinnati, 1974.

"An Indian Muster Day." *Harper's Weekly* 24 (July 24, 1880): 477.

Indians and the American West: Paintings from the Collection of the Santa Fe Industries, Inc. Washington, D.C.: National Archives of the United States, 1973.

Irving, Washington. *Adventures of Captain Bonneville.* Ed. Edgeley W. Todd. Norman: University of Oklahoma Press, 1961.

Isham, Samuel, and Royal Cortissoz. *The History of American Painting.* New York: Macmillan Co., 1927.

James, Edwin. *Account of an Expedition from Pittsburgh to the Rocky Mountains, Performed in the Years 1819–20, by Order of the Honourable John C. Calhoun, Secretary of War.* Philadelphia: H. C. Carey and I. Lea, 1822.

James, George Wharton. *Through Ramona's Country.* Boston: Little, Brown and Co., 1909.

Janson, Anthony F., Sr. "The Western Landscapes of Worthington Wittredge." *American Art Review,* November–December 1976, pp. 58–69.

John Mix Stanley: A Traveller in the West. Ann Arbor: University of Michigan Museum of Art, 1969.

Johnson, Una E. *American Prints and Printmakers.* Garden City, N.Y.: Doubleday & Co., 1980.

Jussim, Estelle. *Frederic Remington, the Camera & the Old West.* Fort Worth: Amon Carter Museum, 1983.

Kimbrough, Mary. "Oscar Berninghaus: St. Louis Portrayer of the West." *Sunday Magazine—St. Louis Globe-Democrat,* February 27, 1977, pp. 4–7, 9.

Kinch, Samuel E., Jr. "Amon Carter: Publisher-Salesman." M.A. Thesis, University of Texas at Austin, 1965.

King, Edward S., and Marvin C. Ross. *Catalogue of the American Works of Art, the Walters Art Gallery.* Baltimore: Walters Art Gallery, 1956.

Kobbe, Gustav. "A Painter of the Western Frontier." *Cosmopolitan* 31 (October 1901): 568.

Krakel, Dean. *Adventures in Western Art.* Kansas City, Mo.: Lowell Press, 1977.

———. "Visions of Today." *American Scene* 5, no. 4 (1964): 57–63.

Krims, Milton. "Jeremiah Johnson: Mountain Man." *Saturday Evening Post* 244 (Winter 1972): 78–79, 128, 131.

Lamb, Thomas G. *Eight Bears: A Biography of E. W. Deming, 1860–1942.* Oklahoma City: Griffin Books, 1978.

Lea, Tom. *A Picture Gallery.* Boston: Little, Brown and Co., 1968.

Leigh, William R. *The Western Pony.* New York: Harper & Brothers, 1933.

Linderman, Frank Bird. *Recollections of Charley Russell.* Norman: University of Oklahoma Press, 1963.

Lomax, John. *Cowboy Songs and Other Frontier Ballads.* New York: Sturgis and Walton Co., 1915.

———. *Will Hogg, Texan.* Austin: Published for the Hogg Foundation by University of Texas Press, 1956.

Longfellow, Henry Wadsworth. *The Song of Hiawatha.* Rev. ed. New York: Thomas Y. Crowell & Co., 1898.

Lummis, Charles F. "A Painter of Old California, Alex. F. Harmer and His Work." *Out West Magazine* 12 (December 1899): 22–23.

McClinton, Katharine Morrison. "L. Prang and Company." *Connoisseur* 191 (February 1976): 97–105.

McCracken, Harold. *The Charles M. Russell Book: The Life and Work of the Cowboy Artist.* Garden City, N.Y.: Doubleday & Co., 1957.

———. *The Frank Tenney Johnson Book: A Master Painter of the Old West.* Garden City, N.Y.: Doubleday & Co., 1974.

———. *Frederic Remington—Artist of the Old West.* Philadelphia: J. A. Lippincott Co., 1947.

McDermott, John Francis, ed. *Audubon in the West.* Norman: University of Oklahoma Press, 1965.

———. *Seth Eastman, Pictorial Historian of the Indian.* Norman: University of Oklahoma Press, 1961.

Mandel, Patricia C. F. "American Paintings at the St. Johnsbury Athenaeum in Vermont." *Antiques* 117 (April 1980): 868–879.

———. "English Influences on the Work of A. F. Tait." In *A. F. Tait: Artist in the Adirondacks.* Blue Mountain Lake, N.Y.: Adirondack Museum, 1974.

Mann, Maybelle. *The American Art Union.* Jupiter, Fla.: Alan Associates, 1977.

Marshall, James L. *Santa Fe: The Railroad That Built an Empire.* New York: Random House, 1945.

Marter, Joan M., Roberta K. Tarbell, and Jeffrey Wechsler. *Vanguard American Sculpture, 1913–1939.* New Brunswick, N.J.: Rutgers University Art Gallery, 1979.

Mathews, Mitford M. *A Dictionary of Americanisms or Historical Principles.* Chicago: University of Chicago Press, 1951.

Matthiessen, Peter. "Native Earth: Man's Harmony with His Surroundings." *American West* 19 (May–June 1982): 44–49.

Maynard Dixon: Images of the Native American. San Francisco: California Academy of Sciences, 1981.

Meltzer, Milton. *Dorothea Lange: A Photographer's Life.* New York: Farrar, Straus, & Giroux, 1978.

Merrick, Lula. "Brush's Indian Pictures." *International Studio* 76, no. 307 (December 1922): 182–193.

Miles, Nelson A. *Personal Recollections and Observations.* New York: Werner Co., 1896.

Miller, Arthur. *Maynard Dixon: Painter of the West.* Tucson, 1945.

Miller, Donald C. *Ghost Towns of California.* Boulder: Pruett Publishing Co., 1978.

Miller, Lillian B. *Patrons and Patriotism.* Chicago: University of Chicago Press, 1966.

Miller, Lucille V. "Edward and Estelle Doheny." *Ventura County Historical Society Quarterly* 6, no. 1 (November 1960): 1–20.

Milsten, David R. *Thomas Gilcrease.* San Antonio: Naylor Co., 1969.

Minahan, John. "C. R. Smith: Reflections." *American Way,* April 1976, pp. 20–25.

Mitchell, Lee Clark. *Witnesses to a Vanishing America.* Princeton: Princeton University Press, 1981.

Montgomery, Walter, ed. *American Art and American Art Collections.* 2 vols. 1889. Reprint, New York: Garland, 1978.

Moran, Thomas. "Utah Scenery." *Adine* 7 (January 1874): 15.

Morgan, Joan B. "The Indian Paintings of George de Forest Brush." *American Art Journal* 15, no. 2 (Spring 1983): 60–73.

Moure, Nancy Dustin Wall. "Five Eastern Artists Out West." *American Art Journal* 5, no. 2 (November 1973): 15–31.

"Mr. Farny among the Sioux." *Cincinnati Daily Gazette,* November 8, 1881, p. 8.

Muller, Nancy C. *Paintings and Drawings at the Shelburne Museum.* Shelburne, Vt.: Shelburne Museum, 1976.

My Bunkie and Others: Pictures by Charles Schreyvogel. New York: Moffat, Yard, & Co., 1909.

National Cowboy Hall of Fame and Western Heritage Center. *American Masters in the West: Selections from the Anschutz Collection.* Oklahoma City, 1974.

Naylor, Maria. *The National Academy of Design Record, 1861–1900.* New York: New York Historical Society, 1943.

——, ed. *The National Academy of Design Exhibition Record, 1861–1900.* 2 vols. New York: Kennedy Galleries, 1973.

Nelson, Mary Carroll. *The Legendary Artists of Taos.* New York: Watson-Guptil Publications, 1980.

Nickerson, Cynthia D. "Artistic Interpretations of Henry Wadsworth Longfellow's *The Song of Hiawatha,* 1855–1900." *American Art Journal* 16, no. 3 (Summer 1984): 49–77.

Northwood, Bill. "Thomas Hill: Master of Yosemite." *Museum of California* (Oakland Museum), September–October 1980, pp. 4–8.

Nye, Russell. *The Unembarrassed Muse: The Popular Arts in America.* New York: Dial Press, 1970.

Oil Paintings by Contemporary American Artists Exhibited in the Free Public Library, April Twentieth to Twenty-fifth, Nineteen Hundred and Eight. Hoboken, N.J.: Free Public Library, 1908.

The Painters' West: A Selection from the Rockwell Collection of Western Art. Corning, N.Y.: Rockwell-Corning Museum, 1976.

Paintings from the C. R. Smith Collection. Austin: University of Texas, 1969.

Paladin, Vivian. *C. M. Russell: The Mackay Collection.* Helena: Montana Historical Society, n.d.

Parry, Ellwood. *The Image of the Indian and the Black Man in American Art.* New York: George Braziller, 1974.

Perlman, Barbara. "Fred Renner Can 'Smell a Russell.'" *Art News* 80, no. 10 (December 1981): 98–102.

Peters, Harry T. *America on Stone: The Other Printmakers to the American People.* Rev. ed. New York: Arno Press, 1931.

Picturesque Images from Taos and Santa Fe. Denver: Denver Art Museum, 1974.

Pratt, Harry Noyes. "Hansen, Great Painter of Old West, Dies." *San Francisco Chronicle,* April 13, 1924.

Purtell, Joseph. *The Tiffany Touch.* New York: Random House, 1971.

The Quest for Unity: American Art between World's Fairs, 1876–1893. Detroit: Detroit Institute of Arts, 1983.

Rathbone, Perry T. *Charles Wimar.* St. Louis: City Art Museum of St. Louis, 1946.

Rawls, Walter. *The Great Book of Currier and Ives' America.* New York: Abbeville Press, 1979.

Reed, Walt, ed. *The Illustrator in America, 1900–1960s.* New York: Reinhold Publishing Corp., 1966.

Reeves, James F. *Gilbert Gaul.* Exhibition catalogue. Huntsville, Ala.: Huntsville Museum of Art, 1975.

Remington, Preston. "The Bequest of Jacob Ruppert: Sculpture." *Bulletin of the Metropolitan Museum of Art* 34 (July 1939): 169–172.

Renner, Frederic G. *Charles M. Russell: Paintings, Drawings, and Sculpture in the Amon G. Carter Collection.* Austin: Published for the Amon Carter Museum of Western Art, Fort Worth, by the University of Texas Press, 1966. Rev. ed. New York: Harry N. Abrams, 1974.

Rindge, Fred Hamilton. "Taos — a Unique Colony of Artists." *American Magazine of Art* 17 (September 1926): 446–453.

Robinson, Doane. *A History of the Dakota or Sioux Indians.* 1904. Reprint, Minneapolis: Ross and Haines, 1956.

Rogers, Millard F., Jr. *Randolph Rogers: American Sculptor in Rome.* Amherst: University of Massachussets Press, 1971.

Roosevelt, Theodore. *Ranch Life and the Hunting-Trail.* New York: Century Co., 1888.

Ross, Marvin C. *The West of Alfred Jacob Miller.* Norman: University of Oklahoma Press, 1951.

Rossi, Paul, and David C. Hunt. *The Art of the Old West.* New York: Alfred A. Knopf, 1971.

Russell, Charles M. "The Horse Hunters." *Montana* 8 (October 1958): 66.

——. "Medicine Man." *Montana* 13 (July 1963): cover.

——. *More Rawhides.* Great Falls: Montana Newspaper Association, 1925.

——. *Rawhide Rawlins Stories.* Rev. ed. with preface and biographical notes by H. E. Britzman. Pasadena, Calif.: Trail's End Publishing Co., 1946.

Russell, Don. *The Lives and Legends of Buffalo Bill.* Norman: University of Oklahoma Press, 1960.

——. *The Wild West.* Fort Worth: Amon Carter Museum of Western Art, 1970.

Samuels, Peggy and Harold. *Frederic Remington.* New York: Doubleday & Co., 1982. Reprint, Austin: University of Texas Press, 1985.

——. *The Illustrated Biographical Encyclopedia of Artists of the American West.* Garden City, N.Y.: Doubleday & Co., 1976.

Sandweiss, Martha A. *Pictures from an Expedition.* New Haven: Yale Center for American Art and Material Culture and the Yale University Art Gallery, 1978.

Santa Fe Railway. *Santa Fe Collection of Southwestern Art.* Exhibition catalogue. Chicago, 1983.

Scher, Zeke. "Wyoming's Room at the Top." *Denver Post,* February 8, 1981, pp. 10–11.

Schimmel, Julie. *Stark Museum of Art: The Western Collection, 1978.* Orange, Tex.: Stark Museum of Art, 1978.

Schwarz, Ted. "The Santa Fe Railway and Early Southwest Artists." *American West* 19, no. 5 (September–October 1982): 32–41.

Shapiro, Michael Edward. *Cast and Recast: The Sculpture of Frederic Remington.* Washington, D.C.: National Museum of American Art, 1981.

Sheldon, George William. *American Painters.* 1972.

——. *Recent Ideals of American Art, 6.* New York, 1888.

Shinn [Strahan], Earl. *The Masterpieces of the Centennial International Exhibition.* 3 vols. Philadelphia: Gebbie & Barrie, 1876. Reprint, New York: Garland Publishing, 1977.

Shirlaw, Walter. "Artist's Adventures: The Rush to Death." *Century Magazine* 47 (November 1893): 41–45.

Simpson, William H. "Thomas Moran — the Man." *Fine Arts Journal* 20, no. 1 (January 1909): 18–25.

60 Years of Collecting American Art. Youngstown, Ohio: Butler Institute of American Art, 1979.

Skow, J. "In Arizona: A Million Dollar Sale of Cowboy Art." *Time* 116 (November 24, 1980): 6.

Smith, Minna C. "George de Forest Brush." *International Studio* 34, no. 134 (April 1908): 47–55.

"The Spell of Indian for Artists." *Literary Digest* 102 (July 13, 1929): 18.

Starr, Kevin. "Painterly Poet, Poetic Painter: The Dual Art of Maynard Dixon." *California Historical Quarterly* 56 (Winter 1977): 290–309.

Stevens, Walter B. *St. Louis, the Fourth City.* 2 vols. St. Louis: 1911.

Taft, Robert. *Artists and Illustrators of the Old West, 1850–1900.* Princeton: Princeton University Press, 1953. Reprint, 1982.

Tarbell, Roberta. *Hugo Robus.* Washington, D.C.: Smithsonian Institution Press, 1980.

Taylor, Joshua C. *America as Art.* New York: Harper & Row, 1976.

Taylor, Lonn, and Ingrid Marr. *The American Cowboy.* Washington, D.C.: Library of Congress, 1983.

Thoeber, Arthur. "Painter of Western Life." *Mentor Magazine,* June 15, 1915, p. 11.

Trenton, Patricia, and Peter H. Hassrick. *The Rocky Mountains: A Vision for Artists in the Nineteenth Century.* Norman: University of Oklahoma Press in association with the Buffalo Bill Historical Center, Cody, Wyoming, 1983.

Truettner, William H. "The Art of History: American Exploration and Discovery Scenes, 1840–1860." *American Art Journal* 14, no. 1 (Winter 1982): 4–31.

———. *The National Man Observed: A Study of Catlin's Indian Gallery.* Washington, D.C.: Smithsonian Institution Press in cooperation with the Amon Carter Museum of Western Art, Fort Worth, and the National Collection of Fine Arts, Smithsonian Institution, 1979.

———. "Scenes of Majesty and Enduring Interest: Thomas Moran Goes West." *Art Bulletin* 58, no. 2 (June 1976): 241–259.

———. "William T. Evans, Collector of American Paintings." *American Art Journal* 3 (Fall 1971): 50–79.

Tucker, Patrick T. *Riding the High Country.* Caldwell, Idaho: Caxton Printers, 1933.

Tuckerman, Henry T. *Book of the Artists: American Artist Life.* 1867. Reprint, New York: James Carr, 1967.

Two Hundred Years of American Sculpture. New York: Whitney Museum of American Art, 1976.

Tyler, Ron. *Visions of America, Pioneer Artists in a New Land.* New York: Thames and Hudson, 1983.

———, ed. *Alfred Jacob Miller: Artist on the Oregon Trail.* Fort Worth: Amon Carter Museum, 1982.

Udall, Sharyn Rohlfsen. *Modernist Painting in New Mexico, 1913–1935.* Albuquerque: University of New Mexico Press, 1984.

Utley, Robert M., and Wilcomb E. Washburn. *The Indian Wars.* New York: American Heritage Publishing Co., 1977.

Viola, Herman J. *The Indian Legacy of Charles Bird King.* New York: Doubleday & Co., 1976.

Vivian, A. Pendarves. *Wanderings in a Western Land.* London: Sampson, Low, Marson, Searle, and Rivington, 1879.

Vorpahl, Ben Merchant. *My Dear Wister.* Palo Alto, Calif.: American West Publishing Co., 1972.

Wainwright, Nicholas B. "Joseph Harrison, Jr., a Forgotten Art Collector." *Antiques* 102 (October 1972): 660–668.

Weinberg, H. Barbara. "Thomas B. Clarke: Foremost Patron of American Art from 1872 to 1899." *American Art Journal* 8, no. 1 (May 1976): 52–83.

West, John O. *Tom Lea: Artist in Two Mediums.* Southwest Writers Series, no. 5. Austin: Steck-Vaughn Co., 1967.

West Comes East: Frontier Painting and Sculpture from the Amon Carter Museum. Worcester, Mass.: Worcester Art Museum, 1979.

White, Edward C. *The Eastern Establishment and the Western Experience.* New Haven: Yale University Press, 1968.

Whittredge, Worthington. "The American Art Union." *Magazine of History* 7 (February 1908): 66.

Whyte, Jon, and E. J. Hart. *Carl Rungius: Painter of the Western Wilderness.* Salem, N.H.: Salem House, 1985.

Wilkins, Thurman. *Thomas Moran.* Norman: University of Oklahoma Press, 1966.

"[William Leigh] Natural Painter." *Time* 37 (March 10, 1941): 66.

Willis, S. A. [Sid]. *Souvenir Illustrated Catalog: The Mint, Great Falls, Montana.* Reprint, 1978.

Wilson, Raymond L. "Painters of California's Silver Era." *American Art Journal* 16, no. 4 (Autumn 1984): 71–92.

Woods, Miriam Carroll. "Joshua Shaw (1776–1860): A Study of the Artist and His Paintings." M.A. Thesis, University of California, Los Angeles, 1971.

Woolaroc. Bartlesville, Okla.: Woolaroc Museum, n.d.

The Woolaroc Story. Bartlesville, Okla.: Woolaroc Museum, n.d.

Yost, Karl, and Frederic G. Renner. *A Bibliography of the Published Works of Charles M. Russell.* Lincoln: University of Nebraska Press, 1971.

Young, M. S. "The Ugliest Thing I Ever Saw." *Apollo* 85 (April 1967): 297.

Index

Abadie, Felicidad A., 126
Aboriginal Hunter (Brown), 31
abstract art, 164
Académie de la Grand Chaumière, 164
Académie Julian, 64
Adams, Alvin, 18
Adams, Ansel, 78
Agnew, Thomas, 184
Akin, Louis, 34
Alamo Tree, The (Hurd), 198
Alarm, The (Boyle), 31
Alert, The (Hansen), 124 n.2
Allan, George William, 12
Allied Artists of America, 148
American Art Union, 14, 15–16, 31, 160, 162, 184
American Chromos series, 132
American Museum of Natural History, 43
American Society of Illustrators, 70
Amon Carter Museum, 44, 46
Among the Sierra Nevada Mountains (Bierstadt), 18
Anderson, John A., 94
Anheuser-Busch Brewing Company, 56
Anschutz, Philip F., 50
Anschutz, Thomas, 126
Antelope on Alert, Madison Valley, Montana (McIntyre), 199
Apache Campaign in the Sierra Madre, An (Bourke), 126
Apache Indians, 94, 124
Apache Medicine Song (Remington), 120
Arapahoe Camp (Chiriacka), 198
Arapahoe Indians, 192
Archaeological Institute of America, 21
Arizona (Groll), 28
Arrival of a Courier (Remington), 124
Arrival of a Courier—Arizona Territory (Remington), 124
Art Academy of Cincinnati, 40, 176
Art Institute of Chicago, 42, 70, 124, 144
Art Student's League, 68, 142, 182, 196
As It Was in the Beginning (Farny), 110
Ashley, Gen. William Henry, 58
Atchison, Topeka and Santa Fe Railroad, 35, 36
Attack of the Crows (Miller), 10
Attack on an Emigrant Train, The (Wimar), 66
Audubon, John James, 12
Ayer, Edward, 40
Ayer Indian Collection, 40
Ayres, Thomas A., 13, 16
Aztec Sculptor, The (Brush), 23

Baldwin, E. J. "Lucky," 43, 72
Baltimore and Ohio Railroad, 35
Banvard, J. J., 12
Barrie, Erwin, 47
Base of the Rocky Mountains, Laramie Peak, The (Bierstadt), 17
Bauer, Theodore, 31

Beach, William N. "Billy," 41
Bear River (Pleissner), 200
Beery, Noah, 38
Before the Battle (Brush), 23
Bell, Clive, 164
Bell, William A., 19
Bellows, George, 296
Beneath a Southern Moon (Johnson), 140
Benjamin, S. G. W., 18
Benton, Thomas Hart, 66
Berninghaus, Oscar E., 35, 36, 42, 54–59
Bertelli, Riccardo, 33
Bierstadt, Albert, 16, 17–18, 20, 41, 60–63, 128, 132, 194
Biltmore Salon, 42
Bingham, George Caleb, 13, 15, 16
Bisttram, Emil, 74, 78
Bit of Acoma, A (Sandor), 28
Blackfoot Indians, 36, 170
Blackmore, William, 19
Blizzard, The (Borglum), 32, 64
Bloomer, Hiram, 136
Blow, Henry T., 14
Blumenschein, Ernest, 36–37, 42
Boccioni, Umberto, 164
Bodmer, Karl, 10
Book of the Artists (Tuckerman), 12–13
Boone and Crockett Club, 41
Borein, Edward, 42, 70, 142
Borglum, Gutzon, 64
Borglum, Solon H., 32, 34, 64–65
Boundy, J. M., 66–67
Bourdelle, Antoine, 164
Bourke, Capt. John G., 124, 126
Bowles, Samuel, 128
Boyle, John, 31
Brangwyn, Frank, 70
Breaking Camp (Farny), 90–91
Breaking through the Circle (Schreyvogel), 28, 174–175
Brewer, Gardner, 17
Brewer, William H., 130
Brinton, Bradford, 43
Broder, Patricia Janis, 186
Bramley, Valentine Walter, 22, 23
Bronco Buster, The (Remington), 25, 33, 37, 38, 64
Brooklyn Museum, 42
Brown, Alexander, 10
Brown, Henry Kirke, 31
Brown, John G., 116
Brownlee, John A., 14
Brush, George de Forest, 21, 22–23, 24, 114
Bryant, William Cullen, 130
Buckaroo (Proctor), 32
Bucking Bronco, The (Borglum), 64
Buffalo Bill (Whitney), 32
Buffalo Crossing the Yellowstone (Wimar), 14
Buffalo Fine Arts Academy, 42

Buffalo Hunt (Shirlaw), 182–183
Buffalo Hunt, The (Bauer), 31
Buffalo Hunt, The (Russell), 33, 38
Buffalo Hunt, The (Wimar), 14
Buffalo on the Platte River (Whittredge), 194–195
Buffalo Signal, The (Remington), 33
Burbank, Elbridge Ayer, 40
Bureau of American Ethnology, 21, 40
Burlington Northern Railroad, 36
Burt, Charles, 162
Bush-Brown, Henry Kirke, 32
Butler, Joseph G., Jr., 40
Butler Institute of American Art, 40
Butman, F. A., 128

Caballos (Dick), 198
California College of Arts and Crafts, 192
California School of Design, 134
Campaña del Desierto: Rondin (Marenco), 199
Canadian Voyageurs (Deas), 15
Canyon de Chelly, N.M., 76
Canyon de Chelly (McIntyre), 199
Captive, The (Chiriacka), 68–69
Captive, The (Farny), 22
Captive Charger, The (Wimar), 14
Carey, Harry, 38
Caribou, Yukon Territory (Rungius), 28
Carnegie, Andrew, 40
Carson, Pirie & Scott (gallery), 42
Carter, Amon G., 45–46, 47, 48, 49
Carvalhol, Samuel, 9
Cather, Willa, 78, 192
Catlin, George, 10–12, 184, 190
Caught in the Act (Russell), 30
Cavalry Charge (Von Schmidt), 192
Cavalry Scrap, A (Remington), 27, 28, 37
Centennial International Exhibition, 20
Central Pacific Railroad, 35
Central Park (New York), 31, 41
Century Magazine, 22, 72, 84, 100, 112, 114, 124, 182 n.3
Century of Dishonor, A (Jackson), 21
Chapman, Charles S., 70
Chapman, John G., 180
Charging Panther (Proctor), 25
Chasing Buffalo (Eastman), 14
Chasm of the Colorado, The (Moran), 19
Cheyenne Chief (Fraser), 32
Cheyenne Indians, 96, 192
Cheyenne River Agency, S.D., 112
Cheyenne Tepees—Montana (Sharp), 176
Chiriacka, Ernest, 68–69, 198
Church, Frederic Edwin, 17
Cielo y Mar (Hinajosa), 198
Cincinnati Art Museum, 40
Cincinnati Art School, 64
Cincinnati Daily Gazette, 84
Cincinnati Museum Association, 42
Circuit Rider (Proctor), 32

Clark, Carol, 19
Clark, Sen. William A., 30
Clarke, Thomas B., 23
Clausen's (gallery), 42
Cleveland School of Art, 164
Clevenger, Shobal Vail, 31
cliff dwellings, 76
Closson Gallery, 42, 45, 47
Clymer, John, 51
Cody, Buffalo Bill, 29
Cody, Wyo., 32
Cole, Philip G., 38, 44, 48
collectors of western art, 37–39, 40–41. *See also names of specific collectors*
Collier's Magazine, 27, 42
Colman, Samuel, 18
Colorado Tourist, 35
Columbia River, 122–123, 128
Columbia River (Gaul), 122–123
Columbian Exposition, 20, 31, 32
Comanche Indians, 92
Come Out of There (Russell), 168
Coming through the Rye (Remington), 27, 32, 33, 34
Coming to the Rodeo (Remington), 27
Converse, Edmund Cogswell, 24
Cook, Clarence, 156
Cooke, George, 9
Cooke, Jay, 19
Cooper, James Fenimore, 190
Corcoran, William Wilson, 14
Corcoran Gallery of Art, 14, 34, 42
Cornwell, Dean, 70–71
Cortissoz, Royal, 26
Cosmopolitan, 68, 140
Council of the Chiefs (Farny), 92–93
Counting Coup (Russell), 33
Couse, E. Irving, 28, 36, 37 n.146, 45, 120, 136
Cow Range and Hunting Trail (Mackay), 38
Cowboy (Farny), 86
Cowboy, The (Remington), 27, 34
Cowboy on Horseback (Dixon), 36
Cowboy Race (Hansen), 124
Cowboy Standing by Horse Watching Indians (Hansen), 124
Cowboy with the Letter "H" (Farny), 86
cowboys: of Dixon, 74–75; of Eggenhofer, 82–83; of Farny, 86–87; in films, 25; of Hansen, 124; of Leigh, 148–149; of Russell, 166–169; in western art, 24–31, 39
Crane, Fred, 29
Crayon, The, 60
Creek Indians, 48
Cristadoro, Charles C., 25
criticism of western art, 26, 42
Crocker, Charles, 20
Crocker, Judge E. B., 16
Crook, Gen. George, 126
Cross, H. H., 29

Crossing, The (Farny), 108–109
Crow Indians, 94, 176, 178
Crow Lodges with Sweat Tipis (Sharp), 178
Cruze, James, 142
Cry for Help (Remington), 37
Cummins, D. Duane, 150
Currier and Ives, 162, 184, 190
Curtis, Edward S., 21, 122
Cushing, Frank, 21
Custer's Demand (Schreyvogel), 29, 174

Dakota Indians. *See* Sioux Indians
Dakota Indians (Gaul), 112–113
Dallin, Cyrus, 31, 32, 33, 34
Danger (Farny), 88
Darley, F. O. C., 182
Dasburg, Andrew, 44
Dash for the Timber, A (Remington), 24, 50
Davidson, William, 46
Deas, Charles, 13, 15, 18, 160 n.2, 190
Death Song, The (Shirlaw), 182 n.3
Death Struggle, The (Deas), 15
Defending the Stockade (Schreyvogel), 172
Deming, Edwin, 25, 28, 29, 42
Dentzel, Carl, 50
Denver and Rio Grande Railroad, 35, 54
Denver Civic Center, 32
Departure of Hiawatha (Bierstadt), 62
Derby, Charles, 15
desert landscapes, 78–81
Desert Ranges (Dixon), 78–79
Destiny of the Red Man (Weinman), 32
Detroit Institute of Arts, 42
Devereaux, French, 33
Dick, George, 198
Dispatch-Bearers, The (Schreyvogel), 172
Dixon, Maynard, 36, 42, 56, 58, 72–81, 192
Dobie, J. Frank, 78, 144
Dodge, Geraldine Rockefeller, 32
Doheny, Edward L., 43
Domes of Yosemite (Bierstadt), 17, 18
Donner Lake (Hill), 20
Donner Lake from the Summit (Bierstadt), 18
Drake, Alexander W., 19
Dresden Royal Academy, 188
Dressler, Bertha, 34, 35
Driving of the Last Spike, The (Hill), 20, 134
Duck Shooting (Ranney), 162
Dunn, Harvey, 42, 68, 70, 192
Dunraven, Earl of, 17–18, 22
Dunton, W. Herbert, 36, 45
Dusseldorf Academy, 66
Duvenek, Frank, 68
Dynamic Symmetry, 74, 78 n.1

Eakins, Thomas, 126
Early California (Harmer), 126–127
Early Start (Farny), 98
Eastern Sioux Indians, 10

Eastman, Seth, 13–14, 15, 18
École des Beaux-Arts, 22
Edmonds, Mrs. George Franklin, 19
Edmonson, Dr. Thomas, 10 n.6
egg tempera, 138
Eggenhofer, Nick, 82–83, 198
Eiteljorg, Harrison, 50
El Tovar Hotel, 35–36
El Tovar Hotel, Grand Canyon (Akin), 34
Elkins, Henry Arthur, 18
Emigrant Train, Colorado, The (Colman), 18
Emigrants, The (Remington), 37
End of the Trail, The (Fraser), 32, 33
Enroute to the Roundup (Eggenhofer), 82–83
Erich-Newhouse, Inc., Galleries, 45
Escape, The (Brush), 22
Esquire, 68
Evans, William T., 23, 26, 32
Exchange of Prisoners (Gaul), 116
expeditions exploring the West, 9–10, 12, 13

Failing, Henry, 23
Fairbanks, Douglas, 38, 142
Fairbanks, Horace, 18
Fairmount Park Art Association, 34
Fairmount Park Association, 31, 41
Farmhouse (Gute), 198
Farny, Henry, 21, 22, 23, 42, 45, 47, 84–111, 176
Fery, John, 36
Field and Stream, 140
Fight for the Water Hole, The (Remington), 27, 37
Findlay, David, 46
Fire Is a Friend, The (Gaul), 118, 120–121
Fired On (Remington), 26
First Ship, The (Chapman), 180
First Ship, The (Shaw), 180–181
Flathead Indians, 122
Folsom Galleries, 42
Force, Gen. M. F., 22
Forsythe, Clyde, 70, 142
Fort Worth Star-Telegram, 45
Fort Yates, N.D., 84
Foster, John, 62
Fox Indians, 10
Fraser, James Earl, 32, 33
Fred Harvey Company, 35–36
Free Public Library (Hoboken), 28
Fremiet, Emmanuel, 64
French, Daniel Chester, 34
Frenzeny, Paul, 84 n.3
Friend or Foe? (Gaul), 116–117
futurist principles of art, 164

galleries exhibiting western art, 42. *See also specific galleries*
Gaul, William Gilbert, 40, 112–123
General, The (Robus), 164–165
George Niedringhaus (gallery), 42
Gérôme, Jean-León, 22

Gilcrease, Thomas, 48–49
Gilder, Richard W., 19
Gisbert, L. de, 104
Git 'Em Out of There (Russell), 168–169
Going for Reinforcements (Schreyvogel), 172–173
Gold Rush, 70–71
Golden, Samuel, 196
Golden Hour, The (Moran), 156–157
Goodrich, Arthur, 64
gouache paintings, 84
Grand Canyon of the Colorado River, The (Moran), 34
Grand Canyon of the Yellowstone, The (McIntyre), 199
Grand Canyon of the Yellowstone, The (Moran), 18, 19, 156
Grand Central Gallery, 47
Grand Central School of Art, 68, 192
Grant, Gen. U. S., 96
Gray, Zane, 25, 140
Great Depression, 45–49
Great Divide, The (Dunraven), 22
Great Northern Railroad, 36, 43
Greely Grum outfit, Judith Gap, Mont., 166
Green River, Wyo., 156
Groll, Albert, 23, 28
Grozelier, Leopold, 66
Gulf States Paper Corporation, 50
Gute, Herbert, J., 198

Hahn, William, 16
Hale, Phillip, 26
Halt on the Prairie (Ranney), 160–161
Hambidge, Jay, 74, 78 n.1
Hamilton, W. T., 30
Hamlin, Edith, 76, 78, 80
Hansen, Herman Wendelborg, 124–125
Happy Hunting Ground, The (Leigh), 43
Harbaugh, Thomas ("Captain Howard Holmes"), 25
Harmer, Alexander Francis, 42, 126–127
Harmer, Douglas, 126
Harmsen, William and Dorothy, 50
Harper's Weekly, 19, 22, 24, 30, 42, 84, 112, 118, 126, 140, 176
Harper's Young People, 84, 88
Harriman, Mrs. E. H., 43
Harrison, Carter H., Jr., 43–44
Harrison, Joseph, 11
Hart, William S., 25, 31 n.111, 38
Hartley, Marsden, 44
Harvest Dance, The (Sharp), 40
Harvey, Eli, 142
Harwood, Mr. and Mrs. Burt, 44
Hayden, Ferdinand V., 9, 18, 19
Hearst, Phoebe Apperson, 40, 176
Hearst, William Randolph, 27, 33, 40
Heinie, F. W., 142
Hennings, E. Martin, 43, 44

Henri, Robert, 68, 142, 196
Hepburn, A. Barton, 26–27, 33
Herbert, Victor, 126
Herd Boy, The (Remington), 37
Herron Art Institute, 42
Hewling, R. B. A., 15
Heye, George G., 23
Higgins, Victor, 36, 37, 43, 45
Hill, Louis W., 36
Hill, Thomas, 16, 18, 20, 130–135
Hillers, John K., 100
Hinajosa, Chajo, 198
Hinkle, Mr. and Mrs. A. Howard, 22, 104 n.1
His First Lesson (Remington), 45, 46
His Right Hand with the Palm Up to Show That He Was Peaceful (Farny), 88
Hogg, Stephen, 37
Hogg, William C., 37–38, 44
Hold Up, The (Russell), 30
Holdredge, Ransome Gillet, 18, 136–137
Holmes, Capt. Howard, 25
Holmes, William Henry, 19, 20, 40
Homeward (Farny), 110–111
Hopi Indians, 72, 74
Hopi Transportation (Leigh), 150–151
Hornaday, William T., 41
horses, 54, 64, 150–151
Hot Day, A (Leigh), 150–151
How Noiseless Falls the Tread of Time (Pleissner), 200
Howard, John, 27
Hudson River School, 154
Humber, Robert Lee, 48
Hunter and His Dog, The (Gaul), 118–119
hunting scenes, 118–119, 162–163, 184–185
Hunting Wild Hogs in Arkansas (Gaul), 118
Huntington, Colis P., 18
Huntsman with Deer, Horse, and Rifle (Tait), 184–185
Hurd, Peter, 138–139, 198
Hutchings, James, 134

I Well Remember (Ufer), 188–189
Illustrated London News, 22
In the Heart of the Sierras (Hutchings), 134
In the Wind (Borglum), 64
In without Knocking (Russell), 30
Indian Attack on St. Louis, The (Wimar), 15
Indian Canoe (Bierstadt), 62–63
Indian Chief (Clevenger), 31
Indian cliff dwellings, 76
Indian culture, 21, 23, 72, 74
Indian Encampment, Yosemite Valley (Hill), 128
Indian Family (Gaul), 112
"Indian galleries," 11–12, 13
Indian Girl (Palmer), 31
Indian Hunter, The (Ward), 31
Indian Hunting Buffalo (Bush-Brown), 32
Indian Hunting Buffalo (Shirlaw), 182

Indian Hunting Buffalo (Wimar), 15
Indian paintings, 9; of Bierstadt, 60–63; of Brush, 21, 22–23; of Burbank, 40; of Chiriacka, 68–69; of Couse, 120; of Dixon, 72–73; of Farny, 21, 84–85, 88–111; of Gaul, 112–117, 120–123; of Hill, 128–129, 132–133; of Holdredge, 136–137; of Johnson, 142–143; of Miller, 154–155; of Narjot de Franceville, 158–159; of Remington, 120; of Russell, 170–171; of Sharp, 120, 176–177; of Shaw, 180; of Shirlaw, 182–183; of Ufer, 186–189; of Von Schmidt, 192–193
Indian Spearing Fish (Eastman), 14
Indian Tilting at Scalp Pole (attributed to Sharp), 182 n.3
Indians, 36, 40, 92, 112, 120, 182
Indians Approaching Fort Union (Wimar), 14
Indians at Campfire, Yosemite Valley, California (Hill), 132–133
Indians of the Northwest (Hill), 128–129
Ingersoll, T. W., 25
Inman, Henry, 9 n.4
Inness, George, 19
Iowa Indians, 11
Isaac Stevens Expedition, 13
Isham, Samuel, 42
Issue Day at Standing Rock (Farny), 84–85
Issuing Government Beef (Gaul), 112 n.4

J. H. Bufford and Sons, 66
J. W. Young Gallery, 42
Jack-Rabbit Hunting in Southern California (Gaul), 118
Jackson, Harry, 51
Jackson, Helen Hunt, 21
Jackson, William Henry, 19, 20, 130
James, Edwin, 10
Jefferson City, Mo., 45, 58
Jicarilla Apaches, 192
Johnson, Frank Tenney, 42, 70, 140–143, 148
Johnson, Lyndon B., 138
Jolly Flatboatmen by Moonlight (Wimar), 14
Jones, Charles S., 47
Judith Basin area, Mont., 168
Jumped (Russell), 170

Kane, Paul, 12, 190
Keith, William, 13, 16
Kemeys, Edward, 41
Kennard, Thomas William, 17
Kennedy Galleries, 48
Keppel & Co. (gallery), 42
Kern, Richard, 9
Keuffel, William L., 28
King, Charles Bird, 8, 9, 50
Kiowa Indians, 92
Kirchbach, Johann F., 172
Knoedler, M. K., 45
Knoedler's (Gallery), 26, 27, 29, 42, 46, 48

Knox, Philander, 42, 126
Koerner, W. H. D., 42

Lachaise, Gaston, 164
Lacrosse Playing among the Sioux Indians (Eastman), 14
Lambelet, Henry, 28
Lame Dog and His Horse (Anderson), 94
Land of the Free, The (Gaul), 114–115
Lander, Col. Frederick, 60
Landscape and Indians (Eastman), 14
Landscape with Children (Farny), 98
landscapes: of Bierstadt, 17–18; of Hill, 20,
 128–135; of McIntyre, 152–153; of Miller, 154;
 of Moran, 18–19, 156–157; of Whittredge,
 194–195
Lange, Dorothea, 72, 76
La Salle (Farny), 110
Lassoing Wild Horses (Borglum), 64–65
Last Arrow, The (Rogers), 33
Last Cavalier, The (Remington), 25
Last Lull in the Fight, The (Remington), 24
Last of the Buffalo (Bierstadt), 17
Last Stand, The (Remington), 142
Laurent, Robert, 164
Lea, Tom, 45, 144–147, 199
Lead Steer, The (Lea), 199
Leigh, William Robinson, 35, 42, 43, 47, 48,
 148–151
Lenders, E. W., 29
Lennox, James, 17
Leopold, King of Belgium, 42
Leslie's Illustrated Weekly, 21, 30, 116
Lessing, Carl, 98
Leutze, Emanuel, 16
Lewis, Henry R., 12, 29 n.101
Lewis, James Otto, 9 n.4
Lewis and Clark expedition, 9
Lewis and Clark Meeting Indians at Ross's Hole
 (Russell), 43
Life Magazine, 138, 146
Lighter Relieving a Steamboat Aground (Bingham), 15
Lillie, Gordon W. (Pawnee Bill), 29–30
Lincoln Park (Chicago), 31, 32
Linde, John, 28
Little Shade, A (Lea), 146
Lockwood, Legrand, 17
Lodge, Henry Cabot, 41
Loma Hinma, 72
Long expedition (1819–1820), 10
Long Expedition, The (James), 10
Longfellow, Henry Wadsworth, 62
Longhorn Ranch, Madison Valley, Ennis, Montana
 (McIntyre), 152–153
Long's Peak, Estes Park Colorado (Bierstadt), 18
Lorenz, Richard, 142
Lorimer, George Horace, 35 n.136
Los Angeles Public Library, 70

Louis Philippe (France), 11
Louis Prang and Company, 132, 184
Louisiana Purchase Exposition, 20, 32
Ludwig, Adolf, 28
Lummis, Charles, 72, 73 n.5, 126
Lyons, Lord, 14

MacBeth Gallery, 42
McClaughry, Anita Baldwin, 43, 72
McClure's, 30, 72
McHenry, James, 17
McIntyre, Peter, 152–153, 199
Mackay, Malcolm S., 38, 39
McKenney, Thomas L., 9
MacMonnies, Frederick, 64
McNay, Marion Koogler, 45
MacNeil, Hermon, 32
Making Medicine (Couse), 28
Maldarelli, Oronzio, 164
Mallards in Flight (Shackleton), 200
Mandan Indians, 10
Marenco, E., 199
Marland, Ernest, 46
Marr, Carl, 172
Mason, E. R., 14
Mastin, T. H., 24
Maurer, Louis, 184
Maximilian, Prince Alexander Phillip, 10
Maximilian-Bodmer collection, 50
Mayer, Oscar, 43, 44
Medicine Man (Russell), 170–171
Medicine Man, The (Dallin), 31, 34
Mellen, William, 30
Men of the Field (Lea), 146
Mentor Magazine, 148
Meriden Britannia Company, 31
Mexican Major, The (Remington), 27
Mexican Nocturne (Johnson), 140
Mexican Revolutionaries (Johnson), 140–141
Mexican Smuggler, A (Johnson), 140
Meyers, F. H., 192
Milch Gallery, 42
Miles, Gen. Nelson, 24, 27
military scenes: of Gaul, 116–117; of Hansen,
 124; of Schreyvogel, 172–175
Millard, Joseph, 192
Miller, Alfred Jacob, 10, 50, 58, 154–155, 190
Mills, D. O., 18
Mirabel, Jim, 188
Missouri Freighters (Eggenhofer), 198
Mix, Tom, 25
Modern Art School, 164
Mofchum, Gerald, 200
Moffat, Yard & Company, 29
Monet, Claude, 54
Montana, 43
Montana Antelope (McIntyre), 199
Montana Encampment (Holdredge), 136–137
Montana Historical Society, 48

Montana Magazine, 170
Moody, W. L., III, 46
Moose Chase, The (Brush), 23
Moran, Peter, 40, 112
Moran, Thomas, 18, 19, 23, 34, 35, 42, 48, 130,
 148, 154, 156–157, 194
Morning in the Mining Camp (Berninghaus),
 54–55
Mouiseau (Farny), 86
Mount, William Sidney, 162
Mt. Hood (Stanley), 128
Mt. of the Holy Cross, Colorado (Hill), 130–131
Mountain Men, The (Remington), 34
mountain men paintings, 54, 58–59
Mountain of the Holy Cross (Moran), 19, 130
Mourning Her Brave (Brush), 22, 23, 114
Muir, John, 134
Munich Royal Academy, 172
Munsey's, 72
murals, 42–43, 70, 72, 74, 144
museums dedicated to western art, 50, 51
Mustangs (Proctor), 32
Muster-Day on an Indian Reservation
 (Frenzeny), 84 n.3
My Bunkie (Schreyvogel), 28, 172

Nadelman, Elie, 154
Nahl, Charles Christian, 13, 16
Namoki, Hopi Snake Priest (Dixon), 72–73
Narjot de Franceville, Ernest Etienne, 158–159
National Academy of Design, 31; Chiriacka and,
 68; Gaul and, 112, 116; Hurd and, 138; Ranney
 and, 162; Remington and, 24; Robus and, 164;
 Schreyvogel and, 172; Sharp and, 178; Shirlaw
 and, 182; Whittredge and, 194
Natoma (Herbert), 126
Navajo Burro (Leigh), 150–151
Navajo Pony (Leigh), 150–151
Navajo Raid, The (Remington), 43
Navajo Reservation, Keams Canyon, 150
Neimerdinger, Professor, 124
New York Tribune, 26, 156
New York Zoological Society, 41
Newark Art League, 172
Newhouse, Bertram, 45, 46
News from the Front (Hansen), 124–125
Nez Perce Indians, 122
nocturnal scenes, 140
Noe (gallery), 42
North, J. T., 17
Northern National Gas Company (Enron), 50
Northern Pacific Railroad, 35
Norton, John, 144
Nude (Mofchum), 200

O'Brien's (gallery), 42
Odessa, Tex., 144
O'Fallon, Maj. Benjamin, 10
O'Keeffe, Georgia, 44

Old King Cole (Parrish), 27
"Old Timer," An (Farny), 86–87
Old Timer, An (Ritschel), 28
Olmsted, Frederick Law, 132
Omaha Dance (Shirlaw), 182
On the Alert (Farny), 106–107
On the Plains, Colorado (Whittredge), 18
On the Prairie (Grozelier), 66
On the Warpath (Narjot de Franceville), 158–159
On the Wing (Ranney), 162
Oregon Trail (Berninghaus), 56–57
Oregon Trail, The (Parkman), 56
O'Sullivan, Timothy, 76
Our New West (Bowles), 128
Out West Magazine, 126
Outing, 30
Over a Dangerous Pass (Schreyvogel), 172

Pahauzatanka, the Great Scalper (Bromley), 23, 24
Palmer, Erastus Dow, 31
Palmer, Fanny, 184
Palmer, Joel, 56
Panama-Pacific International Exposition, 32, 74
panels and murals, 42–43. *See also* murals
Paramount Studio, 68
Paris International Exposition, 24
Parkman, Francis, 41, 56
Parley, The (Remington), 38
Parrish, Maxfield, 27
Pass, The (Farny), 100–101
Pass of the North (Lea), 45, 144
Passing of the Buffalo or The Last Arrow, The (Dallin), 32
Passing of the Nations (Harmer), 126
Pawnee Bill. *See* Lillie, Gordon W.
Peace Be with You (Farny), 88–89
Peale, Titian Ramsay, 9
Pell, Henry W. S., 33
Pellat, Sir Henry Mill, 30
Pennsylvania Academy of Fine Arts, 126, 138
Phillips, Bert Geer, 36
Phillips, Sir Thomas, 11
Picacho Valley, Chavez Ranch (Hurd), 138–139
Picture Writer's Story, The (Brush), 23
Picturesque America, 19
Piegan Indians, 170
Pioneer (Proctor), 32
Plains Indians, 176
Pleissner, Ogden, 200
Polassas, Ariz., 150
Pomarede, Leon, 12
Pony Express Rider (Hansen), 124
Poore, Henry R., 40, 112
Pope, Gen. John, 194
Porter, Edwin S., 25
Porter, Mae Reed, 50
Portland, Ore., 32
Powell, John Wesley, 21

Prairie Fire, The (Anonymous), 190–191
Prairie on Fire, A (Kane), 190
Prang, Louis, 19
Pratt, Harry Noyes, 124
Primal Yoke, The (Lea), 146
Proctor, A. Phimster, 25, 32
Proctor, W. C., 22
Protecting the Emigrants (Schreyvogel), 28
Pueblo of Taos (Higgins), 36, 37
Pummill, Robert, 51
Pyle, Howard, 27, 192

Race, The (Shirlaw), 182
railroad companies, 35–37. *See also specific companies*
ranchers and farmers, 146–147
Randsburg (Dixon), 80–81
Ranney, William, 13, 15, 16, 38, 58, 118, 160–163, 190
Ration Day at Standing Rock (Farny), 84
Ray, Anne, 104
Rearing Stallion (Wickey), 196
Reaugh, Frank, 42
Rebisso, Louis, 64
Redford, Robert, 58
Remington, Frederic, 21, 23, 24, 25–28, 32, 33–34, 37, 38, 42, 43, 45–46, 50, 51, 56, 58, 64, 74, 84, 116, 120, 124, 142, 174
Renner, Fred, 50
Rentschler, George, 45
Report on Indians Taxed and Indians Not Taxed, 40, 92, 182
Rescue at Summit Springs (Schreyvogel), 29
Restlessly at Home (Sharp), 178–179
Retrieve, The (Ranney), 162
Return of a Blackfoot War Party (Remington), 24
Returning the Stray (Ufer), 186–187
Revenge, The (Brush), 22, 23
Richardson, Sid, 46, 49
Ritschel, Will, 28
Robert H. Lowie Museum of Anthropology, 40, 176
Roberts, Marshall O., 13, 17
Robus, Hugo, 164–165, 200
Rocky Mountains, The (Bierstadt), 62
Rocky Mountains, Lander's Peak, The (Bierstadt), 17
Rogers, Randolph, 33
Rogers, Will, 38, 39, 45, 46, 47
Roman Bronze Works, 33
Roosevelt, Theodore, 25, 40, 41, 174, 176
Roping, The (Leigh), 47, 148–149
Roping 'Em (Russell), 168 n.3
Rough Rider, The (Borglum), 64
Royal Academy, London, 124
Royal Institute, London, 184
Rungius, Carl, 28, 41
Ruppert, Jacob, 37 n.147
Ruskin, John, 156

Russell, Charles M., 21, 30, 31, 33, 38, 42, 43, 45, 47, 51, 58, 70, 74, 80, 142, 166–171
Russell, Nancy, 31, 38, 170
Ryder, Worth, 192
Ryerson, Martin, 31

St. Louis, Mo., 14–15
St. Louis Gazette and Public Advertiser, 58
Saint-Gaudens, Augustus, 64
Salem, Ore., 32
Salton Sea, Calif., 78
Sammann, Detlief, 43
San Francisco Art Association, 158
San Francisco Art Institute, 192
San Francisco Chronicle, 124
San Francisco Peaks (Dressler), 34, 35
San Patricio, N.M., 138
Sandor, Mathias, 28
Saturday Evening in the Mines (Nahl), 16
Saturday Evening Post, 42, 68, 192
Sauk Indians, 10
Scalp Dance, The (Russell), 33
Scatter Out and Head 'Em Off (Leigh), 148 n.1
Schafer, Frederick, 18
Schoolcraft, Henry, 14
Schreyvogel, Charles, 28–29, 116, 172–175
Schurz, Carl, 41
Schwabe, August, 28
Scott, Julian, 40, 112
Scribner's, 19, 42, 72, 136
Sculptor and the King, The (Brush), 23
sculpture, 31–34, 41, 64–65, 164–165, 196–197
Seltzer, Olaf, 38
Sentinel Ranch, San Patricio, N.M., 138
Seymour, Samuel, 9, 10
Shackleton, Keith, 200
Sharp, Joseph Henry, 36, 40, 42, 120, 176–179
Shaw, Howard, 32
Shaw, Joshua, 180–181
Sheep Shearing in the Bavarian Highlands (Shirlaw), 182
Sheldon, George W., 19, 24, 156
Shirlaw, Walter, 40, 112, 182–183
Signal of Peace, The (Dallin), 32
Signe de Paix, Le (Farny), 104–105
Simmonsen, Professor, 124
Simpson, William, 35, 36–37
Sioux Camp (Gaul), 112
Sioux Indian Buffalo Dance, The (Borglum), 32
Sioux Indians, 84, 94–96, 112–115
Sioux Indians (Farny), 94–95
Sioux Village near Fort Laramie (Bierstadt), 60–61
Sitting Bull (Farny), 96–97
Slade School of Art, London, 152
Slick Ear, The (Russell), 166–167
Sloan, John, 44
Smile, A (Robus), 200
Smith, C. R., 6, 47–48, 49, 58, 144, 146, 152, 170, 192

Smith, John R., 12
Smithsonian Institution, 8, 9, 11, 13
Smoke Makes Rest (Farny), 102–103
Snake Dance of the Moquis of Arizona, The
 (Bourke), 126
Snedecor Babcock Gallery, 148
Snow Trail, The (Russell), 43
Southern Pacific Railroad, 35, 36
Spaulding, Don, 51
Spokan Indians, 122
Spotted Bird That Sings (Sharp), 40
squaws, 114–115, 178–179
Stampede (Lea), 45, 144–145, 146
Standing Rock Reservation, N.D., 84, 112
Standing Them Off (Schreyvogel), 28
Stanford, Leland, 18, 20, 158
Stanley, John Mix, 13, 18, 128, 190
Stephens, Charles S., 29
Stevenson, James, 19
Stewart, Capt. William Drummond, 10, 154
Still Hunt (Kemeysz), 41
Still Hunting on First Snow (Tait), 184
Stobie, Charles S., 29 n.101
Stoddard, William, 88
Stoic of the Plains (Russell), 170
Strauss, J. C., 42
Sturgis, Russell, 19
Sulking Bull (Wickey), 196–197
Sun Vow, The (MacNeil), 32
Sunday Morning in the Mines (Nahl), 16
Sunset Magazine, 192
Sweat Lodge (Sharp), 176

Tait, Arthur Fitzwilliam, 118, 184–185, 190
Tamer, The (Eastman), 14
Taos Pueblo Indians, 176
Taos Society of Artists, 36, 43, 44, 54, 178, 188
Teal, Joseph, 32
Teddy Roosevelt (Ingersoll), 25
Teddy Roosevelt as a Rough Rider (Proctor), 32
Thornburgh, Maj. Thomas T., 142
Thornburgh's Battlefield (Johnson), 142–143
Thus Far: The Growth of an American Artist
 (Wickey), 196
Tiffany's, 33
Time magazine, 50, 138
Timken, Herman L., 29
Toilers of the Plains, The (Deming), 28
Toning the Bell (Shirlaw), 182
Top of the Ridge (Dixon), 74–75
trappers, 160–161. *See also* mountain men
Trappers around a Campfire with the Wind River
 Mountains of the Rockies in the Background (Mil-
 ler), 10
Trapper's Last Shot, The (Ranney), 160
Traveling by Full Moon, Winter (Farny), 102
Travois (Harmer), 42
Tree, Judge Lambert, 32
Trial of Red Jacket, The (Stanley), 13

Trotsky, Leon, 186
True Magazine, 192
Tuckerman, Henry T., 12–13, 15, 17, 31, 162, 194
Twachtman, John, 142
Twentieth Century-Fox Studio, 68

Ufer, Walter, 36, 43–44, 45, 186–189
Uncle Dick Wootton—Indian Trader (Von
 Schmidt), 192–193
Union Pacific Railroad, 35, 41
University of Oregon, 32
University of Texas at Austin, 32
Unsung Hero, the Mountain Man, The (Berning-
 haus), 58–59
Ute Indians, 142, 172, 192

Van Zandt, William, 14
Vaqueros and Bull (Anonymous), 200
Verrazzano, Giovanni, 180
View of the Rocky Mountains on the Platte 50 Miles
 from Their Base (Seymour), 9, 10
Villa, Pancho, 144
Von Schmidt, Harold, 192–193
Vose, Robert, Sr., 31
Vose Gallery, 42
Voyageurs, The (Deas), 15

wagon trains, 56–57, 66–67
Wales, Prince of, 30, 150
Walla Walla Indians, 122
Walters, William T., 10, 11, 154
Wanderers of the North (Rungius), 28
Wanderings of an Artist among the Indians of North
 America (Kane), 12
War Bridle, The (Remington), 26
Ward, John Quincy Adams, 31
Warner Brothers Studio, 68
Watkins, Carleton E., 128, 132
Weadick, Guy, 82
Weak Never Started, The (Boundy), 66–67
Wealth of 1849 (Cornwell), 70–71
Weinman, Adolph, 32
West, Benjamin, 180
Westcott, James D., 11
Western Academy of Art, 14
Western Art Union, 13, 14
western films, 25, 58, 142
Western Kansas (Bierstadt), 20
Western Pony, The (Leigh), 150
westward expansion, 56, 58
Westward the Course of Empire Takes Its Way
 (Leutze), 16
What an Unbranded Cow Has Cost (Reming-
 ton), 25
Wheeler, Edward, 25
When Law Dulls the Edge of Chance (Russell), 30
White Eagle (Schreyvogel), 29
Whitney, Gertrude Vanderbilt, 32
Whitney, Josiah, 62

Whitney Gallery of Western Art, 48
Whittredge, Thomas Worthington, 15, 18,
 194–195
Wickey, Harry, 196–197
Wild Duck Shooting—On the Wing (Ranney),
 162–163
Wild Horses (Ranney), 13
Willenborg, Carl, Sr., 28
William Findlay (gallery), 42
William S. Hart (Cristadoro), 25
Williams, Virgil, 132, 134
Willis, S. A. "Sid," 30, 46, 48
Wilmarth, Lemuel E., 116
Wilson, O. J., 33
Wimar, Charles, 13, 14–15, 16, 66–67, 190
Winchester Repeating Arms Company, 28
Wind River Country (Bierstadt), 17
Wind River Mountain Range Scene (Miller), 154–
 155
Windsor, Duke of, 42
Winter Encampment on the Plains (Sharp), 176
Winter's Coming On (Sharp), 176–177
Winthrop, Robert Dudley, 26
Wister, Owen, 25, 29, 39, 41
Wolves (Kemeys), 41
Wonderful Country, The (Lea), 146
Wooten, Richens Lacey, 192
Works Progress Administration, 45
Wounded Buffalo, The (Wimar), 14
Wunderlich, Rudolf, 48
Wurlitzer, Rudolph, 22
Wyeth family, 138

Yakima Indians, 122
Year It Rained, The (Lea), 146–147
Yeatman, James C., 14, 15
Yosemite, The (Hill), 134–135
Yosemite Valley, 17, 18, 20, 130, 132
Yosemite Valley (Hill), 132
Yo-semite Valley, The (Hill), 20
Yosemite Winter Scene (Bierstadt), 18
Young Boar (Wickey), 196

Zion Park, Utah (Dixon), 76–77
Zogbaum, Rufus, 21
Zorach, William, 164